Small Bronze Sculpture from the Ancient World

Small Bronze Sculpture from the Ancient World

Papers Delivered

at a Symposium Organized

by the Departments of

Antiquities and

Antiquities Conservation

and Held at the

J. Paul Getty Museum

March 16–19, 1989

The J. Paul Getty Museum

Malibu, California

1990

© 1990 The J. Paul Getty Museum
17985 Pacific Coast Highway
Malibu, California 90265-5799
(213) 459-7611

Mailing address:
P.O. Box 2112
Santa Monica, California 90406

Christopher Hudson, Head of Publications
Andrea P. A. Belloli, Consulting Editor
Cynthia Newman Helms, Managing Editor
Karen Schmidt, Production Manager
Leslee Holderness, Sales and Distribution Manager

Library of Congress Cataloging-in-Publication Data:

Small bronze sculpture from the ancient world : papers
delivered at a symposium held at the J. Paul Getty Museum, March
16–19, 1989 / organized by the departments of Antiquities and
Antiquities Conservation.
 p. cm.
 ISBN 0-89236-176-X (paper)
 1. Bronze figurines, Ancient. 2. Small sculpture, Ancient.
I. J. Paul Getty Museum. Dept. of Antiquities. II. J. Paul Getty
Museum. Dept. of Antiquities Conservation.
NK7907.B88 1990
730′.093—dc20 90-5002

Project staff:
Editors: Marion True and Jerry Podany
Manuscript Editor: Benedicte Gilman
Editorial Assistant: Mary Holtman
Designer: Sheila Levrant de Bretteville
Design: The Sheila Studio
Production Coordinator: Lark Zonka

Typography by Wilsted & Taylor
Printed by Alan Lithograph, Inc.

ISBN 0-89236-176-X

Cover: Bronze hydria. Greek, circa 460 B.C. Malibu,
The J. Paul Getty Museum inv. 73.AC.12.
Photo courtesy The Metropolitan Museum of Art.

Contents

Foreword

These essays are the proceedings of a three-day symposium on ancient bronzes held in March 1989 at the Getty Museum. International symposia of this kind have become an important part of life at the Getty, the Antiquities Department alone having sponsored four: *The Amasis Painter and His World* (1986), *Marble: Art Historical and Scientific Perspectives on Ancient Sculpture* (1988), the present event, and *Chalcolithic Cyprus* (1990).

The topic for this symposium was prompted by an exhibition of small bronzes from antiquity, *The Gods Delight*, organized by the Cleveland Museum of Art, the Museum of Fine Arts, Boston, and the Los Angeles County Museum of Art. Marion True, the Getty's Curator of Antiquities, contributed an essay and entries to the exhibition catalogue and saw an opportunity to organize a meeting that would draw together specialists in archaeology, conservation, science, and classical studies to examine the production of ancient bronzes from many different points of view. She worked hand in hand with Jerry Podany, Conservator of Antiquities and her frequent collaborator on projects, and received invaluable help from our colleagues at the Getty Conservation Institute.

The result was a remarkable meeting by any standards. Taken together, the papers give an up-to-date summary of the state of most technical questions about metallurgy, techniques of bronze-making and finishing, chemical changes undergone by bronze with the passage of time, and the possibilities and limits of technical analysis. Some papers demonstrate that the well-sharpened instincts of collectors and curators can be the most valuable tools of all. And several other papers fit together with uncanny neatness, although they were not planned that way: It is as though Helmut Kyrieleis's Egyptian finds on Samos were made to help validate Robert Bianchi's thesis that the Greeks did not need to look to the ancient Near East for bronze-casting techniques but could learn them from the Egyptians, whose stone sculptures we know the Greeks already emulated. Still other papers revealed our own blind spots. Because we were conditioned by an ideal of truth to materials, we for centuries ignored the evidence that in

antiquity bronzes were painted, Hermann Born points out. Nor could we understand why the Riace bronzes, like other near-duplicate pairs in bronze, resembled each other so closely, writes Carol Mattusch, as she demonstrates that the conception of originality we apply to Greek sculptors is an anachronism.

To each of the authors I offer our warm gratitude. And to the organizers of the symposium and of these proceedings, Marion True and Jerry Podany, I express my admiration for the devotion they have brought to this project, as they have to so many others. The staffs of the departments of Antiquities and Antiquities Conservation deserve our acknowledgment for helping to organize the symposium and this publication.

John Walsh
Director

Dr. Heinz Menzel: In Memoriam

David Gordon Mitten

By the death, on January 2 of this year, of Dr. Heinz Menzel, we have lost the scholar who through his scholarship and leadership began the international movement to study and publish the bronzes of Roman Europe. Through his crucial assistance in securing the loans of Roman bronze statuettes from German, Swiss, French, and Belgian museums for the exhibition *Master Bronzes from the Classical World* (1967) and his contributions to the catalogue for that exhibition and to the proceedings of the symposium that accompanied it, *Art and Technology: A Symposium on Classical Bronzes* (1970), Menzel first brought the aesthetic, cultural, and technological importance of these bronzes to the attention of scholars and connoisseurs in North America. Shortly afterward, he convened a modest conference of bronze scholars in Mainz, the second of a series of biennial "Bronze Congresses," which have met regularly since then; the eleventh is scheduled to take place in Madrid in late May 1990. Each meeting has produced full proceedings of the rich variety of papers that participants from many European countries, east and west, and from North America, have presented; a number were also accompanied by major exhibitions, such as *Guss und Form* (Vienna, Kunsthistorisches Museum, 1986).

Menzel's scholarly energies centered upon the writing of definitive catalogues of major German collections of Roman bronzes. From fragments of monumental bronze sculptures to statuettes, vessels and their attachments, lamps, armor, and utensils, the three volumes of *Die römischen Bronzen aus Deutschland* (Speyer, Trier, and Bonn) served as models for a grand design: the publication of similar catalogues of Roman bronzes in Swiss, French, Austrian, Dutch, and Belgian collections, an effort that continues today. Menzel's article "Römische Bronzestatuetten und verwandte Geräte: Ein Beitrag zum Stand der Forschung," in *Aufstieg und Niedergang der römischen Welt*, provides a masterful summary and synthesis of what we have learned about the subjects, places of manufacture, and uses of bronze statuettes in the societies of the western and northern provinces of the Roman Empire. In addition, his *Antike Lampen im Römisch-Germanischen Zentralmuseum zu Mainz* (second revised edition, 1969) remains a

fundamental reference source for all students of Greek and Roman lamps.

A person of quiet cordiality, exemplary collegiality, and unfailing scholarly energy, Menzel would have enjoyed and participated actively in this conference. The vigorous and growing activity and diversity of classical bronze studies in Europe and North America today constitute a fitting tribute to his scholarly achievement and leadership and will continue to promote his research goals. We shall miss him very much.

A SELECTED BIBLIOGRAPHY OF THE
WORKS OF HEINZ MENZEL

"Zur Entstehung der C-Brakteaten," *MZ* 44/45 (1949/1950), pp. 63–66.

"Elfenbeinrelief mit Tensa-Darstellung im Römisch-Germanischen Zentralmuseum," *MZ* 44/45 (1949/1950), pp. 58–62.

"Lampen im römischen Totenkult," in H. Klumbach, ed., *Festschrift des Römisch-Germanischen Zentralmuseums, Mainz*, vol. 3 (Mainz, 1952), pp. 131–138.

Antike Lampen im Römisch-Germanischen Zentralmuseum zu Mainz (1954; 2nd rev. and enlarged edn., Mainz, 1969).

"Römische Bustengewichte im historischen Museum der Pfalz," *Mitteilungen des Historischen Vereins der Pfalz* 58 (1960), pp. 56–64.

"Etruskische Bronzekopfgefässe, I: Zwei etruskische Kopfgefässe im Römisch-Germanischen Zentralmuseum," *JRGZM* 6 (1959), pp. 110–114.

"Eine römische Bronzestatuette des Mars aus Spahn," *Jahrbuch des Emslandischen Heimatvereins* 7 (1960), pp. 46–52.

Römische Bronzen in Speyer (Mainz, 1960).

Die römischen Bronzen aus Deutschland, vol. 1, *Speyer, Historisches Museum der Pfalz* (Mainz, 1960).

with J. Elgavish, "Lucerna," *EAA*, vol. 4 (Rome, 1961), pp. 707–718.

Bildkataloge des Kestner-Museums, Hannover, vol. 6, *Römische Bronzen* (Hannover, 1964).

"Zwei Bronzestatuetten eines sitzenden Jupiters," *JRGZM* 10 (1963), pp. 192–196.

Die römischen Bronzen aus Deutschland, vol. 2, *Trier* (Mainz, 1966).

"Bemerkungen zum Mars von Blicquy," *Latomus* 26 (1967), pp. 92–95.

"Roman Bronzes," in D. G. Mitten and S. F. Doeringer, eds., *Master Bronzes from the Classical World*, The Fogg Art Museum, Cambridge, Mass., and other institutions, December 1967–June 1968 (Mainz, 1967), pp. 227–233.

Römische Bronzen aus Bayern (with a contribution by A. Radnóti) (Augsburg, Römisches Museum, 1969).

Kunst und Altertum am Rhein, vol. 20, *Rheinisches Landesmuseum Bonn: Römische Bronzen, Eine Auswahl*, with a contribution by E. Künzl (Düsseldorf, 1969).

"Observations on Selected Roman Bronzes in the Master Bronzes Exhibition," in S. Doeringer, D. G. Mitten, and A. Steinberg, eds., *Art and Technology: A Symposium on Classical Bronzes* (Cambridge, Mass., 1970), pp. 221–234.

"Bericht über die Tagung 'Römische Toreutik' vom 23. bis 26. Mai, 1972, in Mainz," *JRGZM* 20 (1973), pp. 258–282.

"Römische Bronzen des Martin-von-Wagner-Museums in Würzburg," *JRGZM* 22 (1975), pp. 96–105.

"Drei Statuetten des thronenden Jupiters aus Pompeji," in J. S. Boersma, et al., eds., *Festoen: Opgedragen aan A. N. Zadoks-Josephus Jitta* (Groningen and Bussum, 1976), pp. 431–435.

"Problèmes de la datation des bronzes romains," *Actes du 4. Colloque international sur les bronzes antiques* (Lyons, 1976), pp. 121–125.

"Les ateliers des artisans bronziers," *Les dossiers de l'archéologie*, no. 28 (Paris, 1978), pp. 58–71.

"Bronzen des ersten Jahrhunderts im Rheinischen Landesmuseum Bonn," Fitz Jeno and Fulop Gyula, eds. *Bronzes romains figurés et appliqués et leurs problèmes techniques*, Actes du VIIème colloque international sur

14

les bronzes antiques (Székesfehérvár, 1984), pp. 49–52.

"Die Jupiterstatuetten von Bree, Evreux und Dalheim und verwandte Bronzen," in U. Gehrig, ed., *Toreutik und figürliche Bronzen römischer Zeit* (Berlin, 1984), pp. 186–196.

"Römische Bronzestatuetten und verwandte Geräte: Ein Beitrag zum Stand der Forschung," in H. Temporini, ed., *Aufstieg und Niedergang der römischen Welt* (Festschrift Vogt), vol. 2, 12.3 (Berlin, 1985), pp. 127–169.

Die römischen Bronzen aus Deutschland, vol. 3, Bonn (Mainz, 1986).

Harvard University
CAMBRIDGE, MASSACHUSETTS

Samos and Some Aspects of Archaic Greek Bronze Casting

Helmut Kyrieleis

Together with marble, bronze is the favorite material of Greek sculpture, and in the Classical period it is even the preferred material. Some of the greatest Greek sculptors, such as Onatas, Polykleitos, and Lysippos, worked almost exclusively in bronze, and the most prestigious representative monuments in Greek cities and sanctuaries were made of bronze.

Because of the value of the material, it was often melted down and reused in later times, so the full artistic wealth of famous masterpieces in bronze has not survived but is known to us mostly through written sources or Roman copies in marble or through the inscribed stone bases of bronze statues. But what little is left of Greek bronze statuary – for instance, the Charioteer of Delphi, the Zeus from Cape Artemision in Athens, the Riace bronzes, or the Getty bronze – can still give us an idea of its outstanding artistic value and makes us understand immediately the high esteem for Greek bronze sculpture in antiquity.[1]

As for the invention and the place of birth of this art, ancient art history seems to have had a very distinct opinion. Our main source is Pausanias, a Greek writer who in the second century A.D. wrote his famous description of Greece, a guidebook which through its minute details is of the greatest value for modern archaeologists and historians. Many of Pausanias's observations have been proved by archaeological excavations. In VIII.14.5–8, dealing with the bronze statue of Poseidon at Pheneos in Arkadia, Pausanias writes: "The first men to melt bronze and to cast images were the Samians Rhoikos, the son of Philaeus, and Theodoros, the son of Telekles." This statement, which is repeated in IX.41.1 and X.38.6, and which in its conciseness sounds like a generally agreed-upon opinion, is used as an art historical argument against the local tradition that attributed the dedication of the bronze Poseidon to Odysseus. For Pausanias this statue of cast bronze cannot be dated as early as the time of Odysseus, for bronze casting would have been invented much later. As a support for this argument Pausanias turns to the history of art and technology, arguing in the same way as modern archaeologists would.

The first bronze figures in Greek art, Pausanias says, were made in the so-called sphyrelaton technique and pieced together (see also III.17.6). The sphyrelaton technique would have been in use until the invention of bronze casting by Rhoikos and Theodoros. The archaeology of Greece, and above all the excavations at Olympia, have confirmed the historical sequence postulated by Pausanias as far as the different bronze techniques are concerned. The first Greek bronze statues in the seventh century B.C. were indeed made of hammered bronze sheets, whereas cast bronze statues occur at the earliest in the sixth century B.C. The sentence of Pausanias that the two Samians were the first men to melt bronze and cast images, however, cannot be taken literally, since on the one hand the technique of melting and casting bronze was known to the Greeks from the Bronze Age on – the casting of bronze statuettes and tripods is characteristic of Geometric art of the eighth century – and on the other hand Rhoikos and Theodoros are dated in the sixth century B.C. by the authority of Herodotos.

The reference to the sphyrelaton technique as a predecessor of bronze casting, however, as well as the context in which Pausanias makes his statement imply that he did not mean to say bronze casting generally was invented by Rhoikos and Theodoros but rather that these two were the first to cast large bronze statues, i.e., life size or over. The production of this kind of statues is possible only in a hollow-casting procedure, and it is in fact this special technique of casting hollow figures (and not bronze casting generally) that historically did replace the sphyrelaton technique.

Judging from extant works, such as a life-size winged figure from Olympia,[2] the art of forming statues by hammering thin bronze sheets into curved shapes that afterward were pieced together, had reached a considerable degree of perfection already in the seventh century B.C.

It may well be that the first idea for this technique for producing large-size bronze sculpture evolved from the highly developed technique of Greek armorers. It is in fact only one step from producing a harness like the seventh-century masterpiece from Olympia[3] to building whole human figures out of analogous sections. Pieces like this harness on the one hand or greaves from Olympia[4] on the other, show a considerable understanding for the forms and function of the human body as well as a highly sophisticated art of stylization of its natural appearance. The art of the sphyrelaton, however, could never deny its relationship with (or even its derivation from) the art of the armorers. It always retained a certain characteristic stiffness and tinny, pieced-together appearance.

These characteristics correspond quite well

with the stylistic trends of Greek art in the seventh century B.C., but could not fulfill the requirements of the stylistic development in Greek sculpture during the sixth century, which tended toward more organic and continuous movement of surfaces and forms.

The casting technique, on the other hand, was the ideal medium to express the artistic trends in Greek sculpture of the sixth century, its basic forming process being modeling in smooth materials, namely clay and wax. A small bronze kouros from Samos gives an idea of the stylistic appearance of bronze sculpture of the sixth century B.C. (fig. 1).[5]

Large sculpture in bronze presupposes the invention of a highly developed hollow-casting technique. That this was what Pausanias had in mind when he referred to the Samian sculptors, is supported also by other ancient writers. Pliny the Elder, for instance, whose *Natural History* is one of the major sources on the history of Greek art and artists, writes (XXXV.152): "Some say that clay modeling was first introduced in Samos by Rhoikos and Theodoros."

At first glance this passage does not make much sense historically, since Pliny, who lived in the first century A.D., must no doubt have known, as well as we do, that clay modeling had since time immemorial been one of the basic spheres of human artistic activity and in any case much older than the time of Rhoikos and Theodoros. "Clay modeling" in this case, i.e., in connection with the names of these artists, must have a more specific meaning. It is reasonable to assume that Pliny (whose text may have come down to us in an incomplete version) refers to the fact that modeling of the clay core and the exterior coating of the wax model is indispensable for the casting of hollow bronzes. Thus Pliny seems to mean that Rhoikos and Theodoros were the first to introduce this technique. That Theodoros among other talents was a bronze sculptor – and that this was in fact his favorite skill – is reported by the same Pliny elsewhere in his *Natural History* (XXXIV.83):

Theodoros who made the labyrinth in Samos cast [a statue of] himself in bronze celebrated for the extreme delicacy of the workmanship. The right hand holds a file, while three fingers of the left hand support a tiny team of four horses, . . . so small that the team, marvellous to relate, with chariot and charioteer could be covered by the wings of a fly which the artist made to accompany it.

The enigmatic term "labyrinth" must be a popular name of the gigantic Temple of Hera in her sanctuary in Samos, which through its double and triple rows of over a hundred columns must have given the impression of labyrinthine complexity, and which

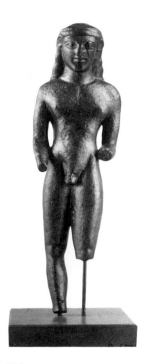

FIG. 1

Small statuette of a kouros. Samos, Archaeological Museum inv. B 652. Photo courtesy DAI, Athens.

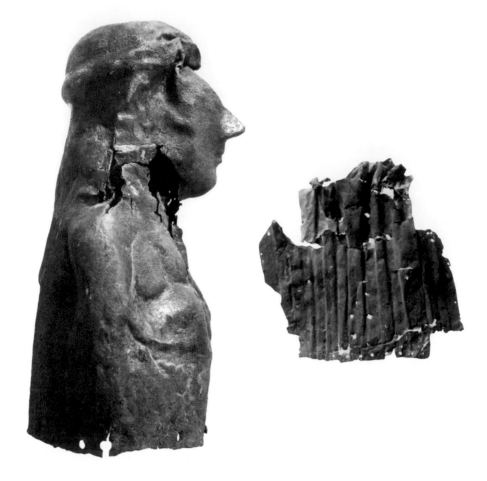

according to Herodotos was built by Rhoikos and Theodoros. The file
the statue had in one hand is the typical tool of bronze workers, and the
miniature quadriga serves here as an example for this artist's stupendous
mastery of modeling and casting in bronze.

Theodoros is also mentioned in Plato's "Ion"
as one of the greatest sculptors. And finally, three centuries later, we have
the testimony of Diodoros, a Greek writer of the first century B.C., who
mentions Theodoros in a peculiar and much debated passage (I.98.5 ff.):
". . . of the ancient sculptors, the most renowned Telekles and Theodoros,
the sons of Rhoikos, who executed for the people of Samos the statue of
the Pythian Apollo . . ."

As you will have noticed, Diodoros and
Pausanias differ about the family relations of Theodoros, Rhoikos, and
Telekles, Pausanias giving, as Herodotos did, Theodoros as son of
Telekles and fellow artist of Rhoikos. The difference must be due to a
misinterpretation of the older tradition by one of these two writers, but it
is not our concern here to discuss this problem at length. What is more
interesting in our context is the way in which, according to Diodoros, the
statue of Apollo was made (I.98.5 ff.):

*For one half of the statue . . . was worked by Telekles in Samos, and the
other half was finished by Theodoros at Ephesos; and when the two parts*

were brought together, they fitted so perfectly that the whole work had the appearance of having been done by one man.

Of course, the whole story has very much the character of an artist's anecdote, as there is no comprehensible reason why a statue should be executed in two different places. The method of producing different parts of a statue separately and putting them together afterward is characteristic of the method of producing large-scale ancient bronzes. We shall return to this shortly.

Summing up we may say that from the very few and mainly rather late ancient sources we get the clear impression that ancient art historians credited artists from Samos, among whom Theodoros seems to hold a prominent position, with the invention or introduction in Greece of one of the most forward-looking and promising branches of ancient art: the casting of large-scale bronze sculpture.

How does this information correspond with modern archaeological evidence? I shall try to answer this question mainly by considering different aspects of the bronze finds from the German excavation in the Heraion of Samos. But before we do so, it is interesting to realize that the chronological outlines given by Diodoros, Pliny, and Pausanias are remarkably in accord with what little we know archaeologically about the beginning of bronze statues in Greek art. Current evidence indicates that the earliest instance of Greek large bronzes is remains of a clay mold of a two-thirds life-size bronze statue of a kouros in a casting pit in the Athenian Agora[6] dated about or after the middle of the sixth century B.C. This seems to be contemporary with or slightly later than the lifetime of Rhoikos and Theodoros, which through their connection with the first large temple of Hera given by Herodotos is generally accepted to be roughly the time before and around the middle of the sixth century B.C.

If Samian bronze workshops had played a leading role in the development of a new casting technique, as the literary sources seem to imply, this could not possibly have happened without the existence of especially favorable conditions in Samos. The invention of a highly sophisticated artistic technique such as the casting of large bronzes would require an immense amount of knowledge and experience in bronze casting generally, which cannot be acquired instantly but would be available only on the basis of long-standing workshop tradition. One should expect, therefore, to find in the archaeology of Samos signs of such a tradition and of above-average activity in this field.

In fact, the finds from the excavations in the Heraion of Samos clearly point to a special position of Samos among the

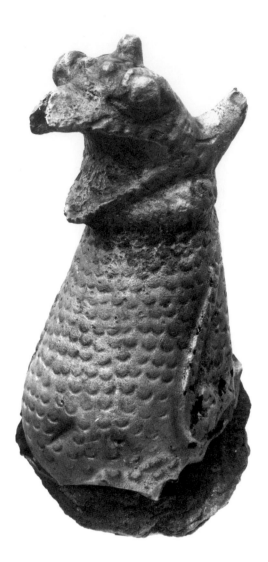

FIG. 4

Griffin-protome. Samos,
Archaeological Museum inv.
B 2520. Photo courtesy DAI,
Athens.

production centers of Archaic Greek bronzes. Except for Olympia, no
excavation in Greece has yielded more – and more important – bronze
finds of the Archaic period than the Sanctuary of Hera in Samos. But
Olympia is a panhellenic sanctuary where works of art from all over the
Greek world were gathered together, and consequently the finds from
Olympia do not reflect much of the production of local workshops but
rather a cross section of Greek bronze art as a whole. The Heraion, on
the other hand, despite its great reputation and wealth, has never been
other than the central sanctuary of the island of Samos, and its Archaic
bronzes can therefore be attributed mainly to Samian workshops.

The development of Archaic Samian art in
bronze is well documented among the finds of the Heraion, as shown by
some recent and mostly unpublished finds from our last excavations in
the sanctuary. The first examples are of the sphyrelaton technique. The
upper part of a female figure (fig. 2)[7] is formed out of different pieces of
thin sheet bronze and joined together by hammering and small rivets.
The somewhat indistinct and simplified forms can be compared
stylistically to Samian terracottas of the early seventh century, so this is

in fact one of the earliest sphyrelata known. The original height of the statuette was about 25 cm, but it seems there were sphyrelata of much bigger size in the Heraion.

At first glance, a fragment of hammered bronze (fig. 3) excavated in 1983 does not seem to be a very attractive find, with its battered surface and ragged outlines. But on closer examination this metal rag turns out to be a most interesting piece. Its parallel pleats of varying width no doubt represent folds of a piece of cloth or a garment, and the rivet-holes along the rim prove that originally it was joined together with other similar pieces. These are strong arguments in favor of an interpretation of this fragment as part of a female sphyrelaton figure wearing a chiton with folds. The size of the fragments and its folds seem to indicate a statue of at least life size. The find context of the fragments date them approximately in the early sixth century B.C., so the original sphyrelaton may be a work of the seventh century.

Of a still earlier date – the beginning of the seventh or even the late eighth century – are griffin-protomes made of hammered bronze sheets. Originally these were fastened as ornaments to the rim of bronze votive cauldrons. One example, for instance figure 4, which was found in 1984, still retains a solid fill of bitumen that served to stabilize the thin metal sheet on the inside and made the fragile hollow body appear solid and heavy.

Bronze cauldrons with griffin-protomes were the most typical and most prestigious among Greek bronze votives of the early Archaic period, and the development of this art form demonstrates in an exemplary way the transition from the sphyrelaton technique to hollow casting. During the seventh century the hammered protomes are replaced by cast ones, as in an example from Samos, found in 1981 (fig. 5). As the cast in bronze is virtually an exact reproduction of the original wax model and the modeling in wax makes it possible for the artist to create much more complicated and precise details than by hammering bronze sheets, this technical innovation marks an important step in the stylistic development toward the linear beauty and impressive liveliness characteristic of these fantastic prototypes of seventh-century Greek bronze art. The casting technique in this case did obviously answer to an artistic demand.

Griffin-protomes very often are of considerable size, many of them reaching a height of 50 cm and more. If made of solid bronze, these protomes would require an immense amount of metal and would be too heavy to be fixed safely to the thin metal of cauldrons. Greek bronzesmiths solved this problem by leaving an empty space on the inside of the protomes in order to save precious material and avoid superfluous weight. At an early, transitional stage, it seems there was

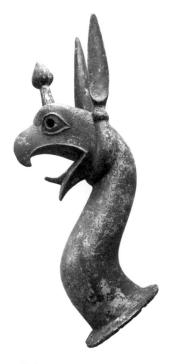

FIG. 5

Griffin-protome. Samos, Archaeological Museum inv. B 2234. Photo courtesy DAI, Athens.

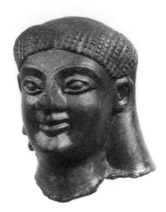

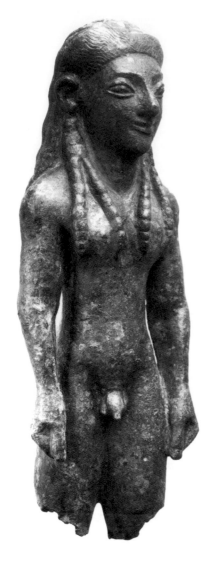

FIG. 6

Small statuette of a kouros. Samos, Archaeological Museum inv. B 2252. Photo courtesy DAI, Athens.

FIG. 7

Head of a kouros statuette. Samos, Archaeological Museum inv. B 2251. Photo courtesy DAI, Athens.

some experimentation with the aim of combining casting and hammering. Thus, some griffin-protomes from Olympia and Samos had cast heads attached to necks of hammered bronze sheets.[8] But since this composite structure obviously is only a less-than-ideal solution, it was soon abandoned, and the artists quickly learned to cast protomes in one piece. Griffin-protomes of this new type seem to be the earliest real hollow-cast bronzes in Greek art – apart from some minor attempts in the late eighth century – and their development from hammered prototypes is yet another proof of the theory that the technique of hollow casting arose from the sphyrelaton technique. According to the archaeological evidence from the Samian Heraion, Samos played an important part in this development and was in fact a main production center of griffin-cauldrons. No other excavation in Greek sanctuaries, including Olympia, has so far produced more griffin-protomes than the Heraion, where more than two hundred examples have been found. And among this amazing number of protomes there is hardly a piece that could be assigned with certainty to a workshop outside Samos. This

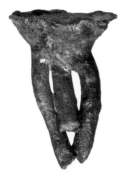

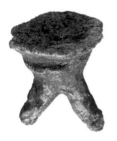

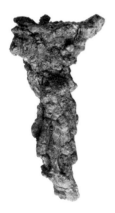

FIG. 8
Bronze fillings of casting funnels.
Samos, Archaeological Museum
inv. B 384, B 130, B 319 (top to
bottom). Photo courtesy DAI,
Athens.

alone would suffice to prove that Samos had a superior bronze industry from the seventh century onward.

The high standard of Samian bronze workshops was maintained and even refined in the sixth century, as illustrated by an excellent horse-protome[9] of the early sixth century found in 1983, which originally adorned a so-called rod tripod, and by the statuette of a kouros (fig. 6)[10] that came to light in 1981 and can be dated about 560–550 B.C. The dynamic yet subtle modeling and the delicacy of details as well as the strong and lively expression make this figure one of the finest kouros bronzes we have. The head of a youth (fig. 7)[11] found nearby, originally part of a similar kouros figure of a slightly later date, is bursting with life and, though only a fragment, gives us a splendid idea of the Ionian, East Greek conception of radiant youth and beauty.

There is good reason to believe that at least some of the Samian bronze founders worked immediately at or in the main sanctuary of the island. This is indicated by a variety of find pieces typical of bronze casting as a working procedure. There are, for instance, quite a lot of bronze fillings of funnels and gate systems (fig. 8), i.e., overflow bronze that filled the cup and channels at the entrance of the mold when the molten metal was poured into the mold. These appendices were useless after the casting was finished and were consequently cut away when the pieces had cooled. The presence of this kind of waste material in the sanctuary clearly indicates the existence there once of bronze workshops. The same is indicated by bronzes that are unsuccessfully cast or in an unfinished stage of production such as for instance handle attachments[12] and griffin-protomes.[13] They still retain irregular casting seams on the surface stemming from molten bronze finding its way into the joints of the clay mold. For some reason these pieces were regarded as unsound or defective immediately after the mold was removed, so it was not worth the trouble to file off the overflow ridges as usual or do any other chasing or cold-working on them.

The immediate proximity of bronze workshops to the sacred area seems to be a fairly common element of Greek sanctuaries in the Archaic period. In Samos, however, an above-average importance of the bronzesmiths' craft is suggested by a special category of finds that are notably frequent in the Heraion, namely bronze ingots of different shapes and weights. The most characteristic type of Samian ingots is a round disc about 10 to 15 cm in diameter, with roughly star- or rosettelike cuttings (fig. 9). This design seems to serve a practical rather than an ornamental purpose: the subdivision into sectors makes it easier to cut single portions of similar weight from the ingot, according to demand. Ingots of this type seem to be appropriate for workshops

specializing in the production of small bronzes. Being essential and valuable pieces of workshop routine, they may well have been dedicated to Hera by Samian bronzesmiths as some sort of professional votives.

If Samian workshops played a decisive role in the introduction into Greece of methods for the production of hollow-cast bronzes, as implied by the griffin-protomes and the written sources, they were, however, by no means the inventors of this technique, which already had a long tradition in Egypt and Mesopotamia. Most probably the Greeks learned the necessary skills of complex bronze casting from the old cultures of the East, and in particular from Egypt. In the seventh and sixth centuries B.C. relations between Eastern Greece and Egypt were exceptionally intense. Suffice it here to recall the founding in about 650 B.C. of Naukratis in the Nile Delta as a common trading port of the most important East Greek city-states. There was ample opportunity at this time for Greek artists to study Egyptian art and skills, whether at home, from imported works of art, or on visits to Egypt. To this historical Graeco-Egyptian exchange, Samos again seems to have made a particularly active contribution, to judge by the archaeological evidence. In fact, no excavation in Greece has produced nearly as many Egyptian artifacts of that period as the Heraion of Samos, where imported Aegyptiaca of bronze and faience run into the hundreds. Among these, there are good examples of hollow-cast bronzes, as for instance a figure of a bald-headed priest or worshiper holding a small vessel against his chest.[14] It is about 40 cm high and is to be dated to the seventh century at the latest. As can be seen from the damaged parts, the casting is done with remarkably thin walls. Figures like this, which antedate Greek hollow-cast large-scale bronzes, must have been a great stimulus for imitation to Greek artists.

In Diodoros's text cited above on the creation of the Samian Apollo statue by Telekles and Theodoros there is preserved a distinct reminiscence of the fact that the special procedure followed by these two artists in executing the statue was derived from Egypt. As I mentioned before, the particular technique employed here, namely the working of the statue in two parts that were subsequently joined together to produce the finished whole, "is followed generally among the Egyptians" (Diodoros I.98.6). Diodoros goes on to point out the sophisticated and standardized system of measuring used by Egyptian artists, which enabled them to work different parts of a statue separately and make them fit together exactly, without additional corrections. The principles of the measuring system of Egyptian sculpture described by Diodoros have been confirmed by actual sculptors' studies from Egypt. The ancient Egyptians had at their disposal an elaborate measuring method based on canonical proportions, and a fund of compatible

anatomical details that made it possible to design and execute statues of absolutely identical form. As a consequence of this high degree of uniformity and proportional calculation, it was quite natural to conceive the whole of a sculpture as the sum of its parts and eventually to produce these parts as single pieces if required for technical reasons. Thus, in the majority of wooden figures from Egypt, for instance, the arms were made separately and fixed to the shoulders by dowels. The same is true for bronze figures from Egypt, and it is interesting in this context to observe that a great number of the Egyptian bronzes found in the Samian Heraion shows the characteristic forms of joining.

The dowel for joining is clearly visible in the left arm of a male figure (fig. 10)[15] whose original height was about 50 cm. The arm is hollow-cast as can be seen from the small fracture. At the upper end is a rectangular tenon, which helped to fix the arm to the figure. The joint may have been concealed by the short sleeve of a garment. Another example (fig. 11)[16] is a beautiful statuette of the goddess Neith (eighth/seventh century B.C.). Her arms were made separately and then attached to the shoulders with rivets in the same way as in wooden figures.

An interesting insight into the composite construction of Egyptian bronze sculpture, finally, is provided by a wooden base found five years ago with two bronze feet still in their original position.[17] Originally, it was part of a seated female figure. The feet inserted into the base are securely glued to the wood by a black substance that seems to be bitumen. The legs were attached to the rest of the figure by means of rectangular tenons with holes for the insertion of metal pins in a horizontal position.

Joining, which makes the production of complex bronze figures much easier, seems to have been a common practice in Egyptian bronze works, and I am sure Samian founders did not fail eagerly to take notice of the different technical possibilities demonstrated by these Egyptian bronzes in the central sanctuary of their island.

At the time when large bronzes begin to be produced in Greece, i.e., by the middle of the sixth century B.C., Samian artists had reached an outstanding level of technological achievement in bronze casting, judging by the small bronzes extant, as is demonstrated by two more examples from our recent excavations in the Heraion.

Perhaps the finest bronze statuette found at the Heraion is a kouros, now in the Antikenmuseum in Berlin (fig. 12).[18] It comes from the first excavations, before World War I, and has ever since been regarded an outstanding and singular piece of Archaic Samian art. The generally accepted opinion is that masterpieces like this were made

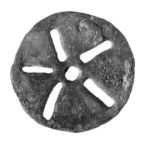

FIG. 9

Bronze ingot. Samos, Archaeological Museum inv. B 150. Photo courtesy DAI, Athens.

individually, as unique works of art. In 1984, however, we had the good
fortune to find a bronze figure (fig. 13) which, according to a dedicatory
inscription on its left side, was a votive of a certain Smikros to Hera.
From the beginning the new bronze looked very much like a twin of the
famous kouros in Berlin from the same sanctuary: the stance, position of
the hands, bodily appearance, hairdo, and every detail being surprisingly
similar in the two pieces, even the peculiar and quite unusual way the
ears are given in both cases, without any articulation of the interior of
the auricles. The first suspicion that the two bronzes were twin pieces
was confirmed when a year later I had the opportunity to take detailed
measurements of the two figures.[19] By means of a compass I have
measured not only the height and width of the two pieces, but have also
taken as many distances as possible between characteristic and
corresponding points of the composition, as for instance from elbows to
nose, from ears to the underside of the testicles, or from the corners of
the eyes to the edge of the coiffure on the back side. As a result of these
comparative spatial measurements the two bronzes proved to be
identical in form precisely to the millimeter! (Some minute differences in
details of the hair are due to cold-working after the casting.)

Obviously the exact similarity of the two
bronzes was possible only with the help of intermediate negative molds.
It is interesting to remember that already in 1979 Ulrich Gehrig
demonstrated that the Berlin bronze was done in hollow casting, and
from indications of seamlike lines in radiographs of this piece he had
convincingly postulated that the wax model of this bronze was made of
at least two negative molds – one for the front and one for the back.[20]
Gehrig's suggestion is supported by the new find. Given the precise
similarity of the sizes of the two bronzes, I think we must exclude the
possibility of kouros A being a copy of kouros B or vice versa: an
immediate copy would be slightly smaller because of the inevitable
shrinking of the second clay mold during the firing process. It seems
much better, therefore, to assume a common model or prototype for
both figures. In my opinion, this "kouros X" of which A and B are
reproductions need not necessarily have been of bronze. A figure made of
wood or of ivory, for instance, could as well have served as a model for
the mechanical process of reproduction by intermediate molds (so-called
master molds) in clay.

However this may be, the twin bronzes shed
some new and unexpected light on the technical possibilities Archaic
bronze artists had at their disposal, and more generally on the Archaic
Greek conception of art. We have to abandon the axiom of master
bronzes being uniques anyway. Samian artists at least had complete
command of the bronze reproduction technique so that what seems to be

FIG. 10

Arm of Egyptian bronze statuette.
Samos, Archaeological Museum
inv. B 1442. Photo courtesy DAI,
Athens.

FIG. 11

Egyptian statuette of the goddess
Neith. Samos, Archaeological
Museum inv. B 354. Photo
courtesy DAI, Athens.

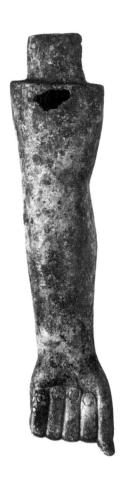
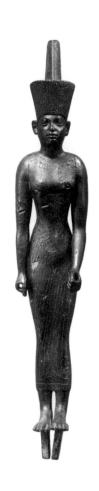

an individual masterpiece to our eyes may in fact be a perfect replica of
another work of art identical in form. The customers apparently did not
mind ordering or dedicating copies or did not ask for originals at any
rate. The uniqueness and originality of a piece of art, it seems, was not an
absolute value in itself.

In the archaeology of the Archaic period, this
unbiased attitude toward replicas was mainly documented in terracottas.
The reiteration of casts from the same mold is a common phenomenon in
the series production of clay figurines and could therefore be taken as
typical for cheap and popular categories of votive art. The twin kouros
figures from Samos, however, clearly indicate that even the much more
demanding technique of the production of master bronzes was
susceptible to a certain rationalization of this kind. That this is not an
isolated case but seems to have been common practice – at least in Samos
– was by surprising coincidence demonstrated by another bronze from
the same excavation trench from which the Smikros kouros came. It is
the figure of a youth (fig. 14), who, according to the characteristic
position of legs and arms, was originally mounted on a horse. The hands
and feet of this little rider are broken away, and there is some damage of
the surface. But those who are familiar with Archaic bronzes will
immediately recognize, as we did in the excavation, a striking similarity
with another famous bronze, found many years ago in the Heraion of

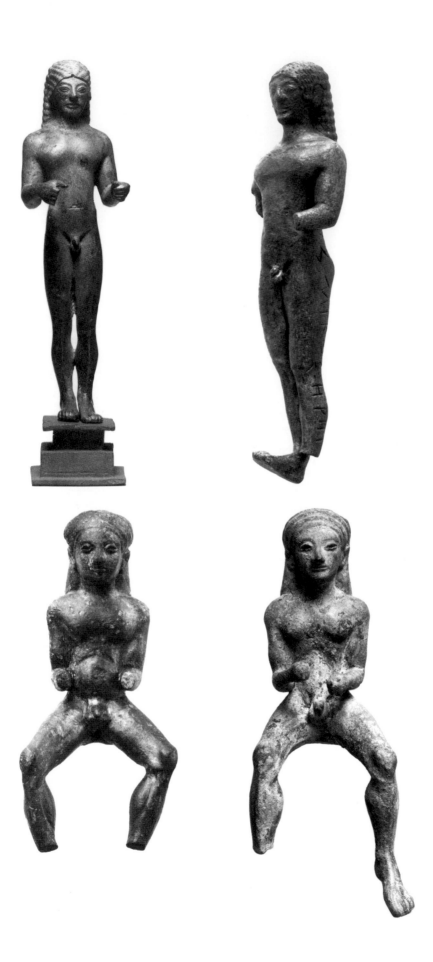

Samos (fig. 15).[21] This rider, who may be called "rider A" just for the moment, is almost perfectly preserved, and from the freshness of modeling as well as from the lively movement and expression one would have taken this statuette as unique. And yet there is a twin figure to this in the recently found rider from the same sanctuary, who may be named "rider B" for convenience. Comparative measuring after the method described before did prove that the two riders are perfectly identical in size and form, and consequently both of them must be cast from master molds from one prototype ("rider X"). There is, however, one difference from the case of the two kouros statuettes: In the riders only the bodies and heads are identical in form, whereas the legs (and probably the arms) are slightly different. The working procedure of the wax models of the two riders, therefore, can be imagined as follows: heads and bodies were formed out of two or more piece molds taken from the prototype. Then the legs (and arms?) in at least one of the figures were modeled separately in wax and added to the body. The slight differences in details of the hairdo are the result of the usual finishing by hand of the wax model before it was finally embedded in the casting mold of clay. Needless to say, the whole procedure required a considerable amount of special experience and skill and again provides good evidence for the technological excellence of Samian bronze workshops in the sixth century B.C.

Of the famous large bronzes of Theodoros and his fellow artists mentioned by Pausanias, Diodoros, and Pliny, nothing has come down to us: no fragments, not even a base or an inscription. But from the archaeological heritage of Samos, out of which I have tried to demonstrate just a few points, it seems quite possible that the experienced and creative bronze industry of Samos, together with the far-reaching interconnections of this island in the Archaic period, provided an ideal substratum for the epoch-making innovations in artistic bronze casting hinted at in the later sources.[22]

Deutsches Archäologisches Institut
BERLIN

Notes

1 With minor modifications, this paper gives the text of the lecture that was delivered in Malibu. The Samian bronzes mentioned – and partly illustrated – here in a preliminary way will be published in detail in the final publication of the Heraion excavation. It is not my intention to provide a full bibliography here: For questions of Greek bronze technique and its history, see C. C. Mattusch, "Casting Techniques of Greek Bronze Sculpture," Ph.D. diss., University of Michigan, Ann Arbor, 1975; and P. C. Bol, *Antike Bronzetechnik: Kunst und Handwerk antiker Erzbildner* (Munich, 1985).

2 Inv. B 6500. A. Mallwitz and H.-V. Herrmann, eds., *Die Funde aus Olympia* (Athens, 1980), no. 95.

3 Inv. B 5101. Ibid., no. 60.

4 Cf., for instance, E. Kunze, 2. *Bericht über die Ausgrabungen in Olympia* (Berlin, 1937/1938), p. 98, pl. 40.

5 Inv. B 652. E. Buschor, *Altsamische Standbilder*, parts 1–5 (Berlin, 1934–1961), p. 13, figs. 35, 37, 38.

6 Mattusch (note 1), pp. 98, 100ff.

7 Inv. B 205. Buschor (note 5), pp. 73f., figs. 313–316.

8 U. Jantzen, *Griechische Greifenkessel* (Berlin, 1955), pp. 63ff., pl. 27; H.-V. Herrmann, *Olympische Forschungen*, vol. 11, *Die Kessel der orientalisierenden Zeit*, part 2 (Berlin, 1979), pp. 118ff., pls. 52ff., 65.

9 Inv. B 2516. J. Boardman and C. E. Vaphopoulou-Richardson (eds.), *Chios* (Oxford, 1986), p. 197, fig. 9.

10 *AM* 99 (1984), pp. 105ff., pl. 17.

11 Ibid., pp. 109ff., pl. 18.

12 U. Gehrig, *AA*, 1979, p. 553, figs. 7–8.

13 Ibid., p. 554, fig. 9. Cf. Jantzen (note 8), pp. 57f.; Bol (note 1), p. 78, fig. 50.

14 Inv. B 2611, unpublished.

15 U. Jantzen, *Samos*, vol. 8, *Ägyptische und orientalische Bronzen aus dem Heraion von Samos* (Bonn, 1972), p. 8, pl. 5.

16 Ibid., p. 23, pl. 27.

17 Inv. H 200. Unpublished.

18 Buschor (note 5), p. 70, figs. 295–300. Gehrig (note 12), p. 554 n. 15, fig. 10.

19 I express my thanks to Professor W.-D. Heilmeyer, who kindly gave the permission to measure the Berlin statuette.

20 Gehrig (note 12), pp. 554ff., figs. 11–13. Cf. Bol (note 1), p. 112, fig. 72.

21 Buschor (note 5), p. 53, figs. 190–192, 198–199.

22 Cf. Jantzen (note 8), p. 60.

Ancient Copper Alloys: Some Metallurgical and Technological Studies of Greek and Roman Bronzes

David A. Scott and Jerry Podany

Careful surface examination of a bronze, including a detailed description and analysis of the patina, can yield a great deal of valuable information. X-radiographic investigations, compositional studies of the metal and core material, as well as the determination of techniques used in the casting of the metal all provide useful information about the object and the fabrication technology used.

This information is yet more valuable if we place it within the context of the culture and society that produced the bronzes. In many investigations, however, we are hampered by the lack of knowledge of the precise origin for the artifacts. This difficulty is especially true when studying museum collections. Investigations of these objects challenge the limits of our techniques and the ingenuity of the investigator.

Perhaps the area of study that has been subject to most controversy and confusion is the relation between the metal composition and the object's place of manufacture. Attempts to relate the composition of a bronze or copper alloy to ore sources, or to deduce groupings in otherwise similar bronze objects on the basis of their trace-element compositions, have consumed great effort on the part of many scientists and have produced as many questions as answers.

There are numerous factors to be addressed when considering this problem. First, elements may be lost or gained on smelting, depending on the type of smelt (for example, whether reducing or oxidizing conditions were employed) and the duration of the smelting operations; the temperature reached in different parts of the furnace; the rate of oxygen supply; the type of fuel; the nature of the flux that may have been added; the type of slag formed in the furnace; as well as a host of other factors that influence the final composition of the metal.

Elements such as zinc and arsenic tend to be lost as volatile oxides if thorough roasting of sulfide ores is carried out before smelting. The absorption of iron into the metal has been suggested as an indicator of the efficiency of the smelting process. With tapped slag furnaces, for example, the iron content in Roman bronzes tends to be higher than that found in less sophisticated extraction procedures.[1]

The consequence of these variables is that we cannot usually say, with any certainty, what the origin of a particular bronze might be in relation to the ores available in the region concerned. In some cases, however, the composition of the alloy is unusual and may be geographically limited in distribution, or we may both know the exact origin of the object and have analyses of stylistically similar objects. More specialized analytical information can be obtained from the examination of lead isotope ratios or from detailed study of trace-element concentrations in combination with technological categories such as those employed by Chanda Reedy and Pieter Meyers in their study of medieval bronzes from Tibet, Kashmir, and Nepal.[2] This further emphasizes the need for the application of many techniques and numerous approaches before a decision as to provenance that is both well argued and sophisticated can be reached.

A relatively large number of analyses of bronze objects from the ancient world has been accumulated, particularly over the last fifty years, many of which have been published by researchers such as Paul Craddock[3] in Britain and Josef Riederer[4] in Germany.

Acquired data concerning alloy composition, even for those objects with poor provenance information or unknown date, may be used to examine questions such as the following:

1 Must "priori" groups of artifacts differ significantly to be accurately grouped?

Here problems arise due to varying opinions on what constitutes a "different" composition, especially if groups are formed on the basis of the presence or absence of a particular element. Most useful in this approach is the broad categorization of alloys into major groups. Scholarly opinion holds that a bronze should have at least 2% tin, while arsenical copper may be considered a deliberate product with 1% or more arsenic present. The properties of brasses change rather slowly as the zinc content rises. Although a zinc level of 1% in antiquity is unusual, it is below the alloying level considered acceptable for naming the product a brass (usually from about 5% zinc upward).

2 Do similarities exist in the compositional data suggesting that artifacts belong to homogeneous groups?

This has been, and can still be, a difficult issue. Determining the variations allowed in composition, yet deciding that enough evidence exists to suggest that the objects concerned are from a particular group, is a delicate balancing act, which is dependent upon reliable and sufficient data in order to draw reasonable conclusions.

This problem is also compounded by difficulties of interlaboratory comparisons of analytical data. One set of

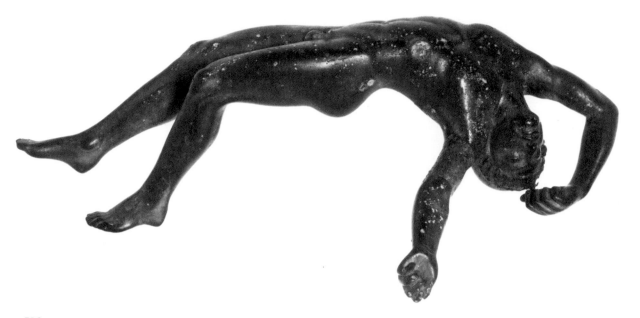

FIG. 1

"Dead Youth." Greek, circa 480 B.C. Consistent with the date of the object, analysis found a very low level of lead in the casting alloy. Malibu, The J. Paul Getty Museum inv. 86.AB.530.

comparisons initiated by Tom Chase[5] produced only partial agreement between the different laboratories that participated in the trials, yet a more recent comparison initiated by G. F. Carter[6] presented much more encouraging results. Nonetheless, while the latter study greatly reduced standard deviations, it would be foolish to pretend that this problem has been entirely solved.

3 Can the groups or number of groups of objects arrived at be integrated with the archaeological data?

Of course, if the objects come from a controlled archaeological excavation, the difficulty is much less than that faced in the case of objects of unknown provenance. In the latter case the objects are often grouped on the basis of their art historical information rather than on the basis of archaeological evidence.

A well-known example of the interrelation between analyses and archaeological data is the gradual shift from the use of arsenical copper to tin bronze in the Bronze Age. If we examine the data acquired by E. R. Eaton and H. McKerrell, for example, we see that during the Early Bronze Age, from approximately 3000 B.C. to 2200 B.C., there was a substantial increase in the use of arsenical copper in Greece.[7] About seventy-seven percent of objects that have been identified as Greek bronzes from this early period are arsenical copper other than tin bronze. Even during the Middle Bronze Age, from about 2200 B.C. to 1600 B.C., some twenty-five to fifty percent of all so-called bronzes were in fact made of arsenical copper. It is only in the Late Bronze Age that arsenical copper really became eclipsed by tin bronze.

Similarly, there is a noticeable change in the lead content of small bronzes from the Classical world. Deliberate additions of lead were very common by the Roman period, sometimes

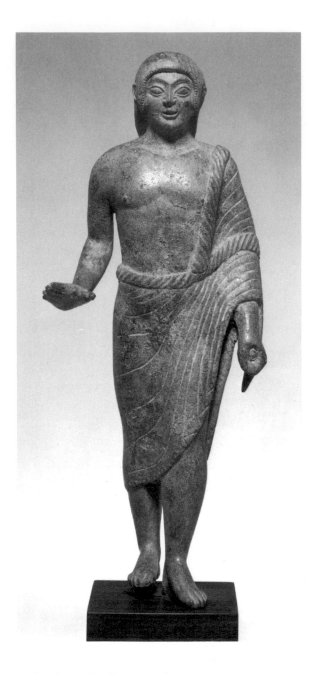

FIG. 2

Kouros. Etruscan, circa 490–480
B.C. Malibu, The J. Paul Getty
Museum inv. 85.AB.104.

rising to as much as 30%. Indeed nearly all Roman bronzes contain
purposefully added lead as a constituent of the cast objects.

Greek bronzes before the Archaic period
seldom contained lead as an alloying element, and it is significant that
the "Dead Youth" (fig. 1), thought to be Greek of about 480 B.C., has the
lowest lead content of any of the bronzes analyzed in the Getty
collections. Although the period of 480 B.C. marks the end of the era of
the Archaic period, the "Dead Youth" is one of the earliest Greek bronzes
in the Getty collections and is, therefore, least likely to contain additional
lead as an alloying component. Craddock suggests that bronze alloys
used for statues or statuettes in Greece were unleaded until the fourth
century B.C., although many contemporary bronzes from other regions

FIG. 3

Near Eastern cylinder seal. Late fourteenth to early twelfth century B.C. This seal was considered to be of hematite, but analysis revealed it to be cupro-nickel alloy (from R. Higgins, *Minoan and Mycenaean Art*, p. 179, fig. 227).

contained lead at that time.[8] The Etruscan kouros (fig. 2) dating to about 490–480 B.C. is an example of an early leaded bronze in the Getty collections. The kouros is cast in an alloy containing about 14.5% lead and 6% tin, although it is roughly contemporary with the previously mentioned "Dead Youth." Other interesting alloys were also used by the Etruscans and the Minoans at a relatively early date. Craddock analyzed an Etruscan statuette of a naked youth in the British Museum dated to the third or second century B.C.[9] The statuette contained 11.8% zinc and only 0.68% tin. This alloy is therefore a brass and suggests a limited, but significant, use of this alloy by the Etruscans. A small Minoan statue of a man, also in the British Museum, had an arsenic content of 1.8% with only a trace of tin: this is an example of an arsenical copper alloy.

There are, of course, equally important areas of interest attached to the patination, corrosion, and metallographic examination of ancient bronzes, which will only be discussed here in relation to one or two specific objects. First, however, it is worth defining a semantic point, since proper evaluation of ancient metal objects is greatly aided by an agreed-upon and accurate vocabulary. The word "bronze" suffers – or benefits, depending on one's point of view – from a rather romantic and attractive connotation, whereas alloys such as arsenical copper or cupro-nickel evoke little emotive response. This is unfortunate, since it leads, without proof, to the labeling of most copper-alloy objects from the ancient world as "bronze" for no particular reason, other than the fact that the term bronze, which we give to alloys of copper with tin, is the one with which we are most familiar.

Part of the reason for this is historical. The existence of significant numbers of ancient copper-alloy objects made of arsenical copper was largely unknown even twenty years ago. It is only within the last ten years that archaeologists, conservators, and scholars have begun to exercise caution and to write "copper-alloy object" on their labels rather than "bronze object." Overly cautious as it might appear, it is correct to do so, for to label something as bronze without proper analysis is really the same kind of error as suggesting that all Classical bronzes are Greek.

Arsenic and tin were not the only alloying elements utilized in antiquity, either intentionally or unintentionally. As an example let us look at a small Near Eastern cylinder seal (fig. 3), which was once described by Reynold Higgins in his well-known book on Minoan and Mycenean art as being made of hematite, or iron oxide.[10] It was once in the Marcopoli collection and is now held in a private collection in the USA. The seal was probably cast, although the figures and inscription are directly engraved. The inscription is in Hittite and reads Ta-ka-na-ni. The crudity of the style and the inscription (which is

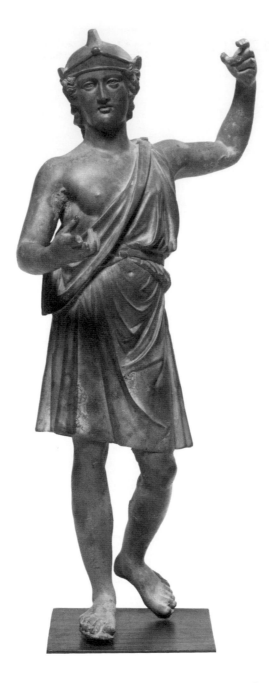

FIG. 4a

Roma. Roman, A.D. 40–68.
Malibu, The J. Paul Getty
Museum inv. 84.AB.671.

upside down) suggest a provincial origin to Dr. Beatrice Teisser, who
examined the seal.[11] She writes that a northern Syrian or southwestern
Anatolian origin is likely and that the seal probably dates from the late
fourteenth to early twelfth century B.C., a time when the Hittites were
active in northern Syria. Nondestructive analysis of the cylinder seal
proved that it was not made of hematite, but instead the X-ray
fluorescence analysis revealed a copper alloyed with nickel, which
contained small amounts of cobalt, iron, and lead.

 We usually refer to these alloys of copper with
nickel as cupro-nickel alloys, not as nickel bronzes. The extent to which
these cupro-nickel alloys were used is unknown, although their use was
probably not as rare as we perceive it to be today.

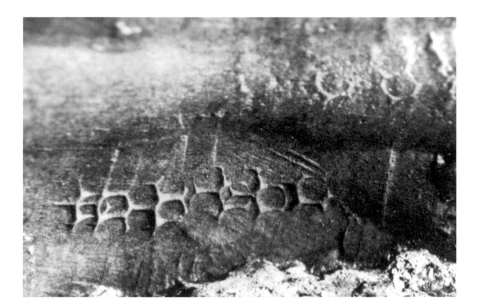

FIG. 4b

Photomicrograph of hexagonal
network pattern present on the
surface of Roma, figure 4a.
Average size is 1 mm across.

A very fine copper-alloy bull's head, analyzed
at the Institute of Archaeology in London and said to come from
Anatolia, was shown by electron microprobe analyses to have the
following composition: Copper: 77.45%, nickel: 20.93%, cobalt:
1.37%, iron: 0.25%. Such compositions are quite startling if one fails to
realize that widespread use was made of cupro-nickel alloys in the
manufacture of decorative objects in the Near East, and that objects
containing nickel have been found from such important sites as Ur, Kish,
and Tell Asmar. It is not certain from where the nickel used to make these
alloys came, since nickel and copper ores are not usually closely related.
C. F. Cheng and C. M. Schwitter[12] assert that one source was China,
while S. Van R. Camman[13] suggests Persia and other possibilities. Some
analyses are given in table 1.

Let us now address objects from the exhibition
The Gods Delight. All of the objects to be discussed are in fact made of
bronze, so we feel confident in referring to them as such. The bronzes
from the Getty collection included in the exhibition were thoroughly
examined by the staff of the Museum's antiquities conservation
department. X-radiographs were taken of each piece and were
supplemented with atomic absorption analyses of sound metal drillings,
X-ray diffraction studies of patina constituents, and some
metallographic investigations of the structure of some of the bronzes.[14]
These analyses were carried out with the aim to either answer questions
regarding the manufacturing technology used or to authenticate the
objects. During the investigation of the corrosion products and patinas
present on these objects, a number of very interesting phenomena were
observed.

The first of these concerns the details visible on
the surface of a Roma figure. Figures 4a–b present an overall view of the
bronze and a detail of the surface under the binocular microscope, which

Table I. Some analyses of ancient cupro-nickel alloys.

		%
Bull's head from Anatolia	Copper:	77.45
	Nickel:	20.93
	Cobalt:	1.37
	Iron:	0.25
Hittite cylinder seal from	Copper:	79.1
Syria or Anatolia;	Nickel:	18.9
date: 14th–12th C. B.C.	Cobalt:	0.7
	Iron:	0.2
Square pin or nail from	Copper:	94.41
Ur[1]	Nickel:	1.77
	Iron:	0.03
	Lead:	trace
	Tin:	not detected
	Sulfur:	not detected
Sheet-metal statue of	Copper:	98.20
Pepy I, Cairo Museum[2]	Nickel:	1.06
	Iron:	0.74
	Lead:	not detected
	Tin:	not detected
	Arsenic:	not detected

1. S. F. Elam, "Some Bronze Specimens from the Royal Graves at Ur," *Journal of the Institute of Metals* 48.1 (1932), p. 97, cat. 4.

2. L. Aitchison, *A History of Metals*, vol. 1 (London, 1960), p. 69.

reveals patches of a curious hexagonal network occurring within the patinated surface. The size of each hexagon is about 1 mm in diameter. Such phenomena are rarely seen on ancient cast bronzes, and a number of suggestions have been presented to account for their presence. The features are most pronounced around the square hole in the back of the bronze, but they also occur in numerous places over the entire surface. Figures 4c–d show the type of microstructural features found when a 1-mm core drilling was taken from the bronze surface in the vicinity of one of the hexagonal surface features. The microstructure (fig. 4c) reveals prominent grain boundaries together with undistorted casting porosity in the form of dark holes. $\alpha + \delta$ eutectoid phase at the grain boundaries of the copper-rich crystals is also seen. Some covering is still evident in the section, which shows a structure typical of an annealed casting.

The Roma is composed of lightly leaded bronze with approximately 6.5% tin and 1.8% lead. Examination of the X-radiograph shows that the torso and head of the statue were hollow

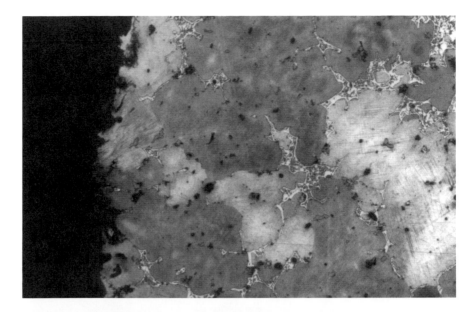

FIG. 4c

Polished and etched metallographic section of Roma, figure 4a, taken from a core sample that penetrated the hexagonal pattern. Etched in alcoholic ferric chloride. Magnification 265×.

FIG. 4d

Polished and unetched metallographic section of Roma, figure 4a, showing the continuity of the hexagonal surface zone with the overall bronze structure. Porosity of cast appears as dark holes. Magnification 265×.

cast in one piece along with the left arm and a small part of the left leg (fig. 4e). The legs and feet of the Roma were cast on, and we suggest the following sequence of operations for this interesting process: a wax sheet could have been applied to the underside of the already cast garment and around the bronze nub that formed the upper part of the left leg proper, sealing the opening into the figure. The object was finished by the separate attachment of wax pillars to the torso. The wax pillar that formed the upper part of the right leg was attached to a wax sheet used to close off the bottom of the cast bronze. The second wax pillar formed part of the mid-section of the left leg proper and was attached to the bronze nub. Precast bronze legs and feet were attached to wax pillars, which in turn were attached to the nub and wax plates. These were then all cast on in place. The texture of the outer surface, the various tool

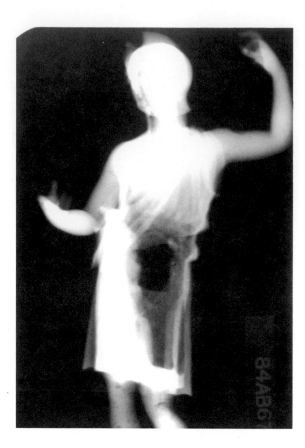

FIG. 4e
X-radiograph of Roma, figure 4a,
showing that the torso and head
were hollow cast. Note the
presence of an additional bronze
flow at the proper right side
interior suggesting a "cast on"
technique used to attach the legs.

marks, and variations in surface corrosion and porosity observed in the
radiographs (fig. 4f) of these areas support this proposal for the general
method of manufacture. In addition, there is a large flow of bronze on
the interior right side of the statuette, which flowed toward the head
before it solidified and must have been caused by casting-on the feet and
sheet section mentioned above (see fig. 4e).

In the context of the interesting information
provided by the X-radiographic examination, it is less surprising that the
Roma metallographic section should appear as it does. A cast bronze of
this type normally has a heavily cored dendritic structure with an
appearance something like the ceremonial Luristan axe fragment from
Iran (fig. 5), which has been etched by interference tint deposition. The
structure consists of interlocking dendrites with the tin-rich $\alpha + \delta$
eutectoid occurring between the dendritic arms. The Roma, on the other
hand, shows a series of equi-axed and sometimes clearly hexagonal
grains, which are surrounded by islands of the eutectoid phase (fig. 6).
The appearance of this microstructure is that of an annealed casting.
Ancient examples of annealed castings are not all that uncommon, but
few of them show any unusual surface features, so we cannot explain the
type of crystallization as a result of an annealing process.

Nevertheless, the type of crystallization is an
important clue in explaining the existence of this unusual feature. The
body of the Roma must have been heated to a relatively high temperature

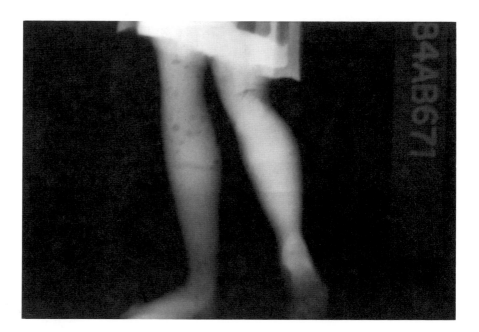

FIG. 4f

X-radiograph of Roma, figure 4a, showing variance in porosity between the torso, middle, and lower segments of the legs.

during the casting-on process for the recrystallized grains to form. Temperatures in the range of 800–900° C would be necessary to account for such recrystallization in an unworked bronze. Alloys do not melt at a single temperature; they soften over a range of temperatures and enter a pasty stage. Perhaps this is what occurred here. Local overheating of the bronze may have induced this surface recrystallization as well as resulted in the annealing of the microstructure of the Roma. This remains speculative, however, and only detailed laboratory studies could answer the question conclusively.

Clean metal drillings from the foot of the Roma and the back of the casting core hole provide analytical data that reveal some difference in composition between the two locations. This difference can be explained here as a result of the method of fabrication of the bronze and is a good argument for the complete study of a bronze before one embarks on a technical discussion of any analytical data. Since the foot and back were individually cast, the precise composition of the individual components varied, as is evident here, although the differences are not great. As seen in table 2, the tin content of the foot is only slightly higher, at 7.12% compared with 6.56% near the casting core hole.

In many duplicate analyses of ancient bronze objects some variation in composition from place to place is evident. In fact, a tin content variation of ± 10% is not uncommon even for an integrally cast object.

Some surface features of the bronzes are more closely associated with corrosion during burial than with the technology of manufacture. Both the incense burners in the Getty collection, for

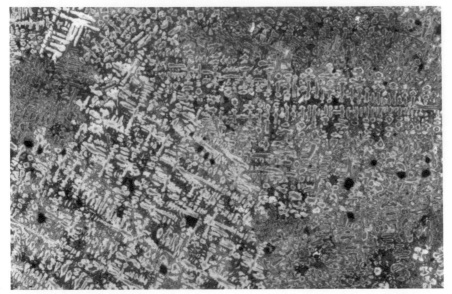

FIG. 5

Metallographic section of a
Luristan axe fragment from Iran.
Note the well-defined dendritic
structure of the casting. The axe
has a high tin content (18%) and
therefore there is a substantial
amount of the α+δ eutectoid
between the copper-rich dendrite
"arms." Etched in sodium
thiosulfate, citric acid, and lead
acetate by interference tint
deposition. Magnification 200×.

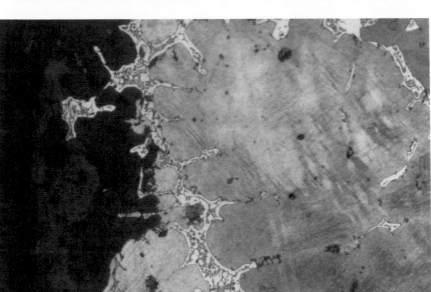

FIG. 6

Metallographic section of Roma,
figure 4a, taken through the
hexagonal pattern, revealing the
depth of the corrosion layer. Note
that the copper-rich phase is
preferentially attacked, leaving a
few isolated islands of the α
eutectoid within the corrosion
layers. Etched in ferric chloride.
Magnification 370×.

example, show a polygonal pattern outlined in the corrosion on their
surfaces (figs. 7, 8a). This corrosion is essentially intergranular; the light
green intergranular product is higher in tin oxides than the grain centers,
which are predominantly cuprite (fig. 8b). This is a good example of
selective attack along the grain boundaries of the bronze, which is
exceptionally well preserved. In most cases where bronze has suffered
initial intergranular corrosion, the buildup of the corrosion products
themselves obscures the form of attack, even in cases where we can
clearly see from microstructural studies that the initial form of corrosive
attack was intergranular.

One sample of the dark corrosion crust of the
incense burner with actor (fig. 8a) was examined by X-ray diffraction.
The patina sample could be separated into two fractions, and analysis

Table 2. Analyses of some bronzes in the J. Paul Getty Museum.

Sample	Object	Inv.	Date	% Cu	% Sn	% Pb	% Zn	% Fe	% As	% Sb	% Ni	% Bi	% Ag	% Au	% Mn	% Cd	% Co
1	Herm[1]	79.AA.138	120 B.C.	68.5	11.44	18.38	nd	0.07	0.40	0.20	0.04	0.04	0.03	0.02	1.4ppb	0.54ppb	416.9ppb
2	Herm[2]	79.AA.138	120 B.C.	69.7	13.94	16.08	nd	0.09	0.47	0.24	0.04	0.02	0.06	0.02	1ppb	0.37ppb	568.4ppb
3	Dead Youth[3]	86.AB.530	Greek ca. 480–460 B.C.	93.87	4.86	0.05	tr	0.16	nd	nd	nd	tr	0.01	nd	nd	nd	nd
4	Incense: actor[4]	87.AB.143	Graeco-Roman ca. 75–25 B.C.	89.73	6.06	3.17	0.04	0.13	tr	0.06	0.04	nd	0.06	nd	nd	nd	nd
5	Incense: stand[5]	87.AB.143	Graeco-Roman ca. 75–25 B.C.	85.91	4.26	3.23	0.10	0.21	0.06	0.13	0.05	0.26	0.06	nd	nd	nd	nd
6	Roma: foot[6]	84.AB.671	Roman A.D. 40–68	89.84	7.12	2.73	0.03	0.055	nd	0.00	0.03	nd	0.06	nd	nd	nd	nd
7	Roma: core[7]	84.AB.671	Roman A.D. 40–68	89.12	6.56	1.77	tr	0.22	tr	nd	0.01	tr	0.06	nd	nd	nd	nd
8	Kouros[8]	85.AB.104	Etruscan 5th C. B.C.	77.13	6.23	14.41	0.008	0.02	0.04	0.05	0.04	0.11	0.07	nd	nd	nd	nd
9	Incense: singer[9]	87.AB.144	Roman 1st C. A.D.	80.64	6.90	7.01	0.02	0.09	0.14	0.06	0.03	tr	0.06	nd	nd	nd	nd
10	Incense: stand[10]	87.AB.144	Roman 1st C. A.D.	79.36	3.96	4.78	0.03	0.20	1.32	1.18	0.03	nd	nd	nd	nd	nd	nd
11	Tinia (Zeus)[11]	55.AB.12	Etruscan ca. 480–470 B.C.	87.58	9.52	1.26	0.22	0.037	0.28	0.01	0.05	0.16	0.08	nd	tr	nd	nd
12	Diana (Artemis)[12]	57.AB.15	Graeco-Roman 1st C. B.C.	81.08	12.57	1.47	0.04	0.35	0.07	0.16	0.03	0.005	0.08	nd	tr	nd	nd
13	Venus: foot[13] (Demeter)	84.AB.670	Roman A.D. 40–68	88.82	6.97	2.25	0.05	0.30	tr	nd	0.008	nd	0.009	nd	nd	nd	nd
14	Venus: hole[14] (Demeter)	84.AB.670	Roman A.D. 40–68	76.09	7.46	2.64	0.008	1.45	0.41	0.09	0.02	nd	0.06	nd	0.007	nd	nd
15	Girl bank[15]	72.AB.99	Roman ca. A.D. 25–50	89.43	5.74	1.53	nd	0.09	nd	0.06	0.04	nd	0.07	nd	nd	nd	nd
16	Togati[16]	85.AB.109	Roman A.D. 40–68	85.74	9.46	2.06	0.006	0.21	0.04	0.10	0.01	0.02	0.05	nd	tr	nd	nd

nd = not detected tr = trace ppb = parts per billion

The reader should be aware of the reliability of the analytical figures themselves, regardless of the variation that may be experienced between samples of the same object taken from different regions. Generally, the results of the analyses are expressed in percentages to which the following standard deviations apply: for all elements present in concentrations over 1%, the usual standard deviation is 1%, for elements between 0.1% and 1.0% the figure is about 10%, and for elements below 0.05% analyzed in flame techniques the figure is about 20%.

Locations of samples taken for analysis:

1. From base of herm.

2. From another region of the base of the herm.

3. From existing mounting hole on the left shoulder blade.

4. From the actor itself: on the underside of the base of figure under right crossed leg.

5. From the underside of the stand.

6. From the underside of the left foot.

7. From the edge of the casting core hole at the back.

8. From the base of the figure.

9. From the resting surface under the left leg.

10. From two holes made on the underside of the base.

11. From already existing mounting hole of the right leg.

12. From the underside of the right foot.

13. From the underside of the left foot.

14. From the edge of the casting core hole at the back.

15. From a square protrusion on the underside of the lap area of the figure.

16. From the underside of the right foot.

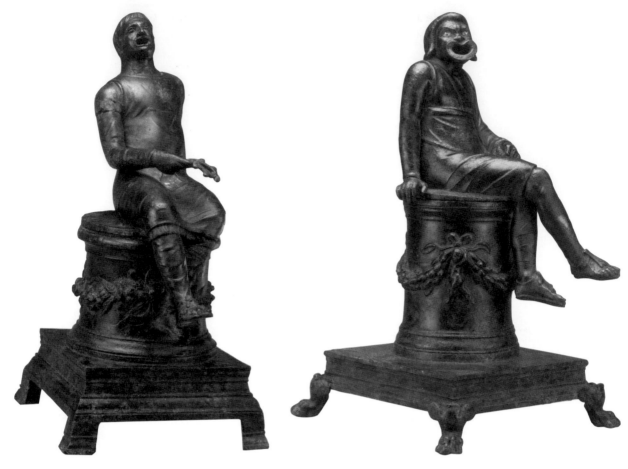

FIG. 7

Incense burner in the form of a
singer. Roman, first century B.C.
Malibu, The J. Paul Getty
Museum inv. 87.AB.144.

FIG. 8a

Incense burner in the form of an
actor. Graeco-Roman, circa 75–
25 B.C. Malibu, The J. Paul Getty
Museum inv. 87.AB.143.

showed the presence of cuprite (Cu_2O), tenorite (CuO), and digenite ($Cu_{1.8}S$) (table 3). The digenite is a less commonly reported copper sulfide corrosion product of bronze, and its occurrence here is interesting to note. Tenorite is normally associated with the transformation of other corrosion products as a result of heating, for example in objects exposed to a fire. Since the object is an incense burner, the presence of tenorite is perfectly compatible with its use.

The construction of the two incense burners is also of special interest. The singer has both the right arm and left leg attached as separate elements. Both segments were cast separately from the main body and attached later. The attaching ends of both the arm and the leg segments terminate in carefully manufactured square tenons, which fit into precisely cast sockets on the adjoining torso surface. No trace of adhesive, grout, or solder remains in either case, but it is clear that some sort of minimal aid to the mechanical attachment must have been provided; excess bronze does not appear on the leg or arm join, suggesting the join was not cast on or fusion welded. The X-rays (figs. 9a–b) show clearly the attachment of the arm and the use of assembly techniques to achieve a more complex and perhaps repeatable form, which could have been produced from a master mold, although there is no definitive proof at the time of writing that this was the case.

Table 3. X-ray diffraction data for some patina constituents of bronzes in the J. Paul Getty Museum.

Object	Inv.	Patina components identified
Togate magistrates	85.AB.109	Pale blue: azurite $Cu(OH)_2CuCO_3$ Light green: malachite $CuCO_3. Cu(OH)_2$ Other samples: cassiterite, malachite SnO_2
Etruscan kouros	85.AB.104	Light green: malachite $CuCO_3.Cu(OH)_2$
Incense burner with actor	87.AB.143	Dark brown: cuprite Cu_2O tenorite CuO digenite $Cu_{2-x}S$
Venus (Demeter)	84.AB.670	Blue: azurite and quartz Off-white: quartz, calcite, cuprite Black: romarchite SnO cassiterite SnO_2 Green: cassiterite SnO_2 Gray: cuprite and quartz
Tinia (Zeus)	55.AB.12	Green: malachite $CuCO_3.Cu(OH)_2$ Gray: chalcocite Cu_2S
Girl bank	72.AB.99	Green: atacamite $Cu_2(OH)_3Cl$
Diana (Artemis)	57.AB.15	Green: malachite Light green: cassiterite

The girl bank shown in figure 10a has an unusual dark-brown-to-black patination. Attempts to identify the nature of this patina have so far been unsuccessful. X-ray diffraction analysis identified only atacamite in one portion, while the other element could not be identified giving only a very diffuse pattern, insufficient to enable interpretation of the X-ray data (see table 3).

The patina tends to flake away from the surface of the bronze, exposing uncorroded metal, which is highly unusual and suggests that the patina is not original. A small sample of the bank was removed from the base for metallographic examination. The bronze is a standard casting with sulfide and oxide inclusions and isolated patches of the $\alpha + \delta$ eutectoid. Details of the structure can be seen in figures 10b–c. The corrosion crust is shallow and trapped in hollowed crevices in the surface in an unusual way. There is nothing odd in the composition of the bronze, nor have any questions as to its authenticity been raised from the art historical viewpoint.

The metallographic section of the girl bank was studied by electron microprobe analysis to supplement the X-ray diffraction information. The results of part of this study are shown in figures 10d–f. The only element detected besides copper and tin in the area of corrosion shown in the backscattered electron image was sulfur,

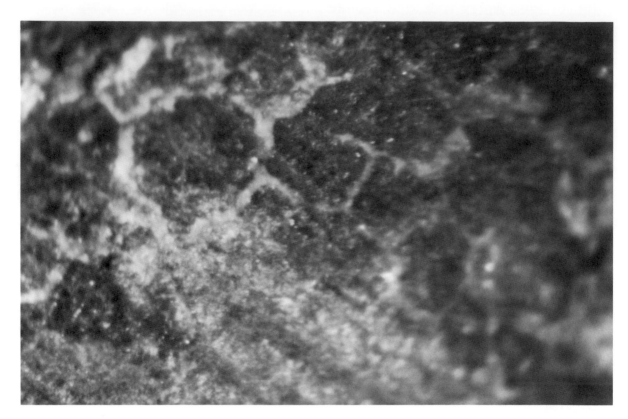

FIG. 8b

Photomicrograph of incense
burner, figure 8a, showing a
polygonal pattern outlined in the
surface corrosion. The pattern is
created by intergranular corrosion,
resulting here in a border around
each of the metal grains.
Magnification 70×.

showing that the brown-black patina is principally a sulfide, which
explains the difficulty of identification by X-ray diffraction: some of the
copper sulfides are poorly crystalline. There is slight enrichment in tin
close to the metal surface, but no indication of any cuprite or of
corrosion in depth.

 The evidence suggests that the girl bank may
well be Roman but has probably been stripped of its corrosion crust at
some stage and has been repatinated. (This was a common practice in
the nineteenth century, and in some circles it is still practiced.)

 In the process of sampling the Getty Venus
(Demeter) (fig. 11) and the relief with two togate magistrates (figs. 12a–b)
it was found that both objects have rare fibrous or needlelike crystals
perfectly preserved as a result of corrosion during burial (fig. 12c).
Finding two objects within a relatively small museum collection with
such surface features is uncommon and suggests the close association of
these two objects, a hypothesis strengthened by the belief that they may
have traveled through the art market from the same source. The burial
environment of both must have been very similar for the whiskerlike
crystals to grow from the surface of both bronzes. The corrosion
products must have had space to grow unimpeded in the site
environment, which is unusual.

 Previously observed crystals of this type have
been reported by Maria Fabrizi and David Scott, who found analyzed
examples to be eriochalcite ($CuCl_2.2H_2O$), nantokite (CuCl), and

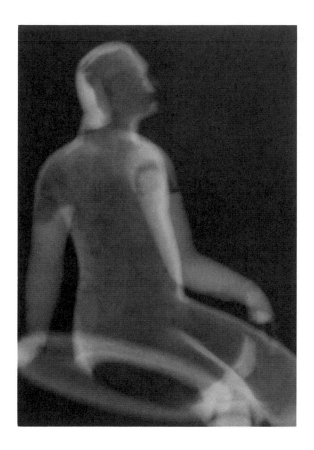

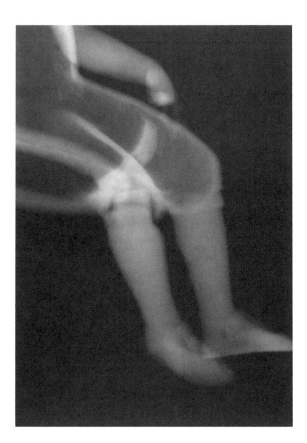

FIG. 9a

X-radiograph of incense burner, figure 7, showing the carefully formed tenon join at the proper left arm (shoulder).

FIG. 9b

X-radiograph of incense burner, figure 7, showing the tenon-and-socket join of the proper right leg.

malachite ($CuCO_3.Cu(OH)_2$), the latter in fibrous form on a Roman seal box.[15] In fact, both of the crystal growths on the Getty's Roman pieces were also identified as malachite, the most common of the three. X-ray diffraction studies of some dark brown corrosion products taken from the proper left hand of the Venus showed the presence of cassiterite and romarchite (see table 3). In cases where enrichment of tin has occurred within the patina of the bronze, it is common to find cassiterite as a product; the presence of romarchite or hydroromarchite, the different forms of stannous oxide (as opposed to stannic oxide), are less commonly noted, but one suspects that they are more common as corrosion products of ancient bronzes than published literature would suggest.

The togate magistrates present another odd observation: three intentional marks on the back, central surface. These marks appear to have been made in the wax before casting and may have served as some sort of numbering system that established the relationship of this bronze to others of a group meant to be viewed together in a certain manner.

Technical problems in relation to casting methods can be found in the case of a Greek herm in the Getty collection (fig. 13a). The analytical data for this piece are presented and tabulated in table 2. It is a heavily leaded tin bronze with about 16% lead and 12%

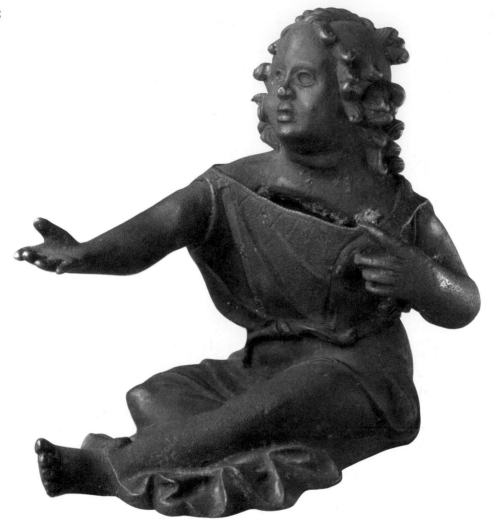

FIG. 10a

Bank in the form of a girl. Roman,
A.D. 25–50. Malibu, The J. Paul
Getty Museum inv. 72.AB.99.

FIG. 10b

Metallographic section of girl
bank, figure 10a, showing
prominent dendrite structure of
the cast and the shallow depth of
the corrosion layer. Etched in
alcoholic ferric chloride.
Magnification 135×.

FIG. 10c

Polished and unetched
metallographic section of girl
bank, figure 10a, showing the
corrosion/patina layer that reveals
a homogenous corrosion product
occurring in frequently shallow
surface depressions. Magnification
90×.

tin. Such alloys have significantly lower melting points than binary tin
bronzes and can be used for highly specialized bronze alloys, such as
those sometimes employed for the manufacture of Roman mirrors, or for
large castings, which are frequently heavily leaded.[16] This addition
facilitates the casting operation since the high temperature necessary to
cast the bronze can accept a certain amount of variation without the
alloy solidifying too quickly. Such is the case with the herm. X-
radiographic study revealed some interesting structural features of the
herm, the most striking one, apparent on the inside of the square boxlike
base, being the presence of four bronze rods that traverse most of the
length of the interior at the midpoint of each section (fig. 13b).

 Each rod stops before the head of the herm, but
each passes over a wax-to-wax join close to the head. There is no sign of
any join between the head of the herm and the base adjacent to it, and
this, together with the evidence of the wax-to-wax join, suggests that the
herm was cast in one operation by the lost-wax process. There are a

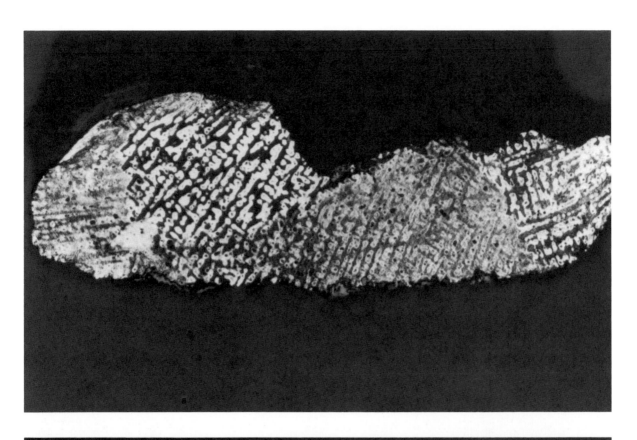

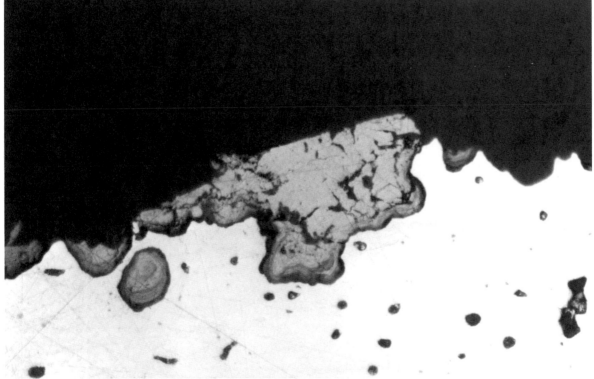

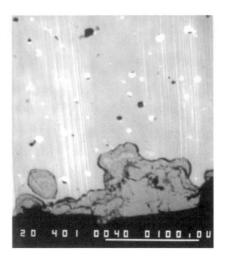

FIG. 10d

Elemental map for sulfur.
Scanning electron
photomicrograph of section of girl
bank, figure 10a. Scale bar
represents 100 microns.

FIG. 10e

Backscattered electron image of
corrosion crust of girl bank, figure
10a. Note the correspondence
between the corrosion and the
sulfur map, figure 10d. Scale bar
represents 100 microns.

FIG. 10f

Elemental map for tin. Scanning
electron photomicrograph of
section of girl bank, figure 10a.
Note the slight concentration of
tin compounds at the border
between the corrosion layer and
the metal. Scale bar represents 100
microns.

number of possible explanations for the presence of the rods: one
suggestion is that they were originally bronze rods and the wax sheets for
the lost-wax casting were modeled over them, incorporating the whole
assembly into the casting mold. Another possibility is that the rods were
originally wax and were converted to bronze as in any usual casting. To
try to understand the interesting technical problems posed by the herm,
we cut a V-shaped section, including some of the rod and accompanying
region adjacent to the wall of the bronze sheet, and mounted it for
metallographic examination.

Figures 13c and d show the sections of the
bronze in the polished condition. The lead is heavily segregated into large
pools that interrupt the pattern of the dendritic structure of the herm. An
unusual feature of this section is the apparent dendritic plate or arm that
can be seen toward the outer surface of the section, representing a
contiguous area between the bronze rod and sheet. Such dendritic
platelike features have been noticed before associated with a weld made

FIG. 11

Venus (Demeter). Roman, A.D.
40–68. Malibu, The J. Paul Getty
Museum inv. 84.AB.670.

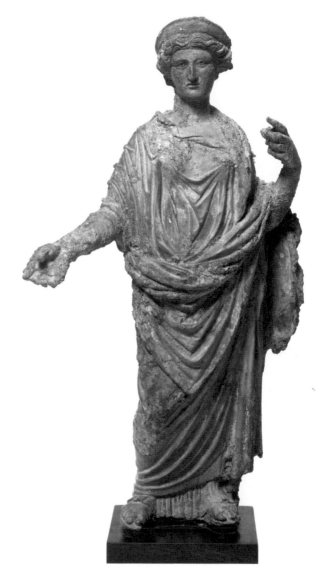

in a region of the joining of two components in a Roman draped male statue.[17] This feature may have been associated with localized rapid cooling, and it is significant that it is only to be seen toward the surface of the section where more rapid solidification may have occurred. Note that other features found around part of the section are small, preserved areas of original casting-core material showing the combination of wood charcoal and mineral components typical of many lost-wax casting cores. A variety of materials may be used for lost-wax casting cores, but clay and charcoal mixtures are widespread. Indeed, almost identical lost-wax casting cores have been noted from the Old and New Worlds in widely disparate cultures and times, illustrating the ubiquity of technical knowledge on unrelated continents.

At the location where we sampled the section of the bronze rod, the rod itself can be seen to be of solid metal with no sign of any interface between the wall of the herm and the structure of the

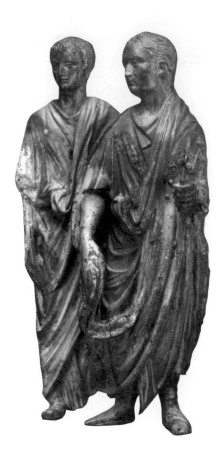

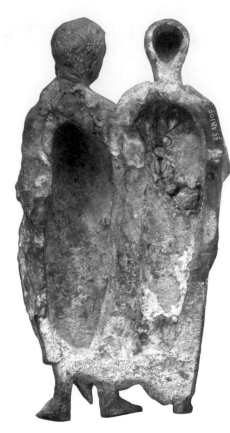

FIG. 12a

Togate magistrates. Front. Roman, A.D. 40–68. Malibu, The J. Paul Getty Museum inv. 85.AB.109.

FIG. 12b

Back of togates, figure 12a, showing the three marks (arrow) that may have indicated the position of the object in an assembly.

bronze rod. Normally in a weld join, evidence of structural differences can clearly be seen between different components. Coupled with the presence of the core material, all the evidence points to the rods as being an integral part of the casting. However, the evidence is not as simple as it appears. Some of the X-radiographic evidence suggests that the rods may be hollow in some regions (fig. 13e), and, indeed, when an attempt was made to take a drilling specifically from one of the rod components toward the base of the herm, the drill bit passed through a thin skin of corrosion products into a hollow interior.

We have established that the rods were an integral part of the casting, but we have not yet explained why the rods are solid metal in some areas and hollow in others. The process of corrosion of the herm complicates the interpretation. It is difficult to know whether the hollow regions were originally formed by a thin skin of metal that flowed into the rod areas but was insufficient to fill them due to a gaseous casting (there are several patches apparent on the herm that have been filled in with small rectangular plugs), or whether the rods could have acted as risers in the casting process, or whether a defective casting resulted in this particular feature, or whether the rods could have been formed from wrapped wax sheets, which contained some hollow regions subsequently filled by the casting core material. At the moment we simply do not know.

A number of other interesting features

FIG. 12c

Photomicrograph of the fibrous
corrosion products found on the
surface of the togates, figure 12a.
Similar crystals also occur on the
Venus (Demeter), figure 11, and
were identified as malachite.
Magnification 215×.

concerning the casting of this herm can be seen on the interior. Some
straight lines with double ridges associated with wax-to-wax joins in the
manufacture of the long, boxlike base can be seen in figure 13f. There is
also a series of flash lines where metal has penetrated into the core (now
removed). One explanation for these features would be that the core was
modeled from lumps of clay and charcoal, which were shaped and then
stacked together to form the core over which the wax was modeled.
This, however, cannot be correct, since the rods were so carefully
modeled in metal and the core had to be carved to shape to make a space
into which the wax rods would be placed before covering them with
sheets of wax. They are too well defined for that to be possible.

One alternative is that the clay and charcoal
core was added in sections, or possibly poured, into the central cavity,
once the wax sheets had been modeled and attached to the wax rods. In
some areas the sheet looks as though it has been physically attached to
the rods with some additional wax being used in the operation. The core
material has cracked preferentially in those areas where the wax wall was
pierced by circular chaplets, which then penetrated into the dried core
material. Eight of the fourteen chaplet holes are associated with flash
lines, which also occur, of course, in modern bronzes, and which lend
strong support to this observation.

These attempts to reconstruct the casting
technology of the herm are still hampered by the observation that the

FIG. 13a

Herm. Greek, 120 B.C. Malibu,
The J. Paul Getty Museum inv.
79.AA.138.

FIG. 13b

Detail of interior wall of herm,
figure 13a, showing remains of
bronze rods/tubes and flash lines
crossing the wall surface.

rods are solid in some areas and hollow in others, an explanation for
which is difficult to deduce from the X-radiographs.

ANALYTICAL RESULTS

The results of the analyses are given in table 2. Since the pieces are small
castings and may well represent slightly segregated compositions if
samples are taken from extremities, duplicate samples were taken from
the Roma and from the Venus (Demeter). In the case of incense burners
87.AB.143 and 87.AB.144, the samples were taken from different
components of the object, namely one sample from the figure itself and
one from the stand on which the cast figure is supported.

Since an effort was made to remove the
samples for analysis from unobtrusive areas, it is apparent from the
analytical figures for the Venus (Demeter) and the Roma that some
degree of compositional variation occurs between the underside of the
feet and the casting core hole at the reverse.

As mentioned above in the case of Venus
(Demeter), there is a 0.5% variation in the tin content, and a similar
variation in tin content is found in the Roma samples. More significantly,
there is a considerable difference in trace-element composition between
the casting core hole area drilled from the back, and the underside of the
feet. Both the casting core hole drillings have higher iron contents than
the feet and different zinc, nickel, and arsenic contents.

This example is a good indication of the degree

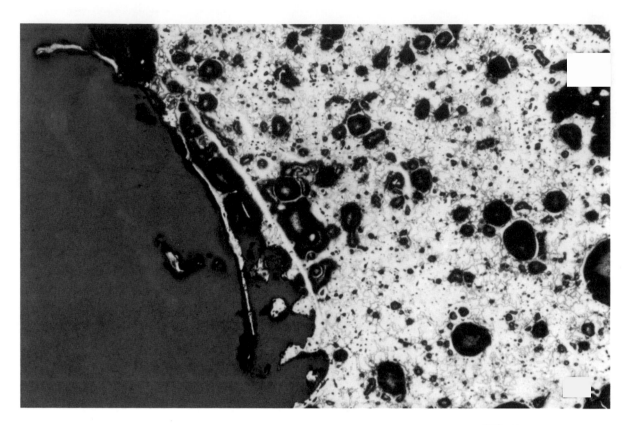

of caution necessary in comparisons between clean drillings, which may
not be representative of typical body compositions, simply because they
have been taken from unobtrusive locations on the object and may
therefore not be representative of the body as a whole. With this caution
in mind we can proceed to examine some of the simple trends in
composition that this small group of analyses reveals.

 The Getty Museum objects of earlier date in
the exhibition, namely the kouros, 85.AB.104, the Zeus, 55.AB.12, and
the "Dead Youth," 86.AB.530, are considered first. It is significant that
the "Dead Youth" (which is thought to be Greek of about 480 B.C.) has
the lowest lead content of any of the samples analyzed. Previous work by
Caley[18] and Craddock[19] suggests that many of the early Greek pieces
were not leaded bronzes, and the dying youth fits into this early group
quite well, since it has no intentional lead content.

 On the other hand, the Etruscan kouros
(85.AB.104) of about the same date displays a very high lead content in
the sample analyzed, namely 14.41%. The Etruscan Zeus, also from the
early fifth century B.C., displays some lead content (1.26%), showing
that Etruscan castings could be heavily leaded at this period, while the
accumulated evidence shows that many Greek bronzes of the same
period were not.

 The lead content found in the Roman examples
analyzed tends to be rather low, with a maximum lead content of 7.01%,
found in one of the incense burner stands.

FIG. 13c

Polished and unetched
metallographic section of herm,
figure 13a, taken from the wall
contiguous with an attached rod.
The micrograph illustrates part of
the area connecting the wall of the
herm with the rod and shows
structural continuity throughout
the casting. Note the platelike
dendritic feature close to the
surface and the large pools of lead
in the alloy. Magnification 55×.

FIG. 13d

Polished and etched section of
herm, figure 13a, showing
preservation of part of the casting
core (arrow). Note the presence of
wooden cellular structures,
preserved as charcoal, within the
mineral components of the casting
core. Magnification 450×.

FIG. 13e

X-radiograph of herm, figure 13a,
showing hollow sections of the
rods or tubes.

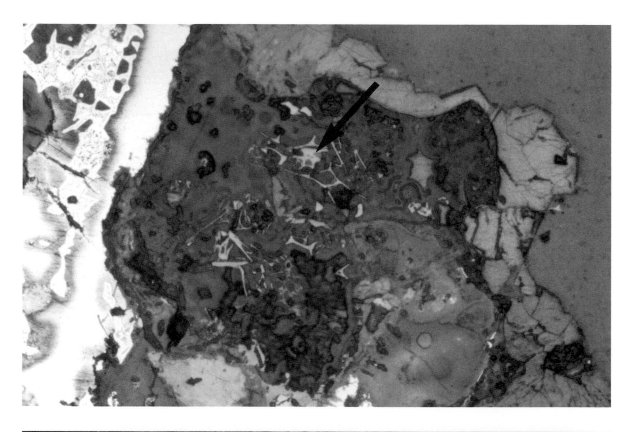

FIG. 13f

Detail of the interior surface of herm, figure 13a, showing evidence of a wax join.

The lead/tin ratios for many of the pieces analyzed in the Getty collections are rather low, although well within the range of variation found in previous analyses. The ratios are as follows, with duplicate values given where they occur:

Object Description	Pb/Sn Ratio
Girl bank	0.26
Venus (Demeter)	0.32
Venus (Demeter)	0.35
Incense burner: actor	0.52
Incense burner: stand	0.76
Roma	0.27
Diana (Artemis)	0.12
Incense burner: singer	1.01
Incense burner: stand	1.20

All these objects are thought to be from about the first century A.D. In general the trend of this series is not very different from that shown by Caley in his study on the composition of Greek and Roman statuary bronzes.[20]

Apart from the Diana (Artemis), which has about 12.5% tin, the bronzes analyzed generally have a moderate tin content in the range from 4% to 9%. It may be significant that the Diana

is thought to come from Asia Minor. None of the objects has any appreciable zinc content, apart from the Etruscan Zeus, which has 0.22% zinc. There is only one object with any appreciable arsenic content, namely the stand for the incense burner with singer, which has 1.32% arsenic. This is sufficient for the stand to be labeled a quaternary alloy of copper, lead, tin, and arsenic; the sample taken was slightly corroded, nevertheless there is also a slightly higher antimony content associated with this incense burner stand. Antimony and arsenic are frequently found in association, and the figures here suggest that either scrap metal has been reused in the casting of the stand, or the ore source was arseniferous. The Venus (Demeter) is the only other piece that was shown to contain a significant amount of arsenic, 0.41%.

A very common impurity in copper that was extracted in antiquity is silver; it occurs here in quite typical amounts, generally between 0.01% and 0.06%. This is a level that is also seen in the work carried out by Craddock on Greek, Roman, and Etruscan bronze.[21]

In this short paper, which has presented a series of representative investigations of bronze objects in the collection of the J. Paul Getty Museum, we have attempted to emphasize the value of collaborative efforts among various disciplines as well as the benefit of combining numerous analytical approaches. While one single method or test may provide specific details, the overall characterizations needed to draw meaningful and informed conclusions regarding any metal object require a more diversified approach. Once the results of these investigations enhance and clarify each newly added bit of the puzzle, the answers come into focus and, inevitably, new questions and challenges appear.

Getty Conservation Institute
MARINA DEL REY

J. Paul Getty Museum
MALIBU

Notes

1 P. T. Craddock and N. D. Meeks, "Iron in Ancient Copper," *Archaeometry* 29 (1987), pp. 187–204.

2 C. Reedy and P. Meyers, "An Interdisciplinary Method for Employing Technical Data to Determine Regional Provenance of Copper Alloy Statues," in J. Black, comp., *Recent Advances in the Conservation and Analysis of Artifacts* (London, Summer Schools Press, University of London, 1987), pp. 173–178.

3 P. T. Craddock, "Copper Alloys Used by the Greek, Etruscan and Roman Civilizations: 1," *Journal of Archaeological Science* 3 (1976), pp. 93–113; idem, "Copper Alloys Used by the Greek, Etruscan and Roman Civilizations: 2," *Journal of Archaeological Science* 4 (1977), pp. 103–123; idem, "Problems and Possibilities for Provenancing Bronzes by Chemical Composition," in J. Curtis, ed., *Bronzeworking Centres of Western Asia Ca. 1000–539 B.C.* (London, 1987), pp. 317–326.

4 J. Riederer, "Die Geschichte des Bronzegusses," *Bronzen von der Antike bis zur Gegenwart* (Berlin, 1983), pp. 277–290.

5 T. Chase, "Comparative Analysis of Archaeological Bronzes," in C. W. Beck, ed., *Archaeological Chemistry*, Advances in Chemistry Series 138 (Washington, D.C., 1974), pp. 148–185.

6 G. F. Carter et al., "Comparison of Analysis of Eight Roman Orichalcum Coin Fragments by Seven Methods," *Archaeometry* 25 (1983), pp. 201–213.

7 E. R. Eaton and H. McKerrell, "Near Eastern Alloying and Some Textual Evidence for the Early Use of Arsenical Copper," *World Archaeology* 8 (1976), pp. 169–192.

8 Craddock, 1976 (note 3).

9 Ibid.

10 R. Higgins, *Minoan and Mycenaean Art* (London, 1967).

11 Beatrice Teisser, personal communication (1984).

12 C. F. Cheng and C. M. Schwitter, "Nickel in Ancient Bronzes," *AJA* 61 (1957), p. 351.

13 S. Van R. Camman, "On the Renewed Attempt to Revive the Bactrian Nickel Theory," *AJA* 66 (1962), pp. 92–95.

14 M. J. Hughes, M. R. Cowell, and P. T. Craddock, "Atomic Absorption Techniques in Archaeology," *Archaeometry* 18 (1976), pp. 19–37.

15 M. Fabrizi and D. Scott, "Unusual Copper Corrosion Products and Problems of Identity" in Black (note 2), pp. 131–134.

16 E. R. Caley, "Chemical Composition of Greek and Roman Statuary Bronzes," in S. F. Doeringer, D. G. Mitten, and A. Steinberg, eds., *Art and Technology* (Cambridge, Mass., 1970), pp. 37–51.

17 H. Lechtman and A. Steinberg, "Bronze Joining: A Study in Ancient Technology," in Doeringer, Mitten, and Steinberg (note 16), pp. 5–35.

18 Caley (note 16).

19 Craddock, 1976 (note 3).

20 Caley (note 16).

21 Craddock, 1976 (note 3).

Egyptian Metal Statuary of the Third Intermediate Period (Circa 1070–656 B.C.), from Its Egyptian Antecedents to Its Samian Examples

Robert Steven Bianchi

Before beginning a study of the sophisticated metal sculpture created in Egypt between the eleventh and seventh centuries B.C. one must acknowledge recent assessments of the Third Intermediate Period itself. Traditionally Egyptologists had regarded this epoch in much the same way as classicists had once regarded the dark ages in Greece at the beginning of the first millennium B.C. From this vantage Egypt's decentralized political system and the seeming eclipse of her influence abroad appeared to be causes contributing to a perceived decline in her material culture.[1] Egyptian art histories, some published as recently as the 1980s, were quick to dismiss the art of the Third Intermediate Period as *retardataire*, lacking in innovation, and uninspired.[2] Today, due in no small part to the increase in the number of specialists focusing their collective attention on the monuments of this epoch,[3] the Third Intermediate Period is being viewed as an epoch of intense creativity and, in certain specific instances, that creativity was itself the source of religious formulations[4] and iconographic programs,[5] which subsequent Egyptian dynasties were to develop and embellish.[6]

The factors contributing to such a cultural flowering are many, but two among them emerge as fundamental. The first is the composition of the Egyptian population, particularly that of its ruling classes. Throughout the history of the Third Intermediate Period the native Egyptians were themselves ruled by foreigners, the first of whom were the Libyans. These Libyans, who for various reasons had earlier settled within Egypt's borders, emerged during the Twenty-second Dynasty (circa 945–713 B.C.) as one of the ruling classes.[7] Lacking a material culture of their own, the Libyans so completely appropriated the external trappings of kingship and other visible aspects of ancient Egypt's culture that their ethnic identity was soon subsumed beneath a thick veneer of what appears to be a progressive egyptianization.[8] The same processes are observable, but to a lesser degree, regarding the Kushites, a people living in Nubia, to the south of Aswan, who invaded Egypt in the eighth century B.C. and eventually ruled from Thebes as pharaohs in their own right during the Twenty-fifth Dynasty (circa 719–656 B.C.), which was initially collateral with the Twenty-second Dynasty.[9]

Both Libyan and to a greater degree Nubian acculturation are characterized by archaizing,[10] a phenomenon that enabled Libyan and Nubian alike to survey Egypt's long cultural past in order to select from that tradition those features that might immediately be borrowed, transformed, and manipulated to suit their specific cultural agenda. Archaizing in many ways masked the respective ethnic identities of these foreign groups and, more significantly, enabled them to proclaim their "Egyptianness."[11]

One further point requires emphasis. Throughout the course of the Third Intermediate Period Egypt was ruled by an inordinately large number of petty despots, each belonging to one or another of the complex series of overlapping, contemporary dynasties that were centered in any number of capital cities throughout the land. Whereas the dynasts were ostensibly in competition with one another, as their simultaneous claims to Egypt's kingship might indicate,[12] these same petty princes might at other times become allied[13] in a political system, whose model is that provided by the feudal lords of medieval Europe. As a result there was a certain uniformity in the material culture of the Third Intermediate Period throughout the Egyptian Delta.[14] This apparent homogeneity in the visual arts and the absence of one specific cultural center responsible for a localized style are of fundamental importance for one's understanding of how Egyptian ideas might be exported to neighboring civilizations. Any errant foreign visitor to the Egypt of the Third Intermediate Period could, in theory at least, observe almost any facet of Egypt's homogenous culture in virtually any Egyptian metropolis that the visitor chanced upon.

An investigation of this process of acculturation as the product of the phenomenon of archaizing[15] reveals that the various epochs into which Egypt's long history is divided are more narrowly interconnected with one another than most have previously admitted.[16] Indeed, these investigations have shown that the ancient Egyptians were both cognizant of their past and quite capable of recalling it.[17] That demonstrable ability to recall the past and to incorporate aspects of that recollection into the cultural patterns of subsequent generations explains why ancient Egyptian art is at once so traditional and so long-lived. It is, therefore, always advisable to assess aspects of ancient Egyptian art as a causal, sequential development of all that preceded it. Indeed, Egyptian art is the product of an ever repeating internal cycle by which each succeeding generation selectively draws its inspiration from a common cultural continuum, only to have its oeuvre, once created, intercalated into that very same system. Tradition may be modified, but it is never discarded, and new developments, once adopted, are ever after at the disposal of the Egyptian artisan.

This study of Egyptian statuettes in bronze
from the Third Intermediate Period is based upon the phenomena just
described and must, therefore, take as its point of departure the
development of the technologies for copper and bronze in Egypt prior to
the period under discussion. A brief review, then, of Egyptian copper and
bronze statuary is in order.

The Egyptians are known to have acquired the
technology for working copper during the fourth millennium B.C.[18]
Nevertheless the earliest evidence for copper statuary is the reference in
the Palermo Stone to such a figure made for King Khasekhem of the
Second Dynasty (circa 2782–2755 B.C.).[19] On the other hand, the earliest
extant Egyptian figure in metal is that made of sheets of copper for Pepy I
of the Fifth Dynasty (circa 2407–2395 B.C.), which is now on view in the
Cairo Museum.[20] By the time of the Middle Kingdom (circa 2000–1715
B.C.) statuettes in copper became more frequent.[21] Moreover, at some
still undetermined point in time between the Old and Middle Kingdoms,
the Egyptians began to use bronze with greater frequency, although there
is evidence that this metal was at least known to, if not manufactured by,
the Egyptians at a much earlier date.[22] This new technology was
dependent upon the availability of tin, which the Egyptians might obtain
locally in their eastern desert in the form of placer deposits of
cassiterite.[23] They soon realized, however, that tin could be replaced with
lead, which was more readily available to them.[24] Because bronze was
originally employed in the Middle Kingdom for tools, weapons, and the
like,[25] some have assumed that this technology was imported into Egypt
from the Orient,[26] perhaps even from Syria,[27] whereas others maintain
that craftsmen immigrating to Egypt from Cyprus were responsible for
its introduction.[28] Whatever its origin(s), the new technology was rapidly
mastered, immediately adopted throughout Egypt, and quickly acquired
by at least one region far to the south.[29] This new material was
immediately exploited by Egypt's artisans, who developed more
sophisticated statue types, as the examples from the Twelfth Dynasty
(circa 1963–1782 B.C.) in both Athens and Cairo reveal.[30] These share
with examples in wood a certain refinement and elegance absent in
contemporary stone statuary.[31] The relationship between woodworkers
and metalsmiths and their respective production is certainly worth
investigating. Nevertheless these cast-bronze figures from Egypt are
possessed of characteristics that remove them from the styles of certain
contemporary Near Eastern bronzes,[32] and they seem to indicate that the
ancient Egyptians had the potential for exploiting the possibilities
inherent in bronze as a medium.

That potential was spectacularly affirmed a
little over two decades ago when a cache of bronze statuettes was

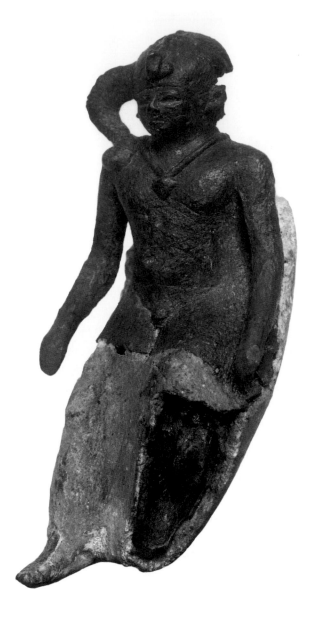

FIG. 1

Hollow-cast statuette in a post-casting plaster investment. Egyptian, circa 1070–100 B.C. The Brooklyn Museum inv. 37.364E. Photo courtesy The Brooklyn Museum.

discovered in the Faiyum. Divided today between at least one private and two public[33] collections, the group has yet to be fully published. Preliminary indications, however, suggest that at least some of these pieces are hollow cast in the lost-wax process (fig. 1)[34] and that some pieces in this lot can be dated to the reign of Amenemhet III (circa 1843–1795 B.C.) according to an assessment of at least one example.[35] Technically the bronzes are accomplished. Individual examples reveal that arms might be separately cast and joined to bodies by an elaborate mortise-and-tenon system[36] and that secondary materials might be inlaid into the bronze, particularly for the eyes. Collectively these bronzes reveal that whatever debt the ancient Egyptian craftsmen may have owed to a foreign source – either for the importation of the bronze technology or for the development of the hollow-casting technique – had been completely suppressed. The technology of casting bronze in the lost-wax method was shackled and pressed into service for the creation of

typically Egyptian statuary types. Tradition is maintained at the expense of any innovation inherent either in this newly adopted technology or the material, bronze. The statuette of an official[37] parallels types known in stone,[38] and the exquisite tripartite modeling of the torso of the figure identified as Amenemhet III[39] recalls the finest torso modeling of the period.[40] These masterful bronzes are completely and thoroughly Egyptian in both their conception and style.

Their appearance forces one to reconsider the subsequent development of bronze casting in ancient Egypt, for these Middle Kingdom bronzes establish the first link of the chain that ultimately extends to the Third Intermediate Period. The second link in this chain is provided by both the historical texts and two-dimensional representations from the New Kingdom (Eighteenth to Twentieth Dynasty, circa 1550–1070 B.C.) that mention and depict statues in bronze.[41] The sheer number of such objects, suggested by that evidence, has been attributed to Egypt's ability to acquire the necessary raw materials in abundance as a result of her greater integration into the international world of trade in the late Bronze Age.[42] The examples from the Middle Kingdom fill a void, thereby enabling one to visualize what the ancient Egyptians were capable of creating during the New Kingdom, a period from which very few actual bronzes survive. Among the rare uncontested examples from the Eighteenth Dynasty is that inscribed for King Tuthmosis IV (circa 1395–1386 B.C.),[43] although a second, uninscribed, piece has been identified as a depiction of King Tutankhamun (circa 1331–1322 B.C.).[44] A study of the former suggests that the bronze was cast over a sand core held in place by metal chaplets.[45] It is truly unfortunate that more examples have not survived, for the Egyptians of the New Kingdom seem to have pushed this technology beyond the frontiers established by the Middle Kingdom. Here one must simply recall the depiction in the paintings on the wall of the Tomb of Rekhmire, dated to the time of King Tuthmosis III (circa 1479–1425 B.C.), in which metalsmiths are shown casting the great bronze doors for the Temple of Amun at Karnak.[46]

If examples of bronze sculpture from the Eighteenth Dynasty are rare, those from the Nineteenth and Twentieth dynasties (circa 1291–1070 B.C.) are almost nonexistent. The magnificent head in Hildesheim, once thought to represent Rameses II, now appears after recent conservation treatment to belong instead to the Egyptian Late Period.[47] The material of a partially preserved *ushabti*, or funerary figure, of King Rameses II (circa 1279–1212 B.C.), although hollow cast, has recently been identified as copper, not bronze.[48]

On the other hand, there are examples in precious metal that reveal that the late New Kingdom, particularly the

Ramesside period of the Nineteenth Dynasty (circa 1291–1185 B.C.), stood at the threshold of what was to develop into a burgeoning metalworking industry in the Third Intermediate Period. Of particular importance in this regard is a splendid statuette, known since 1891, but only recently called to the attention of a wider audience.[49] This silver statuette, cast over a sand core in the lost-wax method, is covered with gold leaf and represents a young pharaoh, identified on the basis of stylistic comparison with the relief representations at Abydos as Sety I (circa 1290–1279 B.C.).[50] If its dating is accepted, this statuette reveals that the ancient Egyptians of the Nineteenth Dynasty could effectively employ the lost-wax method of casting for a variety of metals. Technically the arms are cast separately and attached to the body by means of a mortise and tenon, in keeping with tradition established for some of the bronzes in the cache from the Middle Kingdom and repeated in the New Kingdom example attributed to Tutankhamun.[51]

The astounding numbers,[52] then, of bronze figures hollow cast by the lost-wax method during the Third Intermediate Period (circa 1070–656 B.C.) can be regarded as the logical development of a process that began already during the Twelfth Dynasty.[53] But these figures must themselves first be placed into the context of Egyptian metalwork of that age in order that we may appreciate the broad scope of that Egyptian production. Some idea can be obtained by even a rapid survey of the objects uncovered during the excavations of the royal necropolis at the site of Tanis in the extreme eastern corner of the Nile Delta in the interval between the world wars by the French under the direction of Pierre Montet. Among the unprecedented finds were the silver anthropoid sarcophagus[54] of King Psusennes I of the Twenty-first Dynasty (circa 1039–991 B.C.) as well as a second sarcophagus[55] inscribed for Sheshonq II, who ruled briefly about 890 B.C. These same excavations unearthed an assortment of other funerary paraphernalia in precious metals as well as a variety of gold and silver vessels, some of which – the gold bowl of Wendebawended, for example, with its colored-paste inlays – are exceptionally crafted, whereas others – the same individual's footed bowl – are rather perfunctorily made.[56] Such differences in quality are to be expected in light of the sheer number of such vessels found at Tanis. Far from being an impoverished epoch, the Third Intermediate Period appears to have had the wealth of the ancient Near East and the expanding Mediterranean world at its disposal. The amount of precious metal recovered from the royal tombs at Tanis is reflected in at least one other source from the period. Edouard Naville, excavating at the site of a small temple at Bubastis in the Nile Delta between 1887 and 1889, discovered twenty-nine fragments of a four-sided red granite column

inscribed for King Osorkon I and dated by inscription to his fourth regnal year (circa 980 B.C.).[57] The inscription contains a listing of all of the statues, vessels, utensils, and the like that Osorkon I presented to all of the temples of Egypt. Converting the amounts of gold and silver, listed therein in terms of *deben*, an Egyptian measure for such commodities, to troy weight reveals an aggregate amount of gold and silver combined in excess of 391 tons.[58] The finds from Tanis and this inventory of Osorkon I are, therefore, in and of themselves sufficient to indicate that the Egyptians of the Third Intermediate Period were certainly in the forefront of metallurgical technologies in the early Iron Age. That primacy was the climax of a long tradition that can be traced back to the Middle Kingdom.

The corpus of metal sculpture created during the Third Intermediate Period is consistent with the picture presented by the finds at Tanis and the inventory of Osorkon I and further reveals just how interrelated the metalcasting trades must have been. The tradition established by the Ramesside ateliers for the creation of the silver statuette of Sety I[59] were continued during the Third Intermediate Period, as the group in Paris representing the Kushite pharaoh Taharqa (circa 690–664 B.C.) kneeling before the falcon god Hemen reveals.[60] The entire group was separately cast in bronze, before the base was clad in silver and the god in gold.[61] Individual statuettes might also be cast in gold, as the figure of the god Amun in New York[62] or the figure of the ram god Harsaphes[63] in Boston reveal. More striking, however, is the solid silver image of a seated falcon lavishly embellished with inlays of secondary materials that I was invited to examine in the summer of 1988. The piece, now in a private collection, is datable to the Third Intermediate Period on the basis of that examination.

This brief survey of metalwork was necessary to demonstrate that the sheer number, technical accomplishment, and aesthetic quality of hollow-cast bronze figures are not an isolated Egyptian phenomenon. Such images can only be regarded as a part, perhaps a small part, of an intense and widespread metallurgical industry that characterizes Egyptian culture during the Third Intermediate Period.

Certain points emerge when one now studies these bronze figures as a group. Most of the bronzes are relatively large in size, hollow cast in the lost-wax method, and have their surfaces decorated with secondary materials.[64] All are freestanding, independent creations. In fact, the Egyptians of this period seem to have avoided vessels or other utensils and implements with either human or animal attachments. In this regard, then, their metal production is divorced from that of many of its contemporary Near Eastern neighbors and, as

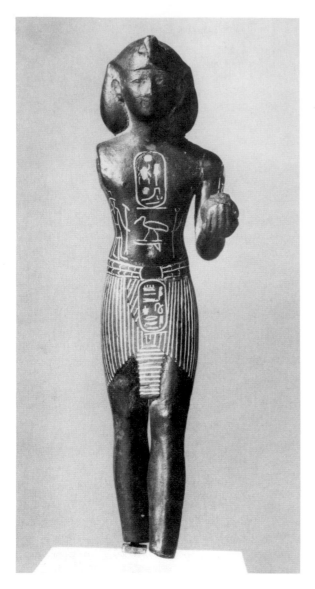 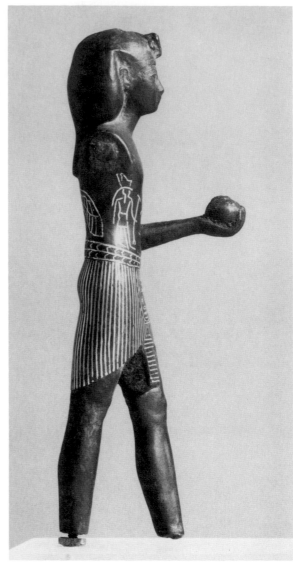

FIG. 2a

Statuette of Pharaoh Osorkon I.
Egyptian, Third Intermediate
Period, Twenty-first Dynasty, circa
980 B.C. Hollow-cast bronze with
gold and electrum(?) inlays. The
Brooklyn Museum inv. 57.92.
Photos courtesy The Brooklyn
Museum.

FIG. 2b

Right side of figure 2a.

such, it stands closer to what the Greeks were to evolve. Further, the largest Egyptian figural bronzes of the period are depictions of women,[65] and of those the representation of Karomama in Paris[66] and of Takushite in Athens,[67] both in excess of 50 cm in height, are the most impressive. The costumes of such statues are articulated by the addition of secondary materials, which here are primarily strands of precious materials hammered into grooves in the bronze. F. W. von Bissing had long ago suggested that this technique may have been in imitation of costly embroidered textiles,[68] as described in *The Tale of Petubastis*, a contemporary Egyptian romance.[69] Such native Egyptian textiles may have been the antecedents of those described and attributed to Alexandria by Pliny.[70] The interpretation of single elements of corresponding inlays on the skin of male figures — as seen, for example, on a bronze statuette of the same Osorkon I mentioned above (figs. 2a–b)[71] — as tattoo,[72] has now been dismissed.[73]

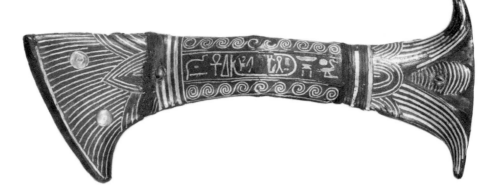

FIG. 3a

Weapon handle inscribed for
Pharaoh Sety I. Side A. Egyptian,
Nineteenth Dynasty, circa 1290–
1279 B.C. Bronze inlaid with gold
and copper. The Brooklyn
Museum inv. 49.167a. Photos
courtesy The Brooklyn Museum.

FIG. 3b

Side B of weapon handle,
figure 3a.

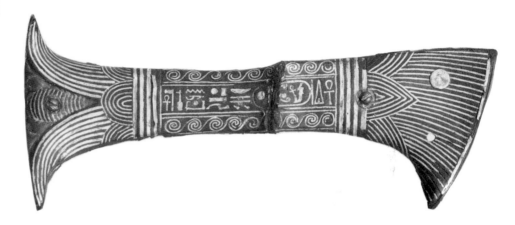

A recent examination[74] of this figure of
Osorkon I, which is in the collections of the Brooklyn Museum, revealed
that the V-shaped concavities into which the precious metal was
hammered had been meticulously incised into the wax matrix before
casting. This regularity was further enhanced by the uniform size of the
inlays themselves, which were added subsequent to the casting. Those
inlays consist of gold of two different colors, a "whiter" (perhaps to be
regarded as electrum?) and a yellower variety. The decision to use gold of
two colors appears to be arbitrary, for both materials appear
indiscriminately side by side in hieroglyphs within the cartouche, or royal
ring, and in one band of inlay directly beneath it. The inlays of this
statuette are qualitatively finer than those on the weapon handle[75] (figs.
3a–b) of Sety I of the Nineteenth Dynasty (circa 1290–1279 B.C.) in
which the V-shaped concavities are less regular and the inlays themselves
are of small lengths with obvious junctions. Clearly, then, the
workmanship of such inlaid bronze work of the Third Intermediate
Period appears to be superior to that produced earlier.

The obviously blackened surfaces of both these
bronzes were also examined, for each has often been adduced as an
example of the so-called black-bronze technique, which John Cooney
repeatedly investigated.[76] In reading historical texts from the Eighteenth
Dynasty (circa 1550–1291 B.C.), he was struck by the frequent mention
of "black bronze," which was invariably accompanied by the mention of

various sorts of inlays.[77] Cooney suggested[78] that a small sphinx in Paris, inscribed for King Tuthmosis III (circa 1479–1425 B.C.), and an adze from the tomb of King Tutankhamun (circa 1331–1322 B.C.) were examples of that technique, which he described as an intentional darkening, or blackening, of the surfaces of the bronze. He argued that the technique was necessary because the natural color of the bronze would visually obscure the inlays of a like-colored material, although he failed to mention that the Egyptians could inlay gold into bronzes, the surfaces of which were not intentionally discolored (figs. 4a–b).[79] He suggested that sulfides were used as the discoloring agent and argued that this technique developed in Mesopotamia, whence it was subsequently imported into Egypt.[80] Later, Cooney suggested that the blade[81] of the dagger of Ahmose, discovered in 1859 and dated to the beginning of the Eighteenth Dynasty (circa 1550 B.C.), was an early example of this black-bronze technique and as such was related to the sword blades later found at Mycene,[82] the technique of which has been termed niello.[83] The discovery of the crocodile[84] reportedly among the cache of Middle Kingdom bronzes discussed above effectively reopens all of these issues, for it appears to be the earliest known Egyptian black bronze with inlays of gold.

A recent attempt to ascertain the nature of the intentional blackening of the weapon handles of Sety I and the statuette of Osorkon I in Brooklyn produced inconclusive results. One side of the weapon handle (fig. 3b)[85] appears to be relatively free of the black alteration product visually identified as copper sulfide, although, admittedly, there are some traces present. The other side (fig. 3a)[86] retains a spotty, lumpy film, visible under magnification, which is associated with that same corrosion product. This film is irregularly distributed. Nevertheless, the surfaces of both sides are generally very smooth and well preserved. Under magnification, the black surface appears to follow the grain structure of the bronze and to continue into the V-shaped concavities, as is visible where the inlay is missing. The surfaces of the statuette of Osorkon I (figs. 2a–b), on the other hand, are more problematic, for the original surface appears to have been altered by a corrosion formation and modern cleaning treatment. As a result, in many areas the bronze is eroded to a level below that of the gold inlays. The evidence suggests that the black layer is a corrosion product that has developed at some point after both excavation and treatment. The surface discoloration, therefore, may be either intentional or the natural result of a reaction of the metal with pollutants.

As a result, the two halves of the weapon handle of Sety I may in fact represent an ancient technique modernly equated with the black bronze of the ancient Egyptian texts, whereas no

FIG. 4a

Statuette of the god Amun.
Egyptian, Third Intermediate
Period, 1070–656 B.C. Hollow-
cast bronze with gold inlays. The
Brooklyn Museum inv. 37.254E.
Photos courtesy The Brooklyn
Museum.

FIG. 4b

Back view of figure 4a.

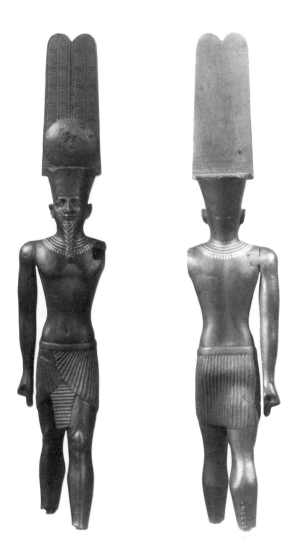

firm conclusions can be drawn about the surfaces of the statuette of
Osorkon I. Additionally, the *nu*, or ritual, jars and the face of this
statuette may have been covered with gold leaf, for gilding is still clearly
visible in the corrosion on these areas.

It still remains to be seen whether the
blackening of the surfaces of the weapon handle of Sety I can be equated
with the black bronze mentioned in Egyptian texts such as the inventory
of Osorkon I. Nevertheless, the matter is worthy of future investigation,
for the nature of this blackening is still being debated.[87] Furthermore, at
least one Hellenistic bronze statuette in the current exhibition, *The Gods
Delight*, that of the Black Banausos(?) (no. 20) – interestingly enough
attributed to Alexandria – has been called an example of black bronze.[88]
It would be significant to determine, if at all possible, whether the
technique employed here is dependent upon that employed for the
blackening of the weapon handle of Sety I. Finally, a second bronze in
this same exhibition, that of a Lasa (no. 50),[89] which had earlier been

identified as a black bronze,[90] appears to have retained very little of its original patination[91] and can, consequently, be removed from all subsequent discussions of this phenomenon.

When one now reviews the bronze production of Egypt during the Third Intermediate Period, one understands just how technically accomplished the Egyptians were in this craft. It has been noted that the metalsmiths of the Third Intermediate Period emphasized the tripartition of the male torso,[92] modeled no doubt upon earlier Egyptian prototypes.[93] This stylistic feature appears so commonly among bronzes of the period as to be taken for granted. And yet this feature did not become fixed in ancient Egyptian stone statuary until the sixth century B.C.[94] Moreover, the experimentation by these same artisans is evident in the way in which they incorporate subsidiary figures, primarily of deities, into their compositions.[95] Such theophoroi, again, anticipate the osirophoroi of the Saite period in stone.[96]

Although the government of Egypt during the Third Intermediate Period was decentralized, this summary of its metal production indicates that raw materials, in astronomical quantities, were placed at the disposal of craftsmen working in any number of centers scattered throughout the country. These craftsmen were capable of producing an array of objects, statuettes included, in gold, silver, and bronze, or any combination, often embellished with the addition of secondary materials. This flourishing industry, which is without parallel in any other culture in the ancient Near East in the early Iron Age, must have relied upon the mutually beneficial interaction of the metalworkers in all of its diverse crafts. Such collaboration doubtless enhanced the ability of the bronzesmiths of the period to perfect their techniques and produce works of outstanding aesthetic value. Indeed, the majority of the bronze statuettes, all of which are freestanding creations, are of technical excellence and exceptional quality. Many of them, as the excavations at Tanis indicate, were not employed as grave-goods but rather seem to have been temple dedications,[97] deposited where they might be seen by any casual visitor. Since these things are so, one can make a very strong case for Egypt as the source of the technology that enabled the Greeks of the eighth century B.C. to develop the lost-wax process for hollow-cast bronzes.

Examining the Egyptian bronze statuettes excavated on Samos, which represent the largest proportion of such foreign imports,[98] tends to support such a position because several of the more distinguished pieces are in fact stylistically akin to several types known from the Third Intermediate Period. So, for example, the wonderful statuette of a goddess, perhaps to be identified as Neith,[99] is perhaps the oldest of the Egyptian bronzes found on Samos. Although

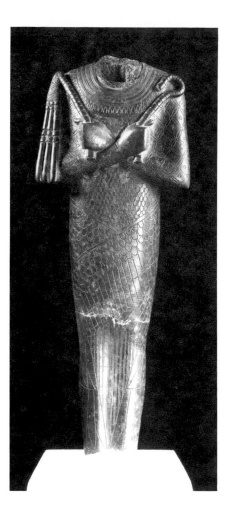 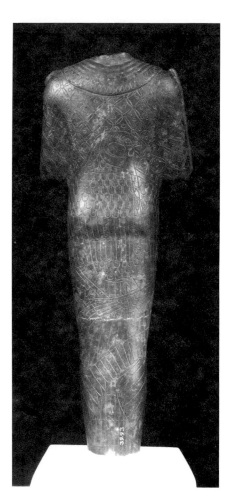

FIG. 5a

Statuette of the god Osiris.
Egyptian, Third Intermediate
Period, 1070–656 B.C. Hollow-
cast bronze. The Brooklyn
Museum inv. 39.93. Photos
courtesy The Brooklyn Museum.

FIG. 5b

Back view of figure 5a.

solid cast, its dating to the Third Intermediate Period seems assured
because of the addition of a gold inlay of a falcon's head on her upper
back, recalling the gold inlays on the statuette of Karomana,[100] but
replicating the corresponding design found in a bronze statuette in
Brooklyn (figs. 5a–b).[101] Such inlays become more infrequent during the
Twenty-fifth Dynasty (circa 719–656 B.C.), and they virtually disappear
during the Twenty-sixth Dynasty (664–525 B.C.) and thereafter.

 The finest Egyptian bronze from Samos is
doubtlessly that of an uninscribed male figure wearing a leopard's
skin.[102] The round configuration of the head,[103] now associated with this
piece, would seem to confirm a date within the Twenty-fifth Dynasty,[104]
as would the proportions of the body, which are less attenuated than
those of similar bronzes from the early Saite period of the Twenty-sixth
Dynasty (664–600 B.C.).[105] Moreover, those Saite examples are cast as
one piece, whereas the Samian bronze, in keeping with a tradition
rampant during the Third Intermediate Period, had its arms cast
separately and subsequently attached by means of a mortise-and-tenon
system on the order of that employed both for the statuette of Osorkon I
(figs. 2a–b), an uninscribed male figure (fig. 6),[106] and a statuette of the
god Amun (figs. 4a–b).[107]

In all three of these last examples the arms, cast separately, were provided with a tenon projection that was slid into a close-fitted mortise cavity. The join seams between the arms and shoulders of each of the statuettes are visible to some extent without magnification. The tenon in the arm of the statuette of Osorkon I (fig. 2b) is basically rectangular with a slight dovetail wedge. The missing right arm permits one to calculate the width of the tenon, which appears to have been approximately three-quarters of the width of the shoulder. Here, the open ends for both arms are located at the back of the statuette.

The shape of the tenon in the figure of the god Amun (fig. 4b) is a sharply angled dovetail. Here, the craftsman has altered the openings of the mortise joint, that for the left arm is on the front, whereas that for the right is at the back. The shape of the tenon projections on the figure of the official (fig. 6) is a rounded rectangle, and that entire configuration traverses the full width of the shoulders. Whereas it was not possible at the time of examination to determine how these arms were actually held in place, the craftsman responsible for the statuette of Amun cold-worked an extra piece of copper alloy into the space between the inner vertical mortise wall of the shoulder and the adjacent vertical wall of the tenon (fig. 4b).

The overwhelming number of Egyptian bronzes from Samos[108] that find their exact parallels in works dated to the Twenty-fifth Dynasty (circa 719–656 B.C.) are representations of female figures. The two most remarkable are those with moveable limbs,[109] which are virtually identical to examples associated with the Kushites (fig. 7).[110] In their Egyptian contexts, such statuettes have alternately been regarded as representations of dolls, queens, and goddesses.[111] They are, nevertheless, the most elaborate of the bronze female figures created during the Third Intermediate Period. Hollow cast with moveable limbs, their surfaces are lavishly decorated with an array of secondary materials as inlays. Whatever their function might have been in Egyptian contexts, on Samos they must have been associated with Hera, a connection made even tighter by the presence of what the Greeks may well have perceived to be the polis-headdress.

A fragmentary Egyptian example of a full-figured woman[112] from Samos recalls the Kushite norms for the female body, as a comparison with the bronze statuette of Takushite in Athens reveals.[113] The incised decoration in the surfaces of a second Egyptian bronze from Samos,[114] also very fragmentary, may be regarded as a less opulent version of such inlays. In fact, a number of Egyptian bronzes from the Third Intermediate Period rely on such incision for their decorative effect.[115]

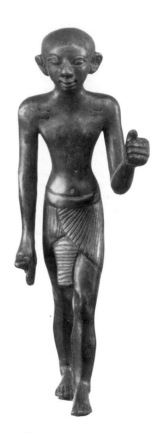

FIG. 6

Statuette of an official. Egyptian, Third Intermediate Period, 1070–656 B.C. Hollow-cast bronze. The Brooklyn Museum inv. 37.363E. Photo courtesy The Brooklyn Museum.

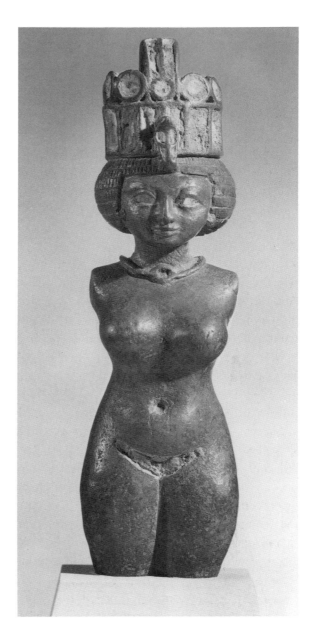

FIG. 7

Doll, queen, or goddess. Egyptian, Third Intermediate Period, Twenty-fifth Dynasty, 719–656 B.C. Hollow-cast bronze with a variety of inlays. The Brooklyn Museum inv. 42.410. Photo courtesy The Brooklyn Museum.

One last Egyptian bronze,[116] also from Samos, compares favorably to a second group of female figures from Egypt, which are assigned to the Twenty-fifth Dynasty (fig. 8).[117] Although the exact provenances for their Egyptian counterparts have not been established, this group shares so many Kushite characteristics in the rendering of the faces that their attribution to the Twenty-fifth Dynasty is assured.

These comparisons between a selected group of artistically accomplished Egyptian bronzes from Samos and their parallels from the Third Intermediate Period enable one to establish the following chronological observations. The majority were created during the Kushite period of the Twenty-fifth Dynasty (circa 719–656 B.C.). As a result, these Egyptian bronzes must have been imported into Samos shortly after their actual manufacture in Egypt, for their suggested

Egyptian dating coincides almost exactly with the dating established for their Samian archaeological contexts. Accordingly, the Samians were exposed to magnificent examples of Egyptian bronze figures made by the lost-wax method at a time when that production was at its height in Egypt.

One must now place this chronological evidence into the broader context of the eighth and seventh centuries B.C. During this period the emerging Greek city-states gradually abandoned certain artistic conventions in favor of others, often derived from a repertoire of forms made available because of their increasing contacts with the older civilizations of the ancient Near East. And while it may be true that several of those Iron Age cultures of the Orient possessed the technology for casting bronze in the lost-wax method,[118] only Egypt was geographically accessible and that accessibility was, as we have seen, responsible for the actual importation of Egyptian bronzes into Samos.

The following hypothetical scenario now suggests itself. One or more Greeks, Samians included, may have visited one or more Nile Delta sites in Egypt during the course of the eighth century B.C. when Egyptian metalworking was without rival in the eastern Mediterranean. There they may have seen what must have impressed them as enormous images of women, less frequently of men, cast in bronze, their own divine material, dedicated in sanctuaries. Upon inquiry, they most certainly would have discovered the centrality of wax to the process. It is even possible that these Samians learned about the magical properties of wax in Egyptian culture. Consider for a moment that wax, in its Egyptian cultural context, was possessed of characteristics that imbued it, as a primeval material, with magical properties, which could both create and destroy.[119] The lost-wax process was an affirmation of that paradox because once created, the wax matrix was destroyed for the sake of creation. This Egyptian view of wax would certainly have enhanced the independent Greek attitude toward the medium of bronze as the gift of the gods.

There is a further dimension to this suggested interaction, for the Samians had, in the course of the eighth century B.C., erected their first temple to Hera. Of unprecedented size, the temple also contained a primitive cult image, if one's interpretation of the base found within the temple is correct. Bronze statuettes of women, dedications in Egyptian temples, would also be suitable ex-votos for Hera. And in fact the finest of the Egyptian figural bronzes from Samos are depictions of women. Some of these, it can be convincingly argued, were brought back by Samians returning from Egypt. The distinct possibility, therefore, does exist that some of these Samians themselves witnessed the manufacture of some of these very Egyptian bronzes that they themselves were bringing home, for their Egyptian parallels and Samian

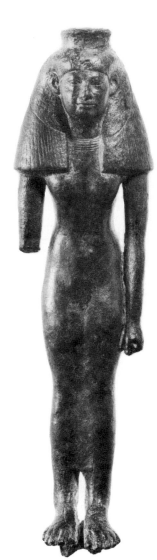

FIG. 8

Kushite female figure. From Samos. Egyptian, Third Intermediate Period, Twenty-fifth Dynasty, 719–656 B.C. Bronze. New York, the Christos G. Bastis collection, on loan to The Brooklyn Museum, acc. L76.9.2. Photo courtesy The Brooklyn Museum.

archaeological contexts suggest that they were deposited in Samos shortly after having been made in Egypt. It is, therefore, almost certain that Samians themselves learned the technology for hollow-casting bronzes in the lost-wax method directly from their Egyptian contemporaries.

And if there is scholarly debate about the name of the individual responsible for the introduction of the lost-wax method, one should remember that the Greeks themselves had a predilection for ascribing contributions in various fields of human endeavor to specific individuals. Samian Theodoros may, therefore, simply represent both the reality and the centrality of the role played by the Samians in general in integrating this new technology into the fabric of their emerging cultural tapestry.

The Brooklyn Museum
BROOKLYN, NEW YORK

Notes

Jantzen:
U. Jantzen, *Samos*, vol. 8, *Ägyptische und orientalische Bronzen aus dem Heraion von Samos* (Bonn, 1972).

Leahy:
A. Leahy, "The Libyan Period in Egypt: An Essay in Interpretation," *Libyan Studies* 16 (1985), pp. 51–65.

Roeder:
G. Roeder, *Staatliche Museen zu Berlin: Mitteilungen aus der Ägyptischen Sammlung*, vol. 6, *Ägyptische Bronzefiguren* (Berlin, 1956).

Ziegler:
C. Ziegler, "Les arts du métal à la Troisième Période Intermédiaire," in Association française d'action artistique, *Tanis: L'or des pharaons* (Paris, 1987), pp. 85–101.

1 Leahy, pp. 51–53, particularly his comments on the pejorative connotations of the phrase "intermediate period."

2 Inter alia, K. Michalowski, *L'Art de l'ancienne Egypte* (Paris, 1968), pp. 295, 309; W. Stevenson Smith, *The Art and Architecture of Ancient Egypt* (rev. edn. by Wm. Kelly Simpson) (New York, 1981), pp. 387–394.

3 D. B. Redford, G. E. Kadish, et al., *The XXIIIrd Dynasty Chapel of Osiris Heka-Djet*, Society for the Study of Egyptian Antiquities Publications, Mississauga, Ontario, Canada, forthcoming.

4 R. A. Fazzini, *Egypt: Dynasty XXII–XXV*, Section 16, Egypt, fasc. 10, of *Iconography of Religions* (Leiden, 1988), pp. 12–13, for the mammisis, or "birth houses."

5 Ibid., pp. 8–9, for the motif of the child god on the lotus.

6 F. Daumas, "La structure du mammisi de Nectanébo à Dendara," *BIFAO* 50 (1952), pp. 133–155; H. de Meulenaere, "Isis et Mout du Mammisi," *Orientalia Lovaniensia Analecta* 13 (= *Studia Paulo Naster Oblata*, vol. 2, *Orientalia Antiqua* [J. Quaegebeur, ed.]) (Louvain, 1982), pp. 25–29.

7 K. A. Kitchen, *The Third Intermediate Period in Egypt (1100–650 B.C.)* (Warminster, 1973), pp. 85–122; Leahy, pp. 53–54.

8 Leahy, pp. 51–56, who acknowledges that most indicators of Libyan ethnicity are concealed by an apparent Egyptian cultural facade, but who argues forcefully that Libyan ethnicity was integral to their social and political systems, which was evident as well in their use of the Egyptian language and in their names.

9 Ibid., p. 57; E. R. Russmann, *The Representation of the King in the XXVth Dynasty* (Brooklyn, 1974), pp. 9–24.

10 *Egyptian Sculpture of the Late Period: 700 B.C. to A.D. 100*, The Brooklyn Museum, October 1960–January 1961 (B. V. Bothmer et al., comps.), pp. xxxvii, 7, 18, passim; H. Brunner, "Archaismus,"

Lexikon der Ägyptologie, vol. 1 (Wiesbaden, 1975), pp. 386–395.

11 Leahy, p. 57.

12 Ibid., p. 58, conveniently summarizing the information contained in the Piankhy Stela (Cairo JE 48862 and 47086–47089), published in extenso by N.-C. Grimal, *La Stèle triomphale de Pi('ankh)y au Musée du Caire* (Cairo, 1981).

13 Leahy, pp. 55, 58, and 59, where he suggests that this political system, which produced harmony rather than chaos, is typically Libyan and as such is an indicator of retained ethnicity.

14 Ibid., p. 59. This phenomenon requires further examination inasmuch as a faience plaque (Brooklyn 57.17, R. A. Fazzini, "Some Egyptian Reliefs in Brooklyn," *Miscellanea Wilbouriana*, vol. 1 [Brooklyn, 1972], pp. 64–65) inscribed for King Iuput II seems to contain stylistic features generally regarded as typically Kushite (idem, in *Neferut net Kemit: Egyptian Art from the Brooklyn Museum*, Isetan Museum of Art, Tokyo, and other institutions, September 1983–March 1984 [R. A. Fazzini et al.], no. 57).

15 Fazzini (note 14), p. 64; idem (note 4), pp. 6–7; Russmann (note 9), pp. 22–24.

16 G. M. A. Richter, "The Origin of Verism in Roman Portraits," *JRS* 44 (1954), pp. 39–46, may be regarded as typical of this stance, which is no longer tenable, as argued by R. S. Bianchi, in *Cleopatra's Egypt: Age of the Ptolemies*, The Brooklyn Museum and other institutions, October 1988–September 1989 (R. S. Bianchi et al.), p. 64.

17 D. B. Redford, *Pharaonic King-Lists, Annals and Day Books: A Contribution to the Study of the Egyptian Sense of History* (Mississauga, 1986).

18 A. Lucas and J. R. Harris, *Ancient Egyptian Materials and Industries*, 4th edn. (London, 1962), pp. 199–217, passim; W. Needler, *Predynastic and Archaic Egypt in The Brooklyn Museum* (Brooklyn, 1984), pp. 21–22.

19 Ziegler, p. 86.

20 Cairo JE 33034, Ziegler, p. 86.

21 New York, ex-Heeramaneck collection, formerly on loan to the Brooklyn Museum as L78.17.31, R. S. Bianchi, "Collecting and Collectors," *Art Gallery* 22.2 (1979), p. 104, for an early example from this period; and Brooklyn 43.137, J. F. Romano, in *Neferut net Kemit* (note 14), no. 20, for a late example.

22 Lucas and Harris (note 18), pp. 218–219, 256–257; W. Helck, "Bronze," *Lexikon der Ägyptologie*, vol. 1 (Wiesbaden, 1975), pp. 870–871; W. V. Davies et al., *Catalogue of Egyptian Antiquities in The British Museum*, vol. 7, *Tools and Weapons*, part 1 (London, 1987), p. 24.

23 D. Schorsch, "Technical Examinations of Ancient Egyptian Theriomorphic Hollow Cast Bronzes – Some Case Studies," in S. C. Watkins and C. E. Brown, eds., *Conservation of Ancient Egyptian Materials: Preprints of the Conference Organised by the United Kingdom Institute for Conservation, Archaeology Section, held at Bristol, December 15–16th, 1988* (London, 1988), pp. 47–48.

24 Ibid.; Ziegler, p. 86.

25 Lucas and Harris (note 18), pp. 218–219; Helck (note 22), pp. 870–871; R. A. David, "Investigations and Analysis of Ancient Egyptian Metals," in Watkins and Brown (note 23), pp. 25–28.

26 Helck (note 22), p. 218; Ziegler, p. 86.

27 C. F. A. Schaeffer, "La contribution de la Syrie ancienne à l'invention du bronze," *JEA* 31 (1945), pp. 92–95.

28 David (note 25), pp. 25–28.

29 Ch. Bonnet, "Un atelier de bronziers à Kerma," in M. Krause, ed., *Nubische Studien: Tagungsakten der 5. Internationalen Konferenz der International Society for Nubian Studies, Heidelberg, 22–25 September, 1982* (Mainz, 1986), pp. 19–22.

30 F. W. von Bissing, "Ägyptische Bronze- und Kupferfiguren des Mittleren Reiches," *AM*

38 (1913), pp. 239–262. One should,
however, note that his suggested datings
for many of the bronzes from later periods
discussed here as well are incorrect in light
of more recent studies. Compare, for
example, his discussion of Paris, Musée du
Louvre E.7692 (pp. 253–257) to that of the
same piece by Ziegler, p. 92.

31 Inter alia, cf. Athens, National Museum,
Collection Demitrio, without number,
Bissing (note 30), pp. 239–243, to Eton
College, Myers Museum 10, *Pharaohs and
Mortal: Egyptian Art in the Middle
Kingdom*, Fitzwilliam Museum and
Liverpool, April–September 1988
(catalogue by J. Bourriau), pp. 39 and 47,
no. 35, in order to assess the freedom
inherent in the use of these two materials.

32 Switzerland, private collection, D.
Wildung, *Sesostris und Amenemhet:
Ägypten im Mittleren Reich* (Fribourg,
1984), pp. 186–187.

33 Paris, Musée du Louvre E.27153, E.
Delange, *Musée du Louvre: Catalogue des
statues égyptiens du Moyen Empire, 2060–
1560 avant J.-C.* (Paris, 1987), pp. 211–
213; Munich ÄS 6080, D. Wildung, *Fünf
Jahre: Neuerwerbungen der Staatlichen
Sammlung Ägyptischer Kunst, München
1976–1980* (Mainz, 1980), p. 5, and
below, note 84; and most recently S.
Schoske, "Statue Amenemhets III.," *MüJb*
39 (1988), pp. 207–212.

34 Delange (note 33), p. 213, with the
accompanying X-ray of this object. For the
evidence of wax matrices and models from
ancient Egypt, see G. Roeder, "Die
Herstellung von Wachsmodellen zu
ägyptischen Bronzefiguren," *ZAeS* 69
(1933), pp. 45–67. Further confirmation is
necessary before accepting the suggestion
that the miniature wax sculpture from the
tomb of Rameses IX was such a matrix, as
indicated by J. Romer, *People of the Nile:
Everyday Life in Ancient Egypt* (New
York, 1982), p. 200. Finally, Brooklyn
37.364E, often cited as an example of an
Egyptian bronze still in its casting
investment (Roeder, p. 119), can now be
dismissed as such. The figure appears to
have been encased in a layer of vegetable

fiber covered by plaster at a time
subsequent to its casting, a process which
would itself have destroyed, or at the very
least, altered the fiber's condition.

35 Formerly, New York, private collection,
Wildung (note 32), pp. 208–209.

36 Delange (note 33), p. 213, with the
accompanying diagram.

37 Ibid.

38 Vienna ÄS 5051/5801, B. Jaroš-Deckert,
*Corpus Antiquitatum Aegyptiacarum,
Kunsthistorisches Museum, Vienna*, vol. 1,
*Statuen des Mittleren Reichs und der 18.
Dynastie* (Mainz, 1987), 1,39–1,49.

39 Wildung (note 32), pp. 208–209.

40 New York, the Metropolitan Museum of
Art 25.6, H. G. Fischer, "Anatomy in
Egyptian Art," *Apollo* (September 1965),
pp. 13–19; below, note 93.

41 Ziegler, pp. 86–87.

42 L. Garenne-Marot, "Le cuivre en Egypte
pharaonique: Sources et metallurgie,"
Paleorient 10 (1984), pp. 87–96.

43 London, British Museum 64564, Ziegler,
p. 87; P. A. Clayton, "Royal Bronze
Shawabti Figures," *JEA* 58 (1972), pp.
167–175.

44 Philadelphia, University of Pennsylvania,
University Museum E.14295, Roeder, p.
292.

45 Ziegler, p. 86.

46 Tomb 100, B. Porter and R. L. B. Moss,
*Topographical Bibliography of Ancient
Egyptian Hieroglyphic Texts, Reliefs, and
Paintings*, vol. 1, *The Theban Necropolis*,
part 2, *Private Tombs*, 2nd edn. (Oxford,
1970), p. 211; C. Aldred, *Egyptian Art*
(New York, 1980), p. 206; Ziegler, p. 87.

47 Hildesheim 384, H. Kayser, *Die
ägyptischen Altertümer im Roemer-
Pelizaeus-Museum in Hildesheim*
(Hamburg, 1966), p. 70. Its attribution to
the Late Period is my own, based on my
examination of the piece in 1987.

48 Berlin 2502, Clayton (note 43), pp. 167–175. One should note that the example cited on page 171, no. 1, is actually Louvre N.656a, and not Louvre 72, as cited; furthermore, this object is probably to be assigned to Sheshonq III, not to Rameses III, as there suggested.

49 Paris, Musée du Louvre E.2743, C. Ziegler, "La donation Ganay: Jeune pharaon présentant l'image de la déesse Maât," *La Revue du Louvre* 38.3 (1988), pp. 181–185.

50 Ibid.

51 Compare the X-ray of Louvre E.2743, Ziegler (note 49), p. 183, fig. 6, to that of Louvre E.27153, Delange (note 33), p. 213; see also above (note 34). This technique appears to be the same as that employed for London, British Museum 64564 (note 43), as well as for one of the Egyptian bronzes from the Third Intermediate Period found on Samos, B 1312 (note 102).

52 Ziegler, pp. 82–93.

53 Aldred (note 46), p. 206.

54 Cairo, number not available, J. Yoyotte, "Pharaons, guerriers libyens et grands prêtres: La Troisième Période Intermédiaire," in Association française d'action artistique, *Tanis: L'or des pharaons* (Paris, 1987), pp. 57–58; H. Stierlin and C. Ziegler, *Tanis: Trésors des pharaons* (Fribourg, 1987), pp. 12–13, 17.

55 Cairo M6287, Yoyotte (note 54), p. 67.

56 Ziegler, pp. 93–96 and 228–230, for Cairo JE 87741 and JE 87740, respectively.

57 Ed. Naville, *Bubastis (1887–1889)* (London, 1891), p. 61, pls. LI–LII; B. Porter and R. L. B. Moss, *Topographical Bibliography of Ancient Egyptian Hieroglyphic Texts, Reliefs, and Paintings*, vol. 1, *Lower and Middle Egypt* (Oxford, 1968), p. 32.

58 The calculations are those of Ziegler, p. 85, based on the inscriptions recorded by Naville (note 57), pls. LI–LII, which have been translated into English by J. H. Breasted, *Ancient Records of Egypt: Historical Documents*, vol. 4, *The Twentieth to the Twenty-sixth Dynasties* (Chicago, 1906), pp. 362–366. In light of such vast quantities of metal it is difficult to agree with J. Padró, "Le rôle de l'Egypte dans les relations commerciales d'Orient et d'Occident au premier millénaire," *ASAE* 71 (1987), pp. 213–222, who suggests that Phoenician sources of tin were central to Egypt's preeminent position in metalwork; above (note 24).

59 Above (note 49).

60 Paris, Musée du Louvre E.25276, Ziegler, p. 93.

61 Russmann (note 9), p. 58, no. 4.

62 The Metropolitan Museum of Art 26.7.1412, Ziegler, p. 92, but more fully in C. Aldred, "The Carnarvon Statuette of Amun," *JEA* 42 (1956), pp. 3–7.

63 Museum of Fine Arts 06.2408, which is inscribed for King Neferkare-Peftaouibastet, Ziegler, p. 93.

64 Ibid., pp. 87–93. Very few of these metal objects have theriomorphic attachments, the vessel in Cairo (CG 53262, R. E. Freed, *Ramesses the Great* [Memphis, 1987], pp. 148–149) being a notable exception.

65 There is some discussion about whether a base (Cairo JE 25572), inscribed for the great chief Sheshonq, belonged to a statuette (Ziegler, p. 91) or to a shrine (J. D. Cooney, "On the Meaning of *bi3*," *ZAeS* 93 [1966], p. 46). On the other hand, a fragmentary bronze statuette (Lisbon, Gulbenkian collection) – preserved from its lower abdomen to the level of the knees and inscribed for King Petubastis I, who is depicted wearing a kilt ornately decorated with inlays of various secondary materials – would be one of the tallest of such exceptional male figures of the period; its original height is estimated to have been about 80 cm (Ziegler, p. 88).

66 Paris, Musée du Louvre N.5000, Ziegler, pp. 88, 177–180.

67 Athens, National Museum ANE 110, Ziegler, p. 89; more fully by N. Boufides, "Takousit, ē thygatēr tou megalou archēgou tōn Maxyōn," *AE*, 1979, pp. 72–94.

68 F. W. von Bissing, "Gewänder mit eingewebten Figuren," *RecTrav* 29 (1907), p. 183.

69 G. Maspero, *Popular Stories of Ancient Egypt* (A. S. Johns, trans.) (New Hyde Park, N.Y., 1967), p. 230: "Pemu stretched forth his hand and grasped a shirt made of byssus of many colours, and on the front of it was embroidered figures in silver, and twelve palms in silver and gold adorned the back."

70 Pliny, *H.N.*, VIII.48, 74, as suggested by Bissing (note 68).

71 Brooklyn 57.92, Roeder, p. 290; Ziegler, p. 88; Aldred (note 46), p. 207; C. Vandersleyen, *Propyläen Kunstgeschichte*, vol. 15, *Das Alte Ägypten* (Berlin, 1975), p. 264, no. 209a.

72 L. Keimer, *Remarques sur le tatouage dans l'Egypte ancienne* (Cairo, 1948), pp. 64–70.

73 J. Yoyotte, "Le dénommé Mousou," *BIFAO* 57 (1958), pp. 81–89; R. S. Bianchi, "Tattoo in Ancient Egypt," in R. Rubin, ed., *Marks of Civilization: Artistic Transformations of the Human Body* (Los Angeles, 1988), p. 27.

74 I wish to thank Jane Carpenter, Ellen Pearlstein, Beverly Perkins, and Leslie Ransick of the Brooklyn Museum's Conservation Laboratory for examining a selection of Egyptian bronze statuettes in those collections. Parts of their respective reports have been incorporated into the various discussions of the Brooklyn objects that follow.

75 Brooklyn 49.167a–b, Roeder, p. 479; H. W. Müller, *Der Waffenfund von Balâta-Sichem und die Sichelschwerter* (Munich, 1987), p. 153, no. 17a. One should note that there are copper inlays as well in this bronze.

76 Cooney (note 65), pp. 43–47; idem, "Siren and Ba, Birds of a Feather," *BClevMus* (October 1968), pp. 268–271.

77 The phrase is a recurring one in subsequent Egyptian inscriptions and is found, for example, in the inventory of Osorkon I from Bubastis (Naville [note 57], pl. LI,

G1–G2, l. 5 = Breasted [note 58], p. 364) as well as in a later inscription from the North Crypt of the Opet Temple at Karnak that indicates that a statue of the god Osiris Onnuphris-the-Triumphant, made in black bronze, was once housed therein (Cl. Traunecker, "Cryptes décorées, cryptes anépigraphes," in Institut d'Egyptologie, Université Paul Valéry, *Hommages à François Daumas*, vol. 2 [Montpellier, 1986], p. 574 n. 33).

78 Paris, Musée du Louvre E.10897, Cooney (note 65), p. 45, Ziegler, p. 86; and Cairo JE 61292, Cooney (note 65), p. 43.

79 Cf., however, the bronze statuette of the god Amun in Brooklyn (figs. 4a–b) (37.254E, below, note 107), on which the gold inlays of the necklace still contrast with the "natural" color of the bronze.

80 Cooney (note 65), p. 47.

81 Cairo CG 25658, Cooney (note 76), p. 268; M. Saleh and H. Sourouzian, *Official Catalogue of the Egyptian Museum, Cairo* (Mainz, 1987), no. 122.

82 Cooney (note 76), p. 268.

83 R. Hampe and E. Simon, *The Birth of Greek Art from the Mycenean to the Archaic Period* (New York, 1981), figs. 173–178.

84 Munich ÄS 6080, above (note 33), where the technique is identified as niello as well. One of the statues, presently identified as a kneeling representation of King Amenemhet III in the collection of George Ortiz, exhibits a similar blackening of its surfaces over which the still-preserved gold leaf had been applied. I thank Mr. Ortiz for his hospitality and access to his collection during a visit in the summer of 1989.

85 Brooklyn 49.167b.

86 Brooklyn 49.167a.

87 Equally equivocal are the comments of F. Shearman, "The Original Decorated Surface on an Egyptian Bronze Statuette," in Watkins and Brown (note 23), pp. 29–34, regarding British Museum 11528, a solid-cast bronze in which "a black substance has been used to highlight a

group of feathers on either side of the beak." Moreover, Cooney (note 76), p. 271, steadfastly refused to identify this blacking as niello, contra both Hampe and Simon (note 83), figs. 173–178, and Wildung (note 33), pp. 14–15. Cooney maintained that "niello differs from black bronze, although related to it, in being an inlay in the form of a sulphide paste to fill an incised design. Black bronze is the reverse, being a sulphide surfacing element spread over the area which contains inlays of a contrasting metal."

88 The Cleveland Museum of Art 63.507, M. True, in *The Gods Delight: The Human Figure in Classical Bronze*, The Cleveland Musuem of Art and other institutions, November 1988–July 1989 (A. P. Kozloff and D. G. Mitten, organizers) (Cleveland, 1988), pp. 128–131.

89 The Cleveland Museum of Art 47.68, S. Fabing, in *The Gods Delight* (note 88), pp. 267–271.

90 Cooney (note 76), p. 270.

91 Fabing (note 89), p. 270.

92 Ziegler, p. 87.

93 Above (notes 39–40).

94 Bothmer (note 10), pp. xxxv, 54, 78, passim.

95 Ziegler, p. 91.

96 Compare, e.g., Berlin 23732, Ziegler, p. 90, to either New York, the Metropolitan Museum of Art 07.228.33 (top), which joins Cairo JE 37442 (bottom), or to New York, the Pierpont Morgan Library 11, Bothmer (note 10), pls. 35 and 36, respectively.

97 Ziegler, p. 93.

98 Jantzen, p. 93.

99 Samos B 354, Jantzen, pp. 23, 27, and 89 with n. 334.

100 Above (notes 66–67).

101 Brooklyn 39.93, not published. This statuette, tentatively identified as a representation of the god Osiris, was acquired in Egypt in 1886. It measures 15.3 cm in height, and its greatest width is 5.9 cm.

102 Samos B 1312, Jantzen, pp. 7–10; above (note 51). For a discussion of the animal represented and the costume, see L. Strock, "Leopard," *Lexikon der Ägyptologie*, vol. 3 (Wiesbaden, 1980), pp. 1006–1007; W. Westendorf, "Panther," *Lexikon der Ägyptologie*, vol. 4 (Wiesbaden, 1982), pp. 664–665.

103 Samos B 1690, Jantzen, p. 9.

104 Bothmer (note 10), pp. 86–87, discusses the head type to which this one belongs.

105 London, British Museum 14466, H. R. Hall, "The Bronze Statuette of Khonserdaisu in the British Museum," *JEA* 16 (1930), pp. 1–2; J. Yoyotte, "Trois notes pour servir à l'histoire d'Edfou,"*Kêmi* 12 (1952), p. 95, is dated by inscription to the reign of Psametik I (664–610 B.C.) of the Twenty-sixth Dynasty, and Selçuk, Efes Müzesi 1965 (E. Winter, "Eine ägyptische Bronze aus Ephesus," *ZAeS* 97 [1971], pp. 146–155), representing the prophet Ihat, who ostensibly began his career under Necho II (610–595 B.C.), whose name on this bronze had been altered to accommodate his successor Psametik II (595–589 B.C.). It is interesting to note that two of the finest Egyptian bronze statuettes of men found in Greek contexts depict them in the leopard's skin (Samos B 1312 and Efes Müzesi 1965).

106 Brooklyn 37.363E, J. Vandier, *Manuel d'archéologie égyptienne*, vol. 3, *Les Grandes Epoques: La Statuaire* (Paris, 1958), pp. 229, 274, whose dating of this piece to the Middle Kingdom has already been challenged by R. Fazzini, *Art of Ancient Egypt: A Selection from the Brooklyn Museum*, Emily Lowe Gallery, Hofstra University, February–April 1971 (catalogue by R. Fazzini), no. 11. Compare this technique to that discussed by J. M. Hemelrijk, "Piece Casting in the Direct Process," *BABesch* 57 (1982), pp. 6–11.

107 Brooklyn 37.254E, Roeder, p. 34; *Images for Eternity*, The Fine Arts Museum of San Francisco and The Brooklyn Museum, July–October 1975 (catalogue by R. Fazzini), pp. 96–97; above (note 79).

108 J. Śliwa, "Egyptian Bronzes from Samos in the Staatliche Museen (Antiken-Sammlung) in Berlin," *EtTrav* 13 (1983), pp. 380–392, deals with eleven such bronzes, four of which were not known to Jantzen. These include a Bes figure (inv. 4), a wig (inv. 6), and two bird's legs (inv. 33 = B57, and 51 = B57[?]). These additional examples, while increasing the number of Egyptian bronzes from Samos, do not appreciably add to an understanding of the material, for they replicate known types already presented by Jantzen. One should, however, mention that the bandy-legged deity, commonly identified as Bes, should more properly be labeled a Bes image, for several different genii of the Egyptian pantheon could be so represented. All such Egyptian images derive from an original leonine deity; see, J. F. Romano, "The Origin of the Bes-Image," *The Bulletin of the Egyptological Seminar of New York* 2 (1980), pp. 39–56. As a result, the association of such Egyptian images, inter alia Samos B 353, with Greek satyrs and sileni (K. Parlasca, "Zwei ägyptische Bronzen aus dem Heraion von Samos," *AM* 68 [1953], pp. 131–136) requires further investigation.

109 Samos B 1216 and B 1517, Jantzen, pp. 13, 16; H. Walter and K. Vierneisel, "Ägyptische Importstücke," *AM* 74 (1959), pp. 36–37, perceptively dated B 1216 to the Twenty-fifth Dynasty.

110 Brooklyn 42.410, E. Riefstahl, "Doll, Queen, or Goddess?" *The Brooklyn Museum Journal* 2 (1944), pp. 5–23; Roeder, pp. 320–321; V. Webb, *Archaic Greek Faience* (Warminster, 1978), p. 29.

111 Contra, Jantzen, pp. 13, 16, who identifies them as "*Liebesdienerinnen.*"

112 Samos B 243, Jantzen, p. 13.

113 Above (note 67).

114 Samos B 204, Jantzen, pp. 8, 10.

115 Berlin 2309, Ziegler, p. 90.

116 Samos B 1287, Jantzen, pp. 23, 28.

117 New York, the Bastis collection, B. V. Bothmer, in *Antiquities from the Collection of Christos G. Bastis*, New York, The Metropolitan Museum of Art, November 1987–January 1988 (catalogue by D. von Bothmer et al.), pp. 36–38. I wish to thank Mr. Bastis, who has generously loaned some of his Classical bronzes to the exhibition *The Gods Delight*, for his kind permission to include the illustration of his piece in this article.

118 Inter alia, O. Muscarella, review of Jantzen, in *AJA* 77 (1973), pp. 236–237.

119 M. J. Raven, "Wax in Egyptian Magic and Symbolism," *Oudheidkundige Mededelingen uit het Rijksmuseum van Oudheden* 64 (1983), pp. 7–48; R. Fuchs, "Wachs," *Lexikon der Ägyptologie*, vol. 6 (Wiesbaden, 1986), pp. 1088–1094.

The Human Figure in Classical Bronze-working: Some Perspectives

Joan R. Mertens

The papers presented this afternoon have addressed two fundamental aspects of the making of bronze objects: first of all the metallurgical one, and secondly, the Egyptian tradition that preceded and influenced the Greek achievement. My concern will be with an ingredient that is equally fundamental, one that is operative from the moment a work begins to be created until it ceases to exist.

 With discrimination, restraint, and universally acknowledged success, the exhibition *The Gods Delight* focuses upon small-scale bronze sculpture that is worked in the round. If we look at the assembled works in the light of the exhibition's full title, wide-ranging perspectives present themselves to us. In particular, I should like to address those that concern human figures as constituents of utilitarian objects, and I shall follow the example set in Cleveland, of moving freely between Greek and Etruscan works. Even though the assembled pieces include a number of mirror karyatids, thymiateria, and cista handles, a more sustained consideration of bronze vessels contributes further insights of interest and import. They will lead us to look again at the anthropomorphism of Greek vases and utensils generally. And they will bring us to the realization that the human figures in classical bronze-working reside not only in the objects before us but also in the individuals who use and handle them – including ourselves.

 At the start of our peregrination, it is worth recalling that, from the very beginning of Greek art, the same creative powers went into a figure intended for a utensil as one intended to be a dedication. The image offered by Mantiklos to Apollo[1] – or, in the words of the inscription, "to the Far Darter of the Silver Bow" – allows us to see, firsthand, in this exhibition, one of the very great, early representations of man. The quality in the piece that I most wish to emphasize is the combination of a sense of structure with the articulation of significant volumes. The axis bisecting the body from the thighs through the face provides the framework for the clear, firm, and lean torso, limbs, and head. And in connection with the head, the opportunity of seeing the top and back leads one to wonder whether there may originally have been something more than decorative

attachments. In any event, the figure is an extraordinarily powerful and firmly grounded presence that emanates vitality; the bow, now lost, was held with absolute authority, and the eyes seem to convert the figure's frontality into a form of energy.

The Mantiklos dedication has no counterpart; a contemporary figure created for a utensil that is comparably expressive of its function, however, is a youth[2] who originally held one of the ring handles of a bronze tripod (fig. 1). The piece comes from Olympia. At first glance, even taking into consideration the distortions it has suffered, the piece differs greatly from that of Mantiklos. And yet, it manifests its own synthesis of structure and volume. Its particular energy lies in the capacity for lithe movement. And, with an impressive height of 36.7 cm (over 14 in.), it served as a remarkably appropriate finial — one might even say apogee or recapitulation — of a very large tripod.

This juxtaposition of the Mantiklos dedication and the tripod accessory prompts two further comments. For our consideration of freestanding votive bronzes in relation to vessel attachments, it is noteworthy that most of the ambitious early figural attachments come from tripod-cauldrons, that is, vessels that were themselves dedications. The sanctity inherent in Mantiklos's offering will have obtained equally for the cauldron of which the ring-holding youth was a part. In later times, figural adjuncts belonged to vases that served mainly in domestic or "secular" contexts; during the late eighth and early seventh centuries, however, many of these adjuncts originated in response to the same circumstances or needs as the freestanding dedications.

A rather more elusive consideration that, nonetheless, bears mentioning here concerns the interaction between an object and the persons who dedicated or used it. In the case of Mantiklos's offering, the inscription is informative; the text reads, "Mantiklos dedicated me, from his tithe, to the Far Darter of the Silver Bow; do you, Phoebus, grant gracious recompense." Whether the image was intended to depict Apollo, Mantiklos, or perhaps an intercessor, it is evident that Mantiklos had a vested interest in his dedication. It may seem preposterous to venture any ideas at all about what an ancient Greek of the seventh or sixth century B.C. may have thought as he looked at, or transported, the tripod with the lithe handle-holder.[3] Still, I suspect that the figural element may have engaged the viewer's attention as much as the cauldron's supports, bowl, or ring handles. In addition to his curiosity, I wonder whether it may not have stirred a sense of tradition or continuity, familiar to all of us when we participate in a time-honored ritual.

Within the development of bronze sculpture,

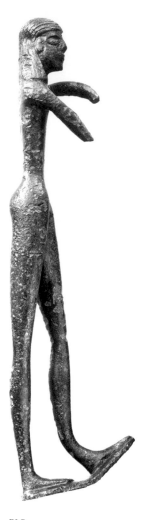

FIG. 1

Youth from the handle of a bronze tripod. Greek, from Olympia, circa 700 B.C. Olympia Museum inv. B 2800. Photo courtesy DAI, Athens.

FIG. 2

Silver oinochoe. Greek, sixth
century B.C. New York, The
Metropolitan Museum of Art acc.
66.11.23, Rogers Fund, 1966.
Photo courtesy The Metropolitan
Museum of Art.

works like the Mantiklos dedication and the handle support belong
among the ancestors of the artistic form that we call "the kouros." In the
exhibition, the Archaic Greek work that best represents the type is the
youth once in the Baker collection, now in the Metropolitan Museum.[4]
He is not strictly a kouros because the attribute in his right hand
introduces an episodic element that is alien to a true kouros.
Nonetheless, he shows the same stance, the nudity, and the grace that
comes of imbuing manliness with moderation. When such a figure
becomes part of a vessel, these features are not compromised; the
sovereignty of the figure remains intact. Of many possible examples, one
may cite the youths who serve as the handle of an oinochoe; the
Metropolitan Museum's collections include an exceptional work in
silver (fig. 2),[5] which admirably complements its more familiar
counterparts in bronze.[6] Pertinent also are the bronze paterae;[7] of a fine
piece once in Berlin, only the youth is still preserved (fig. 3).[8]

 The communality between freestanding and
applied bronze sculpture manifests itself on an equally high and creative

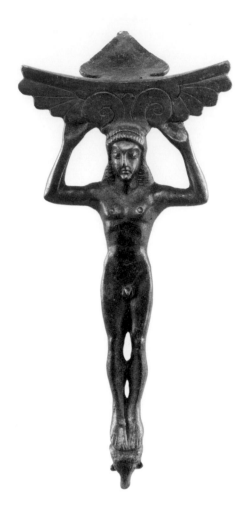

FIG. 3

Bronze patera handle in the form
of a youth. Greek, first quarter of
the fifth century B.C. Berlin,
Antiken-Sammlung, Staatliche
Museen zu Berlin, inv. M.I. 10
162. Photo courtesy Antiken-
Sammlung.

level in the treatment of the draped female figure. The present exhibition
includes examples from both domains. Among the figures in the round, I
should like to single out the image of Artemis dedicated by Chimaridas
to Artemis Daidaleia[9] – certainly one of the consummate bronzes
preserved from antiquity. When employed as karyatids, female figures
occur not only in mirrors but very notably also in thymiateria. The
exhibition includes two Etruscan examples.[10] In the rendering of
movement together with the emphasis upon decorative effect, the
example in Cleveland marvellously illustrates the Etruscans'
reinterpretation of their Greek sources of inspiration. The epitome of
thymiaterion-karyatids is, of course, the uniquely beautiful work of the
mid-fifth century found in Delphi.[11]

 This piece also offers an exceptionally fine
reminder that, as Greek artists rendered the human figure with ever
greater insight, the relationship between figure and vessel became ever
more complex as well. The supine youth lent by the Getty Museum to
the exhibition is a case in point.[12] The first question that it poses is
whether it belonged in a freestanding context or to a utensil. I find it
interesting that the bronzes that afford useful comparisons are Etruscan:
a cista handle in Basel representing the suicide of Ajax,[13] or a class of

FIG. 4
Bronze oinochoe in the shape of a
man's head. Etruscan, from Gabii,
fourth century B.C. Paris, Musée
du Louvre inv. 2955. Photo
courtesy Musée du Louvre.

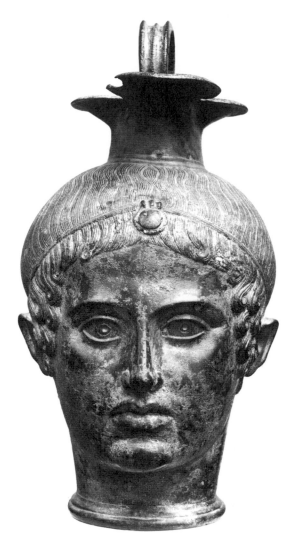

handles with a youth extended between his hounds.[14]

Finally, among the almost unlimited number of
juxtapositions that one could present between freestanding and engaged
figures, it is interesting to consider the Baker dancer[15] and an amusing
adaptation of the figural type to an Etruscan cista handle. The cista, in
the Villa Giulia,[16] is topped by a woman in a semirecumbent position,
propped up against a cushion, and holding a parasol. She, too, is entirely
swathed in a cloak, with only her eyes and left hand exposed. It is
iconographically interesting that the cista is supported by three comic
actors.

Transfixed, and at the same time, transported
as we are by the sculptures in the exhibition, it seemed worthwhile to
begin our musings on the human figure by identifying some of the leads
the pieces offer toward a wider range of material and a wider range of
questions. Some of these leads may seem so self-evident as hardly to
deserve attention. For example, the centrality of the human figure to
Greek art and the relation between freestanding and engaged figures. If,

however, we allow such considerations to operate upon our viewing of the exhibition and our understanding of what the exhibition is about, they open up vistas like the following. All of the pieces we have looked at so far have represented the human figure as a whole. In fact, however, the human figure also appears regularly with only part of the whole depicted. I do not wish to deal with ex-votos of body parts, like the liver in Piacenza,[17] for few of them are significant works of art. I do, however, wish to give some consideration to vases that are in the shape of a part of the body – most commonly the head – or have adjuncts derived from the human body – notably hands. I shall go beyond bronzes for my examples, for a broader canvas offers a truer context for the subjects we are concerned with here.

Vases shaped as part of the human body exist in appreciable quantity, and there can be no doubt that the surviving examples in metal represent but a small fraction of the original number. If we consider head vases in metal, the largest group, those that predate the Hellenistic period are comparatively few, but of fine quality. One of the earliest, most fragmentary, yet also most impressive is the piece from the Idaean Cave, divided between Oxford and Heraklion.[18] The mouth and handle are missing, but have been restored as those of an oinochoe. According to John Boardman, the work was hammered from a single sheet of bronze; details were laboriously traced, as demonstrated by the rows of curls. In style it may well be deemed "provincial"; at the same time, it is worth recalling that the vase issues from the cultural ambient that, during the Bronze Age, produced zoomorphic rhyta of supreme accomplishment. Also of the later seventh century, but more forthrightly Daedalic, is a small head of a woman in the Louvre.[19] It was cast and probably served as a container for perfumed oil, or some such cosmetic.

From the turn of the fifth century comes the justly famous oinochoe in the Louvre (fig. 4).[20] Its exceptional interest lies in its being a masterpiece of Etruscan bronze-working, fully – I would even say, exceptionally – imbued with the attainments of classic Greek sculpture. Its particular qualities emerge all the more forcefully by comparison with an Etruscan bronze vase in Munich that Sybille Haynes places at the end of the fourth century.[21] A roughly contemporary work said to be from northern Greece is a vase, a so-called balsamarium, in the collection of George Ortiz.[22] Its wonderful execution appears as much in the characterization of the woman's face as in the articulation of her hair, necklace, and neckline. Of slightly later date and definitely peripheral provenance are the three gold rhyta from Panagiurishte.[23] They are shaped as the heads of women, probably Amazons; two show their hair bound in a sakkos, one wears an elaborate helmet with griffins and floral embellishments.

FIG. 5

Terracotta vase in the shape of a male bust. Rhodian, circa 600–575 B.C. New York, The Metropolitan Museum of Art acc. 1986.11.14, purchase, David L. Klein, Jr., Memorial Foundation Gift, 1986. Photo courtesy The Metropolitan Museum of Art.

These examples represent only a selection, and we have merely enumerated them. Nonetheless, they bring out several points. First of all, until the Hellenistic period, such head vases in metal seem to have been made individually and show a high order of craftsmanship. Secondly, the fortuitousness of preservation suggests that they were produced throughout the Greek world and, in peripheral regions like Etruria or the Balkans, offer a kind of yardstick as to the nature and degree of Greek influence. Thirdly, it is interesting that, from the beginning, both hammering and casting served for their manufacture, depending on local technical traditions, the material used, and the function to be served. A development of the Hellenistic period, from roughly the third century on, is the occurrence of head vases in large numbers and typologically distinct series. Best known are the Etruscan balsamaria in the shape of women's heads, whose floruit spanned the late third to second century B.C.[24] But there are also other categories, such as the predominantly Etruscan janiform combinations of satyrs and maenads or the renderings of Blacks that may be of Alexandrian origin.[25]

The head vases that flourished in metal during the later periods of Classical art had enjoyed a most vigorous and varied existence in terracotta during the sixth and fifth centuries. Among vases for drinking and pouring, superlative creations exist, particularly among the Ionian face-kantharoi[26] and the Attic head vases.[27] These objects are so familiar that there is no need to enter into particular detail. At the same time, they bear upon the points we raised at the outset concerning the relation between bronze statuettes and figural attachments. The terracotta vases show the same respect for the integrity of the human form and the same effortless assimilation of the requisite features of the cup or jug. It is truly remarkable that the addition of such intrinsically foreign elements as two salient handles and a stemmed foot do not diminish or vitiate the human component. On the contrary, the fusion that is attained makes the kantharos a more splendid kantharos, the oinochoe a more splendid oinochoe.

Before turning from products of the potter to those of the coroplast, I should like at least to mention the mastos, the rather special variety of drinking cup in the shape of a woman's breast.[28] It enjoyed brief favor, especially in Athens, during the late sixth and early fifth centuries. In the present context, it provides an appropriate transition from wheel-made vases to the far more prevalent class of so-called plastic vases, receptacles for perfumed oil.[29] They are datable mainly to the late seventh and sixth centuries and were produced throughout the Greek world – with major centers located in Rhodes, Corinth, and Italy. Moreover, they circulated widely and in large

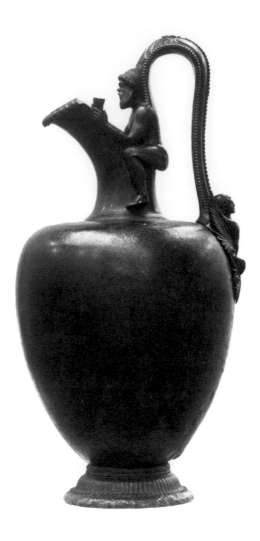

FIG. 7

Bronze oinochoe. Greek, second
quarter of the fifth century B.C.
Budapest, Museum of Fine Arts
inv. 56.11.A. Photo courtesy
Dietrich von Bothmer.

numbers. Within the Rhodian series, which is the most varied, human
heads or busts again predominate: women with long tresses and
helmeted warriors (fig. 5).[30] More unusual are containers in the shape of
straight legs and bent legs, sandaled feet, and male genitals. These types
also occur in fabrics other than the Rhodian.

 Compared with the face-kantharoi and head
vases of terracotta, as well as with the pre-Hellenistic examples of
bronze, the plastic aryballoi give the impression of being of a lesser
artistic order – they lack the others' high seriousness. One factor has to
do with the dismemberment of the body and with the higher estimation
that is often, but not always, accorded the head than the calf of a leg, for
instance. Another factor is the use of molds that permitted, and
produced, replication. Furthermore, there is the use to which the vessels
were put. The plastic vases probably served mainly for cosmetic and
other mundane purposes. Shapes like kylikes and kantharoi, for
example, were used in daily life for drinking, yet a libation would also be
poured from a kylix, and the kantharos brought with it the connection
with a specific divinity, Dionysos. More important, however, than their
relative merits is that these various categories of clay vessels supplement

and complement the evidence in bronze for the many artistic roles and
manifestations of the human figure.

Having progressed in our considerations from
the full figure to a head or a limb made into a vessel, we may take a
further step to the incorporation of parts of the human body into
standard vase-shapes and utensils. This step entails quite a change of
emphasis within the symbiosis of human and utensil. When we look at a
karyatid mirror, a thymiaterion, a cista, or an oinochoe, the center of
attraction – of energy – is the figure, yet it has what we might call an
architectonic relation to the whole. It is a discrete, complete component,
with the lines of demarcation clearly drawn. In the case of a head vase or
a plastic aryballos, the figural element predominates, and the handles or
lip are simply mechanical adjuncts – allowing one to lift, to pour, to
dispense. When we come to vessels with figural attachments, the
interrelationships prove more complex: now the vessel is predominant,
often lending its own corporeality to the attachment, often showing the
most gradual transitions to it.

We may look first at a few examples in
terracotta. From Crete of the mid-seventh century comes a truculent
little juglet (10.3 cm high) now in West Berlin.[31] Within its closed and
continuous contour, the rotund body develops into the head without the
slightest dislocation or interruption. A class of alabastra made about a
century later in Ionia displays a solution that is just as admirably suited
to the elegantly cylindrical form (fig. 6).[32] In both cases, the female head
or bust grows organically out of a standardized vase-shape. The
receptacle itself, therefore, becomes transformed into an extension of the
figure. A characteristically creative and wry invention from Athens is a
small class of kylikes, best known from the example in Oxford, once in
the Bomford collection.[33] An amusing counterpart appears on a
palmette-eye cup in New York.[34]

I should like to draw particular attention to a
cluster of Attic black-figure oinochoai where one can see potters
experimenting with various applications of – mainly female – protomes.
In passing, it should be said that such decorative appliqués occur in other
fabrics, like Corinthian, and on other Attic shapes, notably kyathoi, but
there is rather less creativity in their use. In the trefoil oinochoai by the
Painter of London B 620,[35] the head of a woman appears at either end of
the vertical handle. The heads are given additional prominence by the
white slip that contrasts sharply with the immediately surrounding black
glaze. While they require no justification artistically, any further
significance they may have is difficult to specify. One notes, however,
that from a user's standpoint, the handle is the key part of a jug, and that
the protome has her eye on him from both main views, the front and the

back. In the pair of oinochoai by the Painter of Louvre F 117,[36] the heads
– one male, one female – have moved to the center of the neck, right
under the central lobe of the mouth. These examples lend support to our
notion that they may have served some apotropaic function besides the
purely decorative one. In the works associated with the Painter of Louvre
F 118,[37] a female bust with arms bent up animates the junction of beak
spout and handle. To a greater degree than perhaps any vases considered
so far, this selection of oinochoai brings out how much more closely the
figural adjuncts relate to the shape than to the painted decoration, and,
as a direct corollary, what efforts were made to use them with the
greatest possible expressiveness.

The oinochoai of terracotta at which we have
just glanced of course also have their counterparts – some would say,
their prototypes – in bronze. For the beaked variety, there are two very
beautiful works in Ioannina,[38] where the subordination of the protome
to the pot is remarkable. On the one hand, this embellishment was
deliberately applied, on the other it is conspicuously unobtrusive –
perhaps yet another indication of its having some ulterior function. In a
small, masterfully executed vase on loan to the Basel Museum,[39] the
female head projects prominently from the handle and over the spout;
whether intentionally or not, it is paired with a well-established
apotropaic symbol, a Gorgoneion.

As wonderfully executed as these pieces are,
the integration of the figural adjunct with the vessel does not always
seem perfectly successful. Some experts might maintain that getting a
firm grip on an oinochoe is a man's job (fig. 7).[40] They may have a point.
On the other hand, if we turn to bronze hydriai, we find the shape in
which the most accomplished solutions were reached. For instance, an
exceedingly severe work found at Nemea[41] shows a minimum of surface
articulation. From the top of the vertical handle, however, a woman's
head – of comparable severity and wonderful precision – emerges. By
virtue of their placement and size, the rotelles serve as a foil and a
reinforcement so that, small as it may be, the face really becomes a center
of energy – stronger even than the taut curves of the hydria's body and
mouth. The figural dominance of the pot becomes all the more explicit
on a vase like the especially fine example in Malibu (fig. 8).[42] The
woman's body, wearing a peplos, is shown almost to the waist. The
articulation of the drapery and the rotelles hold one's interest further. But
I should especially like to draw attention to the way in which the
treatment of the mouth of the vase finds an echo in the shoulder and
handles. It is like a musical phrase stated by a violin and rephrased by a
cello.

Since one could go on about these works

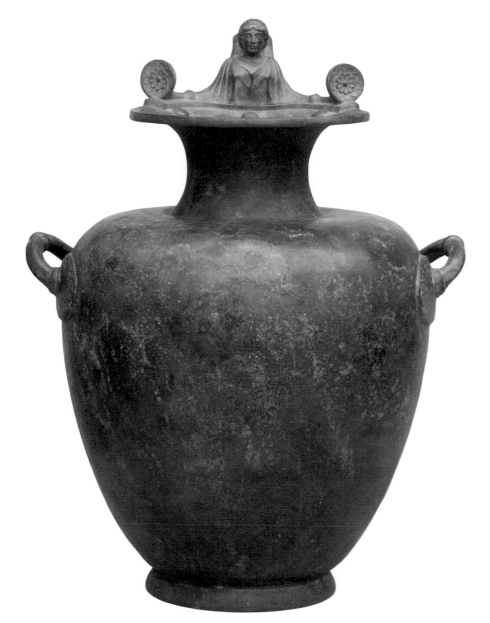

FIG. 8

Bronze hydria. Greek, circa 460
B.C. Malibu, The J. Paul Getty
Museum inv. 73.AC.12. Photo
courtesy The Metropolitan
Museum of Art.

endlessly, I wish to mention just one more detail. A few protomes,[43] like
one in Lyons and another in Copenhagen, have the ends of their hair
brushed up onto the hydria's vertical handle. To my mind, at least, this
tiny element poses, with considerable force, the question of how such
handle-figures relate to the vessels. We are all, of course, perfectly
capable of distinguishing the ponytail from the handle. At the same time,
I hope that we are all aware that what our eyes and reason tell us is not
the whole story. There is an undefinable point at which the figure and
vessel are wholly integrated, at which they are a wholly unified product
of one source – which is the artist's imagination.

In the rendering of the protomes, another of so
many remarkable features is the omission of the figures' hands. The arms
terminate in rotelles, or in some other element proper to the articulation

FIG. 9

Handle of a bronze volute-krater.
Greek, from Didyma, circa 550–
540 B.C. Berlin, Antikenmuseum,
Staatliche Museen Preußischer
Kulturbesitz, inv. M 149 b. Photo
courtesy Antikenmuseum.

of vase-shapes. It is fruitless to speculate on the reason for this solution,
though my hunch is that it has to do with maintaining the subordination
of the figural adjuncts to the composition of the whole vessel. The
presence of hands on a vase or utensil colors one's understanding of it as
much as the use of a head or a foot. In the time remaining, I should like
to give some consideration to the major occurrences of hands, and
certain conclusions they suggest.

 Hands occur as parts of handles.[44] Among
Archaic Greek bronzes, they appear on volute-kraters and their
typological relatives.[45] Four fingers typically curl up around the lower
edge of the handle proper; they are, therefore, only visible when the vase
is viewed from its east or west side. The famous piece from San Mauro[46]
is unique in having the fingers grasping the snakes that, here, are made
into a horizontal handle. The alternative, and more prevalent, solution is
for the snakes to develop from the flanges of the vertical handle and
curve outward. An example, notable especially for the meticulous
articulation of the fingernails, is in West Berlin (fig. 9).[47] As one looks at
these attachments, one wonders how they are to be understood. The San
Mauro krater makes quite plain that the fingers are considered
appendages of the vertical handle. One must then ask whether they serve
as directional symbols – "lift here" – or whether the handle becomes a
kind of metaphorical arm. Something of both most likely obtains.

 Hands were incorporated more frequently into
horizontal handles,[48] which permitted the inclusion of both the left and
right as well as all fingers. The favorite shape for these particular
attachments is the stamnos, especially in Etruria, but a number of such
handles – whose vessels are lost – have also come to light in Greece, on

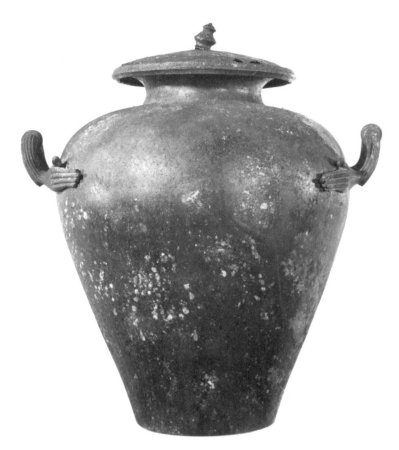

FIG. 10

Bronze stamnos. Etruscan, late
fourth–early third century B.C.
Providence, Museum of Art,
Rhode Island School of Design,
Mary B. Jackson Fund, inv.
35.791. Photo courtesy Rhode
Island School of Design.

the Akropolis[49] and in Delphi,[50] for instance. The well-known stamnos in Providence (fig. 10)[51] demonstrates the completely different character of horizontal from vertical handles. First of all, they are considerably more prominent. Furthermore, they accentuate the corpulence of the body, not only by being attached at the greatest circumference but also by projecting themselves. And perhaps most interestingly, their placement bears a direct relation to the hands of any person who carries the vessel either by grasping the handles or clasping the body. Once again, there is a deliberate ambiguity – one can also say duality – as to whose hands are depicted.

Since ancient artists were always producing remarkable variants, I should like to mention the smaller of the two amphorae found in Paestum in 1954.[52] Each of the vertical handles is riveted to the lip through two lateral flanges that serve, visually, as wrists, and that develop into a pair of hands. The fingers are bent, with the thumb pressing against them. These hands are reaching above the mouth of the amphora to secure a pair of swinging handles, now lost. Their use here presents an informative contrast to the volute-kraters and stamnoi, where a definite interplay existed between the corporeality of the vessel and the attachments. The present solution is entirely logical, but at the same time unexpected, almost foreign, because the anthropomorphic element introduced by the hands really does not

extend beyond them to other parts of the amphora. This, the more familiar situation, can once again be found in two categories of Etruscan implements. A strainer in the McDaniel collection at Harvard shows a handle whose attachment consists of a pair of hands.[53] In a most interesting reversal of the formula, a group of fire-rakes employ a hand, not at the end grasped by the user but as the rake.[54]

From the Mantiklos dedication, with which we began, to the Etruscan fire-rakes, we have traversed considerable terrain rapidly and selectively, so that, in closing it is well to inquire: what have we seen? We have – I trust – seen that, in the realm of Greek bronze-working, the human figure appears in many guises, in many contexts. Owing to the particular qualities of the metal, the human form could be used in its entirety as a handle, or a part could easily be made into a vessel or an attachment. While the fact is perfectly well known, it seemed worthwhile to emphasize the ubiquity of the human figure. What we have observed in the medium of bronze can, of course, be paralleled in every other material employed by Greek artists.

A second observation that we have sought to make, and that proceeds directly from the first, is the ease, the absolute certainty, with which a human figure can be integrated into a vessel or utensil. Nothing is, a priori, irreconcilable or incompatible. Quite the contrary, the tension, the force that gives the shape of a hydria or oinochoe its vigor is, essentially, the same that informs the protome of a draped woman at a handle. It is also the principle that allows the organic integration of widely disparate ingredients into the creatures we know as sphinxes, griffins, Centaurs, etc.

A third observation that our consideration allows is presented most clearly by the attachments in the form of hands. These attachments are an explicit statement regarding the communality that exists between the utensil and the user. An Argive hydrophora of the fifth century B.C. will not have appeared significantly different from the embellishment on one of the vases she carried, and she may well have identified in some way with it. Moreover, in the performance of any ritual – in the sense either of an habitual, mundane action or of a religious celebration – the handles with hands emphasize the bond between implement and officiant. Such a relationship is abundantly familiar from inscriptions on Attic terracotta vases: ΚΑΛΟΝ : ΕΙΜΙΠΟΤ[Ε]ΡΙΟΝ;[55] ΧΑΙΡΕΚΑΙΠΙΕΙΜΕΝΑΙΧΙ;[56] ΧΑΡΙΤΑΙΟΣ : ΕΠΟΙΕΣΕΝΕΜΕ : ΕV[57] – to cite only a few random examples from Little-Master cups. The vase and the drinker participate as equals in the dialogue. A dialogue between principals who are even more remote from one another is symbolized by the handclasp between deceased and survivors that occurs with particular frequency and

immediacy on funerary stelai. These representations make manifest the bridging of the unbridgeable; the dimension of time is entirely obliterated. And this is the thought with which I wish to close, immense though the distances are between the creations of classical bronze-workers and us.

The Metropolitan Museum of Art
N E W Y O R K

Notes

I wish to thank Marion True and John Walsh for the invitation to participate in the symposium sponsored by the J. Paul Getty Museum. Martine Denoyelle, Irmgard Kriseleit, and Arielle Kozloff generously helped with photographs and other material for this paper. A friend of classical bronzes has taught me much about how to look at them.

1 *The Gods Delight: The Human Figure in Classical Bronze*, The Cleveland Museum of Art and other institutions, November 1988–July 1989 (A. P. Kozloff and D. G. Mitten, organizers), no. 2.

2 E. Kunze, *VII. Bericht über die Ausgrabungen in Olympia* (Berlin, 1961), pp. 151–155.

3 Pertinent evidence from Attic vase-painting has now been gathered by I. Scheibler, "Dreifußträger," in M. Schmidt, ed., *Kanon: Festschrift Ernst Berger* (Basel, 1988), pp. 310–316.

4 *The Gods Delight* (note 1), no. 5.

5 D. von Bothmer, *A Greek and Roman Treasury* (New York, 1984), p. 29.

6 H: 18 cm. D. K. Hill, "A Class of Bronze Handles of the Archaic and Classical Periods," *AJA* 62 (1958), pp. 194–201.

7 E.g., U. Jantzen, *Griechische Griffphialen* (Berlin, 1958). Also D. G. Mitten and S. F. Doeringer, eds., *Master Bronzes from the Classical World*, The Fogg Art Museum, Cambridge, Mass., and other institutions, December 1967–June 1968 (Mainz, 1967), no. 77.

8 Dr. Irmgard Kriseleit kindly informed me of its condition and number. H: 19.98 cm.

9 *The Gods Delight* (note 1), no. 4.

10 Ibid., nos. 34, 36.

11 Delphi Museum inv. 7723, recently, *Greek Art of the Aegean Islands*, New York, The Metropolitan Museum of Art, 1980 (D. von Bothmer and J. Mertens), no. 184.

12 *The Gods Delight* (note 1), no. 10.

13 C. Reusser, *Antikenmuseum Basel und Sammlung Ludwig: Etruskische Kunst* (Basel, 1988), no. E 98.

14 See U. Liepmann, "Ein etruskischer Bronzehenkel im Kestner-Museum zu Hannover," *Niederdeutsche Beiträge zur Kunstgeschichte* 11 (1972), pp. 9–23. Cf. also S. Haynes, *Etruscan Bronzes* (London, 1985), nos. 125–126. Of interest as well is a fragment of an Etruscan terracotta bowl with the handle in the form of a sleeping Black, the Metropolitan Museum of Art 1980.11.11.

15 *The Gods Delight* (note 1), no. 14.

16 Villa Giulia inv. 24786, M. Pallottino, *Il Museo Nazionale Etrusco di Villa Giulia* (Rome, 1980), pp. 168–169.

17 E. Richardson, in L. Bonfante, ed., *Etruscan Life and Afterlife* (Detroit, 1986), pp. 222–223.

18 J. Boardman, *The Cretan Collection in Oxford* (Oxford, 1961), no. 378.

19 Louvre MNB 651, A. De Ridder, *Les Bronzes Antiques du Louvre*, vol. 1, no. 1 (Paris, 1913). See also Boardman (note 18), p. 80.

20 H: 32 cm. De Ridder (note 19), no. 2955.

21 Munich inv. 3169, S. Haynes, "Ein etruskischer Bronzekopf vom Bolsenasee," *StEtr* 33 (1965), p. 524.

22 *Master Bronzes* (note 7), no. 114.

23 D. Zontschew, *Der Goldschatz von Panagjurischte* (Berlin, 1959), pp. 11–13.

24 S. Haynes, "Etruskische Bronzekopfgefässe aus hellenistischer Zeit," *RGZM* 6 (1959), pp. 115–127.

25 D. G. Mitten, *Museum of Art, Rhode Island School of Design: Classical Bronzes* (Providence, 1975), pp. 62–65.

26 E. Walter-Karydi, *Samische Gefässe des 6. Jahrhunderts v. Chr.* (Bonn, 1973), pp. 130–131.

27 Especially Class C: The Charinos Class, *ARV²*, p. 1531.

28 A. Greifenhagen, "Mastoi," in U. Höckmann and A. Krug, eds., *Festschrift für Frank Brommer* (Mainz, 1977), pp. 133–143.

29 J. Ducat, *Les Vases plastiques rhodiens* (Paris, 1966).

30 H: 10.8 cm. Ibid., p. 38, no. 2.

31 Berlin F 307, U. Gehrig et al., *Führer durch die Antikenabteilung* (Berlin, 1968), p. 42.

32 H: 25 cm. Ducat (note 29), pp. 72–74.

33 Oxford 1974.344, M. Vickers, "Recent Acquisitions of Greek Antiquities by the Ashmolean Museum," *AA*, 1981, pp. 544–545.

34 New York 56.171.61, D. von Bothmer, *Greek Vase Painting: An Introduction* (New York, 1987), p. 6.

35 *ABV* 434, below.

36 *ABV* 230, above.

37 *ABV* 440, middle.

38 J. Kouleïmani-Vokotopoulou, *Chalkai Korinthiourgeis Prochoi* (Athens, 1975), pp. 3–10.

39 K. Schefold, *Meisterwerke griechischer Kunst* (Basel, 1960), no. 178.

40 H: 32.5 cm. D. von Bothmer, "A Bronze Oinochoe in New York," in G. Kopcke and M. B. Moore, eds., *Studies in Classical Art and Archaeology: A Tribute to P. H. von Blanckenhagen* (Locust Valley, New York, 1979), pp. 65–66.

41 S. G. Miller, "Excavations at Nemea, 1977," *Hesperia* 47 (1978), p. 84.

42 H: 47 cm. D. von Bothmer, "Two Bronze Hydriai in Malibu," *GettyMusJ* 1 (1975), pp. 15–16.

43 See esp. D. von Bothmer, review of E. Diehl, *Die Hydria*, in *Gnomon* 37 (1965), p. 601.

44 The basic article remains B. A. Raev, "Bassin en bronze provenant du Tumulus III de Sokolovski," *Sovietskaya Archeologia*, 1974, no. 3, pp. 181–189 (in Russian).

45 Cf. K. Hitzl, *Die Entstehung und Entwicklung des Volutenkraters* (Frankfurt, 1982), pp. 242–246; D. von Bothmer, review of K. Hitzl, *Die Entstehung und Entwicklung des Volutenkraters*, in *Gnomon* 57 (1985), p. 68.

46 Hitzl (note 45), pp. 242–243.

47 H: 15.9 cm. Hitzl (note 45), pp. 245–246.

48 See Mitten (note 25), pp. 147–150.

49 A. De Ridder, *Catalogue des bronzes trouvés sur l'Acropole d'Athènes* (Paris, 1896), nos. 153–154.

50 P. Perdrizet, *Fouilles de Delphes: Monuments figurés etc.*, vol. 5, part 1 (Paris, 1908), nos. 299–300.

51 H: 39 cm. See note 48.

52 Cl. Rolley, *Les Vases de bronze de l'archaïsme récent en Grande-Grèce* (Naples, 1982), no. 9.

53 D. G. Mitten, "Two New Bronze Objects in the McDaniel Collection," *HSCP* 69 (1965), pp. 163–164.

54 For instance, Haynes (note 14), no. 106. The conceit has a long history that may be traced back to Egyptian utensils. Cf. H.G. Fischer, "Varia Aegyptiaca: The Evolution of the Armlike Censer," *JARCE* 2 (1963), pp. 28–34; also N. W. Leinwand, "A Ladle from Shaft Grave III at Mycenae," *AJA* 84 (1980), pp. 519–521.

55 Rhodes 10527, *ABV* 162.1, below.

56 London B 424, *ABV* 168, middle.

57 Rome, Torlonia, *ABV* 161.1.

The Gilding of Bronze Sculpture in the Classical World

*W. A. Oddy, M. R. Cowell, P. T. Craddock, and
D. R. Hook*

The exhibition entitled *The Gods Delight*[1] presents seventy-three bronze figurines, not one of which is gilded or even retains visible traces that it ever was gilded. A search through the relevant collections of the British Museum has similarly shown that almost none of the large number of small-scale human sculptures is gilded, although there are three or four exceptions, which are listed below.

The scarcity of gilding on small-scale bronze sculpture is confirmed (negatively) in a review by Dorothy Kent Hill, who mentions the use of silver as a decoration,[2] but not gold, although she does discuss the gilding of life-size bronzes.[3] Positive evidence for the scarcity of gilding on sculpture is sometimes available from published catalogues. Stephanie Boucher has described 56 human sculptures (or fragments) in the museum at Vienne, none of which was gilded,[4] while Christiane Boube-Piccot has catalogued the antique bronzes in Morocco, and of 424 pieces listed, only 12 statues and a few fragments of drapery retained evidence of gilding.[5] Similarly, Emeline Richardson has listed only 3 Etruscan figurines retaining traces of gilding from a total of 1366 in her corpus.[6]

Only in Egypt does there seem to have been a long-standing tradition of gilding small-scale bronze figure sculptures before the Hellenistic period,[7] and this can be traced back at least to the New Kingdom. However, there is one important distinction between gilding in Egypt and that in the (later) classical world – the gold was applied by completely different techniques.

Even in Egypt gilding of bronzes was uncommon, but the British Museum contains a remarkable series of New Kingdom (circa 1000 B.C.) and late New Kingdom (circa 880 B.C.) gilded bronze figures standing from 60 to more than 90 cm high that have been gilded by applying a layer of gesso to the surface, followed by a layer of gold leaf.[8] This technique of applying gold leaf over a gesso was, and is, the standard way of gilding stone and wood. Outside of Egypt, however, it is unusual on metal in the ancient world. Recent analyses have shown that the gesso consists either of powdered limestone, presumably originally mixed with glue, or of gypsum (i.e., plaster of

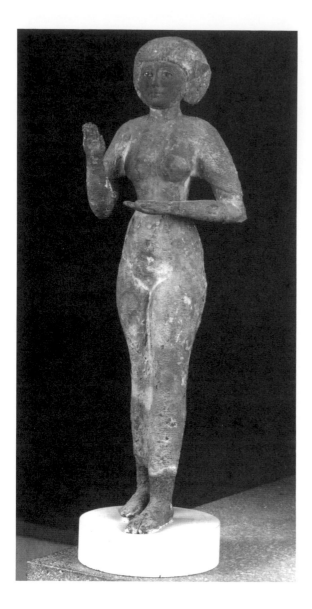

paris), spread thinly over the surface of the metal, which was sometimes deliberately roughened to assist the adhesion. On one of the figures of a woman[9] (fig. 1a) the surface consists of rows of slightly raised dots of metal (fig. 1b), while on a kneeling figure of the soul of Nekhen of the late Dynastic period[10] (fig. 2a), the surface consists of short projecting ridges, on top of which there are short engraved lines arranged in a crisscross manner (fig. 2b).

On both these figures there is no doubt that the raised dots and projecting ridges have been produced as part of the casting process, but on a seated figure of Isis dating to the late Dynastic period, circa 550 B.C.[11] (fig. 3a), areas of the bronze that have been exposed by loss of the gilding and gesso are seen to be engraved with a regular pattern of lines (fig. 3b). This engraving is so regular that it might have been interpreted as a representation of clothing were it not for the former presence of the overlying gilding, and it must, therefore, be

FIG. 1a

Standing figure of a woman with remains of gilt gesso on the surface. Egyptian, Late New Kingdom, circa 880 B.C. London, The British Museum, Department of Egyptian Antiquities, inv. 43373. Photos courtesy Trustees of The British Museum.

FIG. 1b

Detail of figure 1a showing the raised dots or nodules of metal cast into the surface to provide a key for the gesso.

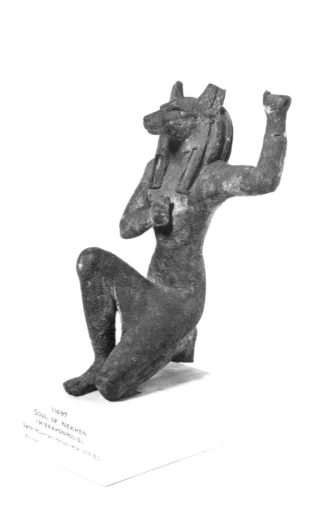

FIG. 2a

Kneeling figure of the soul of
Nekhen with traces of gilt gesso on
the surface. Egyptian, Late
Dynastic period. London, The
British Museum, Department of
Egyptian Antiquities, inv. 11497.
Photos courtesy Trustees of The
British Museum.

FIG. 2b

Detail of figure 2a showing the
projecting ridges and
superimposed engraved lines that
provide a key for the gesso.

present to act as a key for the gesso.

Altogether, the British Museum contains
thirteen gesso-gilded bronzes from Egypt that have been subjected to
scientific examination and a preliminary discussion.[12]

Turning to the classical world, one of the
earliest known smaller-than-life-size gilded bronze statuettes is a fifth-
century B.C. head of a Nike from the Athenian Agora,[13] which was
originally gilded with gold foil. Foil gilding involves wrapping gold foil
around an object and holding it in place by either bending the gold foil
over the edges of the object, by riveting the foil in place, or by cutting
grooves into the surface of the base metal and inserting the edges of the
gold foil into the grooves, which are then hammered closed. A variation
of the latter technique was to lay a piece of gold foil over an area of the
surface and then hammer around the edge of the gold with a punch so
that the gold was forced into the surface of the base metal.

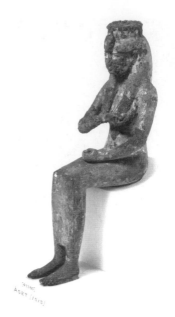

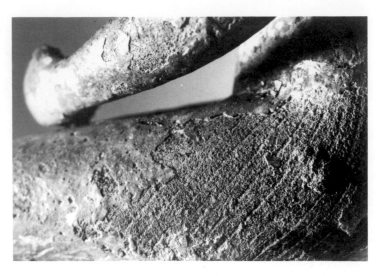

On the evidence of the surviving artifacts, none of these techniques appears to have been common, although the insertion of the edges of the gold foil into grooves cut into the surface was described by Pliny[14]:

The emperor Nero was so delighted by this statue of the young Alexander that he ordered it to be gilt; but this addition to its money value so diminished its artistic attraction that afterwards the gold was removed, and in that condition the statue was considered yet more valuable, even though still retaining scars from the work done on it and incisions in which the gold had been fastened.

Hill has questioned whether the gilding was actually applied on the orders of Nero,[15] and she thinks it more likely that the statue of Alexander was gilded originally, but that the gilding was subsequently stolen and that the story was invented by Pliny to discredit Nero. This theory is given support by the absence of examples of this technique of gilding dating from the Roman period.

Needless to say, the statue in question has not survived, but fragments of a life-size equestrian bronze statue illustrating this technique were recently found in Athens.[16] They have been identified by Caroline Hauser[17] as pieces from a statue of Demetrios Poliorketes and dated to the very end of the fourth century B.C. The surviving fragments consist of a sword, some pieces of drapery, and a leg. All are in good condition with a thin green patina and are cast in leaded bronze (3–4% tin and 23–35% lead), except for the sword (which contains only about 1.7% lead and 7.4% tin). The surface is, however, "scarred" by lines of gold, which are all that remains of a former covering of gold foil. This was attached by cutting grooves in the bronze, inserting the edge of a piece of gold foil, and then hammering the grooves closed to trap the foil. The gold foil has subsequently been torn off the statue, leaving the

FIG. 4

Gilt bronze life-size arm from a
Roman statue found in a well at
Clairmarais, near Rheims. The
overlapping edges of the sheets of
gold leaf are clearly visible.
London, The British Museum,
Department of Greek and Roman
Antiquities, inv. 1904.2-4.1249.
Photo courtesy Trustees of The
British Museum.

edges of the sheets protruding from the surface. There can be little doubt
that the technique of gilding exhibited on the pieces of sculpture from
Athens is identical to that mentioned by Pliny as having been used on the
statue of Alexander.

There are three reasons for the apparent
unpopularity of this method of gilding. First, gold foil is wasteful of gold
when used to cover a surface, since the same decorative effect can usually
be achieved by the use of much thinner gold leaf. Second, the thickness of
gold foil blunts the detail of a sculpture, a problem which is minimized
when using gold leaf. Third, the gold foil is easily stolen!

Of the five methods postulated for gilding
bronzes in the classical period as a whole,[18] only two have been positively
identified by modern scientific examination on bronzes of the Roman
period – leaf gilding and fire gilding.

Leaf gilding involves laying sheets of gold leaf
directly onto the surface of the bronze, using an intervening layer of
adhesive to fix it in place. This adhesive was probably an animal glue
made from skin and bones, or albumin obtained from eggs, milk, or
blood. Gold leaf was well known in the ancient world, and Pliny
comments on it as follows[19]:

*An ounce of gold can be beaten out into 750 or more leaves – four inches
square. The thickest kind of gold leaf is called Palestrina leaf, still bearing
the name taken from the most genuinely gilded statue of Fortune in that
place. The foil next in thickness is styled Quaestorian leaf.*

Several examples of monumental gilt-bronze
sculpture are known on which the small squares of gold leaf that were
used are still clearly visible because, where the squares overlap, the
double thickness of gold leaf has resisted the wear and tear of time,
resulting in a crisscross pattern of gold on the surface. This is visible on

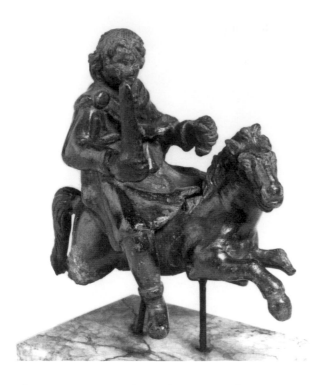

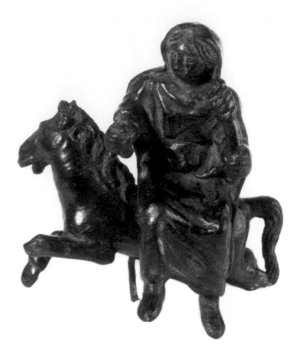

the statuary group from Cartoceto of circa A.D. 27 (now in the museum at Ancona),[20] on the Apollo of Lillebonne of the second century A.D. (now in the Louvre),[21] and on the arm from a Roman statue found near Rheims[22] (now in the British Museum) (fig. 4).

Inevitably, this pattern is not visible on leaf-gilded small objects, such as two equestrian statuettes[23] or the seated figure of a goddess[24] in the British Museum (figs. 5, 6, 7). In fact, only slight traces of gilding are now visible on these, although more may be hidden under the layers of corrosion. Leaf gilding, however, is not a very durable technique, especially when objects are exposed to the weather during their "lifetime" or when they are exposed to the soil during subsequent burial, because of the susceptibility of the animal-product adhesives to biodeterioration.

Table 1 contains a list of analytical results for major and minor elements for leaf-gilded sculptures of the Roman period that have been scientifically examined; all are from life-size or larger pieces, except for numbers 13, 14, 28, 29, and 30. (The full analyses, including trace elements, are given in table 3.)

Examination of these results shows that the lead content ranges from zero to 28.5%, but that only four pieces contain less than 5%. With one exception, tin is in the 1–10% range. Only two compositions can be regarded as particularly unusual, a fragment in Berlin (no. 7) and the Apollo of Lillebonne in the Louvre (no. 24). Both would be more at home in the list of fire-gilded sculpture, but analysis has shown that they were not fire gilded.

The technique of fire gilding copper alloys first appeared in the late Warring States period in China. It is characterized by

Table 1. Composition of leaf-gilded cast-bronze sculpture of the classical period.

	Sculpture	Museum and inv. no.	Date	% Cu	% Sn	% Pb
1.	Left hand found in Xanten	Cologne, Römisch-Germanisches Museum inv. 24.299	Roman	82	4.3	10.8
2.	Statue of a hippocamp	New York, The Metropolitan Museum X.21.79	?	A copper/tin alloy with an appreciable amount of lead (10–18%)		
3.	Leg from a Roman Imperial statue found at Milsington	Edinburgh, National Museum of Antiquities L.1920-1	Roman	67.5	5.2	27.2
4.	Fragment of a griffin or other fantastic animal	Berlin, Antikenmuseum inv. Lipperheide 88	?	69	2.3	25.5
5.	Finger found at Pergamon (large finger)	Berlin, Antikenmuseum inv. P9	Roman(?)	81.5	10.0	8.5
6.	Finger found at Pergamon (small finger)	Berlin, Antikenmuseum inv. P9	Roman(?)	65	6.7	28.5
7.	Fragment of sculpture from Pergamon (smaller fragment)	Berlin, Antikenmuseum	Roman(?)	99.5	1.2	0.06
8.	Fragment of sculpture from Pergamon (larger fragment)	Berlin, Antikenmuseum	Roman(?)	64.5	7.0	26.5
9.	Fragment of sculpture	Vatican, Etruscan Museum inv. 11791	?	95	1.1	4.5
10.	Statuary group found at Cartoceto, near Ancona	Ancona, Museo Nazionale	ca. A.D. 27			
	(a) Head of a horse[1]			67	3.9	27.6
	(b) Body of a horse[2]			79.1	8.1	11.4
11.	Head of a horse[3]	Augsburg, Römisches Museum	Early Imperial Roman	ca. 66	6.4	26.7
12.	Cornucopia, presumably from a statue[3]	Augsburg, Römisches Museum	Early Imperial Roman	ca. 87	3.1	9.5
13.	Male figure, circa half life size[3]	Augsburg, Römisches Museum	Early Imperial Roman	ca. 75	6.2	18.8
14.	Male figure, circa one-third life size	Brescia, Museo Civico inv. MR.339	Roman Antonine period	86.0	7.4	5.3
15.	Equestrian statue of Marcus Aurelius	Formerly in the Piazza del Campidoglio, Rome	A.D. 161–180			
	(a) Front left leg of horse			79	9.2	12.8
	(b) Front right leg of horse			77.5	8.8	12.8
	(c) Right foot of Marcus Aurelius			82	9.7	9.7
16.	Head of Septimius Severus	Brescia, Museo Civico inv. MR.349	A.D. 193–211	89.5	4.2	5.2
17.	Head of Probus	Brescia, Museo Civico inv. MR.350	A.D. 276–282	85	8.4	5.4

No.	Description	Location	Date			
18.	Head of Probus	Brescia, Museo Civico inv. MR.351	A.D. 276–282	69	6.3	23.5
19.	Head of Claudius II Gothicus	Brescia, Museo Civico inv. MR.352	A.D. 268–270	79	8.6	11.5
20.	Head of Claudius II Gothicus	Brescia, Museo Civico inv. MR.353	A.D. 268–270	84	7.0	5.1
21.	Arm, found in a well near Rheims	London, British Museum, Dept. of Greek and Roman Antiquities, 1904.2-4.1249	Roman	76.5	4.9	17.4
22.	Hoof of a horse	London, British Museum, Dept. of Greek and Roman Antiquities, 1856.12-26.624	Roman	87.5	2.8	8.2
23.	Left hand found in London	Museum of London inv. 2079	Roman	65.5	6.6	25.3
24.	Statue of Apollo found at Lillebonne, France	Paris, Musée du Louvre	2nd C. A.D.	Impure copper (77)	(1.7)	(0.8)
25.	Finger	Paris, Cabinet des Médailles inv. 1077	Roman	76.9	4.4	12.8
26.	Finger	Paris, Cabinet des Médailles inv. 1078	Roman	74.7	4.7	18.6
27.	Hoof of a horse found at Saintes	St. Germain-en-Laye, Musée des Antiquités Nationales	Roman	86.8	4.1	4.7
28.	Statuette of a goddess, Demeter(?)	London, British Museum, Dept. of Greek and Roman Antiquities, Walters Catalogue no. 977	Roman	68.0	5.6	25.2
29.	Statuette of a horse with female rider, Selene(?)	London, British Museum, Dept. of Greek and Roman Antiquities, 1901.7-10.2	Roman			
	(a) rider			77.0	3.8	7.7
	(b) horse			76.5	3.4	6.2
				(NB. These objects also contain 10–12% zinc)		
30.	Statuette of a horse with male rider, Alexander the Great(?)	London, British Museum, Dept. of Greek and Roman Antiquities, 1901.7-10.1	Roman			
	(a) rider			77.0	4.2	7.4
	(b) horse			76.0	4.0	6.4
				(NB. These objects also contain 10–12% zinc)		

1. M. Leoni, "Observations on Ancient Bronze Casting," in *The Horses of San Marco*, J. and V. Wilton-Ely, trans. (London, 1979), pp. 180–181.

2. E. R. Caley, "Chemical Composition of Greek and Roman Statuary Bronzes," in S. Doeringer, D. G. Mitten, and A. Steinberg, eds., *Art and Technology: A Symposium on Classical Bronzes* (Cambridge, Mass., 1970), pp. 37–49, table VII.5. More recent analyses are published in Anon., *Bronzi Dorati da Cartoceto: Un Restauro* (Florence, 1987), p. 122.

3. These analyses were kindly carried out by Dr. C. J. Raub of the Forschungsinstitut für Edelmetalle und Metallchemie in Schwäbisch Gmünd using atomic absorption spectrophotometry with the permission of Dr. L. Weber of the Römisches Museum, Augsburg.

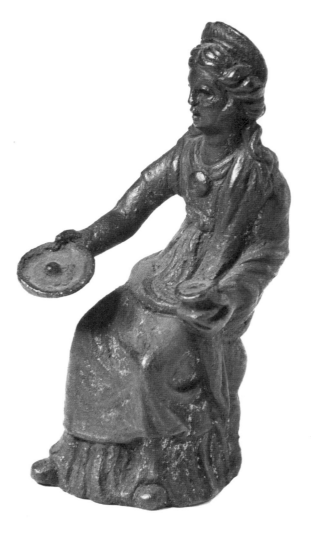

FIG. 7

Seated figurine of a goddess,
perhaps Demeter, that retains
traces of leaf gilding. London, The
British Museum, Department of
Greek and Roman Antiquities,
inv. 1824.40-20.1. Photo courtesy
Trustees of The British Museum.

traces of mercury in the gold. In China the technique continues into the
Han and later periods, but it does not become common in the West until
the second/third centuries A.D.

Fire gilding involves dissolving gold powder or
gold leaf in hot mercury and then squeezing the resulting mixture in a
thin leather bag to remove excess mercury, which passes through the
leather. The resulting amalgam, which remains inside the bag, is applied
to the surface of the copper alloy object after it has been thoroughly
cleaned. The amalgam is rubbed over the surface where it forms a shiny
silver-colored layer. The object is then gently heated over charcoal
embers, and the mercury evaporates, leaving behind a layer of gold that
is very firmly bonded to the copper. This technique of gilding was also
widely used on silver in the Roman world.[25] An alternative technique is
to rub mercury over the surface of the copper and then to apply gold leaf
on top. The gold is immediately dissolved by the mercury, but reappears
on heating gently over embers when most of the mercury evaporates.

Fire gilding remained the standard method of
gilding copper, bronze, brass, and silver until the nineteenth century,

Table 2. Composition of fire-gilded cast "bronze" sculpture of the classical period.

	Sculpture	Museum and inv. no.	Date	% Cu	% Sn	% Pb
31.	Head of Minerva found in Bath	Bath, Roman Baths Museum 1978–1	2nd C. A.D.	94	2.0	2.7
32.	Statuette of Commodus	London, British Museum, Dept. of Prehistoric and Romano-British Antiquities, 1895.4-8.1	191/192 A.D.(?)	97.5	2.0	0.2
33.	Tail of a horse	St. Germain-en-Laye, Musée des Antiquités Nationales	Roman		Impure copper	
				(90.7)	(1.1)	(0.3)
34.	Hoof of a horse[1]	Sparta, Archaeological Museum	Roman(?)	94.7	2.5	1.6
	[2]			94.7	2.0	1.9
35.	Ear of a horse[3]	Bologna, Museo Civico	Roman	77.3	4.9	15.6
36.	Hoof of a horse	New York, The Metropolitan Museum 25.78.70	Roman	83	7.8	9.4
37.	Fragment of sculpture	Vatican, Etruscan Museum inv. 11780	?	96	1.1	2.1
38.	Fragment of sculpture	Vatican, Etruscan Museum inv. 11789	?		Impure copper	
				(85)	(1.1)	(0.8)
39.	Fragment of sculpture	Vatican, Etruscan Museum inv. 11790	?	96	0.8	0.4
40.	Statue of Herakles	Vatican, Museo Pio Clementino inv. Lippold 544	late 2nd C. or 3rd C. A.D.			
	(a) sample from right thigh			96	1.5	1.1
	(b) sample from lionskin			96	2.2	3.0
41.	Horses of San Marco	Venice, facade of the Basilica di San Marco	Roman			
	(a) Horse A			97.5	1.1	1.2
	Horse A: head[4]			98.1	0.8	0.6
	Horse A: head[4]			96.7	1.3	1.2
	Horse A: body[4]			97.7	1.0	1.0
	Horse A: body[4]			97.0	1.2	1.1
	(b) Horse B: body[4]			97.2	1.2	1.0
42.	Statue of Herakles	Rome, Palazzo dei Conservatori	1st/2nd C. A.D.(?)	77	13.0	10.6
43.	Vatican obelisk	Rome, Palazzo dei Conservatori inv. 1066	Roman(?)			
	(a) Ball			96	1.6	1.2
	(b) Spike			92	3.8	4.0
44.	Fragment of sculpture found at the Roman fort of Richborough, Kent, thought to be from the same monument	London, English Heritage, Ancient Monuments Laboratory	Roman, 2nd or 3rd C. A.D.(?)			
	(a) 7351840			96	2.1	1.9
	(b) 7351841			94.5	2.3	2.9
	(c) 7351842			96.5	1.3	1.7
	(d) 7351843			93	3.3	2.8

NOTE: Only elements present in amounts greater than 1% are given above, and all the bronzes contain traces of several other elements (see table 3). Analysis figures given in parentheses indicate that the results do not approximate to 100% due to the presence of corrosion products in the samples. Nevertheless an *estimate* of the relative proportions of copper, tin, and lead may be obtained by scaling up.

1. This analysis was kindly carried out by Dr. K. Assimenos of the National Archaeological Museum, Athens, using atomic absorption spectrophotometry.

2. M. Leoni, "Metallographic Investigations of the Horses of San Marco," in *The Horses of San Marco*, J. and V. Wilton-Ely, trans. (London, 1979), pp. 190–199, esp. p. 191.

3. This analysis was kindly carried out by Dr. L. Follo of the Museo Civico, Bologna, using atomic absorption spectrophotometry.

4. See note 2.

when it was largely superseded in the West by electro-gilding. It has, however, remained in use in some Oriental countries, especially for the gilding of religious figurines.[26]

Table 2 contains a list of analytical results for major and minor elements for fire-gilded sculptures or sculpture fragments from the Roman period that have been scientifically examined. With the exception of number 32 all are either life size or greater. Mercury has been detected in the gilding on all these pieces either by X-ray fluorescence analysis or by emission spectroscopy. The full analyses, including trace elements, are given in table 3.

Examination of the results shows that with only three exceptions the lead content is less than 5%, usually significantly less. Tin usually lies in a similar range to that of the leaf-gilded sculpture, 1–8%, although most analyses crowd the lower end of this range ($<5\%$).

Three analyses, in particular, stand out as unusual: those of a horse's ear in Bologna (no. 35), a horse's hoof in the Metropolitan Museum (no. 36), and a statue of Herakles in Rome (no. 42). All would sit more comfortably in the list of leaf-gilded statues, were it not for the fact that the gold on the surface contains mercury.

In the famous treatise on metal technology written under the pseudonym of Theophilus early in the twelfth century there is an excellent description of fire gilding.[27] In this work, Theophilus twice mentions the importance of removing lead from copper alloys that are destined to be fire gilded:

. . . *if brass is to be gilded it should be completely pure and purged of lead.*[28]

It [i.e., coarse brass] cannot be gilded, since the copper has not been completely purged of lead before the alloying.[29]

Theophilus also comments on problems encountered with the gilding of brass:

. . . *silver and unalloyed copper can be gilded more easily than brass.*[30]

Table 3. Complete analysis results for the sculpture listed in tables 1 and 2.

No.		% Cu	% Pb	% Sn	% Ag	% Fe	% Sb	% Ni	% Au	% Co	% As	% Bi	% Zn	% Cd	Analysis total
1.		82	10.8	4.3	0.12	0.04	0.9	0.26	0.0035	0.005	0.45	0.21			99.1
2.		Semi-quantitive analysis only													
3.		67.5	27.2	5.2	0.1	0.007	0.15	0.02	0.01		0.01		0.017		100.2
4.		69	25.5	2.3	0.05	0.03	0.35	0.054			1.4				98.7
5.		81.5	8.5	10.0	0.08	0.45	0.05	0.09			0.2	0.005	0.03		100.9
6.		65	28.5	6.7	0.065	0.2	0.13	0.08			0.3	0.01	0.025		101.0
7.		99.5	0.06	1.2	0.003	0.005	0.07	0.03		0.003	0.05				100.9
8.		64.5	26.5	7.0	0.165	0.81	0.16	0.06		0.017	0.23	0.01	0.065		99.5
9.		95	4.5	1.1	0.05	0.08	0.10	0.02			0.02	0.005			100.9
10.	(a)	67.1	27.6	3.9											98.6
	(b)	79.1	11.4	8.1		tr		0.05					tr		98.7
11.			26.7	6.4	0.06		ca. 0.1	0.02				tr	0.2		
12.			9.5	3.1			tr	0.007				tr			
13.			18.8	6.2	0.06		tr	0.007				tr	0.08		
14.		86	5.3	7.4	0.07	0.3	0.08	0.07			0.18	0.004	0.8		100.2
15.	(a)	79	12.8	9.2	0.07	0.12	0.13	0.05			0.04	0.003	0.03		101.4
	(b)	77.5	12.8	8.8	0.07	0.06	0.10	0.02	0.06			0.001	0.03		99.4
	(c)	82	9.7	9.7	0.06	0.12	0.10	0.03			0.03	0.005	0.04		101.8
16.		89.5	5.2	4.2	0.06	0.16	0.07	0.03			0.02	0.003			99.2
17.		85	5.4	8.4	0.04	0.01	0.1	0.02			0.05	0.004	0.002		99.0
18.		69	23.5	6.3	0.1	0.01	0.1	0.03			0.04	0.005	0.02		99.1
19.		79	11.5	8.6	0.06	0.09	0.2	0.05			0.03	0.004	0.05		99.6
20.		84	5.1	7.0	0.08	0.08	0.09	0.03			0.25	0.005			96.6
21.		76.5	17.4	4.9	0.07	0.24	tr	0.03			tr	tr	0.22	0.025	99.4
22.		87.5	8.2	2.8	0.065	0.39	0.13	0.04			0.2		0.2		99.5
23.		65.5	25.3	6.6	0.06	0.44	0.14	0.03			tr		0.86		98.9
24.		76.8	0.78	1.68	0.06	0.04	0.12	tr	tr	tr	0.11	tr	0.02	tr	79.6
25.		76.9	12.8	4.4	0.10	0.11	0.71	0.22	tr	tr	0.40	0.01	0.02		95.7
26.		74.7	18.6	4.7	0.06	0.02	0.10	0.03	tr	tr	0.05	tr	0.08	tr	98.3
27.		86.8	4.7	4.1	0.06	0.03	0.14	0.04	tr	tr	0.14	tr	0.12		96.1
28.		68	25.2	5.6	0.12	0.12	0.11	0.05		0.03		0.02			99.3

No.															Total
29.	(a)	77	7.7	3.8	0.08	0.41	0.04	0.09		0.005	0.06	0.008	10.4		99.6
	(b)	76.5	6.2	3.4	0.09	0.31	0.05	0.08		0.002	0.01	0.008	11.2		97.9
30.	(a)	77	7.4	4.2	0.09	0.4	0.06	0.15		0.01	0.03	0.01	10.9		100.3
	(b)	76	6.4	4.0	0.1	0.5	0.07	0.07			0.01	0.01	11.5		98.7
31.		94	2.7	2.0	0.035	0.025	0.13	0.015			0.1	0.012	0.013		99.0
32.		97.5	0.23	0.2	0.03	0.45	0.01	0.01			0.1	tr			98.5
33.		90.7	0.25	1.1	0.03	0.39	0.02	0.01	tr	tr	0.09	tr	0.3	tr	92.6
34.	(a)	94.7	1.55	2.45	0.301	0.88	0.20	0.02		0.004	0.1	tr			100.1
	(b)	94.7	1.92	1.96	tr	tr	0.08	tr			tr				98.7
35.		77.3	15.6	4.85	0.04	0.08	0.15	0.02					0.04		98.1
36.		83	9.4	7.8	0.055	0.005	0.11	0.02		0.02	0.18	0.02			100.6
37.		96	0.75	1.1	0.06	0.05	0.10	0.005			0.02	0.005	0.02		98.1
38.		85	0.75	0.8	0.18	0.10	0.10	0.02			0.05	0.005	0.02		87.0
39.		96	0.4	1.1	0.05	0.08	0.10	0.02			0.02	0.005			97.8
40.	(a)	96	1.1	1.5	0.04	0.08	0.3	0.02			0.03	0.015	0.01		99.1
	(b)	96	3.0	2.2	0.05	0.10	0.1	0.02			0.03	0.02			101.5
41.	(a)	97.5	1.26	1.08	0.054	0.15	0.2	0.016	0.003	0.002	0.02	0.01	0.01	0.05	100.4
		98.1	0.55	0.77	0.006	0.022	0.15								99.6
		96.7	1.16	1.31	0.005	0.13	0.25								99.6
		97.7	0.98	0.95	0.009	0.023	0.17								99.8
		97.0	1.14	1.22	0.015	0.19	0.21								99.8
	(b)	97.2	1.04	1.22		0.10									99.6
42.		77	10.6	13.0	0.04	0.11	0.08	0.02			0.2	0.005	0.03		101.1
43.	(a)	96	1.2	1.6	0.03	0.01	0.01	0.01			0.02	0.005			98.9
	(b)	92	4.0	3.8	0.03	0.10	0.02	0.01			0.03	0.005			100.0
44.	(a)	96	1.9	2.1	0.04	0.04	0.05	0.02			0.5		0.01		102.7
	(b)	94.5	2.9	2.3	0.03	0.03	0.02	0.02			0.07		0.01		99.9
	(c)	96.5	1.7	1.3	0.04	0.04		0.02			0.5	tr			100.1
	(d)	93	2.8	2.2	0.04	0.02	0.08	0.02			0.03	tr	0.01		98.2

NOTE: "tr" indicates an unquantified trace. Where no analysis result is given for a particular element, it can be assumed, in most cases, that it was below the detection limit of the particular instrument at the time of analysis. In some cases, however, limitations on the instrument mean that some elements could not be analyzed, so their absence from the table should not be regarded as significant. Analysis totals that fall significantly below 100% indicate the presence of corrosion products in the sample.

Unless otherwise indicated, the analyses were performed in the British Museum over a number of years using atomic absorption spectrophotometry, following the procedures outlined in M. J. Hughes, M. R. Cowell, and P. T. Craddock, "Atomic Absorption Techniques in Archaeology," *Archaeometry* 18 (1976), pp. 19–37. Changes in the analytical equipment and methodology during this period have resulted in varying analytical precisions and detection limits. As a guide, however, the analyses should have precisions of approximately ±2% for copper, ±5–10% for tin, zinc, and lead, and up to ±30% for the trace elements, with the precision deteriorating as the respective detection limits are approached.

*The amalgamation of brass must be done more scrupulously and
carefully and it must be gilded more thickly and washed more often and
dried for a longer time. When it begins to take on a yellow color (during
the heating process), if you see white spots emerging on it so that it
refuses to dry evenly, this is the fault of the calamine,[31] because it was not
evenly alloyed, or of lead, because the copper was not purged and refined
free of it.[32]*

The underlying scientific reason for the
problems encountered in gilding alloys of copper is the greater solubility
in mercury of lead, tin, and zinc than of copper. The saturated weight
percentage for the three metals at 20° C is 2.15% for Zn, 0.62% for Sn,
and 1.3% for Pb, whereas the comparative figure for copper is only
0.00032%. Lead is a particular problem as it exists as separate globules
in the bronze, which are often concentrated at the surface.[33]

These passages in Theophilus, together with a
scientific examination of a statuette of "Herakles" in the British
Museum[34] (fig. 8) were the key to a new understanding of the technology
of gilding in antiquity. When the "Herakles" figure, recently identified by

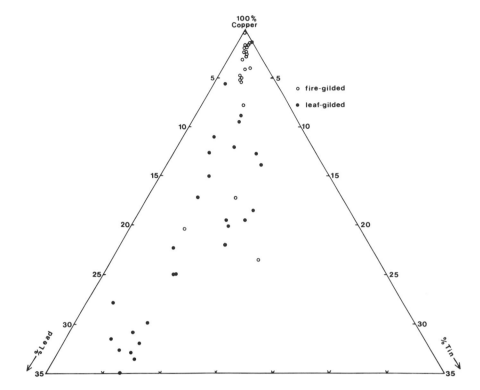

FIG. 9

Ternary diagram of the composition of gilded Roman statuary bronze. The analysis results are listed in tables 1–3.

Coulston and Phillips[35] as a statuette of the emperor Commodus, was analyzed by Paul Craddock as part of a study of bronze composition,[36] he noted the unusual composition of the alloy and consulted with Andrew Oddy, who was independently engaged in a study of gilding.[37] The fact that the statuette is fire gilded made sense of the unusual composition when reference is made to Theophilus.[38]

The question must be asked, however, whether a text written in Germany in the early twelfth century A.D. can be applied to bronzes cast in the Roman Empire. Taking the Romanesque period first, Oddy et al.[39] have shown that the copper content of ungilded cast secular and ecclesiastical metalwork ranges from 70 to 91%, while that of fire-gilded cast copper/bronze objects ranges from 81 to >99%. Both lead and zinc contents tended to be lower than in the ungilded ones. This is also supported by more than thirty other unpublished analyses of gilded medieval metalwork (mostly candlesticks, crucifixes, and figurines) carried out by Roger Brownsword and Duncan Hook.

For the early medieval period (before A.D. 1000) very few analyses of comparable gilded and ungilded objects are available, but what little evidence is published fails to show any significant difference in lead contents between the two groups.

In the Roman period, however, the difference is even more marked than for the twelfth/thirteenth century, especially when comparisons are restricted to objects of a similar type. Gilded Roman figure sculpture is a good example, and when the analyses listed in tables 1 and 2 are examined, they approximate to two groups

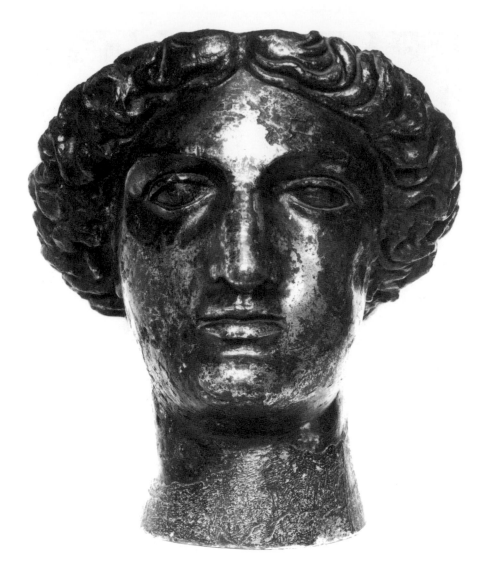

FIG. 10a

Head of Minerva. Bath, Roman
Baths Museum, inv. 1978-1.
Photos courtesy Trustees of The
British Museum.

according to whether the lead content is more or less than 5%. These
groups correlate closely with whether the gilding was carried out with
gold leaf or by fire gilding.[40] If the analyses are plotted on a ternary
diagram, those statues that are fire gilded are concentrated toward the
apex representing 100% copper (open circles on fig. 9), while those
which are leaf gilded are much more widely spread (closed circles on fig. 9).

It is interesting to note that the same is true of
the composition of gilded and ungilded Chinese belt hooks of the late
Zhou and Han periods.[41] The analyses were carried out by Tom Chase at
the Freer Gallery of Art and, although he did not analyze for mercury in
the gilding, his analyses are entirely consistent with the type of low-lead
copper alloy that is required as a base for fire gilding. Of about 150
examples analyzed, 29 of the 40 with gilding contained more than 95%
copper and 26 of these contained less than 1% lead. (Some of the 10
gilded examples containing less than 95% copper and between 10 and
25% lead may not be authentic Zhou or Han pieces.) Chase's results also

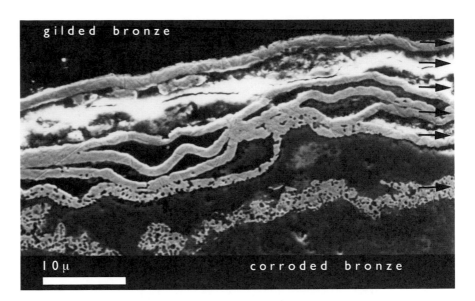

FIG. 10b

Metallurgical cross section through the gilding on the head of Minerva, figure 10a. Six layers of gilding are visible (indicated with arrows on the right): the inner two are porous and are fire gilded; the outer four are leaf gilded.

show that a significant number of the ungilded belthooks were made of fairly pure copper, but this is not important. The important fact is that *few* of the *gilded* ones contain significant amounts of lead. It is thus clear that the importance of copper-alloy composition for fire gilding was known from the earliest emergence of the technique.[42]

In the past twenty-five years knowledge of the composition of Roman statuary bronze has greatly increased, culminating in the recent publication of several thousand analyses of Greek, Etruscan, and Roman metalwork.[43] In a review published in 1970, however, Earle Caley listed only seventeen analyses of statuary,[44] at least two of which were from gilded objects. However, both had high tin and lead contents and must either be presumed to be leaf gilded (table VI.1) or are now known to be leaf gilded (table VII.5), and so he did not come across the unusual composition associated with fire gilding.

Maurice Picon et al., however, in a series of papers published in the period 1966–1973, did note that some gilded objects had unusually low levels of tin and lead.[45] They attributed this to the need for the copper alloy to remain malleable so that sheets of gold could be used, as described above, by having their edges hammered into grooves in the bronze. These authors appear not to have extended their analysis program to include the gilding layer, and so they did not notice the presence of mercury in the gilding on low tin/low lead bronzes.

The recognition of the relationship between gilding technology and composition has important implications for authenticity and for the dating of certain objects. To return to the figure of Commodus, for instance; it has recently been suggested on stylistic and iconographic grounds that the statuette may be either Etruscan,[46] Renaissance,[47] or nineteenth century.[48] On technical grounds an Etruscan date can be discounted, as the method of gilding and composition of the alloy cannot be paralleled in the Mediterranean area

at this period.[49] The technology is entirely consistent with a Roman date (cf. the other pieces listed in table 2), but not enough scientific work has been published on Renaissance and nineteenth-century bronzes to allow a comparison to be made for these periods. A nineteenth-century date seems unlikely, but the fact that the figure is a solid cast and is in remarkably good condition may have some bearing on whether it is Renaissance or Roman. This needs further consideration.

Technology is similarly the clue to the dating of the four horses of San Marco. Nowadays no one seriously suggests that they are Greek in origin,[50] but again the method of gilding and the composition of the alloy rule out a date before the second century A.D., and in view of the difficulty of casting large amounts of almost pure copper, a later date may be preferable.[51]

Because of this difficulty – caused by the higher temperature needed to melt copper than to melt bronze, and by the higher viscosity of molten copper, and by its tendency to oxidize rapidly – it may seem strange that fire-gilded copper statues were actually produced at all. The answer lies in their increased durability in the open. Fire gilding creates a continuous and strongly bonded layer of gold on the surface, which can be expected to protect the statue for many years from corrosion in the open air.

Nevertheless, regilding must be expected in the course of routine maintenance, and a number of metallographic examinations have shown that it did take place in antiquity. A good example is the head of Minerva[52] in the Roman Baths museum at Bath (fig. 10a), which has been shown to have at least six layers of gilding (fig. 10b). Analysis of a flake of the gilding by emission spectroscopy showed the presence of mercury in the gold, but when the individual layers were analyzed on the scanning electron microscope with an X-ray analyzer, the level of mercury was too low to be detected. However, there is a very clear physical difference between the inner two layers of gold, which are porous, and the outer layers, which are not. The technique of fire gilding gives rise to porosity in the gold, and it can thus be postulated that the Minerva figure was originally fire gilded, probably on two separate occasions, and subsequently regilded a number of times with gold leaf.

A similar result has been observed in the examination of a small sample from the tail of one of the horses of San Marco.[53] At least four layers of gilding have been observed, and the gold nearest the copper alloy of the horse is more porous than the outer layers. The inner layer also contains mercury. Thus again it can be suggested that the horses were originally fire gilded, but that they were subsequently regilded, probably by attaching gold leaf to the surface with an adhesive.

Another sample from the horses examined by Massimo Leoni revealed two layers of gilding, and he noted a difference in appearance in color and compactness (i.e., porosity), which led him to conclude that gold leaf was added to the surface after the application of a gold amalgam and before heating to evaporate the mercury.[54] Experiments in the British Museum have shown that the application of gold leaf on top of an amalgamated surface tends to cause the gold leaf to dissolve in the amalgam, so it would seem more likely that the outer layers do, in fact, represent a subsequent restoration with gold leaf.

Regilding has also been observed on leaf-gilded statues. One of the well-known sculpture group from Cartoceto has two layers of gold,[55] and a horse's hoof in the British Museum[56] has at least four layers in one area.

From a practical point of view, regilding of a statue in situ can only be carried out with gold leaf and an adhesive, and not by the fire-gilding technique. This is because fire gilding will only work on a scrupulously clean metal surface, free from dirt and corrosion products. In addition, controlled heating of the statue to drive off the mercury would be difficult. Leaf gilding, on the other hand, can be applied with an adhesive to any relatively smooth surface, so the presence of corrosion products is not a problem, provided that any loose material is first removed by gentle abrasion.

Although the gilding of figure sculpture can be traced back to the beginning of the first millennium B.C. in Egypt, it seems to have been rare in the classical world before the Roman period. Even then it was not common. The gilding of the Roman period was carried out by two different methods, and the copper alloy used to cast the sculpture varied according to the method of gilding to be used.

The British Museum
L O N D O N

Notes

All photographs are copyright of the Trustees of the British Museum and we are grateful to W. V. Davies, Keeper of Egyptian Antiquities, to B. F. Cook, Keeper of Greek and Roman Antiquities, and to Dr. I. H. Longworth, Keeper of Prehistoric and Romano-British Antiquities, for permission to illustrate objects in their care. In addition, grateful thanks are due to all the various museum curators who have allowed small samples to be removed from their objects for analysis. Additional analyses have kindly been carried out at our request by Dr. C. J. Raub, Dr. L. Follo, and Dr. K. Assimenos. Dr. Caroline Hauser, Miss Catherine Johns, Dr. Judith Swaddling, and Jeffrey Spencer gave unstintingly of their knowledge when discussing the dating of some of the pieces.

W. A. O. is also grateful to British Olivetti, Ltd., who provided a travel grant for the collection of samples from a number of museums in Italy in 1979.

1 *The Gods Delight: The Human Figure in Classical Bronze*, The Cleveland Museum of Art and other institutions, November 1988– July 1989 (A. P. Kozloff and D. G. Mitten, organizers) (Cleveland, 1988).

2 D. K. Hill, "Bronze Working: Sculpture and Other Objects," in C. Roebuck, ed., *The Muses at Work* (Cambridge and London, 1969), pp. 76ff.

3 Hill (note 2), pp. 71–72.

4 S. Boucher, *Inventaire des Collections publiques françaises*, vol. 17, *Vienne: Bronzes Antiques* (Paris, 1971).

5 C. Boube-Piccot, *Les Bronzes Antiques du Maroc* (Rabat, 1969).

6 E. Richardson, *Etruscan Votive Bronzes* (Mainz, 1983).

7 A. Oddy, P. Pearce, and L. Green, "An Unusual Gilding Technique on Some Egyptian Bronzes," in S. C. Watkins and C. E. Brown, eds., *Conservation of Ancient Egyptian Materials*, IAP Publications for the United Kingdom Institute for Conservation, Archaeology Section (London, 1988), pp. 35–39.

8 British Museum, Department of Egyptian Antiquities:

60717	Osiris	New Kingdom, ca. 1000 B.C.
60718	Osiris	New Kingdom, ca. 1000 B.C.
60719	Osiris	New Kingdom, ca.1000 B.C.
43371	Figure of a woman	Late New Kingdom, ca. 880 B.C.
43372	Figure of a woman	Late New Kingdom, ca. 880 B.C.
43373	Figure of a woman	Late New Kingdom, ca. 880 B.C.

9 British Museum, Department of Egyptian Antiquities, inv. 43373.

10 British Museum, Department of Egyptian Antiquities, inv. 11497.

11 British Museum, Department of Egyptian Antiquities, inv. 43380.

12 Oddy, Pearce, and Green (note 7).

13 T. L. Shear, "The Sculpture," *Hesperia* 2
 (1933), pp. 519–527; D. B. Thompson,
 "The Golden Nikai Reconsidered," *Hesperia*
 13 (1944), pp. 173–209; H. A. Thompson,
 "A Golden Nike from the Athenian Agora,"
 HSCP, Suppl. 1 (1940), pp. 183–210.

14 H. Rackham, ed., *Pliny, "Natural History,"*
 vol. 9 (London, 1968), p. 175.

15 Hill (note 2), pp. 71–72.

16 T. L. Shear, "The Athenian Agora:
 Excavations of 1971," *Hesperia* 42 (1973),
 pp. 121–179, esp. pp. 165–168.

17 C. Hauser, "An Honorary Statue in the
 Agora of Athens," in J. N. Coldstream and
 M. A. R. Colledge, eds., *Greece and Italy in
 the Classical World*, Acta of the 11th
 International Congress of Classical
 Archaeology (London, 1979), p. 222; idem,
 *Greek Monumental Bronze Sculpture of the
 Fifth and Fourth Centuries B.C.* (New York
 and London, 1987), pp. 255–281; idem, "A
 Golden Horseman in the Athenian Agora:
 Demetrios Poliorketes," forthcoming in
 Hesperia.

18 W. A. Oddy, "Vergoldungen auf
 prähistorischen und klassischen Bronzen," in
 H. Born, ed., *Archäologische Bronzen:
 Antike Kunst, Moderne Technik* (Berlin,
 1985), pp. 64–71.

19 Rackham (note 14), p. 49.

20 Anon., *Bronzi Dorati da Cartoceto: Un
 Restauro* (Florence, 1987), color pl. 10.

21 E. Esperandieu and H. Rolland, *Bronzes
 antiques de la Seine-Maritime*, Suppl. 12 of
 Gallia (1959), pp. 24–25.

22 British Museum, Department of Greek and
 Roman Antiquities, 1904.2-4.1249.

23 British Museum, Department of Greek and
 Roman Antiquities, 1901.7-10.1 and 2.

24 H. B. Walters, *Catalogue of the Bronzes,
 Greek, Roman and Etruscan in the . . .
 British Museum* (London, 1890), no. 977.

25 W. A. Oddy, "The Gilding of Roman Silver
 Plate," in F. Baratte, ed., *Argenterie
 Romaine et Byzantine* (Paris, 1988), pp.
 9–25.

26 W. A. Oddy, M. Bimson, and S. La Niece,
 "Gilding Himalayan Images: History,
 Tradition and Modern Techniques," in W. A.
 Oddy and W. Zwalf, eds., *Aspects of
 Tibetan Metallurgy*, British Museum
 Occasional Paper, no. 15 (London, 1981),
 pp. 87–101.

27 J. G. Hawthorne and C. S. Smith,
 Theophilus: On Divers Arts, 2nd edn. (New
 York, 1979), pp. 110–115.

28 Hawthorne and Smith (note 27), p. 139.

29 Hawthorne and Smith (note 27), p. 144.

30 Hawthorne and Smith (note 27), p. 145.

31 Calamine is the name of the common
 carbonate ore of zinc, now known as
 smithsonite.

32 Hawthorne and Smith (note 27), pp. 145–
 146.

33 P. T. Craddock, "Copper Alloys Used by the
 Greeks," *Journal of Archaeological Science* 4
 (1977), pp. 103–123.

34 J. W. Brailsford, *Guide to the Antiquities of
 Roman Britain*, 2nd edn. (London, 1958), p.
 54.

35 J. C. Coulston and E. J. Phillips, *Corpus of
 Sculpture of the Roman World: Great
 Britain*, vol. 1, fasc. 6, *Hadrian's Wall West
 of the North Tyne and Carlisle* (London,
 1988), pp. 77–78.

36 P. T. Craddock, "The Composition of
 Copper Alloys Used in the Classical World,"
 Ph.D. diss., Institute of Archaeology,
 London University, 1975.

37 P. A. Lins and W. A. Oddy, "The Origins of
 Mercury Gilding," *Journal of
 Archaeological Science* 2 (1975), pp. 365–
 373.

38 The authenticity of this "Herakles" has
 recently been questioned and is discussed
 briefly below. Its composition and the
 technology of the gilding are, however,
 consistent with a Roman date, and, whether
 or not it is genuine, it was the "catalyst" that
 led to our understanding of composition vs.
 gilding technology for Roman statuary.

39 W. A. Oddy, S. La Niece, and N. Stratford, *Romanesque Metalwork: Copper Alloys and their Decoration* (London, 1986).

40 W. A. Oddy, "Gold in Antiquity: Aspects of Gilding and of Assaying," *Journal of the Royal Society of Arts* 130 (1982), pp. 730–743.

41 Oddy (note 18), figs. 6a and b.

42 H. Wang, "Survey of Gilding" (in Chinese), *Journal of the Gugong Museum, Beijing* (1984/2), pp. 50–58, hypothesizes that the origin of fire gilding should be in the late Spring and Autumn period (722–481 B.C.). In fact, however, the earliest fire-gilded objects to be scientifically examined are from the Warring States period (481–221 B.C.).

43 P. T. Craddock, "Three Thousand Years of Copper Alloys," in P. A. England and L. van Zelst, eds., *Application of Science in Examination of Works of Art* (Boston, 1985), pp. 59–67 and microfiche.

44 E. R. Caley, "Chemical Composition of Greek and Roman Statuary Bronzes," in S. F. Doeringer, D. G. Mitten, and A. Steinberg, eds., *Art and Technology: A Symposium on Classical Bronzes* (Cambridge, Mass., 1970), pp. 37–49.

45 M. Picon, S. Boucher, and J. Condamin, "Recherches Techniques sur des Bronzes de Gaule Romaine," *Gallia* 24 (1966), pp. 189–215, esp. p. 208; idem, *Gallia* 25 (1967), pp. 153–168, esp. p. 158 and n. 22.

46 E. Richardson, personal communication to W. A. O.

47 George Ortiz in a comment following the presentation of this paper.

48 F. Nikolaus-Havé, "Der Herkules von Birdoswald – Unikum oder Fälschung?" *AA*, Heft 3 (1986), pp. 571–581.

49 Although the three gilded Etruscan figures listed by E. Richardson (p. 261, no. 15; p. 320, no. 29; and p. 325, no. 1 in ref. 6) have not been scientifically examined, the scanty traces of gilding indicate the likely use of gold leaf with an adhesive.

50 D. W. S. Hunt, "An Archaeological Survey of the Classical Antiquities on the Island of Chios . . . March and July 1938," *BSA* 41 (1940–1945), pp. 29–52, esp. p. 47.

51 W. A. Oddy, L. Borrelli Vlad, and N. D. Meeks, "The Gilding of Bronze Statues in the Greek and Roman World," in *The Horses of San Marco, Venice*, J. and V. Wilton-Ely, trans. (London, 1979), pp. 182–186; W. A. Oddy, "Scientific Dating of the San Marco Horses," MASCA *Journal* 2.2 (1982), pp. 45–47.

52 J. M. C. Toynbee, *Art in Roman Britain*, 2nd edn. (London, 1963), no. 25.

53 Oddy (note 51), pl. 3.

54 M. Leoni, "Metallographic Investigation of the Horses of San Marco," in *The Horses of San Marco* (note 51), pp. 191–199, esp. p. 192 and fig. 230.

55 *Bronzi Dorati* (note 20), color pl. 18b.

56 British Museum, Department of Greek and Roman Antiquities, 1856.12-16.624.

The Casting of Greek Bronzes: Variation and Repetition

Carol C. Mattusch

I should like to review the evidence for some of the processes that the Greeks developed for casting bronzes, the reasons for those processes, and the consequences of using them. I shall begin with certain theories that have been proposed in the modern scholarship on ancient casting, and then consider the ancient evidence, the bronzes, the production materials, and the ancient literary sources. Then I should like to raise some questions regarding the Greeks' adherence to stylistic types, the implications of freestanding groups of statues, and the accompanying need for a casting process that allowed for repetition. Finally, I shall ask how the artists who were commissioned to produce large groups may have solved the problems of repetition, but still maintained originality.

It has been a long time since Kurt Kluge, a sculptor, presented his theories about how ancient bronzes were cast. In one of two publications on the subject, he named certain large bronzes dating to the Greek period that he thought had been cast in sand after a wooden model.[1] For example, Kluge cited the skirt of the Delphi Charioteer, whose columnar appearance suggested to him that the model had been cut from a tree trunk (fig. 1).

Since Kurt Kluge was a sculptor, his work on the complex subject of ancient casting techniques was welcomed and widely accepted. From the 1920s, when his publications appeared, until 1960, references to ancient bronze technology were heavily dependent upon Kluge's work. Most scholars simply restated the details of his sandbox theory or revised them slightly.[2]

Rhys Carpenter recognized opposing trends in Greek sculptural styles, which he thought derived from carving the original model in wood or modeling it in clay, and he called these styles "glyptic" and "plastic." He argued that because early bronzes came from carved wooden models, they look carved, like stone sculpture, and that the technique of carving wooden models gave rise to a glyptic tradition that survived until the late fourth or the third century B.C., at which time modeling largely replaced carving for the production of bronzes, with the result that later sculptures were plastic in appearance.[3]

Recently, much more has been learned about

FIG. 1

Bronze Charioteer. Delphi, circa
474 B.C. Delphi Museum inv.
3484, 3540. Photo courtesy Ecole
française d'archéologie, Athens.

ancient casting techniques. By 1960, Denys Haynes had gathered
significant new evidence for the use of wax models, not wooden ones,
and for the exclusive use of the lost-wax process to cast ancient bronzes.[4]
Like Kluge, Haynes looked very closely at ancient bronzes, inside and
out, but his observations led to radically different conclusions, and his
persuasive arguments for the use of the lost-wax process initiated a
general trend toward the abandonment of Kluge's theory of wooden
models and the sandbox process. There is now widespread agreement
among scholars that the lost-wax process, and no other, was used to cast
all ancient bronzes. The time-honored theory of sand casting from
wooden models must now be discarded, as must ancillary observations
about the carved appearance or the "glyptic" style of some bronzes.

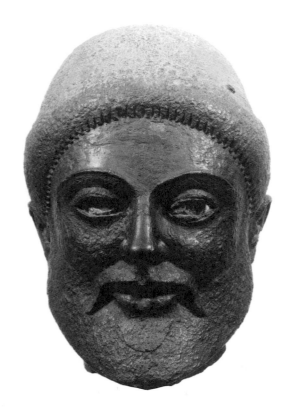

FIG. 2

Marble head of warrior. Aegina,
Temple of Aphaia pedimental
sculpture. Early fifth century B.C.
Athens, National Museum inv.
1938. Photo courtesy National
Museum.

FIG. 3

Bronze head of warrior. Athens,
Akropolis. Early fifth century B.C.
Athens, National Museum inv.
6446. Photo courtesy National
Museum.

As an illustration of the changes in thinking
that are occurring, let us consider the Aeginetan sculptural tradition (fig.
2). Pliny tells us that a particular alloy of bronze was produced on the
island of Aegina.[5] And Pausanias refers more than once to an Aeginetan
school of artists, whose style was evidently recognizable in any medium.[6]
But neither Pliny nor Pausanias says that the Aeginetan artistic school
was based in the medium of bronze. In fact, Pausanias makes it quite
clear that a particular *style* identified the Aeginetan school, not any
one *medium*.

Nonetheless, the literary evidence has long
been understood to mean that Aeginetan works in bronze affected the
style of works in other media, such as the marble pedimental sculptures
from the Temple of Aphaia.[7] To be sure, the pedimental sculptures from
Aegina were augmented with bronze – locks of hair, bows and arrows,
quiver straps, belts, and helmet and cuirass decorations;[8] and these
bronze parts, like the sculptures themselves, were no doubt locally made.
The sculpture itself is angular in appearance and could be called
"glyptic," the term that Carpenter used to describe early bronzes that he
thought had been cast from carved wooden models, believing as he did
that technique influenced style.[9]

Consequently, the idea arose that if the use of
carved wooden models resulted in carved-looking bronzes, then these
influenced the appearance of works in other media, like marble, so that
they also looked carved or angular. But now that we have discarded the

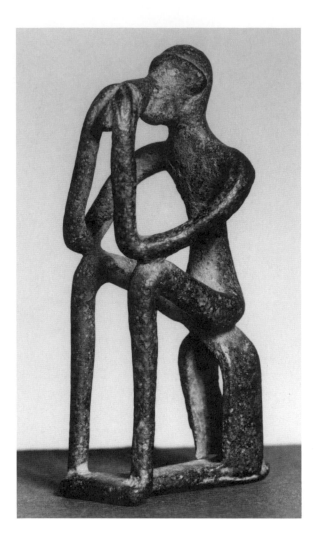

FIG. 4

Bronze seated flute-player. Second
half of the eighth century B.C.
Baltimore, The Walters Art
Gallery inv. 54.789. Photo
courtesy The Walters Art Gallery.

idea of carved wooden models, the technical link between Aeginetan
pedimental sculptures and Aeginetan bronzes no longer exists.

The well-known bronze warrior from the
Athenian Akropolis is a close parallel to some of the marble heads of the
pedimental sculptures from Aegina, but the carved appearance of the
bronze has nothing to do with using a carved wooden model, because
the model was not wood at all, but wax[10] (fig. 3). However, wax is *like*
stone and wood to the extent that it *can* be carved, though it need not be.
And the wax model for this head certainly *was* carved, and the work
clearly conforms to the style that is termed early fifth-century Aeginetan.

Let us look in more detail at the direct and
indirect lost-wax processes, and at the ways in which they were exploited
during antiquity. The earliest solid bronze dedications in Greek
sanctuaries were cast by the direct lost-wax process. A wax figurine was
carved or modeled and then invested with a mold. Then the wax was
melted out, and molten bronze was poured in its place to produce a solid
casting. The direct process could also be used to make a hollow casting,
by starting with a clay core, and inserting pins through the wax into the

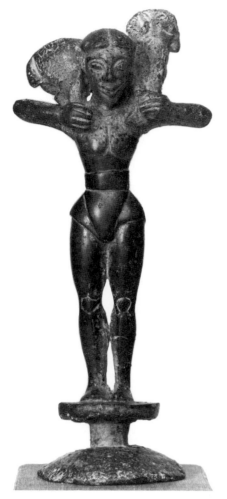
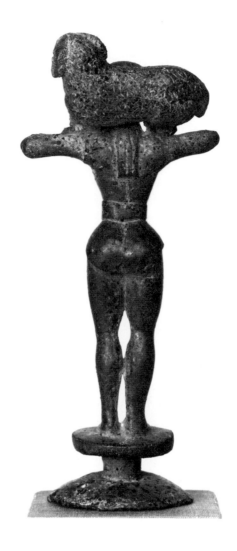

FIG. 5a

Bronze kriophoros. Front. Late
seventh century B.C. Berlin,
Antikenmuseum, Staatliche
Museen Preußischer Kulturbesitz,
inv. misc. 7477. Photos courtesy
Antikenmuseum.

FIG. 5b

Back of kriophoros, figure 5a.

mold to hold the core in place while the wax was being melted out. If
anything went wrong during production by the direct process, and the
casting failed, as must often have happened,[11] the model, once melted,
was irretrievably lost.

 This brings us to the indirect process, which, in
its pure form, eliminates the risk of destroying the original model. Here,
the artist could make a model out of any material and take molds in
pieces from it, before putting aside the model. Thereafter, he might
rejoin all the pieces of this master mold for a small work, or, for a larger
one, such as a statue, proceed in sections, keeping separate, for example,
the molds for the torso, for the head, the arms, and the legs. He would
line the rejoined molds with a layer of wax, core the wax, set aside the
master mold, and pin the core in place within the investment mold, from
which the wax would be melted out and bronze poured to replace it.

 Actually, early casters in Greece did not use the
indirect process in this pure form. The bronzes themselves suggest that
the direct and indirect methods were neither distinct nor immutable, as
they had once been described by Denys Haynes.[12] Instead, there were

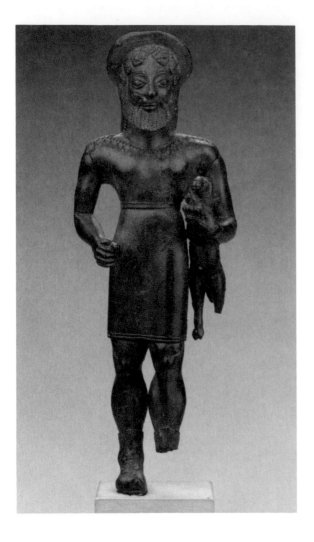
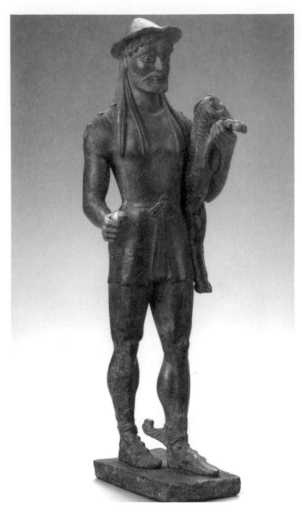

FIG. 6

Bronze Hermes Kriophoros. Late
sixth century B.C. Boston,
Museum of Fine Arts, H. L. Pierce
Fund, 04.6. Photo courtesy
Museum of Fine Arts.

FIG. 7

Bronze Hermes Kriophoros. Late
sixth century B.C. Boston,
Museum of Fine Arts, H. L. Pierce
Fund, 99.489. Photo courtesy
Museum of Fine Arts.

infinite variations, combinations of the two processes, which were
developed according to the requirements of particular commissions, or
the idiosyncracies of individual artists and workshops, or the availability
and costs of materials and facilities.

 Even at an early date, many alternatives were
utilized to make small solid castings. The Peloponnesian artist who made
a small seated flute-player simply rolled the limbs out of wax strips, cut
the seat and base from small wax slabs, and then stuck all of the wax
pieces together, before investing the little figure in clay for casting[13] (fig.
4). A late seventh-century kriophoros from Crete appears to have been
made in separately molded sections, which were pieced together before
casting, sections which might have been used to prepare a series of
similar kriophoroi[14] (figs. 5a–b). And two Archaic kriophoroi in Boston
represent a highly sophisticated variation on solid casting: each figurine
was cast in pieces, the left arm with the ram having been modeled and
cast separately, and then attached to the figurine[15] (figs. 6, 7). This
allowed the artist to reach each part of the figurine, in order to work it
over. Indeed, Dorothy Kent Hill has documented a later convention of

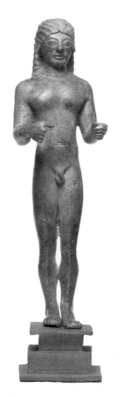

making left arms separately and attaching them.[16]

In the case of a hollow statuette, like a large
later Archaic kouros from Samos, much less bronze would be needed for
casting, making a quick and easy pour, and the finished figurine would
weigh less and cost less than if it had been cast solid[17] (fig. 8).

Pausanias tells us that two Samian artists,
Rhoikos and Theodoros, were "the first to melt bronze and cast statues"
(VIII.14.8).[18] Pliny reminds us that Rhoikos and Theodoros also
introduced clay modeling to Samos (H.N., XXXV.152), and in fact the
evidence from ancient bronze foundries indicates that whatever else clay
may have been used for, such as for models, it was universally used for
cores and investment molds.[19]

The two innovators are reported to have lived
during the sixth century B.C., a date that would fit well with the earliest
archaeological evidence, from Olympia and Athens, for the production
of large bronzes. In Olympia, the broken legs and right hand of a 40–50-
cm-high kouros can be dated to the first quarter of the sixth century. The
thighs and hand are hollow, though very thick-walled[20] (fig. 9). In
Athens, a clay mold for most of a meter-high kouros, with the head
evidently cast separately from the body, comes from a context of
approximately 550 B.C.[21] (figs. 10a–b).

The Agora mold provides what may be the
earliest actual evidence for large-scale piece casting, a process to which
scholars were alerted long ago by the literary testimonia. Philo
Byzantius, writing in the second century B.C., outlines piece casting as if
he knows of no other process: "First the craftsmen model the (other)
statues, then, after cutting them up into their natural parts, they cast
them, and in the end they put the pieces together and stand the statue up"
(De septem Miraculis, 4). That Quintilian, in discussing oratory, can
draw analogies with piece casting is further proof that the method was
widely recognized, if not fully understood. In one passage, Quintilian
observes that "a statue is begun when its parts are being cast" (II.1.12).
Elsewhere he adds that "although all the parts have been cast, it is not a
statue until it is put together" (VII.1.2).

Today it is widely accepted that all large
ancient bronzes were made in pieces. The statue of an athlete illustrated
by the Foundry Painter is the most frequently cited evidence for the use of
large-scale piece casting in Greece[22] (fig. 11). If the Foundry Painter is not
simply showing a statue that is nearly finished, and wants us to think
that this statue was made in only four pieces — hands, head, and the rest
of the figure — that is not impossible. The mold from Athens was used to
cast a whole figure, without its head. The Piraeus Apollo, too, was
evidently cast in only four pieces — the head, the two arms, and the rest of

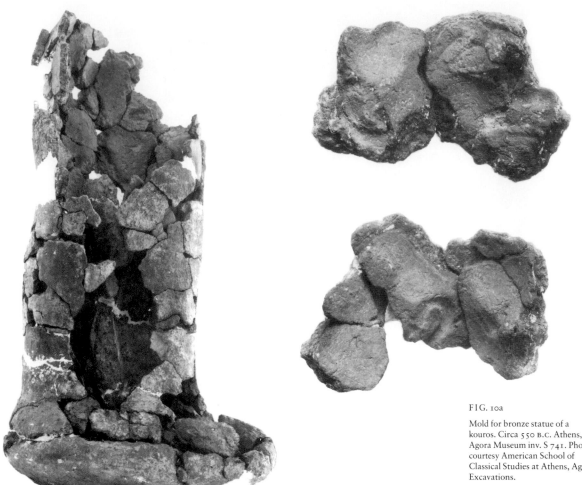

FIG. 10a

Mold for bronze statue of a
kouros. Circa 550 B.C. Athens,
Agora Museum inv. S 741. Photos
courtesy American School of
Classical Studies at Athens, Agora
Excavations.

FIG. 10b

Mold for head of a bronze kouros.
Circa 550 B.C. Athens, Agora
Museum inv. S 797.

the statue. Later on, statues were cast in many more pieces, as was the
life-size Lady from the Sea, made in the late fourth or early third century
B.C. Although fragmentary, she consists of ten separately cast pieces.[23]

There were many opportunities for artists to
make choices in the casting process, and the evidence shows that there
was little uniformity, that Greek artists varied their techniques a great
deal. There might be differing opinions about many topics, such as about
how to section the master molds and thence the statue parts for casting,
which alloy to choose, whether to use iron or bronze chaplets, how to
form props to support molds for casting, and so on.[24]

It is widely believed that Greek artists did not
make copies of statuary as the Romans did. But pairs and groups of
bronzes of many kinds were often called for, which presupposes a need
for some reuse of basic models in the casting process. No one would be
surprised to learn that the Greeks cast some utilitarian objects in series,
simply to save time and effort. And there is evidence for this practice. In
fact, repetition was also known beyond the realm of purely practical
objects: examples of identical statuettes are occasionally cited.[25]

Already by the seventh century B.C., groups of
up to six protomes were made to decorate the bronze cauldrons that
were being dedicated in quantity in sanctuaries all over the Greek world.
Artists were called upon to produce groups of heads and necks that were
similar in both size and general appearance. Groups of similar protomes
have long been recognized, and, more recently, technical similarities have
also been observed. Denys Haynes argued convincingly that master
molds taken from a single model were used to produce a series of waxes,
each of which was worked over individually and then cast, by the indirect
method, into a group of bronze griffins that are similar enough to be
usable on one cauldron, but that do not exactly duplicate one another.[26]

I have identified an example of another, quite
different, method by which a series of matching bronze protomes was
produced in the middle of the seventh century B.C. An artist or workshop
cast at least three huge griffin's heads for some colossal dedication at
Olympia[27] (figs. 12, 13, and 14). These protomes were not made from
master molds taken from a single model. Instead each head was formed
separately, but from an identical set of thin wax slabs, which were
shaped and melted together, starting with the palate, which was then
joined to the sides of the head. After the heads had been shaped, the
waxes would have been stabilized by the addition of core material. Scales
and other details were marked with the same set of tools; tongues,
knobs, and ears were made separately in wax and added to the heads
before investment and casting. In the end, each head was a separate and
original production, but together they were relatively uniform in size and
appearance, so as to be appropriate for use as a group on one cauldron.[28]

Repetition then, was necessary for the

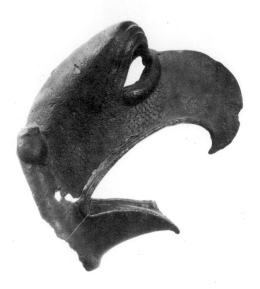

FIG. 12

Head of bronze griffin-protome.
Circa 650 B.C. Athens, National
Museum inv. 7582. Photo
courtesy National Museum.

production of protomes, but the evidence so far shows that during the
orientalizing period repetition implied neither copying nor exact
duplication. Because each protome was separately worked, it retained its
originality, even if several protomes were made in one workshop from
duplicated sets of waxes, which were worked over with one set of tools.
If we keep this stricture in mind, it is not difficult to find evidence for a
similar tradition of repetition in freestanding statuary.

Herodotos tells us about Kleobis and Biton,
distinguishing them by name alone, and describing them as if they shared
the same character and abilities (I.31). Their two portraits, which were
erected side by side at Delphi, also look like marble twins: even looking
closely, we see almost no differences between them.[29] And Kleobis and
Biton are not unusual. Of the six figures comprising the mid-sixth-
century Geneleos dedication in Samos, the three korai in the middle
repeat one another, their three right fists gathering up the folds of their
three skirts.[30] Dermys and Kittylos stand side by side in mirror image of
one another; and the Tyrannicides, though back to back, have essentially
the same stance, with only the positions of their arms reversed.[31]

Is Pausanias talking about repetition or about
copying when he mentions a pair of statues that looked alike but that
stood in different cities?

*The statue [of Apollo Ismenios in Thebes] is the same size as the one in
Branchidai, and the form is no different; whoever has seen one of these
statues and learned its sculptor, does not need great skill when looking at
the other to see that it is a work of Kanachos. They differ in this way: the
one in Branchidai is bronze, the Ismenios one is cedar. (IX.10.2)[32]*

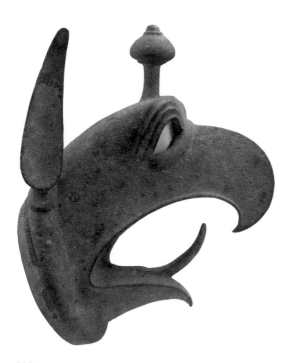

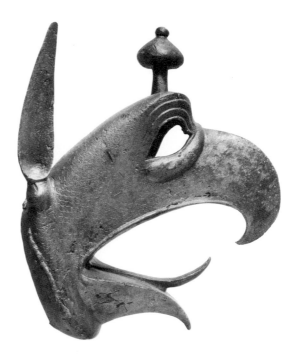

FIG. 13

Head of bronze griffin-protome. Circa 650 B.C. New York, The Metropolitan Museum of Art, Bequest of Walter C. Baker, 1971, acc. 1972.118.54. Photo courtesy The Metropolitan Museum of Art.

FIG. 14

Head of bronze griffin-protome. Circa 650 B.C. Olympia Museum inv. B 145, B 4315. Photo courtesy DAI, Athens.

Even though the two statues were made of different materials, they could have had the same model, and this could conceivably have been the wooden figure in Thebes. The passage remains puzzling. Usually, the literary testimonia refer to pairs or groups of figures that were made in one medium and that belonged together.

Kalamis made a row of bronze boys, we do not know how many, which stood on one wall of the Altis at Olympia (Pausanias V.25.6). Their right hands were all outstretched in supplication: were they all alike? Lykios made a group of twenty-three figures on one base at Olympia – Zeus, Thetis, and Hemera in the middle; on either side of them were five pairs of opposing heroes from Troy, ready for battle (Pausanias V.22.2).[33] Were these pairs similar? Were opposite pairs alike, or were they mirror images of one another? And there also stood at Olympia a dedication commemorating a chorus of thirty-five boys who had drowned; a chorus is by nature more or less uniform, and when Kallon made it, he included the boys' trainer and flute-player, perhaps thinking that the group needed some variety (Pausanias V.25.2–4).

At Delphi, nine different artists worked on a monument commemorating the Spartan victory at Aigispotamoi. It consisted of about thirty-six statues, six of them gods; the rest were humans, including Lysander and his allies, eleven of them made by Tisander, an artist who is otherwise unknown (Pausanias X.9.6–10). How much latitude was Tisander allowed? How different was one statue from the next one? A smaller dedication at Delphi, financed by the spoils from Marathon, carried thirteen statues on one base, and Phidias made

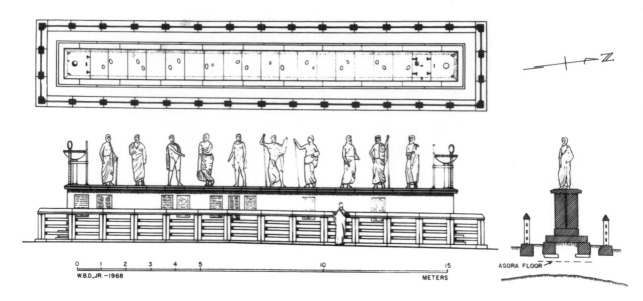

FIG. 15

Plan and reconstructed drawing of monument to the Eponymous Heroes by W. B. Dinsmoor, Jr. Fourth century B.C. Athens, Agora Museum. Photo courtesy American School of Classical Studies at Athens, Agora Excavations.

them all – Athena, Apollo, Miltiades, seven eponymous heroes of Athens, and Kodros, Theseus, and Neleus (Pausanias X. 10. 1–2). Pausanias does not distinguish among the heroes, and we might reasonably conclude that they at least, if not all the figures except Athena, resembled one another.

Statues of the eponymous heroes existed in Athens, too, during the fifth century, but we do not know who made them. And there was a later, fourth-century installation of the eponymoi on the west side of the Agora (fig. 15). At that time, ten life-size bronze statues were erected on a base within a fenced enclosure in front of the Metroon. Only a few of the uppermost blocks of the base are preserved, showing a few of the cuttings for the dowels that held the row of standing statues. Maybe this was just a reinstallation of the fifth-century group, or maybe it was a new group that was produced during the fourth century. A foundry in the vicinity would suggest the latter, for statues were made in it, and the workshop has yielded tantalizing fragments of clay investment molds for portions of drapery and of body parts[34] (figs. 16, 17). Unfortunately, too few pieces are preserved to reconstruct even one complete figure.

When we read ancient references to groups of standing figures, such as a row of supplicating boys; or seven eponymous heroes in Delphi and ten in Athens; or twenty-eight commanders, eleven of them by one artist; or thirty-five chorus boys; we can assume that the figures in any one of these groups were somewhat alike. If authors occasionally mention particular figures, such as Athena and Apollo, a flute-player and a trainer, or five pairs of warriors, we can tell that they would have been distinguishable from the group as a whole. These unique figures of course had to be made individually.

Commissions for figures that closely resembled one another also required technical consideration of the problems that they posed. The statues all had to fit on one base and be of the same

general sizes and proportions. Artists and founders had to work out procedures that would allow them to complete a commission on time, avoid technical problems, and make some profit in the end.

I think that the Riace bronzes may provide a key to the way in which groups of figures were produced during the Classical period. Scholars have picked carefully through the differences between these two statues and arrived at a wide variety of conclusions regarding their dates and provenances, identifications, and attribution.[35] But let us review the similarities and consider whether they may once have comprised at least part of a group.

Although their heads and musculature are quite different, the general outlines of the two statues are almost exactly the same. Both stand firmly on the right foot, with the left foot forward, knee relaxed, the right hip thrust out, the right hand lowered (and once holding a weapon?), left forearm raised to the horizontal to support a shield, head turned to the right. But statue A has a broad, youthful face, framed by long loose curls, and a cascading layered beard, whereas statue B has a longer, narrower face and short compact hair and beard. Statue B's body is leaner and flatter than statue A's, the right hip thrust more firmly outward.

Edilberto Formigli has reconstructed the process by which the Riace bronzes were cast, showing that in each case master molds were taken from the original model and lined with a layer of wax, which was worked over extensively before casting.[36] As we know, there was much variation in how artists chose to cast bronzes, and these two statues, though found together and very similar in appearance, differ in the composition of the bronze alloy and in that of the clay core material.[37] However, the two figures vary in height by only one centimeter, and the many other measurements that have been taken of them are virtually identical.[38]

These measurements make me think that only one original model was used to produce the Riace bronzes. If so, two sets of master molds would have been taken from an original rough model, each set removed in the same groupings of molds, with the result that the statues were eventually cast in the same pieces: from neck to mid-foot; with heads, arms, genitals, fronts of feet, and middle toes separate. This is a good way to make a group of statues of one type for one commission, and it explains both the striking similarities and the differences between the Riace bronzes.

Wherever the original model was prepared, the master molds taken from it could easily have been packed up and taken to whoever had been contracted to make the waxes for casting. Once the master molds had been transferred, perhaps even to another workshop

or another city, the artist(s) could make their waxes, then model each group of waxes individually. These bronzes, though produced from exactly similar groups of master molds, differ significantly because the original model was a rough one. Being of the same height and proportions, and of the same general configuration, the two statues easily fit one commission, and they could have stood on one base. But they are not alike: one head turns more than the other; hair and beards were added on and worked over; muscles, arms, and legs were freely modeled and thus altered. Had a detailed original model been used, the bronzes produced might not differ at all, being simply copies of a model.

Steeped as we are in the belief that the Greeks of the Classical period did not duplicate statues, we may at first find it difficult to accept the notion that the Riace bronzes, or any Greek statues for that matter, may have been made as a series. But series production in other areas, at least, cannot be disputed. And we have seen in the production of a group of protomes that series production need not result in exact copies but might serve instead to repeat a particular type as often as necessary. The same principle no doubt applied to statues, and it was far easier to carry out in bronze than in marble. Two or more statues of the same type could have been made from one original model and could have looked similar, even strikingly so. However, this need not have compromised the individuality of any work, for two statues that, like the Riace bronzes, were made by a combination of direct and indirect lost-wax casting would never have looked just alike. The use of one original model would only have started a commission in the right direction: this rough model would have controlled size and proportion, beyond which came endless opportunities for artistic expression and for individualized treatment of a statue.

Bronze was the ideal medium to use for such a project, since it allowed for what might be called generalized repetition. Using bronze also made it fast and easy for one or more artists, perhaps working in different places, to produce groups of bronzes, without sacrificing the originality that they wished to impart to individual works.

Greek bronzes with thick and uneven walls, which testify to the use of direct modeling in the waxes, and which characterize large-scale production during both the Archaic and Classical periods, become much less common during the early Hellenistic period. Later they disappear altogether, to be replaced by lightweight bronzes with uniformly thin and even walls.

The literary evidence suggests that a change occurred in the production methods for bronze statues during the fourth century B.C. The information comes from Pliny's discussion of modeling. He reports that the individual who was responsible for this innovation

FIG. 16

Fragment of a clay mold for drapery. Fourth century B.C. Athens, Agora Museum inv. B 1189l. Photo courtesy American School of Classical Studies at Athens, Agora Excavations.

FIG. 17

Fragment of a clay mold for fingers. Fourth century B.C. Athens, Agora Museum inv. B 1189f. Photo courtesy American School of Classical Studies at Athens, Agora Excavations.

was Lysistratos, an artist who, like his brother Lysippos, worked in bronze. The passage reads:

The first person who formed a likeness in plaster from the face itself and who established a method of pouring wax into this plaster mold and then making corrections in it [that is, in the wax] was Lysistratos of Sikyon, the brother of Lysippos. . . . And he established a method of reproducing likenesses, for before this they had tried to make them as beautiful as possible. The same person invented a method of molding copies [that is, taking casts] from statues, and the method became known to such a degree that no figures or statues were made without clay. (H.N., XXXV.153)

As it stands, the passage may be out of place, part of it belonging elsewhere, and various interpretations of its meaning have been proposed.[39] But this much of it, either by itself, or as part of Pliny's discussion of modeling, makes good sense to me.

Here is how the passage fits into the context. As elsewhere, Pliny is proceeding chronologically. He speaks of innovators in the modeling of clay, first Boutades, and Rhoikos and Theodoros,[40] with a reference to the potters who introduced modeling to Italy, then back to Boutades, before mentioning Lysistratos and a series of even later artists. In light of what we now know about ancient casting, we can quite easily explain what Pliny says about Lysistratos.

Lysistratos introduced a pure form of the indirect process. His innovation was simply this: he began using actual human beings as his models, or he made models that were finished and complete. When he took master molds from his models, the waxes made in them did not need improvement, only touching up: after this, they could be invested and cast. This meant that an artist was not needed to finish the waxes; instead, a technician could be hired to make the waxes, clean them up, and cast the essentially unchanged model.

Using the indirect lost-wax process by itself, rather than combining it with the direct process, saved time, effort, and money. The thin layer of wax that was spread in the master molds need

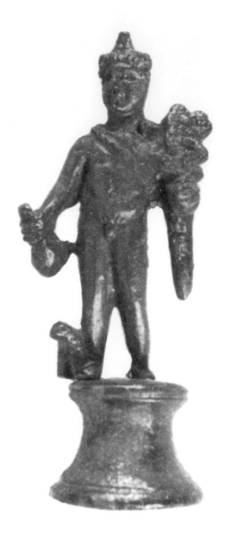

FIG. 18

Bronze Hermes. Early Roman.
Athens, Agora Museum inv. B
248. Photo courtesy American
School of Classical Studies at
Athens, Agora Excavations.

not become thick and irregular by further modeling: thus less bronze was used in the pour. Furthermore, the chances of a successful casting were increased. In case of failure, the artist need not be called back to work: the molding and casting could be repeated by technicians. The result of this development was the introduction of exact duplication.

 The evidence suggests that during the Hellenistic period public dedications of groups of statues were challenged by the increasing popularity of private commissions – portraits, and groups of house and garden sculpture. I think that by the end of the second century, when a work like the well-known head from Delos was cast, the faster, cheaper process of pure duplication was already in vogue. Individually modeled statues or groups – Pliny's earlier "beautiful" figures – were more laborious and expensive to produce and had become less common. In the end, it seems that the older, more complicated combined process, with its infinite variations, was probably no longer economically feasible for the production of large works. Thin, even castings, easily and rapidly produced, became the norm. The original model, detailed instead of rough, might be highly imaginative, the resulting bronze truly realistic, but the production process was

simplified to reproduction of the already finished model.

A reproductive casting process was closely related to the later widespread production of copies. And with the great popular demand for statuary during the Roman period, large-scale originals in all media were evidently less frequently commissioned, but copies of famous statues were the norm. It is in this context that we should read Lucian's second-century A.D. reference to the famous Hermes that stood in the Athenian Agora: "He is all covered over with pitch on account of being molded every day by the sculptors" (*Zeus Tragoidos*, 33) (fig. 18). It was an age of taking casts from older originals, which had served, most of them, as dedications, in order to produce copies that would perform altogether different functions from what had once been intended for the originals.

George Mason University
FAIRFAX, VIRGINIA

Notes

1 I am grateful to Richard S. Mason and Harriet C. Mattusch for their great assistance in the preparation of this project and for their patience throughout.

"Holzerz": K. Kluge, "Die Gestaltung des Erzes in der Archaisch-Griechischen Kunst," *JdI* 44 (1929), pp. 1–30. See also K. Kluge, *Die Antiken Großbronzen*, vol. 1, *Die Antike Erzgestaltung und ihre technischen Grundlagen*, K. Kluge and K. Lehmann-Hartleben, eds. (Berlin, 1927).

2 For a summary of Kluge's theories, and a review of the dependent scholarship, see C. C. Mattusch, *Greek Bronze Statuary: From the Beginnings through the Fifth Century B.C.*, (Ithaca, N.Y., 1988), pp. 22–28.

3 Carpenter saw Lysistratos as the innovator, who, as the first to take casts from the human form (see Pliny, H.N., XXXV.153), ushered in the "plastic" in Greek sculpture: "Observations on Familiar Statuary in Rome," *MAAR* 18 (1941), pp. 75–80; idem, *Greek Sculpture* (Chicago, 1960), pp. 67–79.

4 See D. E. L. Haynes, "Technical Appendix" to S. Haynes, "Bronze Priests and Priestesses from Nemi," *RM* 67 (1960), pp. 45–47.

5 H.N., XXXIV.8, 10–11, 75.

6 Pausanias I.42.5, V.25.13, VII.5.5, VIII.53.11, X.17.12, X.36.5.

7 See, for example, Carpenter, *Greek Sculpture* (note 3), pp. 115–116.

8 There are also marble attachments, such as quivers and cheek pieces, and bronze could be used to attach them, as was done with the marble snakes on Athena's aigis, on the later East Pediment. Bronze was also used for the pupil of a huge ivory eye from the cella of the temple.

9 See, for example, Athens, National Museum inv. 1938, H: 23 cm.

10 Athens, National Museum inv. 6446, early fifth century B.C., H: 29 cm.

11 See, for example, P. C. Bol, *Antike Bronzetechnik* (Munich, 1985), p. 27, fig. 9.

12 See, for example, "Some Observations on Early Greek Bronze Casting," *AA*, 1962, cols. 803–807.

13 Baltimore, Walters Art Gallery inv. 54.789, H: 7.1 cm. See *The Gods Delight: The Human Figure in Classical Bronze*, The Cleveland Museum of Art and other institutions, November 1988–July 1989 (A. P. Kozloff and D. G. Mitten, organizers) (Cleveland, 1988), pp. 49–51, no. 1: circa 750–700 B.C.; D. K. Hill, *Catalogue of the Classical Bronze Sculpture in the Walters Art Gallery* (Baltimore, 1949), p. 77, no. 167, pl. 36.

14 Berlin, Staatliche Museen inv. misc. 7477, total H: 18.1 cm, *Antikenmuseum Berlin: Die ausgestellten Werke* (Berlin, 1988), p. 51, no. 1, circa 620 B.C. For the argument that the parts of the figure were molded separately and then joined for casting, see U. Gehrig, "Frühe griechische Bronzegusstechniken," *AA*, 1979, pp. 547–553.

15 Boston, Museum of Fine Arts, H. L. Pierce Fund, 04.6, H: 17.1 cm; and H. L. Pierce Fund, 99.489, total H: 26.4 cm. *The Gods Delight* (note 13), pp. 77–86, nos. 8, 9; M. Comstock and C. Vermeule, *Greek, Etruscan and Roman Bronzes in the Museum of Fine Arts, Boston* (Greenwich, 1971), pp. 24–26, nos. 22–23.

16 See D. K. Hill, "Note on the Piecing of Bronze Statuettes," *Hesperia* 51 (1982), pp. 277–283.

17 Berlin, Staatliche Museen 31098, total H: 32.6 cm, *Antikenmuseum Berlin* (note 14), p. 89, no. 13, circa 530 B.C. The statuette was X-rayed with radioactive iridium 192: Gehrig (note 14), pp. 554–558.

18 See also IX.41.1, and X.38.6.

19 Some plaster master molds have been identified from a late Hellenistic context at Nea Paphos, K. Nicolaou, "Archaeological News from Cyprus," *AJA* 76 (1972), pp. 315–316.

20 Olympia B 1661 + Br. 2702 + Br. 12358, H: 15.5 cm, dated by style to circa 600 or 550 B.C. See P. C. Bol, *Olympische Forschungen*, vol. 9, *Großplastik aus Bronze in Olympia*

(Berlin, 1978), pp. 7–8, no. 1, circa 600 B.C.; Mattusch (note 2), pp. 53–54, 600–575 B.C.

21 Athens, Agora S 741, preserved H (without head fragments): 75 cm. See Mattusch (note 2), pp. 53–60 with references to earlier publications.

22 Berlin, Staatliche Museen F 2294. See C. C. Mattusch, "The Berlin Foundry Cup: The Casting of Greek Bronze Statuary in the Early Fifth Century B.C.," *AJA* 84 (1980), pp. 435–444.

23 Izmir, Museum of Archaeology inv. 3544, H: 81 cm. See *Art Treasures of Turkey*, Smithsonian Institution, 1966–1968 (Washington, D.C., 1966), p. 91, no. 130, fourth century B.C.; B. S. Ridgway, "The Lady from the Sea: A Greek Bronze in Turkey," *AJA* 71 (1967), pp. 329–334, early third century B.C.
 An interesting comparison can be made with an Etruscan draped girl from Nemi; less than a meter in height, the figure was cast in eight pieces, London, British Museum inv. 1920.6-12.1, H: 97 cm, Haynes (note 4); S. Haynes, *Etruscan Bronzes* (London and New York, 1985), pp. 320–321, no. 196, 200–100 B.C.; M. Cristofani, *I Bronzi degli Etruschi* (Novara, 1985), p. 274, no. 68, first half of third century B.C.

24 Pliny on alloys: *H.N.*, XXXIV.5–12. For a summary of technical variations, see Mattusch (note 2), "Appendix," pp. 219–238.

25 For a group of bronze clamps, cast together in a row, from a fourth-century B.C. context, see Olympia B 1113, total H: 7.5 cm, W.-D. Heilmeyer, "Giessereibetriebe in Olympia," *AA*, 1969, pp. 17, fig. 23; 18. For one example of statuettes, see D. K. Hill, "An Egypto-Roman Sculptural Type and Mass Production of Bronze Statuettes," *Hesperia* 27 (1958), pp. 311–317. For a sixth-century example, see H. Kyrieleis, "Samos and Some Aspects of Archaic Greek Bronze Casting," this volume, pp. 15–30.

26 D. E. L. Haynes, "The Technique of the Erbach Griffin-Protomai," *JHS* 101 (1981), pp. 136–138.

27 Athens, National Museum inv. 7582, H as preserved: 17.5 cm; New York, the Metropolitan Museum of Art 1972.118.54, H: 25.8 cm; Olympia B 145 + B 4315, H: 27.8 cm. See U. Jantzen, *Griechische Greifenkessel* (Berlin, 1955), pp. 19, 65–66, nos. 77–79; H.-V. Herrmann, *Olympische Forschungen*, vol. 11, *Die Kessel der orientalisierenden Zeit* (Berlin, 1979), pp. 49–50, nos. G 104–G 106; C. C. Mattusch, "A Trio of Griffins from Olympia," forthcoming in *Hesperia* 59 (1990).

28 Further physical examination of protomes that have been grouped stylistically may very well broaden the evidence for the production of groups of objects by a repetitive process.

29 See G. M. A. Richter, *Kouroi*, 3rd edn. (New York, 1970), p. 49; E. Guralnick, "Proportions of Kouroi," *AJA* 82 (1978), pp. 461–472; idem, "Profiles of Kouroi," *AJA* 86 (1982), pp. 267–268; B. S. Ridgway, *The Archaic Style in Greek Sculpture* (Princeton, 1977), pp. 23, 26, 70, 81, 150, 296–298, 301.

30 See J. Boardman, *Greek Sculpture: The Archaic Period* (London, 1985), fig. 91.

31 Dermys and Kittylos: Richter (note 29), no. 11, figs. 76–77; Ridgway (note 29), pp. 149–150, 172, 175–176, 178. Tyrannicides: S. Brunnsaker, *The Tyrant-Slayers of Kritios and Nesiotes* (Stockholm, 1971). On the subject of repetition: V. M. Strocka, "Variante, Wiederholung und Serie in der griechischen Bildhauerei," *JdI* 94 (1979), pp. 143–173.

32 See also Pausanias I.16.3, VIII.46.3, and Pliny, *H.N.*, XXXIV.75.

33 Lykios also made a group of the Argonauts: Pliny, *H.N.*, XXXIV.79.

34 See R. E. Wycherley, *Agora*, vol. 3, *Literary and Epigraphical Testimonia* (Princeton, 1957), pp. 85–90, nos. 229–245; H. A. Thompson and R. E. Wycherley, *Agora*, vol. 14, *The Agora of Athens* (Princeton, 1972), pp. 38–41, pls. 6, 32; C. C. Mattusch, "Bronze- and Ironworking in the Area of the Athenian Agora," *Hesperia* 46 (1977), pp. 350–356.

35 For excellent illustrations, and for opinions presently held on these subjects, see *Due bronzi da Riace: Rinvenimento, restauro, analisi et ipotesi di interpretazione, BdA*, spec. ser. 3, vol. 2 (Rome, 1985); for a summary of these opinions, see Mattusch (note 2), pp. 207–208.

36 E. Formigli, "La tecnica di costruzione delle statue di Riace," in *Due bronzi*, vol. 1 (Rome, 1985) (note 35), pp. 107–142.

37 I am grateful to Dr. Gerwulf Schneider for this information, which is part of an investigation of the core materials of statues, in which he and Edilberto Formigli are currently involved.

38 H of statue A: 1.98 m, of statue B: 1.97 m. For full measurements, see C. Sabbione, "Tavole delle misure," in *Due bronzi* (note 36), pp. 221–225, appendix 2.

39 *Hominis autem imaginem gypso e facie ipsa primus omnium expressit ceraque in eam formam gypsi infusa emendare instituit Lysistratus Sicyonius, frater Lysippi de quo diximus. hic et similitudines reddere instituit, ante eum quam pulcherrimas facere studebatur. idem et de signis effigies exprimere invenit, crevitque res in tantum ut nulla signa statuaeve sine argilla fierent.*
There is one more sentence – *quo apparet antiquiorem hanc fuisse scientiam quam fundendi aeris* ("Hence it is clear that this skill [of forming clay] is older than that of casting bronze") – which may belong instead to XXXV.152, as L. Urlichs, *Chrestomathia Pliniana* (Berlin, 1857), p. 375. For further discussion and bibl., see G. M. A. Richter, *Ancient Italy* (Ann Arbor, 1955), p. 113.

40 These two had to be innovators in that field in order to introduce large-scale bronze casting to Greece, for which they were famous: see above (note 18). I have argued elsewhere that the process that they introduced was piece casting: "The Earliest Greek Bronze Statues and the Lost Wax Process," in H. Schiefer, ed., *Griechische und römische Statuetten und Großbronzen*, Akten der 9. Tagung über antike Bronzen (Vienna, 1988), pp. 191–195.

Practical Considerations and Problems of Bronze Casting

Paul K. Cavanagh

If the way in which many of the seventy-three bronzes in this exhibition were cast is described, to all intents and purposes it portrays how many small bronzes are still cast today. More complex processes are now used for casting large sculpture, but for the casting of small bronzes from wax models, little has changed in thirty-five centuries, except the method for heating the bronze. Charcoal made particularly from ash wood was the most common ancient fuel. Oil, gas, and electricity are the modern substitutes.

Fire can change matter from one state to another. This fact, which today is elementary and obvious, was not so millennia ago. Those early metal craftsmen were elevated to the rank of demigod or held in awe as being endowed with divine or magic powers. Only such powers could explain the ability to modify a part of the "world" by fire. They were able to accelerate a natural process of transformation and also, and more importantly, create something new out of what could be found in nature.

Early bronze casting was steeped in mystery, particularly if one was not an initiate to the process. An observer of an early craftsman would note that after making a wax image or sculpture, the craftsman would surround it with a special clay mixture. This mixture of wet clay, powdered terracotta, and maybe cow dung would form a sarcophagus around the image. Mysteriously, the completed clay lump would be placed into a fire so that all the wax would melt away.

The original wax figure had disappeared; the founder had destroyed it. All that remained was a hard clay shell. The craftsman would then take some lumps of heavy brown gray rock or a bright green powdery earth and a little silver gray material, place them in a ceramic vessel, and place the whole in a fire. We now know these lumps were native copper and tin. The man would then coax the charcoal fire with bellows. Unforeseen, the copper and tin freed from the ore were combining to form the alloy bronze.

Meanwhile, the dried clay husk was buried in a pit. The ore that once was brown and green was now inexplicably a glowing golden red. The craftsman poured the golden fluid into one of

the openings left in the clay husk.

The husk now had to wait for many hours to cool. When cool, the clay was broken away exposing the recognizable bronze figure that had been freed from its earthen womb.

As an observer you would have witnessed a wax figure destroyed and reborn in heavy metal from liquid fire. You would have watched a brown sponge or a green powder become a dust-covered image, which the craftsman scraped and polished into a red gold. In time the metal would go through another mysterious change. The red gold would turn to a warm brown or green or azure once again.

The fear and respect given the ancient craftsmen was based on their "Earth Mother's" work when they accelerated and perfected the "growth" of an ore by transplanting it in a sort of "artificial womb," the furnace.

There is a deep magic in bronze, which is not explained by its practicality, by the fact that the molten metal pours more easily than copper and is harder when it cools, or that its color moves mysteriously from red gold to deep green or azure as time handles it. It is not that bronze served all practical purposes before iron slowly replaced it for common implements and thus elevated it to the metallic aristocracy. It is not even that much of the world's greatest sculpture has been made in bronze. Because it is not a precious metal, it does not prompt greed before admiration. It prompts love, and it has inspired myth.

If we were to watch the same process today, there would be differences. Certainly much of the mystery has gone. Perhaps the image would be cast hollow. The mold materials are readily available, and the bronze could be purchased from a smelter who specializes in combining copper with other metals.

Interestingly, we are as limited today as were the ancient founders by the nature of our materials. The materials for making molds that can withstand the temperature of molten bronze are quite few. Moreover, the clays, waxes, sands, and metals of today still possess all the limitations that are inherent in their nature. The same techniques for using and understanding of the variables involved must be known now as they had to be centuries ago to achieve a successful casting. The distinct difference today is that we have a number of ways to measure the variables and limitations of these materials. Furthermore, we depend on these materials to be combined or processed to produce consistent quality. Centuries ago the craftsman had to use the raw materials as they were available, without much secondary processing. Techniques also varied with the availability of materials and the level of technical skill. The results produced a wide variety of quality.

Many of the same problems of bronze casting exist for the craftsman today that must have existed in any age. The issues of whether a burn-out was successful and whether the bronze had been poured at the right temperature to fill the mold, remind us that there never has been a way to know if you have been successful in casting except to open the mold and examine the cast. On second look, you may only have a casting if it can be repaired and made usable.

Since antiquity the alloy bronze has been the metal most often chosen for casting statuary. It is the oldest artificial alloy. Bronze is composed principally of copper and tin. The proportions are roughly 90% copper and 10% tin. Copper on its own does not pour easily and is subject to contamination by hydrogen gas from the atmosphere. Today as in the past copper is frequently alloyed with other metals, usually tin, zinc, and lead. The use of other metals with copper by early craftsmen was determined by availability as well as the physical properties desired in the bronze. Tin hardens copper, zinc reduces the retention of gases in the castings, and lead facilitates the clean-up and chasing after the image is cast by making the metal more malleable.

While melting bronze, care must be used to prevent contaminants from combining with the metal. The elements of the alloy must be as free as possible of all oxides, inclusions, or foreign particles. The container in which the metal is melted must be free of foreign material as well as be stable at the elevated temperatures required to melt bronze. Most bronze melts at 1900° F. If there is a flame, it must be adjusted to a neutral condition, for both reducing and oxidizing flames can produce contaminants that can alter the quality of the bronze. Prior to melting, the total amount of metal to be melted must be weighed. Once the melting process has started, small amounts, or "charges," of bronze are added to the particular melt or "heat." These charges must be added at regular intervals so that the metal at no point overheats, which would cause hydrogen gas to be retained in the bronze. Once bronze has become contaminated by hydrogen gas, it is difficult to remove the gas.

In order to understand the ancient bronze, it is essential to understand the order of manufacture of the lost-wax process. The sequence remains the same as it was in the earliest times. The following descriptions of the casting processes are meant as a survey treatment only of a very complex subject.

The process must start with the production of a wax either directly modeled or duplicated from an original sculpture in another material. The material a sculptor chooses depends on personal preference. Some sculptors prefer to carve rather than model their original image. Today emphasis is placed on the use of flexible molds to

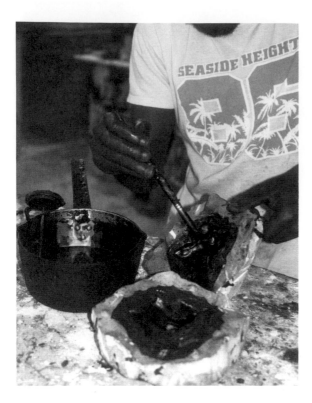
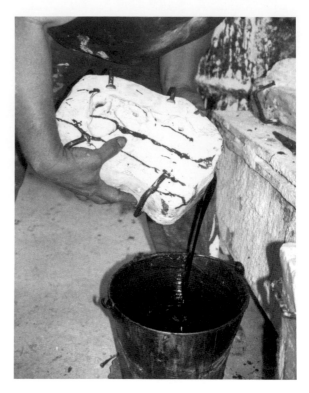

produce the wax duplicate. This flexible mold is desirable because it allows for simple creation of a hollow wax and a method to make many copies of the same image. There are now many different types of flexible mold materials, which can either be poured or painted against an original model. The original model can be made of virtually any material. The flexible mold material must be backed by a shell of plaster of paris to keep it rigid until the wax cast is removed (fig. 1). For centuries wax images have been produced from piece molds of clay or plaster in a similar manner as a clay-slip mold is produced by a potter.

In foundry vocabulary the term "wax" refers to both the material and the cast from the flexible mold. There are many hundreds of different kinds of wax. All of them could be used for the lost-wax process, but only a limited number having specific physical properties are used. The usual wax characteristics are softness and plasticity, but the wax must also be strong and not become deformed by frequent handling during the steps in casting. For centuries beeswax has been the preferred wax. It still is, but due to its scarcity and expense, substitutes with similar characteristics are now used. Usually two waxes are used to produce a wax from a flexible mold. The first type is painted into the flexible mold with a soft brush. It is for this step that the beeswax or beeswax substitute would be used. This soft, low-shrinkage wax adheres to all the inner walls of the mold. The mold is then closed and a second wax is poured into the mold, filling the entire cavity. The wax remains in the mold until the desired build-up of wax is achieved on the inside wall, and then the remaining liquid wax is poured out (fig. 2).

FIG. 1

Flexible mold material backed by a shell of plaster of paris.

FIG. 2

Liquid wax being poured out of the mold.

By using this method of producing a hollow wax, the founder facilitates the production of a hollow bronze casting since the wax thickness will accurately determine his metal thickness in the investment mold. The hollow wax can be filled with investment material to form a core.

A "retouching" of the wax image is necessary once it has been carefully removed intact from the flexible mold. This retouching removes the seam marks left from the flexible mold and corrects any small imperfections in the wax.

The interior space of the hollow wax is filled with a refractory material called the core. The core is either made of the same material as the outer mold or of a more porous clay material. Cores in large waxes are put in before the wax is removed from the flexible mold. Otherwise, the waxes would become damaged because of the fragile quality of the thin wax shell and the size or complexity of the image. Long steel nails are pushed through the wall of the wax to hold the core in position with the outer mold once the wax has been melted out. These nails or pins are called "chaplets." Some hollow ancient bronzes were produced by modeling wax over a preformed core.

Recent examinations of the ancient technique of including organic materials into a clay core have revealed some interesting results. The regularity of the wall thickness of some ancient castings and the inhibiting sculptural technique of attempting to model wax over a pre-existing core suggest the possibilities of techniques that are used today. An assumption was made that the core for a number of ancient bronzes was poured into a hollow wax while the wax was still in a piece mold. If the opening to pour in the core in such a wax was small in size compared to the volume of the core, then if a clay-sliplike material was used, it would have no way of "setting" or losing its moisture and thus could not exist as a core.

Pliny the Elder in his history of the fine arts does not mention a molder or a caster. However, Pliny, Plutarch his contemporary, and Philostratos writing in the third century A.D., frequently refer to gypsum and its uses. It seems reasonable to conclude that the art of casting with gypsum was not separated from the art of the sculptor.

Gypsum or limestone cement alone will break down at temperatures needed to cook the mold and remove the wax. Some other heat-resistant material must be added so that the mold can be processed at sufficient temperature. The additive material most readily available to the ancient bronze caster was clay.

If a small amount of gypsum is added to dried clay and sufficient water is added to make a thick pourable slurry, it would seem that the gypsum should cause the clay to become rigid

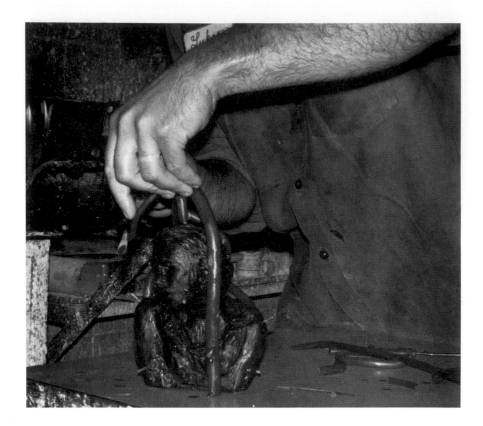

FIG. 3

Gates and vents being applied to
the wax mold.

enough to form a core. In fact there still remains enough free moisture so
that the mixture remains very soft and pliable. When a small amount of
wood shavings and straw is added to the mixture, the mixture sets and
becomes quite firm. The organic materials have absorbed the free
moisture and allowed the gypsum to set. This setting occurs even inside a
wax with a restricted opening.

 Molds with cores made of clay in this manner
must be filled with molten bronze when they are warm. If the molds are
allowed to cool, the residue organic material will absorb atmospheric
moisture and cause a reaction with the molten metal. The results might
then be a series of defects in the casting or its total loss.

 Once the core is in place, the wax must have
applied to it a system of "gates" and "vents." The former is the
distribution system to transport molten metal to every point in the cavity
created when the wax melts out. The vents are passages for air to escape
from the mold as it is displaced by the metal. Both the gates and vents are
formed from flexible wax rods that must be firmly attached to the wax
model prior to investing (fig. 3). At the top of this gating system there is
affixed a wax pouring cup, which will become the point at which the
molten bronze enters the mold. The whole system must be thought out
for each wax image. The bronze must go to the bottom of the mold first,
then start filling into the image cavity. As the bronze fills, vents will allow
air to be released from areas where it could become trapped.

 The refractory material that surrounds the wax

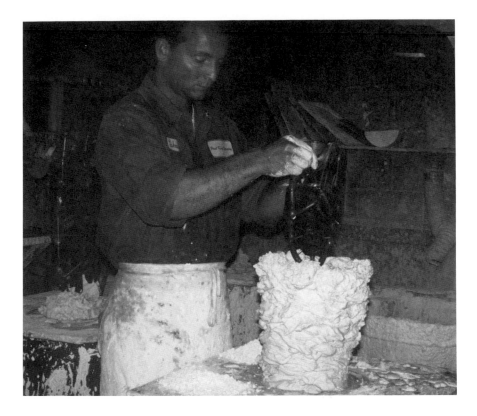

FIG. 4

The wax model and the
investment mold.

image and gating system is called investment (fig. 4). Investment or mold material can be composed of a number of different substances. Today molds of this type are made of mixtures of plaster of paris, brick powder, ceramic grain, ground sands, and other heat-resistant materials.

The first coat of the investment is extremely important because it is to become the exact negative duplicate of the wax. It must be applied in a way to insure that the inner surface of the investment mold will be bubblefree. Since the investment material sets, it is important to accomplish this quickly. Usually, the mold is built from the bottom upward. In order to insure that there are no voids or weak areas, it is necessary carefully to construct the mold using a successive circular layering technique. As the setting progresses, the mold is gradually built out to a cylindrical shape with a flat top and bottom. The size of the mold is only determined by the size of the wax image inside. The thickness of investment does not add significantly to the strength of the mold either before or after the mold has "burned out."

The investment material must be sufficiently strong to withstand a temperature of 1250° F. It is at this temperature that all water is driven from the mold and any residue wax still remaining in the mold is turned into carbon dioxide, carbon monoxide, and water vapor. This is a very critical stage in casting. Unless the mold is thoroughly dry and free of all carbon residue, there will be a reaction when the molten bronze is poured into the mold. These imperfections can be as major as losing the entire cast because the mold blew up or as

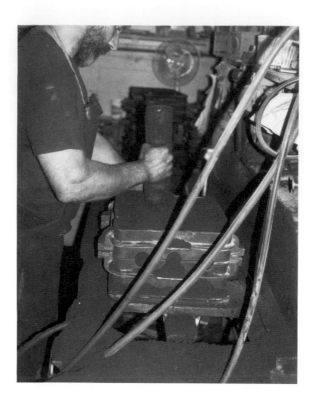

FIG. 5

Moist sand being compressed into container supporting mold.

small as losing some critical detail. A very simple test is used to determine the critical point at which a mold is "cooked," or burned out: A small hollow metal tube is placed into the oven and into the hole in the bottom of the mold from which the wax has drained while the oven is still operating. If on drawing a mouthful of air from the tube there is any indication of smoke, then the mold is not done. If on the other hand the air is clear, then the mold is done.

The oven for burning out the molds is frequently built around the molds after the molds have been set onto the oven floor in two rows. The oven may be built of bricks that are stacked to the desired height, one on top of the other, and held in place with a plaster stucco. The flame, either gas or oil, must not come in direct contact with the molds, for the flame temperature is much higher than 1250° F, and thus contact could cause the molds to disintegrate. Drain troughs are placed below the molds to catch the molten wax as it flows from the mold. The wax is "lost." Smaller molds are inverted during the burn-out, and larger molds have a drain hole, which must be plugged when the burn-out is complete. The normal time for a burn-out is twenty-four hours for molds about the size of a life-size head and smaller casting. Much larger molds may take more than a week to be processed.

Ancient founders frequently had to pour their molds immediately after the burn-out was complete, while the molds were quite warm, because their investment core material contained organic materials. Today molds are allowed to cool undisturbed until they reach room temperature. They are then moved to the pouring area

floor, containers are set around them, and moist sand is compressed into the container to support the mold (fig. 5). It is essential that the sand not be too moist, because dampness seeping through the walls of the mold could incite an explosion with the molten metal. Care must also be taken that no grains of sand make their way into the top of the mold through the pouring cup.

When all the preparation of the mold has been accomplished, the bronze is brought to the melting point in a furnace. The container for the molten bronze is a crucible and is made of either graphite or silicon carbide. Both of these materials melt at temperatures much higher than that of bronze and thus are sufficiently strong at elevated temperatures, and they will not be a contaminant to the bronze. The furnace is composed of a cylindrical steel container, which has been lined with a refractory or heat resistant material. The removable cover is usually made of the same refractory material. The crucible is set above the floor of the furnace, and the flame is introduced to one side so that the heat can circulate evenly over the whole surface of the crucible. The internal temperature of the furnace must be well above the melting point of bronze. The exact temperature to which the molten bronze is elevated depends on the alloy as well as on the relative thinness or thickness of the wall of the casting. Thinner wall dimensions require a higher temperature of the molten bronze to ensure that the liquid fills the entire cavity. Thin walls are always desirable as the best method of controlling the shrinkage associated with heavy sections. Frequently the particular configuration of the sculpture contains a combination of thin and thick walls, and thus a judgment must be made on a temperature to account for both conditions.

Many methods have been used to determine the temperature of molten metal. Today a pyrometer accurately indicates temperature. An analysis of the relationship of the alloy and its melting time along with a consistency in the adding cycle are another time-honored accurate means of achieving an exact, repeatable temperature.

The crucible containing the molten bronze is lifted from the furnace by means of tongs and placed into a "shank." The shank cradles the crucible, which is lifted by two men and brought to the place where the investment molds have been rammed in sand. The molten bronze is poured into the pouring cup, and the flow continues until metal can be seen in the air vent ends at the top of the mold, next to the pouring cup (fig. 6).

When very large molds are to be poured, the molds are moved to the burn-out oven and then to the pouring floor with

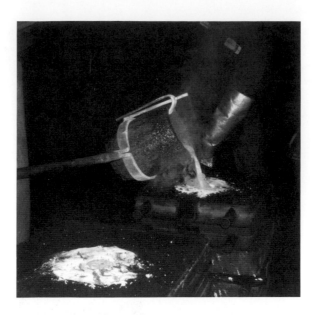

FIG. 6
Molten bronze being poured into
investment mold rammed in sand.

the aid of overhead hoists. The metal needed for the pour is also
transported in this manner. The craftsmen in ancient times would
frequently work on a hillside with large molds and set the burn-out pit at
a point below the melting pit on the hill. When the metal was sufficiently
molten, an opening was made in the melting pit so that the molten
bronze would flow downhill to the mold in the burn-out pit.

After sufficient time has been given for the
bronze to solidify, usually a number of hours, the investment mold is
broken open. Each layer of investment is carefully removed, until the first
indication of the enclosed casting (fig. 7). Care must be exercised in the
removal of the remainder of the investment so that the casting is not
scratched or marked. The casting at this point resembles the original
gated wax image. The completion of this stage calls for the removal of all
the gates and vents attached to the casting. This is now usually done by
power tools, but it can also be accomplished by hand with a hammer and
chisel. What remains on the surface of the casting are small bumps of
metal where the gates and vents once were. These small stubs must
further be filed down.

The nails that were put through the wax to
hold the core in relation to the outer mold must be removed and the
resulting hole filled with bronze. This repair may take two forms. One
can either use the same or a similar bronze rod and weld the hole shut, or
one can drill and tape or thread the hole left from the nail and insert a
bronze rod or pin that has been threaded. The bronze pin is then cut
flush to the surface of the cast, and any resulting stub is filed down.

In this initial finishing stage it is also necessary
to remove the core from the casting. This is generally done by mechanical
means, usually by a stiff wire in a power drill. The whipping action
pulverizes the dried core material, and the resulting powder can then be
poured from the casting. This can also be done by hand with a firm steel

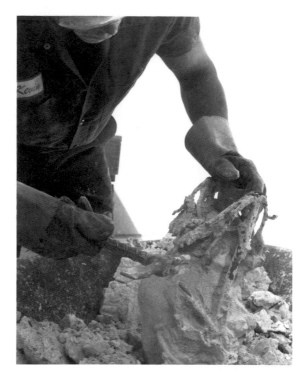

rod. It is very important to remove the core so that it does not react with the casting in the presence of atmospheric moisture. The resulting by-product of this reaction of the residue core leaches through small porous holes in the casting out onto the surface of the casting. This reaction is the start of the deteriorating condition called "bronze disease."

The next stage of finishing calls for removing all remaining stubs of gates and vents and returning the surface beneath each of these areas to the same surface texture that was on the original wax. This step is greatly aided by power tools, but ultimately most of the careful detail work must be done by using chasing tools, that is, chisels, lining tools, matting tools, punches, and a variety of other chisellike tools used with a hammer to carve and texture the surface (fig. 8).

Further, any other defect in the casting in the form of an inclusion must be removed and the resulting hole filled by either welding or pinning. These areas must then go through the same restorative process as in treating the nail holes.

If the sculpture is composed of many castings, once they are all individually chased, they are assembled or joined together. Joining today is usually done by welding, but most large bronzes must also be constructed using an ancient technique. The interlocking internal joining system by which sections are mechanically joined is called a "Roman joint."

A bronze left in its as-cast state will gradually change color. Patination refers to this natural color change and also to the artificially induced color change on the surface of bronze. Today and

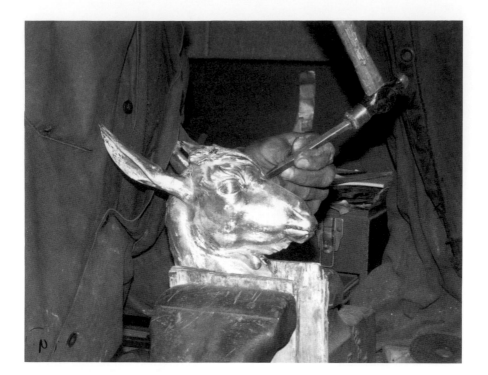

FIG. 8

Chasing tools being used to carve
and texture the surface of the cast.

for about the last one hundred years, sculptors have preferred to control
the coloring of the surface of their bronzes and take steps to preserve the
color. The purpose in coloring bronzes is to produce an effect in its
appearance in a short time that might ordinarily occur in nature but
would take much longer and might require special conditions. This
induced patination is done by chemically treating the bronze. The casting
is either immersed in a solution, or the solution is brushed onto the
surface of the casting. The most common technique is to apply the
chemicals with a brush while heating the bronze with a torch (fig. 9).
When the desired result has been achieved, the bronze is carefully
washed with water. The chemical reactions and colors resulting are not
yet fixed and may still change by a variety of factors, including handling
and airborne chemicals. It is therefore necessary to protect the surface of
the patina with either a protective spray or a wax to slow the further
reaction. The final buffing of the wax coat gives luster to the surface of
the finished bronze.

Sand casting is also a process that has its
origins in antiquity. It is extensively used today to produce a variety of
industrial castings. The material for sand casting varies in composition.
It can be described as a cohesive, plastic, fine-grained sand. A negative
mold in two halves is taken from the object to be cast. This is
accomplished by first setting the object into a rectangular frame, or
"flask," filled with sand that has been compressed or "rammed" to a firm
state. The flask is made in two parts resembling open frames. The upper
part of the mold is called the "cope" and the lower part the "drag." The
flask parts are keyed so they will fit together perfectly without

FIG. 9

Brush and blowtorch being used to achieve chemically induced patination.

movement. The object is embedded in the sand, leaving only half of the object exposed. A talc or parting powder is sprinkled onto the bed. Another flask half is set over the first half. Sand is added to the flask and then rammed. The ability of the sand to be compressed and hold together allows the second half of the mold to be removed from the first half. The model is again exposed and can be removed from the first half. The result is a very accurate negative chamber in sand. If there are areas on the model that are under-cut, then it is necessary to construct a "false core," or piece-mold section, prior to ramming the flask half. Generally speaking, sand casting is best suited to more or less symmetrical patterns where the dividing line or parting line is not too irregular and separation of the mold parts can easily be accomplished.

The main gate is then cut into the mold and connected to a pouring cup at the junction of the two halves of the mold. The craftsman must be conscious of the path that the molten metal will take. Heavy castings present a further problem because of shrinkage or the localized depression created in a surface because of slow cooling and concentrated heat caused by the relative heaviness of the section of casting. To compensate for this condition it is necessary to add a reservoir, or "riser," to the heavy section. The riser has a mass and cross section larger than the area in the casting it is feeding. A sand mold does not generally require any vents since the sand is permeable and allows the passage of air through it.

When the two halves of the mold have been completed, they are then realigned by a pin mechanism on the side of the flask. The mold halves must be clamped or weighted to prevent their

separation during the time they are filled with molten bronze.

Some works of large size need to be fitted with a core so the casting will be hollow. The core is made by filling the negative in the mold with sand. The mold is then closed, and the sand becomes packed hard. Upon opening, one sees a duplicate in sand of the original model. This sand duplicate is then shaved down to the thickness that the casting will be, which usually is one-quarter of one inch. Cores must be supported between the two halves of the molds by rods that extend from the core onto the inner face of the mold. It is important with sand-cast cores to have a vent from the center of the core to the outside of the mold to allow for the escape of heated air and gases developed during pouring. Core venting is not a requirement in most lost-wax situations unless there are organic materials in the core.

Pouring the bronze into sand molds is different than pouring bronze into lost-wax molds. Sand molds are poured at a higher temperature and much greater speed than lost-wax molds. The reason for this is that the baked investment does not "steal" the heat from the metal as quickly as the moist sand does.

The castings from a sand mold do not resemble those taken from a lost-wax mold. Sand castings have much fewer gates and one pronounced seam circumventing them entirely. The process for removing this seam as well as correcting flaws is the same as the one for lost-wax casting. Likewise, patination and protective finishes are applied in the same manner for both processes. As is the case with lost-wax casting, only one bronze casting can be made from a sand mold. The sand close to the casting has burned and turned to powder so that when the mold is opened, no internal definition remains. If additional copies of either lost-wax or sand-mold process castings are required, it is necessary to start at the beginning of each process again.

A well-trained eye can usually detect which process has been used to produce a casting. This visual system may not be sufficient if the authenticity of an ancient bronze is being questioned. There are many things that can be done to alter a bronze casting and suggest it is a product of antiquity when it is not.

In 1982, the Paul King Foundry was contacted by Andrew Liebman, who is a television producer for Chedd-Angier, Inc. He asked if we would be interested in participating in an experiment that ultimately would be shown on the "Discover the World of Science" television program. We were told that a team had been organized to see whether an "authentic" Shang dynasty Chinese bronze "kuang," or ceremonial wine vessel, could be produced. We agreed to work with the team. Harvard University's Fogg Art Museum agreed to loan an original Chinese vessel from their collection.

If we were to study the possibility of creating a forgery, then we had to try to anticipate what a forger might do. We knew there would be no records anyone could rely on to establish authenticity, in fact, there was no way to tell if a bronze was a forgery except through scientific testing. Museum laboratories routinely test objects using these methods, but the art world is full of rumors about forgeries so carefully made that scientific testing could not detect them.

Arthur Beale, one of the team members, who was then the conservator at the Fogg Art Museum, made a rubber mold of the kuang. We decided to use the lost-wax process. We knew that ultimately the resulting bronze copy would be tested at the laboratory for the Freer Collection at the Smithsonian Institution in Washington, D.C. Thomas Chase, Laboratory Director, was a team member, but his staff at the Smithsonian were not told of the experiment. We used the two-volume study of the Freer Collection that had been published by the Smithsonian as our guide on how to produce the casting. Conveniently, they told us exactly what they would expect to see in a bronze from the Shang dynasty. Charts of metal contents, descriptions of mold materials, details from X-rays, and assorted other details were supplied. We proceeded with the experiment, being very cautious to avoid any markings from twentieth-century power tools. We devised ways to join sections of the casting so that when X-rayed they would appear authentic.

Once our portion of the experiment was completed, the casting was taken and irradiated so that a level of radioactivity would be trapped in the clay that had been implanted in the back of the handle. This level of radioactivity in the clay would become a key test on authenticity. The last step in producing our forgery was to take the bronze to Bill Rostoker's laboratory at the University of Illinois. Dr. Rostoker is a specialist in finishes on ancient metals. He proceeded to give the bronze a patina that would be consistent with a Shang dynasty bronze.

Upon arrival at the Smithsonian the bronze was X-rayed, which indicated that the internal structure was correct. A sample of the metal was taken by drilling a small hole in the base of the casting: the components of the alloy were within the proper proportions. When a sample of the clay material from the handle was sent to a testing laboratory for thermoluminescence testing for levels of natural radioactivity, the initial report indicated that the sample was about twenty-eight hundred to three thousand years old. Upon further testing the forgery was uncovered because the acid bath used in conjunction with the patina process had not cut deep paths into the metal. Thus, under magnification there was no indication of intergranular corrosion.

At first it seemed that the experiment had been a success. All the team members expressed surprise that the casting had passed so many tests. The very disturbing data that was discovered was that in fact our modern testing procedures cannot always be relied on to give the last definitive word on authenticity. Authenticity can only be established with some level of certainty by a cooperative effort of the art historian and the technical specialist in conjunction with proper testing. With this approach data can be produced about the age, quality, and, ultimately, the value of the bronze object.

Paul King Foundry
JOHNSTON, RHODE ISLAND

Surface Working, Chiseling, Inlays, Plating, Silvering, and Gilding

S. Boucher

The emperor Nero was so delighted by this statue of the young Alexander that he ordered it to be gilt; but this addition to its money value so diminished its artistic attraction that afterwards the gold was removed, and in that condition the statue was considered yet more valuable, even though still retaining scars from the work done on it and incisions in which the gold had been fastened.[1]

This story told by Pliny is probably true; it redounds to the credit of the Romans, whose taste has often been questioned, as well as to that of Nero, who elegantly acknowledged his mistake. On the other hand, Plutarch records a judgment by Polykleitos[2] suggesting that what mattered most was the making of the model proper.

If both stories seem exaggerated, however, the bronze finishing did hold an important place in the achievement of the work of art.

SURFACE WORKING

When it emerges from the mold, a bronze statue is not yet finished.[3] In most cases, there are faults that must be repaired. Depending on how fine the mold was, the surface of the bronze will appear more or less even. Sometimes a mold is broken during casting, damaging the statue beyond repair. Then the whole object is submitted to another casting, or the faulty segment is removed and replaced by a new element.

When the casting is completed, the first work is smoothing the surface to eliminate the imperfections. Several tools are employed: rasps, scrapers, files, polishers, burnishers, and smoothing tools. It is likely that in antiquity pumice and abrasive powders were also used. The tools were made of stone, steel, iron, or bronze. The bronze tools must be harder than the worked bronze, which is achieved with an alloy containing a higher proportion of tin. Generally, bronze used for making statues contains 8–12% tin. A bronze tool that contains 20% tin is therefore hard enough for tools, especially as the statuary bronze often contains lead as well, which makes it more malleable (fig. 1).

The bronze surface may offer more or less important irregularities requiring repairs: fissures, holes, bubbles,

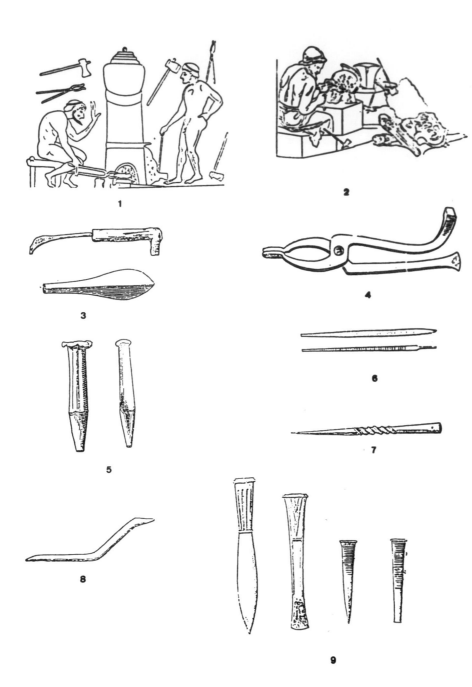

flowings[4] (fig. 2). Some statuettes have preserved this primitive aspect: they were not repaired because they were not very precious and satisfied the buyer as they were. If a better quality was required, some repair was done. It was possible to heat the surface of the object and pour melted bronze from a small melting pot into holes and cracks. More frequently, the bronze surface is hollowed in patterns that may be rectangular or more complicated. Thus the great dolphins (figs. 3, 4) in the Vienne Museum (France)[5] appear as a veritable patchwork of small imbricated bronze items, extremely varied in shape, which have been hammered out and finally gilded. These small elements were fastened together in different ways. It is probable that to secure a good adherence, the metal

was first roughened. In some cases,[6] the sides of the hollowed section were chamfered, so that the element could be hammered and fastened into place. But often, especially for elements placed side by side, the fastening was done either with melted metal spread over the heated surface, or with animal or vegetable glue. In other cases, when the element to be repaired or added was more substantial (locks, clothing, etc.), the technique used was riveting,[7] and the effect was concealed through one of the processes listed above. The dolphins of Vienne illustrate the use of both processes[8] (fig. 5).

CHISELING
(CAELATURA, τορευτίϰη)

Whatever the quality of the model and the mold, after the surface was finished, the statue was submitted to further elaboration, for the fashioning of hair, eyes, ears, mouth, muscles, bones, hands, feet, and clothing.[9]

Special mention must be made of the bronzes made by cold-working (sphyrelaton). The bronze is annealed – brought to a red heat and then cooled – and hammered. This technique is used mostly in an early period[10] (fig. 6). The statues are made of a sheet of bronze surrounding a wooden core. Some parts of these statues may also be made of melted bronze and brazed to the hammered parts.[11] These hammered parts are treated in "repoussé" or embossing and completed with dies, swages, and stamps; the surface is finished off with chisels and sharp points, so as to set off the designs.

For cast bronzes in general, the chiseling processes are subordinated to the hardness of the metal. Adding lead, a frequent practice with statuettes, makes the detail work easier. Analyses of small-sized Greek and Etruscan bronzes (sixth/fifth century B.C.) and more recent pieces, have established that lead was frequently used as a component, as it was in Roman bronzes, and not only as an impurity in the alloy. More recent analyses, however, which were made in the laboratory of the Catholic Institute in Lyons on bronzes from the Musée de la Civilisation Gallo-romaine, have shown no lead. These items were chosen because of the apparent quality of the objects. It seems that in the beginning of the Roman epoch, particularly good bronzes were cast without lead, in accordance with the indication of Pliny the Elder (*H.N.*, XXXIV.97: *temperatura statuaria* and *tabularis*). Among bronze techniques, this one contains the lowest proportion of lead. Of course, in Pliny's text we must not confuse *plumbum nigrum*, which is lead, with *plumbum album*, *candidum*, and *argentarium*, which is tin. This *statuarium aes*, as well as the *tabulare* (the *tabulae* are "notice boards" such as the bronze plaque with part of a speech by Claudius that was

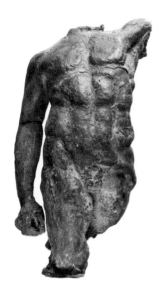

FIG. 2

Unfinished torso. Second century A.D. Chalon-sur-Saône, Musée Denon inv. 49-5-8. Photo courtesy Musée Denon.

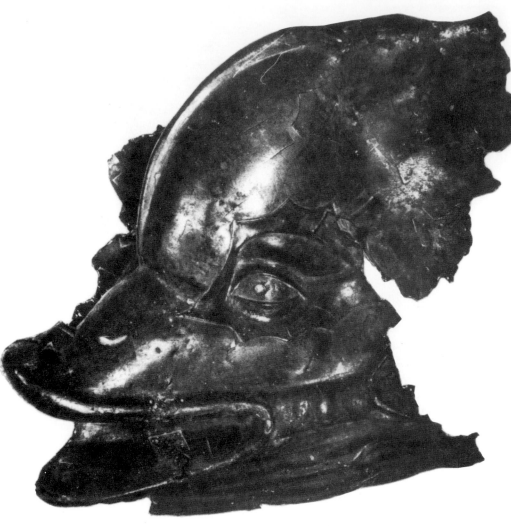

FIG. 3

Dolphin. First century A.D.
Musées de Vienne inv. 1840.1.
Photo: R. Lauxerois.

FIG. 4

Joining by hammering. Dolphin.
First century A.D. Musées de
Vienne inv. 1840.1. Photo: R.
Lauxerois.

FIG. 5

Joining by riveting. Dolphin. First
century A.D. Musées de Vienne
1840.1. Photo: R. Lauxerois.

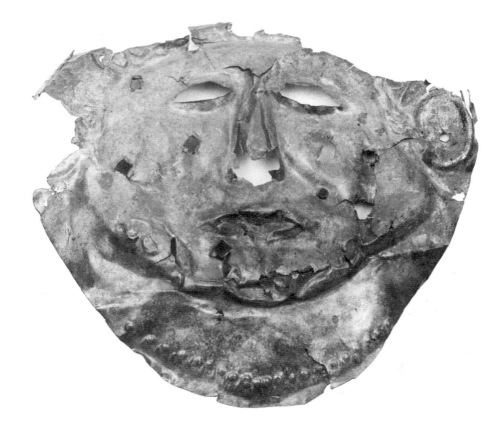

FIG. 6

Sphyrelaton technique. Bronze mask. Sixth century B.C. Vieil-Evreux, Musée d'Evreux inv. 4835. Photo courtesy Musée d'Evreux.

found in Lyons), are the best. In a Latin funerary inscription (*CIL*, XIII.5709), the dead man asks for a statue either "marmorea," or "ex aere tabulari quam optimo": it is the best bronze, the hardest, the most difficult to chisel, and it is used for the best statues.[12] For statues of larger size, it seems in fact that lead is used more sparingly, but that is not absolutely clear.[13]

Whatever the composition of the bronze, different operations for obtaining linear details must be distinguished:

- *Tracing* is done with a chisellike tool with a slightly blunt edge that is pushed with a little hammer; it gives a "linear impression." The metal is displaced, turned again on the sides, and afterward leveled with a hammer
- *Engraving* is done with a graver, a sharp, hard-cutting tool; the metal is cut and pushed, so that the tool removes a long, thin curl of metal.[14] Lip outlines were engraved[15]
- For wider furrows, a gouge or hollow chisel is employed
- For circles, rings, or half-circles, as well as for hollow designs, chisels and swages are used[16] (fig. 7)
- For *punching*, engraving points are used

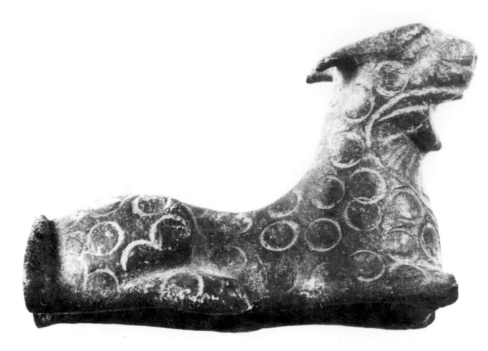

FIG. 7

Engraved decoration. Panther.
Second–third century A.D.
Chalon-sur-Saône, Musée Denon
inv. CA 375. Photo courtesy
Musée Denon.

In Greece and Etruria during the Archaic
epoch and Severe Style chiseling was particularly appreciated. In the
exhibition *The Gods Delight*, Hermes Kriophoros, number 8,[17] shows
beard, hair, and collar accurately drawn; the eyebrows are detailed
between two profound grooves; the salient eyes surrounded by thick
eyelids resemble those of stone sculpture of the same epoch.

This vogue of chiseling was even more
pronounced in Etruria: thus, for example, a statuette in Lyons[18] with a
deliberate addiction for decorativeness and little interest in realism
(figs. 8a–b).

During Greek classicism chiseling came to
reflect reality more and more closely. The hair and beard on Zeus,
number 29 in the exhibition,[19] show realistic details that nevertheless
remain formal, idealized, and stereotyped. This manner continued
throughout the Graeco-Roman period. The surface-working and the
search for "stability" were brought out by a supple form of chiseling,
which is not merely decorative but admirably enhances the outlines of
the object. This is not incompatible with realistic details, as shown by
the pricked skin of the *embades* of a Lar from Weissenburg.[20]

In the Hellenistic period the characteristic
features are often dramatic contrasts and search for effects.

The young Black man (no. 19) has deeply
chiseled eyes and lips; by contrast, his short hair appears as an
undifferentiated mass.[21] The Banausos (no. 20) with the exomis[22] is
treated in a baroque spirit, with inharmonious features, small curls
flattened to the skull, and a draped tunic with stiff folds, for effective
pattern. The same spirit is reflected in the artisan (no. 22), in which there
is a deliberate contrast between the exomis with its rigid folds and the

FIG. 8a

Chiseled decoration. Etruscan statuette. Front. Fifth century B.C. Lyons, Musée des Beaux-Arts inv. A 2009. Photos courtesy Musée des Beaux-Arts.

FIG. 8b

Back of figure 8a.

conspicuous details of the little hairlocks.[23]

This twofold heritage, Classical and Hellenistic, appears on some bronzes of the Roman period. The small girl beggar (no. 70) shows a special interest in realistic details: inlays in red copper strips and the working of the tunic's rim; but the hair is treated as a series of sparsely implanted haircurls.[24]

The systematic recurrence of certain specific details makes it possible to distinguish between workshops and creates so many manners and styles. That is the case for some bronzes found in Schwarzenacker,[25] Vieil-Evreux,[26] and Straubing.[27] Often these details are characteristic of a certain mediocrity that could be called "provincial." In such cases, the defects or faults are innate in the "manner."

Furthermore, it is worth noting that, in contrast to long-held opinion, this mediocrity does not necessarily characterize "provincial" bronzes. As a matter of fact, there is a strong

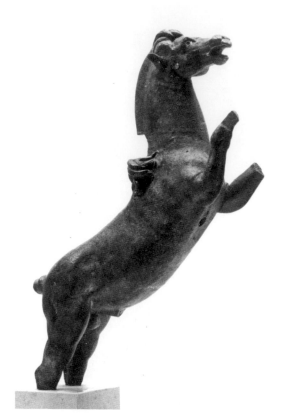

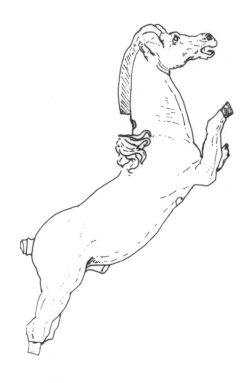

FIG. 9a

Inlay and mounting. Horse. First century B.C. Vieil-Evreux, Musée d'Evreux inv. 4818. Photo courtesy Musée d'Evreux.

FIG. 9b

Drawing of horse, figure 9a, showing the thin plates for mounting the hooves and the tail. Drawing by Th. Bonin.

probability that at a very early stage there were a few outstanding workshops in Gaul deriving their inspiration directly from Greek works and under the rule of *Greek* artists, without any Roman intermediaries.[28] This would seem particularly to apply to the Jupiter of Evreux (France) and to the one of Brée (Belgium), which probably do not owe their style to any Roman influence.[29]

INLAYS

Inserted pieces may be either inlays or on mountings: placing a crown or a bracelet in order to hide a soldering point, or adjusting a hairlock or coattail through riveting and gluing. A good example of a piece that has both mountings and inlays is a horse statuette in the Evreux Museum (France) (figs. 9a–b): the hooves and the tail were riveted and glued onto small plates, and the sides were hammered and turned down into grooves.[30]

Valuable statues and statuettes show inlays in contrasting colors meant to set off the inlaid part of the body. Eyes are most frequently cast together with the whole of the statuette; the iris and the eyeball are then incised afterward and possibly inlaid with gold, silver (fig. 10), glass paste, or some other precious stone.[31] In some cases (for instance, number 27 in the catalogue), the eye socket is hollowed to receive an eyeball prepared separately.[32] In large-sized statues, the place of the eyeball remains empty. Such eyeballs have been found, as have irises that certainly were glued or soldered into the socket of the eye.

FIG. 10

Inlaid eyes of silver. Head of Jupiter. First century A.D. Musée de Bavay inv. 59.B.1. Photo: H. Bitar.

FIG. 11

Inlaid lips. Head of Jupiter. First century A.D. Vieil-Evreux, Musée d'Evreux inv. 5404. Photo courtesy Musée d'Evreux.

Likewise, eyelashes were prepared separately.[33] Peter Bol has contrived the reconstruction of an eye, assembled in a bronze cone, which was ornamented with silver, gold, ivory, precious stones, and glass paste.[34]

The outlines of the lips can simply be indicated by an engraved line.[35] But mouths and lips may be made separately, especially in the case of large statues and precious objects, with an alloy of a different color from the tint of the statue[36] (fig. 11). Prefabricated lips may occasionally be inserted into the mold before the casting of the statue;[37] they are also inlaid after the casting process, but then the placement is more difficult, and fastening tabs may remain visible; the simplest course was certainly to glue the piece into place, perhaps after heating the surface of the bronze. One may also mention silver or ivory teeth, but, curiously, not fingernails.

Sometimes nipples are also inlaid, in red bronze[38] with a small central hole for the insertion of a tiny piece of another color.

The insertion of ornamental metal strips called *angusti clavi* is frequently observed, particularly on Lares statuettes. They are made of red bronze[39] (fig. 12). Often the strips have been removed, but we clearly see the large, hollow grooves into which they had been glued and hammered, after the casting, with no regard for the natural pattern of the folds; it was very easy to pull the strips out.

In the same manner, two holes appear on the head of a Mercury in the Louvre[40] (fig. 13). They were used for inserting

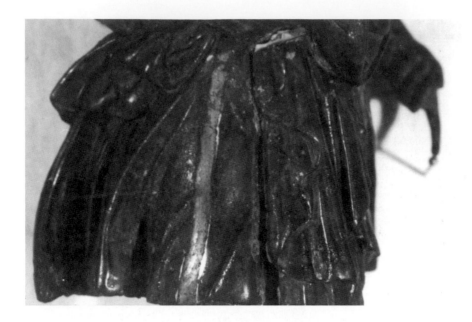

FIG. 12
Ornamental inlay of red bronze.
Clothing of a Lar. First–second
century A.D. Musée de Bavay inv.
59.B.14. Photo: H. Bitar.

the two little wings of the god, probably made of gold or silver.

More delicate inlays are seen on bases of statues, as well as on strips decorating bases and various pieces of furniture[41] (fig. 14). The design is engraved with a sharp cutting tool and the grooves are filled with another metal – silver, gold, or copper – which contrasts with the basic one. These decorative bands are held in place by the narrowness of the groove, consolidated by hammering, and polished off. Mixed metals (such as niello: sulfur, silver, lead, and copper), which have a relatively low melting point, can be heated until they overflow the bronze groove.[42]

PLATING

Revetting or overlaying consists in plating a sheet of metal (silver or gold) onto a bronze by pressing or gluing it. The surface has previously been roughened for better adherence. Examples of this can be seen on a Venus statuette discovered in Yugoslavia;[43] it clearly shows the place of the *strophion*, which covered the breast. The Aphrodite (no. 17)[44] bears the marks of two silver fillets in the hair. And on a bronze corner plate in Bavay (France) (fig. 15), an ornamental silver disk is glued onto the bronze.[45]

In most cases, the revetting with silver is obtained by direct hammering onto the object. Two gladiators in the Musée Rolin in Autun (France) offer such revetting, in which only the silver part is carefully fashioned; the cores in bronze have no proper finishings[46] (fig. 16). The Mercury from the Weissenburg treasure[47] presents a much more simplistic technique of revetting: a silver sheet, pierced with two holes for the wings, is simply set over the *petasos* and hammered down all around.

This kind of plating brings us back to Pliny's

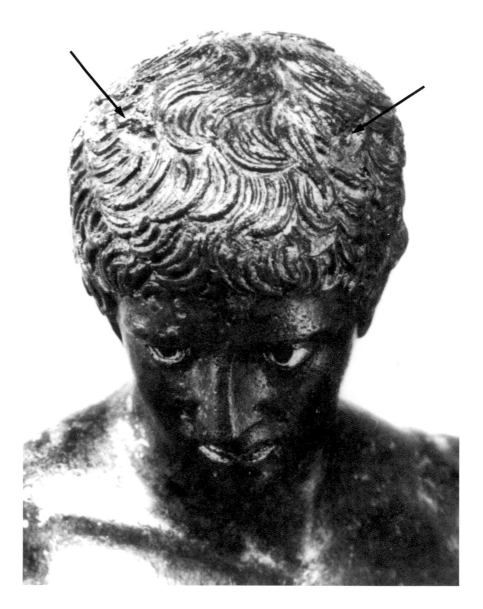

FIG. 13

Holes used for insertion of wings on the head of Mercury. First century A.D. Paris, Musée du Louvre inv. BR 183. Photo courtesy Musée du Louvre.

text about the Alexander statue that Nero ordered to be gilded.[48] Once the gold had been removed, there were scars and incisions where the gold sheets had been fastened. This barbaric maltreatment seems to have been rather infrequent. Peter Bol, however,[49] refers to a leg and a head from Athens that were revetted with such gold plates, which were fastened with grooves. We can suppose that this kind of gilding was very expensive and fortunately not very usual.

The large Greek chryselephantine statues belong to the tradition of the sphyrelaton[50]: gold and ivory sheets are placed on a wood core. We know of silver or gold busts of Roman emperors, but without wood cores. It is an early tradition: the Mycenean masks were made from genuine gold sheets.

SILVERING AND GILDING

The treasures discovered in the Greek and Roman world, in Central

FIG. 14

Decorative inlay on the base of a statuette. First–second century A.D. Musée de Bavay inv. 69.B.1. Photo: H. Bitar.

FIG. 15

Silver ornamental disk glued onto a corner plate. Second century A.D. Musée de Bavay inv. 69.B.70. Photo: H. Bitar.

Europe, and in Southern Russia give credence to the idea of an antique world overflowing with gold and silver. However, although the gold and silver vessels are well known, there are few statues of solid gold or silver.

The interest in gold and silver plating for bronze statues lies in gold's low reaction to oxygen. Silver, however, is more susceptible than gold, which perhaps accounts for the small number of silvered bronze statues; in the case of silver, a thicker and stronger plating was chosen to overcome the problem. On silvered objects (appliqués of vases, for example) one often sees that the bronze oxidation works its way through the silver, partly destroying it in the process. Symptomatic is the fact that Pliny does not mention silvering techniques, while he is very much interested in the gilding processes.

Gold sheets (*bracteae*) are used for cold gilding. They are sometimes glued to the bronze with egg white.[51] This technique, according to Pliny, is a fraudulent one when compared to that based on quicksilver (*hydrargyrum, vivum argentum*), the only metal that can be

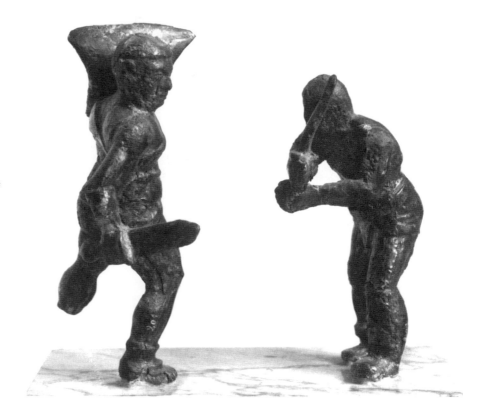

FIG. 16

Silver revetting. Gladiators.
Second century A.D. Autun, Musée
Rolin inv. 3033.V.201. Photo
courtesy Musée Rolin.

mixed with gold. In this case, the surface of the bronze is prepared, cleaned, probably heated, and covered with quicksilver and gold sheets. There must be a sufficient quantity of gold (several sheets), otherwise the color of the mixture will be too pale. The cold-amalgam, strongly pressed and probably heated, gives a reasonably fast gilded surface; it is that which appears on the large-sized dolphins in Vienne (see above, p. 162) (fig. 17). Here the traces left by the sides of the gold sheets are still visible.

The same preparations are used for fire gilding (cleaning, roughening, heating). Gold dust is heated together with mercury, and the mixture is applied to the surface of the bronze object. When the object is heated, the mercury evaporates, leaving the gold firmly bonded to the bronze. This is probably the method employed for small items, while the cold leaf-gold process, as well as the plating, better fit larger surfaces, which may support all processes.

Statuettes of gilded bronze are not very numerous. A beautiful statuette of a goddess(?) (fig. 18) may be mentioned,[52] as well as a Centaur from Dacia,[53] and, among great statues, the Apollo from Lillebonne.[54]

Using recent analyses, one can make a few remarks. The bronzes discovered in Gaul[55] often present a percentage of lead, and later of zinc, exceeding the rate of impurities (2–3%) and often rising to more than 10% of the alloy. Peter Bol[56] thinks that these metals could create alterations of the gilded surface and induce white spots. None of the analyses carried out in the Lyons Catholic Institute supports

FIG. 17

Traces of gilding on dolphin, figure
3. First century A.D. Musées de
Vienne inv. 1840.1. Photo
courtesy Musées de Vienne.

this hypothesis. More specifically, a horse's leg and a life-sized human
foot, in which the presence of lead has been determined to be 22% and
26%, respectively, display no trace of alteration on the gilded surface and
are not different from the other objects studied in the same period, which
present a very small percentage of lead.[57]

It has also been observed about a bronze oar in
the Musée de la Civilisation Gallo-romaine in Lyons[58] that the surface
gilding is covered in some places with brown oxidation; the gilding
reappears where, for analytical purposes, the bronze is cleaned. Gold
certainly affords a protection against oxidation of the bronze, but this
protection is incomplete. The gold, however, is not destroyed.

The remarks above certainly fail to treat the
subject exhaustively. Ancient texts refer to statues that were of different
colors.[59] Pliny tells us about bronzes that wore "the colors of life."[60] How
were these obtained? In what way could rust, when added or applied to
bronze, simulate the blushing of shame?[61] Why were asphalt or bitumen
used and applied to statues?[62] Numerous ancient texts refer to these
points. It should be borne in mind that the Greeks and Romans were
very fond of polychromy: there are traces of such coloring on numerous
marble statues and on stone monuments. What was the appearance of a
bronze statue when it was finished? Were there dyes or artificial patinas,
such as existed in the Renaissance period? To a modern mind and
sensibility, an antique bronze that has just been cleaned, stripped of its
surface (even if the latter is the product of a long exposure to earth or
water, and not the original one), is apt to appear naked, cold, soulless.
On the other hand, one cannot help having reservations about modern
patinas, which are supposed to protect statues and statuettes, but do so

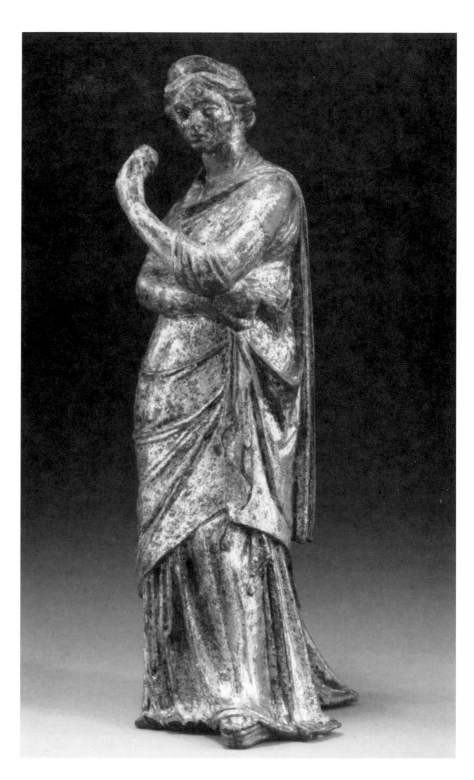

FIG. 18

Gilt bronze statuette of a goddess. First–second century A.D. Fort Worth, ex-Hunt collection. Photo courtesy Sotheby's, New York, Jerry Fetzger.

only very imperfectly and endow them with an unfortunate stereotyped aspect. These are other problems.

Centre National de la Recherche Scientifique
ST. CYR AU MONT D'OR

Notes

Bol:
P. C. Bol, *Antike Bronzetechnik: Kunst und Handwerk antiker Erzbilder* (Munich, 1985).

Boucher, *Bronzes antiques*:
S. Boucher, *Bronzes antiques: Statuaire et Inscription*, Musée d'Evreux (Evreux, 1988).

1 Pliny, *H.N.*, XXXIV.63, Loeb Classical Library, vol. 9, H. Rackham, trans. (Cambridge, Mass., 1961).

2 Plutarch, *De prof. virt.*, 17; idem, *Quaest. conv.*, II.3.2.

3 A. Steinberg, "Technique of Working Bronze," in D. G. Mitten and S. F. Doeringer, eds., *Master Bronzes in the Classical World*, The Fogg Art Museum, Cambridge, Mass., and other institutions, December 1967–June 1968 (Mainz, 1967), pp. 9–16. The latest important work about bronze technique is Bol.

4 S. Boucher, *Les bronzes figurés antiques*, Musée Denon, Chalon-sur-Saône (Chalon-sur-Saône, 1983), p. 156, no. 144.

5 S. Boucher, *Inventaire des Collections publiques françaises*, vol. 17, *Vienne: Bronzes antiques* (Paris, 1971), p. 108, no. 83.

6 Bol, p. 140.

7 Bol, p. 120.

8 Boucher (note 5), p. 109.

9 Steinberg (note 3); V. Freiberger, K. Gschwantler, and A. Pacher, "Beobachtungen zur Oberfläche des Jünglings vom Magdalensberg," in H. Schiefer, ed., *Griechische und römische Statuetten und Großbronzen*, Akten des 9. Tagung über antike Bronzen (Vienna, 1988), pp. 28–34; DarSag, s.v. caelatura.

10 Steinberg (note 3), pp. 8–9; bronze sheet with Italic designs, S. Boucher, *Bronzes grecs, hellénistiques et étrusques des Musées de Lyon* (Lyons, 1970), pp. 141–142, nos. 157–158; eadem, *Bronzes antiques*, p. 22, no. 1.

11 Bol, pp. 96–109.

12 M. Picon, J. Condamin, and S. Boucher, "Recherches techniques sur des bronzes de Gaule romaine, III," *Gallia* 26 (1968), p. 250; S. Boucher, "Pline l'Ancien, *H.N.* XXXIV, Plumbum argentarium," *RBPhil* 51.1 (1973), p. 157; E. L. Caley, "Chemical Composition of Greek and Roman Statuary Bronzes," in S. F. Doeringer, D. G. Mitten, and A. Steinberg, eds., *Art and Technology: A Symposium on Classical Bronzes* (Cambridge, Mass., 1970), pp. 37–49, who provides numerous data about Roman bronzes, but is less informative about Greek bronzes, especially those earlier than the third century B.C.

13 A. Vendl and B. Pichler, "Naturwissenschaftliche Untersuchungen zur Authentifizierung der Bronzestatue vom Magdalensberg," in *Griechische und römische Statuetten* (note 9), pp. 39–41; W. D. Heilmayer, "Der Bronzekopf von Kythera, Neue Beschreibung," ibid., p. 64; H. Born "Zum derzeitigen Stand der Restaurierung antiker Bronzen und zur Frage nach Zeitgenössischen polychromen Oberflächen," ibid., p. 179; however, G. Zimmer, "Das Mädchen von Kysikos," ibid., p. 71 and n. 32, notes that there is a large amount of lead in the lower part of a large-sized statue and refers to Picon, Condamin, and Boucher (note 12), pp. 245–278. We must note that there was often a larger amount of lead in the lower part of the statuettes, because the heavier lead sinks down as the alloy cools. Where the greater amount of lead ends up depends on the orientation of the statuette during the casting and cooling. Concerning the large statues, the lower part was heavier, with a larger amount of lead, which stabilized them better. J. Riederer, "Die naturwissenschaftliche Untersuchung eines Bronzearmes," in *Griechische und römische Statuetten* (note 9), pp. 158–164, studies an arm that contains a large proportion of lead. About the gilded bronzes, see above p. 169ff.

14 All these precisions in Steinberg (note 3), p. 12.

15 Freiberger, Gschwantler, and Pacher (note 9), p. 30, fig. 13.

16 Boucher (note 4), p. 131, no. 115.

17 *The Gods Delight: The Human Figure in Classical Bronze*, The Cleveland Museum of Art and other institutions, November 1988–July 1989 (A. P. Kozloff and D. G. Mitten, organizers) (Cleveland, 1988), p. 77, no. 8. Numbers throughout the rest of this article refer to entries in that catalogue.

18 Boucher (note 10), p. 79, no. 58.

19 *The Gods Delight* (note 17), p. 168, no. 29.

20 H. J. Kellner and G. Zahlhaas, *Der römische Schatzfund von Weissenburg* (Zurich, 1984), p. 27, no. 22, fig. 18.

21 *The Gods Delight* (note 17), p. 124, no. 19.

22 Ibid., p. 128, no. 20.

23 Ibid., p. 137, no. 22.

24 Ibid., p. 353, no. 70.

25 A. Kolling, *Forschungen in römischen Schwarzenacker*, vol. 1, *Die Bronzestatuetten aus dem Säulenkeller* (Saarbrücken, 1967).

26 Boucher, *Bronzes antiques*, p. 10.

27 R. Fleischer, "Zum römischen Schatzfund von Straubing," *ÖJh* 46 (1961–1963), Beiblatt, col. 171. S. Boucher, *Recherches sur les bronzes figurés de Gaule pré-romaine et romaine* (Paris and Rome, 1976), p. 238, figs. 398–399.

28 S. Boucher, "Figurations de bronze: Grèce et Gaule," *RA*, 1976, p. 251; eadem, *Bronzes antiques*, pp. 12, 32.

29 H. Menzel, "Die Jupiterstatuetten von Brée, Evreux, und Dalheim," in *Toreutik und figürliche Bronzen römischer Zeit*, Akten der 6. Tagung über antike Bronzen, Berlin, 1980 (Berlin, 1984), pp. 186–196; Boucher, *Bronzes antiques*, pp. 12, 34; K. A. Neugebauer, in *AA*, 1935, col. 321, already talks about Gallic workshops.

30 Boucher, *Bronzes antiques*, p. 51, no. 20.

31 Jupiter, Bavay Museum, unpublished.

32 *The Gods Delight* (note 17), p. 160, no. 27.

33 Bol, p. 150, figs. 107–108.

34 Ibid., fig. 106.

35 See Freiberger, Gschwantler, and Pacher (note 9), p. 30, fig. 11.

36 Boucher, *Bronzes antiques*, pp. 21, 32.

37 Bol, pp. 148–149.

38 Freiberger, Gschwantler, and Pacher (note 9), p. 31, fig. 14.

39 Lar, Bavay Museum, unpublished.

40 S. Boucher, "A propos de l'Hermès de Polyclète," *BCH* 100 (1976), p. 95; eadem (note 27), p. 103, figs. 173–175.

41 Base, Bavay Museum, unpublished.

42 Steinberg (note 3), p. 13.

43 L. Tadin, *Sitna rimska bronzana plastika u Jugoistočnom delu Provincije Panonije* (Belgrade, 1979), p. 65, no. 18, pl. XI.

44 *The Gods Delight* (note 17), p. 113, no. 17.

45 Bavay Museum, unpublished.

46 S. Boucher, *Bronzes figurés antiques*, Musée Rolin, Autun (Autun, 1975), pp. 74–76, no. 121.

47 See above (note 20), p. 22, no. 18, fig. 13.

48 See above (note 1).

49 Bol, p. 158.

50 Ibid., pp. 104–109.

51 Pliny, *H.N.* XXXIII.100; DarSag, s.v. Hydragyrum; Bol, pp. 159–160. W. A. Oddy, *The Horses of San Marco, Venice* (London, 1979), pp. 182–187; idem, "Gold in Antiquity: Aspects of Gilding and of Assaying," *Journal of the Royal Society of Arts* 130 (1982), pp. 730–743; idem, "Vergoldung auf prähistorischen und klassischen Bronzen," in H. Born, ed., *Archäologische Bronzen: Antike Kunst, Moderne Technik*, Museum für Vor- und Frühgeschichte, Staatliche Museen Preußischer Kulturbesitz, Berlin, June–September 1985 (Berlin, 1985), pp. 64–79.

52 *Wealth of the Ancient World*, Kimbell Art Museum and other institutions, June 1983–June 1984, J. F. Tompkins, ed. (Fort Worth, 1983), p. 13, no. 39.

53 E. B. Thomas, "Vergoldete Kentaurenstatue aus Dazien," in *Griechische und römische Statuetten* (note 9), pp. 353–356.

54 E. Espérandieu and H. Rolland, *Bronzes antiques de la Seine-Maritime*, Suppl. 13 of *Gallia* (1959), p. 24, no. 10, pls. III–V; Boucher (note 27), p. 128, fig. 77, pl. 16.

55 M. Picon, J. Condamin, and S. Boucher, "Recherches techniques sur des bronzes de Gaule romaine, I," *Gallia* 24 (1966), pp. 189–215; II, *Gallia* 25 (1967), pp. 153–158; III, *Gallia* 26 (1968), pp. 245–270.

56 Bol, p. 159.

57 *Gallia* 26 (1968) (note 55), p. 160.

58 S. Boucher, *Bronzes antiques*, vol. 1, *Inscriptions, Statuaire, Vaisselle*, Musée de la Civilisation Gallo-romaine à Lyon (Lyons, 1976), p. 103, no. 114; *Gallia* 25 (1967) (note 55), p. 160, no analysis 39, 40.

59 Bol, p. 148.

60 Pliny, *H.N.*, XXXIV.8; Bol, p. 157; Born (note 13), p. 177.

61 Pliny, *H.N.*, XXXIV.140; Bol, p. 148.

62 Pliny, *H.N.*, XXXIV.21; E. Kluge, *Die antiken Grossbronzen*, vol. 1 (Berlin and Leipzig, 1927), p. 177; Bol, p. 157; Born (note 13), p. 177.

Patinated and Painted Bronzes:
Exotic Technique or Ancient Tradition?

Hermann Born

Bronze is one of the topics that has been dealt with in interdisciplinary studies in museums, both in the past and in the present, and it serves as a good example of change in restoration and conservation practice as well as ideological development.

The difficulties posed by the cooperation between archaeology, science, and conservation have yet to be solved satisfactorily. Attempts to do so have been restricted to isolated projects. Today this cooperation is needed more than ever as museums grasp the importance of physical examination and, perhaps more so, as they realize that understanding of the manufacture of objects – in this case bronzes – is a crucial addition to typological, chronological, and iconographic information.

A small cartoon featured in an exhibition about archaeological bronzes held in Berlin in 1985 clearly exaggerates the situation (fig. 1).[1] We see the specialists musing in their separate ways over an object and finally departing in opposite directions with differing ideas. What remains is the uncertainty whether a competent solution can be derived from the common consideration of the three viewpoints. There is, however, hope for improvement if the different specialists consider common ideas about how to develop a cooperative approach in order to come to the necessary understanding of ancient materials and manufacturing techniques. This presents the conservators with particular challenges, for their education does not necessarily include advanced university degrees, thus making them seem unequal partners in a debate with archaeology and science.

As a rule, an archaeological object spends more time in the hands of the conservator than it spends with either the archaeologist or the scientist. The conservator therefore makes important observations and documents many details, which may at first have been thought unimportant. Clearly much of this goes beyond the conservator's training and experience. A few decades ago, for instance, there were practically no museum personnel who were informed about ancient manufacturing technology and material composition. A professional course that would lead conservators to a specialization in

FIG. 1

Cartoon (from *Archäologische Bronzen: Antike Kunst, Moderne Technik*, fig. 1).

FIG. 2

Friedrich Rathgen in his Berlin laboratory. Photo courtesy Rathgen-Forschungslabor.

the field of "technology of ancient materials" is either in its infancy or remains wishful thinking.

For a long time, the restoration of archaeological bronzes was either more or less a matter of chance, or dependent on the taste of the period involved. The reasons for this go back to the beginnings of modern conservation, around the middle of the nineteenth century, during the time when the recently founded great European museums began to house laboratories to care for and preserve their antiquities.

The word "laboratory" points to the scientific disciplines from which the first conservators, mainly chemists, came. Their approach to restoring those objects made of copper and its alloys that still contained a metallic core reflected their education and involved liquid chemical, electrochemical, and electrolytic restoration techniques. The different surfaces that survived this treatment did so as a matter of chance, except for bronzes with so-called noble patination. Completely corroded objects were not considered restorable.

The German scientist Friedrich Rathgen (1862–1942) founded the first chemical laboratory in the royal museums in Berlin in 1888 and did pioneering work there for thirty-nine years (fig. 2).[2] He developed techniques for the preservation of museum objects, worked on physical analysis, and interested himself in ancient manufacturing techniques. His name was given to the new investigative laboratories in the State Museums of Prussian Cultural Property (SMPK) in West Berlin in 1975.

As early as 1889, a year after the foundation of the Berlin laboratories, Rathgen wrote a paper called "On a New Application of Electric Current for the Conservation of Antique

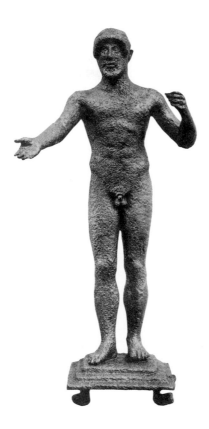

Bronzes," and in 1924 he published his comprehensive work on "The Conservation of Ancient Finds." Thus it is impossible to bypass Rathgen and his contemporaries when attempting to review the developmental history of the conservator's art. Although their achievements were enormous, they also managed to sow confusion, especially in the treatment of archaeological bronzes.

We often hear of chemical reducing techniques in conjunction with metallically well-preserved bronzes, of the use of acids in preliminary cleaning, and even of the removal of the core from hollow-cast bronzes, techniques that are still used in some museum workshops today. The international professionals of the 1890s remained in close communication with each other, and their methods were thus changed and refined. Although Rathgen writes chapters warning his colleagues to employ differentiated methods depending on the degree of preservation of the bronzes, the result was unfortunately predictable as the procedure chosen was invariably the complete removal of all corrosion products through electrolysis, a quick and easy method that could be employed by everybody. The consequences were catastrophic from today's standpoint, but the results were much appreciated by the raw-material oriented aesthetes of the Bauhaus-influenced '20s in Europe. Entire inventories of many Central European museums and their foreign dependencies were affected. Thus some of the finest bronze finds from the German excavations in the Greek sites of Olympia and Samos were reduced to their metallic cores quite soon after discovery.

Two examples show the result of this treatment: the famous Archaic bronze head of Zeus, and the Archaic

FIG. 4
Electrochemically cleaned surface. Magnification 16×. Photo: Author.

FIG. 5
Mechanically cleaned surface and antique tool marks from a lathe (arrows). Silenus mask on the handle of a spouted Etruscan bronze jug, fifth century B.C. Berlin, Museum für Vor- und Frühgeschichte, Staatliche Museen Preußischer Kulturbesitz, inv. VIIIa 516. Photo courtesy Museum für Vor- und Frühgeschichte.

statuette of a sacrificing hero from Olympia (fig. 3). Two photographs illustrate the difference between a chemically or electrochemically damaged surface (fig. 4) and an intact surface that was subjected to mechanical cleaning and therefore still shows original traces of ancient workmanship (fig. 5). The tragicomic aspect of this "electrolytic wave" was the fact that this became the "pet" restorative method of German museums, with the disastrous result that the most interesting bronzes were the first to be treated.[3] The Americans were comparatively lucky, as their excavations in the Athenian Agora and in Roman Corinth did not produce as many bronzes as did Olympia, and hence the restoration of bronze was not given the same priority.

As criticisms of chemical cleaning – which were raised early on – became more and more vociferous, the reaction to these destructive procedures set in, and freshly excavated or hitherto untreated bronzes were left in the condition in which they were found. Finally the absurd conclusion was reached that corrosion products, patina, as well as dirt of varying form and appearance, simply belong to the "genesis" of an artifact.

We have known quite definitely for as long as twenty years that the ancient surface of many bronzes is found within the corrosion layer.[4] The main argument against the use of all chemical and electrochemical processes to clean ancient bronzes is that these methods are impossible to control. Grave abuses of the conservator's craft are committed when chemically scoured bronzes are prettified by using plastics, ground corrosion products, sand, and other ingredients in order to regain the aesthetically satisfying antiquish green look.

Technical developments during the last thirty years allow us to tackle the problem of removing in an increasingly elegant manner the corrosion products that do not belong to the original

surface plane. Working under a binocular microscope it is possible to use not only scalpels and scrapers for mechanical work but also more delicate instruments, including the electric engraving burin, the ultrasonic scaler, and electronically operated diamond polishing instruments.[5] The future will provide us with further developments in delicate driven tools for surface preparation.

Microscopy is important for all these procedures and includes work under the stereo microscope, binocular microscope, or at least under a magnifying glass. The optimal instrument has proven to be the so-called discussion microscope, for dialog with professional colleagues, which makes it possible to assess surfaces, determine the boundaries of a restoration, and identify manufacturing techniques more clearly. With an enlargement of up to thirty times it makes it possible to reach the best results in microphotographic documentation. Specialist investigations, like those under the scanning electron microscope, which visually reduces surfaces to minute segments, are used only rarely in the normal museum laboratory. Yet because they are so spectacular, they tend to gain more attention than the routine day-to-day work.

Corrosion products of bronze are a focus of interest for the conservator, for they contain a wealth of information, and, as mentioned previously, we can now definitely say that the antique surface lies within these corroded structures. Tracing and exposing the antique surface is not always easy, and the change in surface color that accompanies this search, a factor of no practical significance, continues to irritate many museum people.[6] The question of the original appearance of antique bronzes is increasingly becoming important as examinations of the surface and investigations of production techniques gain popularity. There is no other material from excavations that presents more difficulties in determining ancient color than metals – and particularly bronze. The exception is those cases where easily recognizable techniques are involved, such as inlays, overlays, and appliqués.

One of the problems facing the modern conservator is determining whether a fine patina, a so called noble patination, is the result of natural corrosion or of deliberate manipulation such as patination, painting, etc. The difficulty in solving this problem stems in part from the difficulty in obtaining fresh material, that is, exceptional bronzes such as armor, statuettes, and statues, in pristine condition. On foreign excavations such pieces are decalcified, washed, and scraped in the first euphoria of discovery, much as was done a century ago, and material that has passed through the hands of art dealers has usually gone through even worse treatment. Thus the

FIG. 6a

Bronze belthook with domeykite
and glass inlays. Koban, second
millennium B.C. Berlin, Museum
für Vor- und Frühgeschichte,
Staatliche Museen Preußischer
Kulturbesitz, inv. IIId 5453.
Photos courtesy Museum für Vor-
und Frühgeschichte.

possibilities of making a thorough examination are decreasing, and a
piece in its original condition is a true rarity.

 The question raised in the search for traces of
ancient patination and painting is: What was the practical basis for
artificial coloration of objects made of copper alloys? A forged or beaten
copper or bronze object loses its original metallic appearance through
repeated annealing, which is necessary to keep the metal forgeable. The
oxidation which results leads to changes in the surface coloring, which
can range from orange and red to brown and black. Oxides of the
dominant copper are responsible for these changes in surface pigment,
orange-red tones being the result of copper-(I) oxides (Cu_2O) and brown-
black colors resulting from the more stable copper-(II) oxides (CuO).
These discolorations, which result from differing oxidizing levels and are
referred to as secondary copper alloys, are a patina, which can be
removed after the forging process either by chemical means, i.e.,
removing with acids, or by mechanical methods such as brushing,
scraping, grinding, etc. Both methods were probably known and
practiced in antiquity. Similar techniques are used to remove the rough
casting skin from cast bronzes. Cold-hammering these cast objects not
only served to remove flash and miscastings but also to give the surface a
uniform polished finish. The metallic hue was attained by this
mechanical treatment and could be intensified through chemical and
thermal techniques. The ancient craftsman was thus confronted with the
effect that certain manufacturing practices and techniques had on the
color of the surfaces of cast and forged bronzes on a casual and daily
basis. What could have been more likely than for him to make use of
these chromatic permutations in order to achieve a lasting and effective
color palette, i.e., consciously to use the device of artificial patination. It
was possible to produce two basic colors, red and black, as well as many
variations, through simple oxidation of the surface.

FIG. 6b
Detail of belthook, figure 6a.

Metalworkers had been trying to imitate gaudy minerals such as copper oxides and copper carbonates as well as cuprite, tenorite, malachite, and azurite on the metal objects they were producing since the fourth/third pre-Christian millennium, a process which became particularly popular in the Bronze Age. The ores themselves were often used as inlay material, a practice that was more popular in the Far East than in the Near East and Europe. Early examples for the production of color contrasts by the use of inlaid or even sintered minerals are found in the Bronze Age cultures of Anatolia and Caucasia. Copper sulfides and arsenical copper were used in decorative metalwork and were either inlaid into the metal surface or cast onto it. A handsome example is a belthook from Caucasia that documents the use of the rare copper arsenic alloy domeykite (Cu_3As) (figs. 6a–b)[7] in the late second millennium B.C.

Contemporary methods of metal coloration included the use of chemical treatment of copper on bronze surfaces, for instance, or the use of chemically reacting solutions.[8] It seems clear that the empirical and experimentally minded metalworkers of this early period had a quick and easy grasp of a wide spectrum of color and wide range of effects.

Traces of artificial black patination have survived, yet it is generally impossible to identify them as such. This difficulty arises because analysis can only reveal minerals that could also have originated through natural chemical and electrochemical processes, which could have affected the surface of an artifact in the ground. Certain indications of artificial patination can be seen on the solid-cast

FIG. 7a

Hellenistic bronze mirror. Fourth/
third century B.C. Berlin,
Antikenmuseum, Staatliche
Museen Preußischer Kulturbesitz,
inv. 10555. Photos courtesy
Antikenmuseum.

FIG. 7b

Detail of mirror, figure 7a,
showing blackened stippled areas
between the polished figures.

hilt of a Central European Bronze Age dagger[9] whose color contrasts
with its blade, and on an Urartian black bull's head with polished horns[10]
in London's British Museum.

The course of this technical development saw
the expansion of these methods and materials. In the Near East and
Greece for instance, bitumen or asphalt was used for black, and mineral
and vegetable colors were used for red. In the classical world gems, glass,
stones, organic materials, and chemical compounds such as niello (a
silver-lead-copper sulfur alloy), penetrating with oils, and many other
methods were used to add color and contrast to bronzes. The black and
red color contrasting with the golden shining bronze surface, the
combination mentioned above, is still used on many nonferrous metal
products the world over. Today the methods used to achieve these colors
are restricted to inlays, synthetic paints, and plastics. Thus it is possible
that certain decorative techniques on bronze surfaces served as the basis
upon which incrustations or paint could be applied.

A series of Hellenistic mirrors with engraved or
screened decoration serve to illustrate this phenomenon. The first
example of such a mirror (fig. 7a) dates to the fourth or third century
B.C. and is decorated by the interesting use of two punches to create a
densely stippled background against which the polished metal figures are
set (fig. 7b). The clearly visible blackening of this stippled surface has yet
to be investigated. Another example illustrates the use of patination to
decorate prehistoric and classical bronzes. A bronze celt from Ticino,[11]
which dates to the eighth century B.C., has an original black patination
(fig. 8a). Only the green corroded strips had in antiquity a metallic luster
after the artificial patination of the celt. A detail of such a band still

FIG. 8a

Bronze celt. From Ticino, eighth century B.C. Berlin, Museum für Vor- und Frühgeschichte, Staatliche Museen Preußischer Kulturbesitz, inv. II 950. Photos courtesy Museum für Vor- und Frühgeschichte.

FIG. 8b

Detail of figure 8a.

shows the brush strokes from the treatment (fig. 8b).

These few examples demonstrate the difficulties in discovering and interpreting patinated metals. The difficulties confronting those who try to recover traces of painting, priming, glues, or colored inlays on classical bronzes are as great or greater, even with the use of optical or analytic technology. The discoveries of examples of painted ancient marbles are well known and justly famous. Marble is a material that is especially susceptible to investigation with ultraviolet reflex photography, for instance, and traces of original coloration can be recovered with relative ease.[12] A well-known example of this is the so-called audience scene on the inside of a shield on the Alexander Sarcophagus in the Archaeological Museum in Istanbul (fig. 9), which can be seen with striking clarity under ultraviolet radiation.[13] The fact that decorative marbles, including statuary, were painted has never been seriously disputed. Indeed, Classical illustrations of the painting process have been recovered, including the picture of the painting of a Herakles statue by an artist on a krater of the fourth century in the Metropolitan Museum of Art in New York (fig. 10).[14]

Bronze, however, which is a fusion, a mixture,

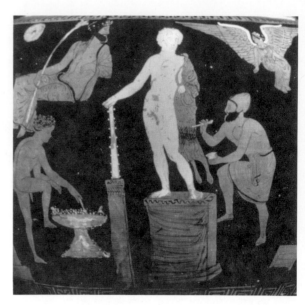

FIG. 9

The so-called audience scene on the inside of a shield on the Alexander Sarcophagus. From Sidon, late fourth century. Istanbul, Archaeological Museum. Photo courtesy Dr. Ch. Wolters, Institut für Museumskunde, Staatliche Museen Preußischer Kulturbesitz, Berlin.

FIG. 10

Painting of the lionskin on a Herakles statue. Krater, fourth century B.C. New York, The Metropolitan Museum of Art, Rogers Fund, 1950, acc. 50.11.4 Photo courtesy The Metropolitan Museum of Art.

an alloy of different metals, is returned to its original mineral state through the different electrochemical onslaughts during its thousands of years of subterranean existence. Through totally different soil conditions the complete range of corrosion can be found on objects lying sometimes only a few centimeters apart. Thus our interpretation of the appearance of these bronzes has been and is based on disparate sources, including texts of mainly Hellenistic and late antique date. There are, however, hardly any direct references to the painting of small-scale bronzes in Classical texts or paintings. The more plentiful antique references to polychrome Classical Greek monumental bronzes or Roman statuary, which will not be dealt with in this article, have usually been discounted by archaeological and philological scholars as being either rhetorical exaggerations or formalized descriptions.[15] This assessment will probably be slow to change under the weight of increasing evidence, but the mounting indications and evidence for patinated bronze statues is at any rate so convincing that modifications of this position seem inevitable.[16]

The Homeric texts, which modern research dates to the mid-eighth century, offer the first clues to the intentional coloring of metals, either through oxidation or painting. The playwright Aischylos, who lived circa 525–456, has given us a description of shields in his tragedy "Seven Against Thebes" that probably refers to painted or patinated shield emblems[17] of which hundreds of illustrations are known from Greek vase-paintings. One such is depicted in figure 11. In the same vein Socrates learns from the armorer Pistias that "even so some people prefer to buy colored or gilded corslets."[18] And finally, Pausanias's description of the Olympian treasuries includes the shrine of Myron and the Treasury of the Sikonians, in which, among other things, a shield was found "with a bronze coating and a colored painting within."[19]

Greek vase-painting is an invaluable source for

FIG. 11

Painted escutcheon. Attic
amphora, circa 530 B.C. Munich,
Staatliche Antikensammlungen
und Glyptothek inv. 1410. Photo
courtesy Staatliche
Antikensammlungen und
Glyptothek.

reconstructing Classical armament, a fact underlined by the recurrent
experience that finds of new types of arms and armor usually have their
parallels on vases. An interesting and unique example of a bronze
Corinthian helmet crest[20] from Southern Italy, for instance, demonstrates
the close correspondence between vase-painting and reality, as hundreds
of vases show crests with stylized ram's or bird's heads, and it shows that
the Classical artist was not as prone to fantastic inventions as some
might think. We thus consider vase-painting to be an interesting source
for details of armaments without wishing to stress its exactitude.
Helmets and other defensive armaments with scaled or lancet-shaped
decoration are illustrated on vase-paintings (fig. 12), and it is worth
noting that archaeology has failed to produce a helmet decorated with
this pattern in Greece itself. But a helmet dating to the first half of the
first millennium B.C. with a probably north Italian provenance (fig. 13a)
may be a useful parallel. It is made of copper with plain painted
decoration (fig. 13b) in white (calcium carbonate and quartz), red
(hematite, an iron oxide, commonly known as red ochre), gray (a mixture
of vegetable black and white), and light red (white and red ochre). The
fixative used in these colors could not be ascertained,[21] a point that need
not be stressed too strongly as a series of organic adhesives, including
albumen, gum, sap, plant juices, and fruit jellies, would have served the

FIG. 12

Greek weapons. Hydria. Paris,
Musée du Louvre inv. G 179.
Photo courtesy Musée du Louvre,
M. Chuzeville.

purpose admirably. Before leaving this point it is worth stressing once
more that archaeology has so far failed to produce evidence for a helmet
decorated with this pattern using appliqués, inlays, engraving, or
modeling (fig. 14).

A fifth-century Gorgoneion from Thebes in the
Antikenmuseum in West Berlin is another example of colored armament
(fig. 15a). As early as 1892 observers were astonished to find traces of
painting on the exterior of the black patinated copper sheeting.[22] We can
see dark brown teeth on a light green background, a red tongue, light
green eyes with red corners, and black pupils. It was only possible to
sample the red-painted tongue with laser-microspectroscopical
analysis.[23] The pigment turned out to be cinnabar (mercuric sulfide), the
first use hitherto discovered of this pigment on antique metal. It was
unfortunately not possible to determine the composition of the primary
coat beneath the cinnabar as the sample was too small. The technique
used on this piece can be described as genuine color coating rather than
simple painting directly on the metal surface. A detailed view of the
tongue shows the tiny laser probe (see arrow on fig. 15a). Figure 15b

FIG. 13a

Painted helmet, said to come
from Italy. Mainz, Römisch-
Germanisches Zentralmuseum
inv. o.39510. Photos courtesy
Römisch-Germanisches
Zentralmuseum.

FIG. 13b

Detail of palmette design on the
lower rim of helmet, figure 13a.

FIG. 14

Decorated helmets. Kylix by the
Penthesilea Painter, circa 460 B.C.
Achilles kills Penthesilea. Munich,
Staatliche Antikensammlungen
und Glyptothek inv. 2688. Photo
courtesy Staatliche
Antikensammlungen und
Glyptothek.

FIG. 15a

Priming and painting on dark patinated sheet bronze. Gorgoneion, Thebes, fifth century B.C. The arrow points to a laser probe on the tongue. Berlin, Antikenmuseum, Staatliche Museen Preußischer Kulturbesitz, inv. misc. 8183. Photo courtesy Antikenmuseum.

FIG. 15b

Reconstruction of painted Gorgoneion, figure 15a. Photo: Author.

shows the reconstruction of the plaque.

It should be noted that dark or black patinated bronze or copper sheet surfaces must have been common in antiquity. I have noticed the application of this technique a number of times, for instance on copper leaves from Pergamon, which were painted on one side and patinated on both (fig. 16).[24] Once again, it is a vase-painting, here an illustration of the design on an amphora by the Achilles Painter in the Vatican, that shows us the possible use of such a small plaque on a Greek composite cuirass (fig. 17). As there are no traces of any other means of attachment, it seems likely that this very light object was glued onto the cuirass. Another painted Gorgoneion is in Munich in the Antikensammlungen.[25] The head of that Gorgoneion has obviously been patinated black with painted red pupils against a white background. The disk on which the head is mounted was originally polished bronze. Other painted bronzes in the Antikensammlungen in Munich include Hellenistic griffin heads or protomes from the central Italian necropolis at Todi.[26] The red paint on its surface has been examined and shown to be a mixture of red ochre and neutral white lead.[27] Eleven of the nineteen bronze protomes of this type still carry remains of original painting. A more complicated design survives on identical examples made of lead with white priming, a red tongue, and black eyes, nose, and beak.

It is understandable that finds from graves preserve remains of coloration particularly well. Whether there was a tradition that involved painting metal objects as part of the funerary ritual, or whether burial rites may have involved an increased use of colored metals, is a totally open question.

The discovery of artificial patina and traces of

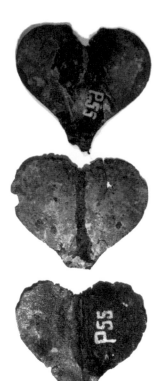

painting on Classicial statuettes is particularly difficult, indeed it is not
always possible to find definite evidence for the coloration of
Renaissance material. The reasons for this are readily understandable, if
complicated, and involve the destructive combination of wear and tear
on the originally painted or patinated surface caused by handling,
corrosive mechanisms, and above all repeated cleaning and conservation
through the centuries by museums and art dealers, a process that is
continuing to the present day. This makes it all but impossible to find
evidence of such surface treatment, and in fact the number of bronzes
where traces have been observed up to now is minimal.[28] Yet it should be
possible to recognize increasing numbers of these interesting prehistoric
and classical bronzes with remains of coloration, and there are many

clues about objects, indeed whole series of bronzes, in our museums that ought to be investigated.

My main interest at the moment reflects the possibilities offered by the public and private collections in West Berlin. It involves investigating the surfaces of mainly Greek and Italian defensive bronze armament from the second half of the first millennium B.C. and the possibility of their artificial patination and coloration. The results promise to reveal quite astonishing details that are sure to enliven future discussions. Often enough footnotes in earlier art history publications mention remnants of color on bronzes and invariably claim these to be peripheral and exceptional. Perhaps it is not the colorations themselves that are the exception but rather the conditions of preservation that allow us to see them.

Roman bronzes have to date been completely ignored in this inquiry, as polychrome metals survive on a wider range of objects, and are found more frequently. However, technical investigations, not to mention publications on this topic, remain outstanding. The Classical tradition of ποικίλλειν,[29] which may also indicate the coloration and decoration of weapons, statuettes, and statues, is slowly emerging as being as relevant for bronze alloys in the ancient world as it was in the Renaissance, when this technique was until recently thought to have had its origin.

Greek sculptures will probably prove upon examination to be good for a few surprises, and we may well have to get used to the idea that in certain cases the classical sculptor and/or his patron was not simply interested in displaying the metal glint of his or their product, or in simply inlaying it, but in further enhancing the surface with other forms of coloration.

Museum für Vor- und Frühgeschichte
Staatliche Museen Preußischer Kulturbesitz
WEST BERLIN

Notes

1 *Archäologische Bronzen: Antike Kunst, Moderne Technik*, Museum für Vor- und Frühgeschichte, Staatliche Museen Preußischer Kulturbesitz, Berlin, June–September 1985 (H. Born, ed.) (Berlin, 1985).

2 *Berliner Beiträge zur Archäometrie*, vol. 4, *Das chemische Laboratorium der Königlichen Museen in Berlin* (1979).

3 A. Mallwitz and H.-V. Herrmann, eds., *Die Funde aus Olympia: Ergebnisse 100-jähriger Ausgrabungstätigkeit* (Athens, 1980). In 1955 Ulrich Jantzen wrote the following in the introduction to his book *Griechische Greifenkessel*: "Man sollte Bronzen nur im gereinigtem Zustande veröffentlichen, da sich dann die ganze Form, zu der ja auch die feineren Details der Ritzung oder der Einlegearbeit gehören, erschließt. Welche Methode der Reinigung man bevorzugt, ob die elektrolytische, die auf Samos, in Olympia und auch sonst mit Erfolg angewendet wurde, oder eine mechanische, ist dabei zunächst minder wichtig, hängt auch von den verschiedenen ab."

4 P. Eichhorn, "Bergung, Restaurierung und Konservierung archäologischer Gegenstände aus Bronze," in Born (note 1), pp. 148ff. The topic of conservation is so complex that it is only possible to refer to the bibliography of the Art and Archaeology Technical Abstracts in this context.

5 The different uses of these apparatuses are described in H. Born, "Ban Chiang Bronzes: Manufacturing Techniques and Restoration," *Preprints IIC* (Kyoto, 1988), pp. 130ff.

6 H. Born, "Korrosionsbilder auf ausgegrabenen Bronzen: Information für den Museumsbesucher," in Born (note 1), pp. 86ff.

7 H. Born, *Meisterwerke kaukasischer Bronzeschmiede* (Berlin, 1984).

8 The best-known example is the so-called bull from Horoz Tepe in northern Anatolia, 2100 B.C., Museum of Fine Arts, Boston: C. S. Smith, "An Examination of the Arsenic-rich Coating on a Bronze Bull from Horoz Tepe," in W. J. Young, ed., *Application of Science in Examination of Works of Art* (Museum of Fine Arts, Boston, 1973).

9 London, British Museum inv. 137, said to be from Neunheiligen, East Germany.

10 London, British Museum, Department of Near Eastern Art, inv. 91240.

11 Berlin, Museum für Vor- und Frühgeschichte, Staatliche Museen Preußischer Kulturbesitz, inv. II 950.

12 V. Brinkmann and V. von Graeve, "Marmorpolychromie archaisch griechischer Plastik (Technische Untersuchungen an Originalen)," a Deutsche Forschungsgemeinschaft project at the University of Munich, 1982.

13 Deutsches Archäologisches Institut, *Archäologie und Photographie* (Berlin, 1978), fig. 30.

14 New York, the Metropolitan Museum of Art 50.11.4. D. von Bothmer, *BMMA* 9 (1950/1951), pp. 157ff.

15 S. Altekamp, "Zu den Statuenbeschreibungen des Kallistratos," *Boreas* 11 (1988), pp. 77ff.

16 H. Born, "Zum derzeitigen Stand der Restaurierung antiker Bronzen und zur Frage nach zeitgenössischen polychromen Oberflächen," *Tagungsband der 9. Internationalen Tagung über antike Bronzen* (Vienna, 1986), pp. 175ff.

17 K. Fittschen, *Der Schild des Achilleus*, Archeologica Homerica, Bildkunst, part 1 (Göttingen, 1973). Aischylos, *Die Sieben gegen Theben*, W. Schadewaldt, trans., Griechisches Theater (Frankfurt, 1964), p. 68.

18 Xenophon, *Mem.*, X.9–15.

19 Pausanias, *Description of Greece*, VI.4.

20 Berlin, Axel Guttmann collection inv. AG 248. A sickle-shaped helmet crest made of thin segments of bronze sheeting riveted together and decorated on both sides with waved ornament and ram's heads. A further wavy bronze strip (5 cm wide) is riveted between both segments and protrudes above the mount forming the crest. A hole in which

a pommel may have been attached
perforates the lower end of the ram-
protome, and a larger hole lies slightly above
the conical end of the crest mount, which
served to attach it to the helmet itself.

21 I wish to express my gratitude for the
thorough scientific analyses to Prof. Dr. E.-
L. Richter, Staatliche Akademie für Bildende
Kunst, Stuttgart.

22 A. Furtwängler, in *AA*, 1892, p. 110.

23 I wish once again to express my gratitude to
Prof. Dr. E.-L. Richter for the thorough
scientific analyses.

24 Berlin, Antikenmuseum, Staatliche Museen
Preußischer Kulturbesitz, inv. P55.

25 Munich, Staatliche Antikensammlungen
und Glyptothek inv. 3459. A. Furtwängler,
"Bronzekopf des Kaisers Maximin," *MüJb*,
1907, pp. 9ff.

26 Munich, Staatliche Antikensammlungen and
Glyptothek inv. 3779a. F. Jurgeit,
"Hellenistische Greifenköpfe aus Todi,"
lecture given at the Thirteenth International
Congress for Classical Archaeology, Berlin,
July 1988.

27 Pigment analyses by the Rathgen-
Forschungslabor, Staatliche Museen
Preußischer Kulturbesitz, Berlin.

28 A selection of papers about polychrome
bronzes: P. C. Bol, *Olympische
Forschungen*, vol. 9, *Großplastik aus Bronze
in Olympia* (1978), pp. 87ff. (alloys and
coloration); H. Born, "Polychromie auf
prähistorischen und antiken Kleinbronzen,"
in Born (note 1), pp. 71ff.; R. Hughes and
M. Rowe, *The Colouring, Bronzing and
Patination of Metals* (London, 1982),
Historical Introduction, pp. 9ff.; E. M.
Moormann, *La pittura parietale romana
come fonte di conoscenza per la scultura
antica* (Assen, 1988); E. Pernice,
"Untersuchungen zur antiken Toreutik, V:
Natürliche and künstliche Patina im
Altertum," *ÖJh* 13 (1910), pp. 102–107; P.
Reuterswärd, *Studien zur Polychromie der
Plastik (Griechenland und Rom)*
(Stockholm, 1960), with an extensive bibl.;
C. S. Smith, "Historical Notes on the
Colouring of Metals," in A. Bishay, ed.,

*Recent Advances in Science and Technology
of Materials*, vol. 3 (New York, 1974), pp.
157ff.; Ph. D. Weil, "A Review of the History
and Practice of Patination," National Bureau
of Standards, Special Publication no. 479
(Maryland, 1977), pp. 77ff.

29 The common derivatives from the root
ποικιλλ surely have dual meanings. In
Homer's epics the combinations are used to
describe "gleaming and colored weapons":
Il., 4.226; 5.239; 6.504; 10.75; 10.322;
12.396; 13.181; 14.420; 16.134.

Scientific Approaches to the Question of Authenticity

Arthur Beale

Today strong export regulations try to protect most excavated cultural antiquities from leaving their country of origin. Those objects that find their way out through illegal channels almost always lose connection with their burial site and context. Even those that are traded in the market from older collections usually do not have well-documented find locations. As with any scarce item, prices are high, and when this situation is combined with a frequent lack of knowledge about origin, forgeries will abound. Strictly speaking, I define a forgery as something made in imitation of an original with the intent to deceive. This could apply to an entire object, a surface of an object, or a restored part of an object. With a code of ethics for conservators now well defined internationally, unethical deceptive restorations can more easily be placed within this definition. This is particularly true when the restoration objective is strictly to enhance the value of an object.

Before proceeding further, the reader should be cautioned that despite the title of this paper, the author is not a scientist but rather a conservator responsible for the administration of a scientific program in a large museum.[1] It is hoped that this particular perspective, while not offering any new scientific methodologies, may combine information in a manner useful to all those concerned with the authentication of ancient bronzes and, hence, improve communication. For example, the relative value of scientific information will be explored in relation to cost and, when a sample must be taken, in relation to potential damage to an object.[2]

In today's museum, authentication by scientific means is often initially applied to objects regardless of the quality of their provenance. The reasons are numerous but are all related to the premise that one should have as much information as possible in hand when making an important and often expensive decision. Although this paper confines itself to a particular approach to authentication, it should be stated that the process should be a team effort, with the expertise of the art historian/curator or knowledgeable collector and conservator complementing the work of the scientist. Further, it has been my experience that the art dealer who has a reputation to protect rarely

takes an adversarial position and has considerable knowledge to share.

Labeling the occupations of the various team players seems simple enough, but in reality there are gray areas where tasks overlap. Scientific approaches to authentication, for example, at least in their less technical manifestations, can be practiced by all concerned. What it requires is adherence to basic scientific principles such as being systematic and exact. Primary to any scientific study of objects is a thorough and careful optical examination and methodical recording of observations, including careful measurements. Obviously individuals from different disciplines, due to the nature of their training and experience, will observe and find relevant different features and details. At this point in the process, however, it is not necessary and perhaps even dangerous to draw any conclusions. Many observations become steps that lead to the next test. Others become evidence that is put aside until it is time to assemble the case.

When dealing with bronze antiquities, the questions to be asked will vary on a case-by-case basis, but one can anticipate that a limited number of common possibilities exist. The first is that the bronze was made in antiquity and survived a thousand years or more of burial with a minimum of alteration. The second group are bronze antiquities that are heavily and perhaps disfiguringly corroded. These are probably the ones we spend the least time authenticating. Knowing this, those engaged in deceptive practices have sometimes resorted to the creation of the third possibility, the pastiche object made of bits and pieces of ancient copper or bronze. Some might claim that the pastiche is restoration technique, but for the sake of our discussion, let us reserve the fourth possibility for the most common occurrence, the "restored" bronze. Here again the possibilities are extensive: mechanical, electrochemical, and even electrolytic cleaning methods have been widely used. Ancient bronzes cleaned to bare metal, perhaps to eliminate chlorides, are commonly repainted with chemicals to imitate burial corrosion. Clearly, a bronze with a uniformly colored, naturally altered surface is considered more desirable and hence more valuable than one restored. But the question as to whether a repatination is intended to deceive or rather to be a cosmetic solution, is often unanswerable. Overzealous mechanical cleanings can also be deceptive when original decorative details, ambiguous in corrosion products, are reworked. Totally fabricated designs such as those inscribed modernly on undecorated ancient surfaces, e.g., on mirror cases and cists, are fake while their substrates can be genuine.

Objects with intentionally faked surfaces and/or surface details constitute a group of their own, separate from restored bronzes. Complicating matters is the restoration that adds

missing parts and perhaps decorates and patinates them to match the original elements. Again, when evidence points to an intent to deceive, we say the object has fake parts rather than restorations. However, since codes of ethics for conservators are a relatively new development of the past twenty-two years, we should perhaps not be too quick to judge "intent" in restorations done in the nineteenth and the first half of the twentieth centuries.

Another possibility we must consider is that the ancient bronzes we are examining are misattributed in date of manufacture, culture, or perhaps even artist. For example, I have studied "Renaissance" bronzes that turned out to be ancient Greek and Roman and vice versa. Occasionally an "authorized" museum reproduction loses its identity and for a while is represented as an original. The reproduction or fabrication that is made as an imposter is at the center of our final possible group, the forgery.

Having established some of the common possibilities for a bronze we might be examining, we can now formulate some basic questions to be answered by scientific methodology. If we begin by describing what we observe, rather than what we are told we will observe, we can assume the proper scientific posture of only accepting what can be proven.

Because absolute proof is rarely achieved with any single test, the scientific approach dictates conduction of multiple tests, whose results are reproducible and that lead to defensible conclusions.[3] Of course, this is an ideal program, which in reality is not always followed for a number of reasons. First, the tests one would like done are not always commercially available, especially for collectors in the private sector. Second, some of the most useful tests, e.g., the metallographic section, require that substantially large samples be taken, which is often not feasible. Third, the time it takes to conduct some tests may exceed the time frame within which a conclusion must be reached. Fourth, the cost of the test may be higher than it is reasonable to pay in relation to the value of the object. Fifth, the likelihood that a particular test will yield useful information when weighed against cost or risk to the object may not be good enough to warrant proceeding. And last, enough information may have been gained from other tests to be able to obtain the answer sought without proceeding further.

All of these reasons for a less than complete scientific examination presuppose that authentication is the goal. When doing a technical study of a bronze or a group of bronzes to ascertain some specific information, e.g., alloy composition, some of the same considerations may be relevant. However, an additional consideration to be made when more than one object is being studied is the comparability

of results. In this instance the same techniques and even the same instrument and sample size are important to the quality of the research. Since the goal here presupposes authenticity, the scientific analysis is aimed at obtaining basic accurate and reproducible data. It is not surprising, therefore, for some relatively large samples (50–60 mg) to be taken from each object in a study of this sort. The outer material and resulting surface enrichment layer in a drill sample might be discarded or used for determining lead isotope ratios, and the metal shavings from drilling a $\frac{1}{16}$ in. (1.6 mm) to $\frac{3}{16}$ in. (4.8 mm) hole from the object are used as the sample for alloy determination. Sometimes more than one hole is drilled in an object to be able safely to collect that much sample material. Objects consisting of more than one section may have separate samples taken from each section for comparative purposes. Once the basic sample has been taken, it is then carefully weighed out and subdivided for analysis by separate techniques. For example, quantitative elemental composition might be determined by atomic absorption spectrometry (AAS) using 10 mg of sample. Neutron activation analysis might also be done using another 20 mg of the sample. This would still leave adequate samples to repeat the tests or do other tests.[4]

 This short digression from the main topic offers one important basic point. Studies of the type just described may not be motivated by authentication but they are ultimately essential to the process. If we do not have the baseline data that spells out what to expect the materials and techniques specific to a particular artist, workshop, culture, or period to be like, then we can eliminate many of the possible scientific characterization techniques used to authenticate as being purely academic. The importance of publications that include thorough scientific analysis of excavated objects or objects with good provenance is inestimable for those working on authentication.[5]

VISUAL EXAMINATION

Since the emphasis of this paper is on scientific approaches rather than any one technique in detail, before considering more complex instrumental techniques, some more basic examination tools should be noted. Perhaps the best reason for emphasizing this step is that it is usually through these means that the condition of an object is determined, including the presence and nature of any restorations. For example, viewing a bronze under ultraviolet light of between 250 and 380 nm often reveals the presence of glues, nonmetallic fill or restoration materials, varnishes, and other coatings. Solubility tests with organic solvents on suspicious areas can then be conducted as a simple verification of the presence of restorative additions without violating the integrity of the original object.

Using microscopes with magnification from ten to a hundred times will often yield information about surface treatment. For example, some preliminary idea of the corrosion products present can be observed, as can mechanical or perhaps even chemical surface cleaning. Three-dimensional design areas can be studied to see whether they may recently have been carved into corrosion layers. Any accretions can be looked at to see if they appear to have been acquired from burial in the earth or may be more recent additions. Restored areas may also be more apparent when seen under magnification. Conservators who have spent many hours mechanically cleaning ancient bronzes with the aid of microscopes have as a result become experienced in making some of these preliminary observations.

At this point in a scientific examination, certain hard evidence may already have been revealed, while other suspicions that may have been raised need to be confirmed or denied by material identification.

X-RAY FLUORESCENCE (XRF) AND PROTON INDUCED X-RAY EMISSION (PIXE)

Among the so-called nondestructive (nonsampling) techniques, X-ray fluorescence (XRF), when used as an independent instrument, would in most circumstances be the next test applied. If an anomalous surface material had been suspected as a result of a visual examination, then its presence might be confirmed and a preliminary identification made by this technique. In addition, a basic alloy identification could also be accomplished. Of the two detectors used in conjunction with X-ray fluorescence instruments, the energy-dispersive one is more commonly used than the wavelength-dispersive one. Advantages of the energy-dispersive detector are that the orientation of the surface of the object relative to the X-ray source, or other excitation, and detector is not as critical as it is with the wavelength-dispersive detector, and, in addition, results are obtained more quickly. From a practical point of view, this means that in less than an hour a number of surface areas on one bronze can be analyzed without taking a sample. Computer programs make some instruments quantitative, and by using bronze standards of known composition and interpolation, the performance of others can be improved. At latest count, approximately a dozen units of this type are being used in United States museums today.

The greatest drawback of the instrument is that it is analyzing surface phenomena to an approximate depth of 10–25 microns. Of course this is a plus if one is looking for traces of gilding that might not otherwise be visible. Corrosion products and resultant surface enrichment or depletion of certain metals in an alloy do lead to

inaccurate results. Thus choosing a spot on a bronze for analysis that may have little or no corrosion may improve reliability. Removing an area of corrosion for the test site will likewise improve the results, but it also moves the test into the "destructive" category.

Another technique that does surface analysis is proton-induced X-ray emission, or PIXE, which uses a particle beam instead of X-rays to excite secondary emission from a surface. Its principal advantage over X-ray fluorescence is the lower detection limit that it can achieve. The drawback as with XRF is that it only analyzes a very small surface area, which may not be compositionally representative of the whole.

X-RAY DIFFRACTION

A purist would say that taking any sample violates the object, but from a realistic point of view the loss of the fraction of a milligram of sample needed for X-ray diffraction analysis in the Debye-Scherrer camera is virtually undetectable without a microscope. The main purpose of the test of crystalline corrosion products is for identification, including any unusual by-products of a natural or artificially induced patina or mineral pigment in a paint. The test, traditionally conducted on instruments that run at 15 milliamperes, takes many hours to run and perhaps another hour for identifying the diffraction patterns. Although faster instruments are available, they are not yet very accessible to museum laboratories. Despite this fact, X-ray diffraction is still a widely used technique, for much useful information for authentication can be gained from a very small sample.

RADIOGRAPHY

If a visual examination has encountered evidence of major structural restoration, interesting joins, or other techniques of manufacture, radiography will probably add clarity to those findings. If the bronze is hollow cast, then perhaps an armature or chaplets will be seen, as will the limits of the core and the wall thickness of the cast. Radiography is important for determining both the condition of an object and its probable method of manufacture. For most bronze antiquities a 300 kilovolt X-ray unit is needed and, while not found in every major museum lab, they are used for industrial purposes and are therefore accessible.

Although radiography generally is classed as a nondestructive test, caution is always suggested when clay core material present might be thermoluminescence (TL) dated because the high-energy radiation needed to penetrate a metal cast for a radiograph will potentially alter TL results. Accordingly, one of two procedures is usually

followed. First, the sample for TL testing can be taken before the radiography; or second, the exact exposure rate and time is recorded for later use in mathematical factoring in the TL test. Although one X-ray exposure is not going to have a significant impact on a TL-dating test that is to distinguish between core material subjected to high temperatures two thousand years ago as opposed to a hundred years ago, multiple X-ray exposures will have a more significant impact. Radiography of three-dimensional objects, if it is to be at all useful, often does involve multiple views and sometimes even stereo views. Perhaps its greatest drawback is that radiographs are difficult to interpret and, like all the approaches under discussion, they require an experienced eye to get the most out of them.

THERMOLUMINESCENCE DATING

Getting access to core material in a bronze that might be TL-dated is often difficult, if not impossible, without significantly violating the integrity of an object. It is unusual to find core or mold material normally exposed by design as you might within the handles of an ancient Chinese bronze vessel. Occasionally an object will break, exposing the core inside. Most often a 3/16 in. (4.8 mm) drill hole will have to be made in the bronze wall of the object to reach the core. Of course, these bronze drillings will have great value for other tests and will therefore serve as more than just an access port. While 50 mg of sample will be needed for the predose thermoluminescence technique, additional samples will allow for characterization by other techniques of the core material itself, which may also prove valuable for authentication, as well as for increasing knowledge of past technologies. The fact is, once the difficult decision has been made to penetrate the surface of the bronze, the ample core material available inside it is rarely guarded as carefully as the skin that houses it.

Unlike the other analytical techniques, which are mostly inferential, thermoluminescence is considered a direct or absolute dating technique. When one infers a date for an ancient bronze through scientific means, one does so either by the appropriateness of the materials and techniques identified, or by the nature and extent of the deterioration or alteration of those materials. It is not surprising that when the choice of a single authentication technique is necessary for some of the reasons previously discussed, despite the fact that a sample must be taken, thermoluminescence ranks high. The technique is commercially available as well as used by a few of the larger museum labs that have the equipment. While the cost of approximately two hundred dollars per sample is comparable to many other tests, few have achieved such widespread acceptance as an authentication tool.

Unfortunately, its applicability to antique bronzes is quite limited because so few have accessible cores.

METALLOGRAPHIC SECTION

When core material is not present for thermoluminesence analysis, the second most definitive test for the antiquity of a bronze is a mounted and polished metallographic cross section that includes surface corrosion layers. Even when a bronze has been mechanically or electrochemically cleaned of surface corrosion, small amounts of intergranular corrosion exist at the subsurface level, which can usually be seen and identified in a cross section. Sample size will vary, but ideally it would measure 1–5 mm^3 for viewing under a metallographic microscope. When accessible, the sample can come from the inside of an object as well as from the exterior. However, unlike drill samples, the section is much harder to take because it must be sawn or cut away without causing significant damage to the section or the object.

The value of the cross section relies on the fact that naturally formed alteration of metal is distinguishably different from artificially induced accelerated corrosion. The distinctions are usually related to the nature of the corrosion products present, the layering order in which they are found, the depth of penetration, and the extent of intergranular corrosion. If a section includes enough corroded metal or perhaps a join area, then etching and staining will reveal metallurgical details as to how the metal was worked, e.g., cast, hammered, annealed, soldered, etc. The appropriateness of a metal-working technique can also be useful evidence to infer antiquity.

SCANNING ELECTRON MICROSCOPY (SEM) AND ELECTRON BEAM MICROPROBE ANALYSIS

In the previous discussion of metallographic sections, identification of individual corrosion products was mentioned. While some of the most accurate determinations of specific crystalline materials may be done by X-ray diffraction, when properly prepared, the metallographic section can also be analyzed in a scanning electron microscope (SEM) with an X-ray fluorescence attachment. Some modern SEM instruments have energy-dispersive detectors on their X-ray fluorescence systems, making them extraordinarily useful not only for characterizing morphology but also for mapping the chemistry within a given sample. The modern electron beam microprobe instrument operates on a similar principle, but can have both energy-dispersive and wavelength-dispersive detectors as part of their X-ray fluorescence systems, offering more versatility and better detection limits than the SEM .

Both techniques can carry out accurate analyses of areas of a metallographic section as small as a few microns, or even less, and they can be used to analyze equally small samples.

Because of their high cost, these instruments are found only in a few museum labs, but they are common in the science labs of the larger universities and are therefore usually accessible on a time-rental basis. Often the information from these techniques offers acceptable precision for authentication, and they are quick and relatively inexpensive to perform.

ATOMIC ABSORPTION AND INDUCTIVELY COUPLED PLASMA (ICP) EMISSION SPECTROMETRY

When it becomes critical to obtain a quantitative alloy analysis of a bronze, atomic absorption spectrometry has been a commonly used technique. It is a very sensitive technique with detection levels typically as low as 0.01%. The instrument is found in some museum labs but has drawbacks for bronze authentication. First, as previously noted, drill samples of 10–20 mg are typically needed for this technique. Second, it is labor intensive to operate since the sample must first be put in a solution and then each element sought individually. Its more modern cousin, the inductively coupled plasma (ICP) emission spectrometer, overcomes some of these drawbacks by allowing for simultaneous analysis of main alloy components as well as trace elements with even lower detection limits. In this way it is more similar to the grandparent of both instruments, the optical emission spectrograph (OES). The OES was the workhorse of many labs, but even with improvements, such as the laser microprobe attachment, it has one major fault for bronze analysis. Elements in high concentrations, such as copper, cannot be easily quantified. Although ICP-OES is expensive, it appears to be very useful for quantitative alloy analysis and likely to see increased usage in the future.

LEAD ISOTOPES

Using a mass spectrometer one can quantitatively identify the various isotopes of lead in a small (5 mg) sample from a bronze. The various proportions or ratios of one lead isotope to another in a sample is a kind of fingerprint that can potentially relate that lead to its parent ore source. When these connections can be made, they clearly help with provenance and authentication. Unfortunately, not all bronzes contain enough lead for this technique to be used. In addition, information on lead isotope ratios for lead ores is very spotty, and what is available shows overlaps that make some results ambiguous.[6]

NEUTRON ACTIVATION ANALYSIS

Even though neutron activation analysis requires the ultimate in instrumentation, the nuclear reactor, this technique has nevertheless been used extensively for the study of ancient bronzes. The technique is extraordinarily sensitive and has detection limits to as low as parts per billion and is therefore often used to identify trace elements. Although useful information can be obtained from relatively small samples, like nearly all of the techniques discussed, the larger the samples the more they represent the whole and the less experimental error there is likely to be in the results.

The preceding has been a very simplified review of some of the current techniques used in the authentication of ancient bronzes. Several points that have not previously been mentioned may help put some of the techniques discussed in perspective. The accuracy of most instrumental methods, especially those that are potentially quantitative, is very dependent on the quality of the standards used in the analytical procedure. The instruments that are designed to produce sensitive results are themselves sensitive and require careful maintenance and recalibrating. In addition, they require that standards be run as part of each day's work or in some circumstances as part of each analysis.

Another point to be made is that reproducibility of data acquisition can be a measure of accuracy. However, when working with minute samples reluctantly taken from irreplaceable objects, there is rarely enough material to conduct a procedure more than once.

Finally there has been a general tendency toward pursuing techniques that offer the most detailed information, especially in regard to trace elements (less than 0.1%). The purpose is that if a particular alloy or element of an alloy, such as copper, can be accurately fingerprinted, then perhaps similar studies of ore samples will reveal relationships. In other words, if the ore sources for a particular bronze can be identified, then one has evidence useful in determining provenance. The use of multivariate statistical methods combining as much information as is possible helps further group objects with similar characteristics.

The problem is that the techniques have improved much faster than the profession's ability to conduct, publish, and disseminate a significant body of detailed analyses of ancient bronzes and ores. It is my hope that improved understanding and communication between those interested in these objects will result in more productive collaborations and published studies that will foster future comparisons.

Museum of Fine Arts
B O S T O N

Notes

1 For a more scientific approach to the topic,
 see U. Leute, *Archaeometry: An Introduction
 to Physical Methods in Archaeology and the
 History of Art* (New York, 1987).

2 The subject has also been broadly covered by
 R. Newman, "Roles of Scientific Examination
 in the Study of Works of Art," *Museum
 Studies Journal* 3.2 (1988), pp. 20–32.

3 For a case study using multiple techniques,
 see K. C. Lefferts, L. J. Majewski, and E. V.
 Sayre, "Technical Examination of the
 Classical Bronze Horse from the
 Metropolitan Museum of Art," *Journal of the
 American Institute for Conservation* 21.1
 (1982), pp. 1–42.

4 P. Meyers, L. L. Holmes, and E. V. Sayre,
 "Elemental Composition," in R. W. Bagley,
 ed., *Shang Ritual Bronzes in the Arthur M.
 Sackler Collections* (Cambridge, Mass.,
 1987), pp. 553–557.

5 For an example of one study of this kind, see
 P. T. Craddock, "Three Thousand Years of
 Copper Alloys: From the Bronze Age to the
 Industrial Revolution," in P. A. England and
 L. van Zelst, eds., *Application of Science in
 Examination of Works of Art* (Boston,
 Museum of Fine Arts, 1985), pp. 59–67.

6 For an example of one study of this kind, see,
 I. L. Barnes, W. T. Chase, and E. C. Deal,
 "Lead Isotope Ratios," in Bagley (note 4), pp.
 558–560.

How Important Is Provenance? Archaeological and Stylistic Questions in the Attribution of Ancient Bronzes

Beryl Barr-Sharrar

To Peter Heinrich von Blanckenhagen for his eightieth birthday, March 21, 1989

A discussion of the historical and cultural environments from which small bronze images of gods and men arise must begin with a definition of terms. Provenance means the fact of coming from some particular source or quarter, that is, the origin or derivation of something. The origin of the word provenance is the Latin *provenire*, meaning to come forth, arise, originate. In archaeology, the word usually means place of origin in the sense of find spot, that specific geographical location where an ancient object was discovered, whether by purposeful excavation or by chance. This can only sometimes be considered also the place of origin of the object in the sense of location of its manufacture. Many of the silver and bronze vessels found in fourth-century tombs in Macedonia reveal regional taste influenced by Thracian and even Persian shapes and may have been produced locally, that is, near the court of Philip II, but the ceramic ware found with the bronzes is recognizably Attic, not Macedonian.

While, given the evidence for eclectic taste in art at the time of Philip II and Alexander the Great, we may never, in all probability, be able clearly to identify a single and distinct overall Macedonian style[1] – just as, except for royal portraiture, it is difficult to define a Ptolemaic or an Alexandrian style[2] (a subject to which I will return) – the localization of manufacture suggested by "Attic" focuses our attention on terms such as "style," "workshop," and "school." After all, the detailed consideration of regional styles of Greek vase-painting began as early as the middle of the nineteenth century, by which time the school of Attic pottery had been traced back to the François Vase.

As archaeologists, art historians, and connoisseurs, we are accustomed to thinking about style and the history of style. Categories such as workshops and schools help us place style in historical sequences; and historical sequences can inform us about changes in economic and social milieus, as well as developments in artistic and aesthetic values. Likewise, carefully identified contexts and find spots – graves, sanctuaries, or houses, described in their geographical locations, which we call provenances – can reveal useful information about burial practices, religious customs, and domestic taste

in the concomitant regions, hopefully within substantiated time frames.

The purpose of this paper is to discuss, briefly and necessarily summarily, the problems of the attribution of small ancient bronzes to regional origins of manufacture. The only tool we have for such investigation, so far, is the art historian's informed perception, that is, perception fortified by extensive and considered experience. I will discuss Greek bronzes – Archaic, Classical, and Hellenistic – as well as a few examples from the early Roman Imperial period. In most cases, the actual find spot is more or less established, or fairly reliably reputed.

The practice of assigning ancient Greek and Roman bronzes to workshops at urban centers has accompanying problems that vary in both degree and kind with the relative chronology of the material. For the period in which Greek city-states existed *as* states, regional attribution of bronzes is not only easier but has greater historical validity if it is true – as seems likely – that each state that produced small bronzes in any quantity and with any consistency, cultivated, in its independence, its own distinctive sculptural style. Most scholars believe that the history of Archaic art is the history of single art centers identified in their activity with the political and economic character of the polis to which they were tied; yet in this early period it is often as difficult to achieve a scholarly consensus about the development of styles, their origins, and dates, as it is in later, Hellenistic times when the Greeks had a widespread common artistic language, or *koine*.

The first scholar to try to differentiate early sculptural styles by city-states was Ernst Langlotz in *Frühgriechische Bildhauerschulen*, published in 1927.[3] Langlotz started with the conviction that an individual regional style in the Archaic and early Classical periods would be recognizable in both the region's small-scale figural sculpture, in terracotta as well as in bronze, and its large sculpture, in marble, and – where it still existed – in bronze. He included some Roman copies, a practice now known to be unreliable. He believed that careful scrutiny of the facial structure and features, as well as the body structure and musculature of modeled or carved figures associated with a specific region by provenance or in some cases by an inscription[4] could establish criteria for the identification of related works. He also believed that the group thus formed could be shown to have maintained a recognizable artistic integrity during his time frame of 600–470 B.C., with some developmental change and evolution, which he attempted to document. These style groups, then, were designated by the associated regions, in some of which creative local styles may have grown up as early as the second half of the eighth century, when the political organizations known as city-states or *poleis* began: Corinth, Sikyon, and

FIG. I

Archaic bronze statuette of Zeus. Said to be from Dodona. Munich, Staatliche Antikensammlungen und Glyptothek inv. 4339. Photo courtesy Staatliche Antikensammlungen und Glyptothek.

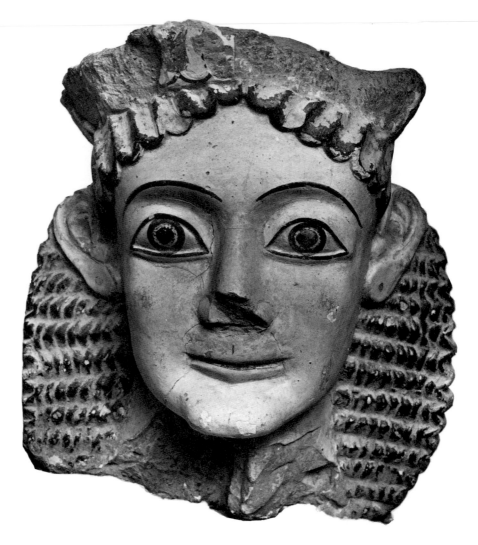

FIG. 2
Archaic terracotta akroterion.
From Kalydon. Athens, National
Museum, no inv. number. Photo
courtesy DAI, Athens.

Argos in the northeastern Peloponnesos; Athens and Attica; Lakonia
with its capital Sparta; individual Cycladic islands; Samos, Ionia;
Magna Graecia with Sicily; and so on.

Thus characterized by Langlotz, with
occasional changes in the inclusion or grouping of districts, these
regional artistic identities have ever since been more or less accepted by
most scholars for the Archaic period, with attributions among them
constantly shifting from one to the other.[5]

The sculptural style of Corinth very soon
became an important focus, largely because the amount of terracottas
produced there allows greater possibility for comparative study than
other cities, from which we lack a significant amount of finds. As the
most important center of commercial expansion in the seventh and sixth
centuries B.C., Corinth exported many products, including its art —
especially terracottas. Consequently, while much Archaic Corinthian
sculpture understandably has a provenance in Corinth, in the nearby
sanctuary of Perachora, and in Corinthian colonies in Epiros and
Akarnania, it has also been found in the nationally important

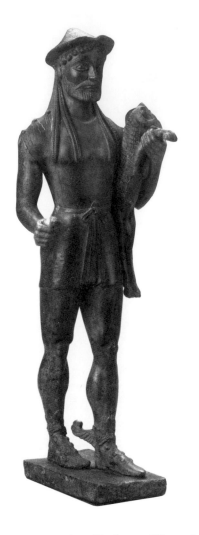

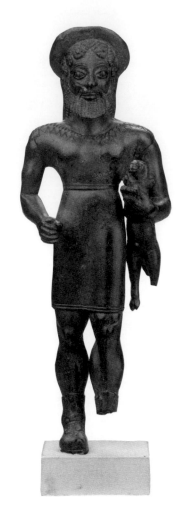

FIG. 3

Archaic bronze Hermes
Kriophoros. Said to be from
Sparta. Boston, Museum of Fine
Arts, H. L. Pierce Fund, inv.
99.489. Photo courtesy Museum
of Fine Arts.

FIG. 4

Archaic bronze Hermes
Kriophoros. Said to be from
Arkadia. Boston, Museum of Fine
Arts, H. L. Pierce Fund, inv. 04.6.
Photo courtesy Museum of Fine
Arts.

sanctuaries: Dodona, Olympia, and Delphi, in other parts of Greece, and
in Magna Graecia. Due to the work of Humfry Payne,[6] Klaus
Wallenstein,[7] and others who added observations along the way, the
Corinthian style is today probably the most clearly described of those
first isolated by Langlotz.

One of the bronzes attributed by most scholars
to the Archaic Corinthian school is a statuette of Zeus, 18.6 cm high, in
the Staatliche Antikensammlungen in Munich (fig. 1), dated to 530–
520,[8] and said to have been found at Dodona. If this provenance is
correct, it was undoubtedly a votive gift in the Zeus sanctuary.

An early sixth-century terracotta sphinx (fig.
2),[9] certainly produced by a craftsman from Corinth or one strongly
influenced by the artistic style of that city, will serve to demonstrate the
Corinthian style in clay. It was an akroterion on one of the gable corners
of the Archaic Artemis temple at Kalydon in Aitolia, on the north coast
of the gulf of Patras at the entrance to the gulf of Corinth. The modeling
of the clay sphinx is broader than that of the bronze, which reveals great
refinement of technique in the working of the original wax model, and
the eyes of the sphinx are exaggerated to frighten. Affinities between
their faces are apparent, however, despite the years between

manufacture. The shape of the faces is the same, so is the structure of cheek and brow, the modeling of the mouth, the outline and shape of the eyes, and the nature of the protruding ears.

The famous marble kouros found in 1846 in Tenea, only seven miles from Corinth, is also generally considered Corinthian.[10] Although the Zeus is probably some three decades younger than the marble kouros, and his body frame more sturdy, the two figures share the narrow waist common to Corinthian figures and, perhaps more telling, a particular quality of tension and alertness in both body and facial expression. They also have similar facial structures. These characteristics suggest a common origin, although in making regional attributions of Archaic sculpture, one must place in perspective those stylistic aspects that characterize the *period style*, that is, aspects of style common to sculpture from all over Greece by the middle of the sixth century and subsequent decades, especially body structure: "long thighs, narrow flanks, a flat abdomen, a relatively high chest, and pronounced curve at the small at the back."[11]

Neighboring Sikyon is reported by ancient sources to have been a major center for the production of bronzes at this time, rivaled only by Corinth, but if an Archaic regional style was really focused in this city, that style is so far archaeologically allusive. Langlotz attributed to this city-state the two Hermes Kriophoros statuettes in the Boston Museum of Fine Arts – one, 25 cm high, said to be from Sparta, the other, 16.7 cm high, allegedly from Arkadia[12] – along with terracottas from the Heraion near Argos and from Olympia, and bronzes from many parts of Greece.[13] The regional stylistic origin of the Hermes from Sparta (fig. 3) has been in continuous controversy since Langlotz's first attribution. Its provenance is no help, as among those who argue against its origin in a Lakonian workshop is a scholar who has done considerable research on the art of that region, and she believes it to be Corinthian.[14]

Although it shares with Corinthian images some general characteristics of the period style – with elongated proportions similar to those of the Tenea kouros – and an emphasis on decorative detail, juxtaposition of the Hermes Kriophoros from Sparta (fig. 3) and the Munich statuette of Zeus (fig. 1) demonstrates a difference in artistic approach not only in the sharpness of the delineation of its facial features but in a sober coolness that contrasts sharply with the warmer and more energetic expression of the Corinthian figure.

The second Boston Hermes Kriophoros (fig. 4) is the best crafted among other small bronzes of this subject, none of which, notably, was found in Sikyon. Less austere and cold in facial expression than the larger Boston figure (fig. 3), it shares the sharp-

featured, highly stylized quality. Said to have been found in Arkadia, it
has at various times been assigned to an "Arkadian" school.[15] This was
not one of Langlotz's original regional designations, although Arkadia
was the reputed provenance of three of the five Hermes Kriophoroi that
Langlotz listed in his Sikyonian group,[16] and the region has produced a
good number of minor works in bronze of this and related subjects, most
modeled with considerably less refinement than the Boston statuettes.

While a cult statue of Hermes Kriophoros is
associated by Pausanias with Pheneos in northern Arkadia, whose
townspeople were said to have dedicated one at Olympia, and it is
reasonable to suppose that bronze-casting workshops at local
sanctuaries produced images meaningful to the shepherds of Arkadia,
these may well have been copies of prototypes from more sophisticated
ateliers, as is suggested by images of the Athena Promachos found in
Lykosoura.[17] Marion True assigns several Hermes Kriophoros statuettes
of lesser quality to Arkadia, and the Boston bronzes to Sikyon.[18] Unless
the larger Hermes (said to be from Sparta, fig. 3) is an example of late
Hellenistic "comprehensive" archaism, as that term is defined by J. J.
Pollitt,[19] both Boston Hermes Kriophoroi can probably be attributed to a
major center in the northeast Peloponnesos.

While compartmentalizing individual styles
within that area of Greece is complicated by the cross-influencing that
was undoubtedly inevitable given the mutual proximity of the reputed
bronze-working centers there (not only Corinth and Sikyon but also
Argos and Aegina), Sparta might be thought to have been sufficiently
isolated from other city-states geographically – if not politically – to have
developed a recognizable originality of style during the sixth century.

But while the interdependence of some bronzes
is quite clear, the provenance of many bronzes within Lakonia itself
greatly aids the establishment of a school. Discoveries in Sparta and
nearby of further examples of a series of figurative karyatid mirrors of
striking uniqueness,[20] for example, have given considerable weight to
Langlotz's original argument that the mirrors and handles of this group
then known to him – which included a mirror from Hermione in the
Argolid now in the Antikensammlungen in Munich (fig. 5) and a handle
said to be from Kourion in Cyprus in the Metropolitan Museum of Art,
New York (fig. 6) – are in fact Lakonian.[21] An 18.2-cm-high statuette of a
young man – probably Apollo – from the beginning of the fifth century,
found at Geraki near Sparta[22] (fig. 7), has the same broad, triangular face
and sharp, somewhat pinched features of the mirror figures. There can
be no question, however, that the provenance of this latter bronze is
helpful to the identification of its regional workshop origin.

A 27-cm-high bronze statuette found on the

FIG. 5

Archaic bronze mirror. Said to be
from Hermione in Argolis.
Munich, Staatliche
Antikensammlungen und
Glyptothek inv. 3482. Photo
courtesy Staatliche
Antikensammlungen und
Glyptothek.

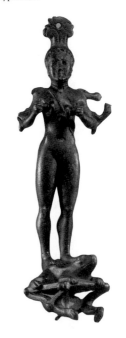

FIG. 6

Archaic bronze mirror handle.
Said to be from Kourion, Cyprus.
New York, The Metropolitan
Museum of Art, the Cesnola
Collection, purchased by
subscription, 1874–1876, acc.
74.51.5680. Photo courtesy The
Metropolitan Museum of Art.

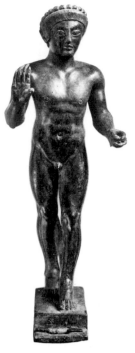

FIG. 7

Bronze statuette of Apollo. Found
at Geraki near Sparta. Athens,
National Museum inv. 16365.
Photo courtesy DAI, Athens.

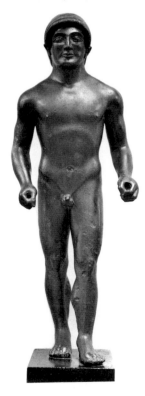

FIG. 8

Bronze statuette of an athlete.
Found on the Athenian Akropolis.
Athens, National Museum inv.
6445. Photo courtesy DAI,
Athens.

Akropolis in Athens (fig. 8),[23] contemporary with the Lakonian figure, demonstrates the forthright energy that distinguishes the Attic school of sculpture at the turn of the century, however dependent its structure may be on workshops in the northeast Peloponnesos. While we know that non-Athenian artists were employed for large dedications on the Akropolis, and styles were multiple, and, while it is unlikely that all artisans of small works in the prosperous and powerful city of Athens at this time were born there,[24] most small bronzes found on the Akropolis, with the exception of some imports, are generally considered Attic. Most – both votive statuettes and decorative figures from vessels – can be dated to the Late Archaic period, roughly from 530 to 480/479 B.C.,[25] the time of the sack of the city by the Persians, who toppled the buildings and statues on the Akropolis.

Small Attic bronzes of this time are closely related to contemporary large sculpture. Besides the series of statuettes of athletes found on the Akropolis – from several different workshops and represented by the statuette mentioned above (fig. 8) – there is a series of Athenas that must be based to some extent on the large Archaic Athena Promachos that stood on the Akropolis before the Persian attack. The latest in the series (fig. 9), 29 cm high, dates to soon after 480 B.C.[26]

Centers other than Corinth, Lakonia, and Athens are sometimes described as having local styles during the Archaic period, with greatly varying possibilities of demonstrable proof. Those characteristics considered typical of sculpture at this time from Argos[27] do not seem to be much in evidence in the category of small figurative bronzes, but the bronze workshops of the city appear to have had considerably more activity and influence after the first quarter of the fifth century. There were important centers in the Archaic period in Western Greece (Magna Graecia and Sicily), especially Tarentum – a Lakonian colony – and Lokroi Epizephyrioi – a colony of Lokris – which produced distinctive bronzes (and terracotta reliefs) from the middle of the sixth century to the end of the fifth.

By the early fifth century, regional styles on the mainland are increasingly difficult to separate. The developments and innovations in sculpture so important to the unfolding of this century are seen throughout mainland Greece and Magna Graecia, but the provenance of the earliest examples of the so-called Severe Style in small bronzes and the area with the greatest quantity of such works, is, perhaps not surprisingly after the Persian destruction of Athens, the Peloponnesos. Within the Peloponnesos, the principal distinctions of origin are between north and south: an Argive-influenced northern school including Corinth and Sikyon, and one in the southeast oriented toward Lakonia and increasingly influenced by workshops in Arkadia.[28]

Since Langlotz's day, the famous bronze statuette found in Ligurio in Argolis (14.7 cm high, fig. 10),[29] with full, heavy body, developed musculature, and a new balance of weight, has been considered a work from the school of Argos, the center in which Polykleitos was trained. But bronze figures with this new, naturalistic, and finely balanced pose are found as far away from the northern Peloponnesos as Magna Graecia: a 19.5-cm-high figure making a libation who stands in this new way was found in Adrano, Sicily. It is sufficiently distinctive to be considered local to that region (fig. 11).[30]

Statuettes from Athens from the middle of the century show the influence of Phidias: e.g., a youth said to have been found on the Akropolis, 17.7 cm high, who also pours a libation (fig. 12).[31] A statuette of Dionysos found in Olympia (fig. 13),[32] 22.5 cm high, from a workshop in the northeast Peloponnesos, perhaps Argos, on the other hand, further demonstrates the movement and freedom of pose that must have preceded the early work of Polykleitos.

For the rest of the fifth and the fourth centuries, what small bronze statuettes survive either reflect well-known sculptures or may be described in relation to the styles of some of the well-known artists, such as Phidias or Polykleitos, whose individuality was remarkable enough to have been recorded by ancient writers. The provenance of Classical-looking bronze statuettes is of special importance because of the many copies and adaptations made by the Romans of sculptural prototypes from this period that have been mistaken for Greek. The lack of evidence from this century and a half suggests that the practice of offering small bronze statuettes to the gods in their sanctuaries was much reduced. Despite the scarcity of figural bronzes from this period, however, there is evidence for the continuation of bronze-working throughout the fourth century in many parts of Greece in the form of cast bronze vessels and folding mirrors, frequently with elaborate decorative relief. These survive principally in certain areas where they were placed in tombs: Northern Greece, the Crimea, and Southern Italy.

After the death of Alexander the Great in 323 B.C., new centers for bronze-working in the Greek tradition inevitably developed over a great geographical span—from Egypt to Afghanistan—as large numbers of Greeks moved east to take advantage of opportunities in the major cities of the new possessions won by the Macedonian king, where they lived side-by-side with the numerically dominant local population. Bronzes apparently continued to be produced in some of the traditional Aegean centers: those of Corinth and Lakonia, at least, maintained a certain fame.[33] But there was a distinct, if gradual, decentralization of production.

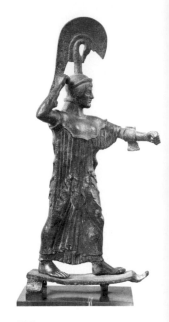

FIG. 9

Bronze statuette of Athena Promachos. Found on the Athenian Akropolis. Athens, National Museum inv. 6447. Photo courtesy DAI, Athens.

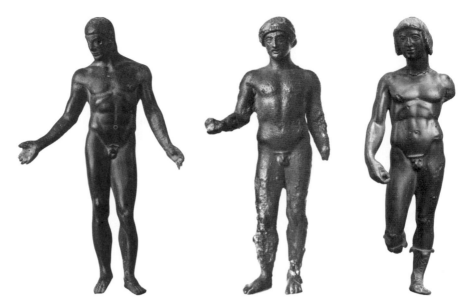

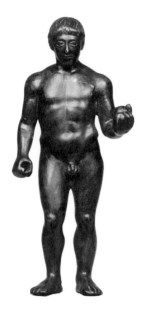

FIG. 10

Bronze "ball-player." Said to be from Ligurio in Argolis. Berlin, Antikenmuseum, Staatliche Museen Preußischer Kulturbesitz, inv. 8089. Photo courtesy Antikenmuseum.

FIG. 11

Bronze statuette of a youth pouring a libation. Found in Adrano, Sicily. Syracuse, Museo Archeologico Regionale inv. 31.888. Photo courtesy Soprintendenza ai Beni Culturali ed Ambientali di Siracusa.

FIG. 12

Bronze statuette of a youth pouring a libation. Said to be from the Athenian Akropolis. Paris, Bibliothèque Nationale, Cabinet des Médailles, inv. 928. Photo courtesy Cabinet des Médailles.

FIG. 13

Bronze statuette of Dionysos. Said to be from Olympia. Paris, Musée du Louvre inv. Br 154. Photo courtesy Musée du Louvre, M. Chuzeville.

A superbly crafted, 47-cm-high statuette of Dionysos (fig. 14), dated to the middle of the second century B.C. by Semni Karouzou,[34] was found by chance near a remote village in the rough and mountainous interior of Aitolia, north of Karpenision not far from the southern border of Thessaly. No Hellenistic city or sanctuary existed near this find spot, but the bronze may originally have been a dedication at one of the temples in the Sanctuary of Thermon.

The bronze is clearly based on a fifth-century Polykleitan prototype. Mrs. Karouzou has ingeniously suggested that the Classical tradition that it represents was familiar to the Aitolians because of the many fifth-century Argive dedications at Delphi, which the Aitolians — as the dominant force in the Amphictyonic League (278–222) — administered over a long period. Socially and economically Aitolia remained backward during the Hellenistic period, however, and the production of a bronze of such high quality either in one of its few cities, which were small, or at the sanctuary itself — which was in a remote area — is remarkable. It is conceivable that the bronze was stolen — as Mrs. Karouzou suggests — since the Aitolians were infamous for their piracy. It is also possible that it was an import, perhaps from northeastern Peloponnesos, where the prototype originated. Other bronzes of high quality, however, have apparently been found in Aitolia.

On the basis of style alone, the attribution of a workshop location for the three male statuettes found in the Antikythera shipwreck, also to be dated to the second century B.C., is totally problematic. Stylistically similar, all three — like the Dionysos found in Aitolia — depend on the Polykleitan stance (one, 43 cm high, fig. 15).[35] They could have been made in any of several Hellenistic centers of bronze production. A very tentative connection of the ship with the pirate attack and destruction of Delos in 69 B.C. has been suggested, as

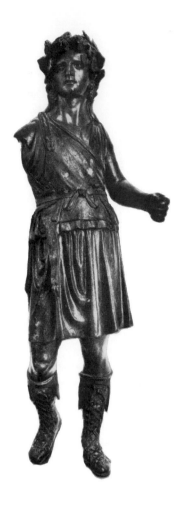

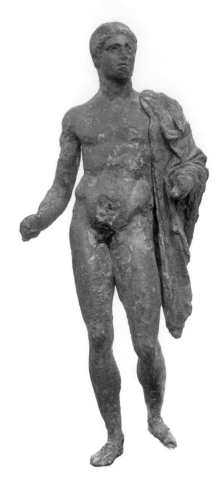

FIG. 14

Bronze statuette of Dionysos.
Found in Aitolia. Athens, National
Museum inv. 15209. Photo
courtesy DAI, Athens.

FIG. 15

Bronze male figure with a
himation. From the Antikythera
shipwreck. Athens, National
Museum inv. 13398. Photo
courtesy DAI, Athens.

the marble statues found in the wreck had been removed from their
bases,[36] but more recently Nicolaos Yalouris has associated the ship's
contents with Asia Minor.[37] The bronze Hermes from the Mahdia
shipwreck, a classicizing, late-Hellenistic continuation of the Lysippean
tradition associated with Sikyon, also demonstrates the complexities of
assigning workshop origins during the Hellenistic period. Some scholars
attribute the Hermes to mainland Greece; Werner Fuchs, more
specifically, to Athens.[38] In the total absence of indicative evidence, these
attributions must be considered suggestions only.

 A few Hellenistic bronzes have actually been
found in the context of their use, however, allowing at least fair
assumptions of their probable workshop origin. These were not found in
sanctuaries but in private houses, where small sculptures – both bronzes
and marbles – were set up during the Hellenistic period as objects of
veneration in the practice of domestic cults, as votive offerings to gods
(as in sanctuaries), and for apotropaic purposes.[39]

 A 46-cm-high statuette of Poseidon from a
house in Pella (fig. 16)[40] was found, still attached to its gray limestone
base, near the door to a room in which it appears to have been the focus
of a domestic shrine.[41] A second-century creation, it is based on a statue
type represented by the marble Lateran Poseidon, the original of which is

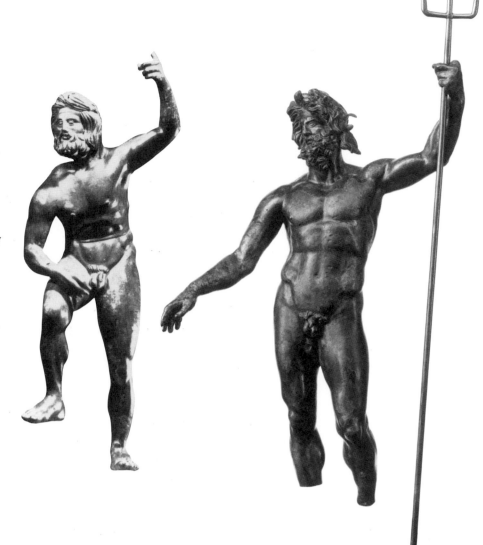

FIG. 16

Bronze statuette of Poseidon.
Found in a house in Pella. Pella
Museum inv. 383. Photo courtesy
DAI, Athens.

FIG. 17

Bronze statuette of Poseidon.
Trident modern. Munich,
Staatliche Antikensammlungen
und Glyptothek inv. Sig. Loeb 15.
Photo courtesy Staatliche
Antikensammlungen und
Glyptothek.

usually attributed to Lysippos. It is very likely that the bronze statuette
was produced in Pella.[42] Although the city did not possess the wealth
under the Antigonids to compete culturally with Antioch or Alexandria,
as the home of the Macedonian kings since the end of the fifth century
(reign of Archelaos, 413–399), Pella may nevertheless have continued to
produce bronzes for local use throughout the Hellenistic period.[43]

A smaller Poseidon figure (28.7 cm high, fig.
17) of similar date in the Loeb Collection in the Staatliche
Antikensammlungen in Munich,[44] without known provenance, is
undoubtedly from a different workshop. It may have had a similar
function, although dedications engraved on bases discovered in niches in
house walls in Hellenistic cities prove that statuettes of deities were
placed within private houses not only for veneration but as votive gifts to
various gods.[45]

A bronze silenus (Herakles?) herm (fig. 18), 22
cm high, was found in a house in the Skardhana quarter of Delos, which
has a burn level establishing a terminus ante quem of the second quarter
of the first century B.C.[46] The hollow figure, placed on top of a marble or

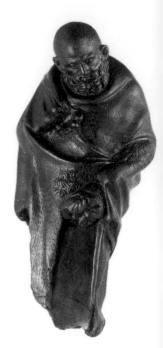

wooden pillar, may have been positioned for apotropaic function before a door or in a place needing guarding within a room, a custom documented in ancient literature,[47] although like images of gods, herms could also be venerated.[48] The striking introspective quality that characterizes the silenus herm is reminiscent of Delian portraiture contemporary to it, and ancient literature makes it clear that bronze casting was an important industry on Delos in the Hellenistic period.[49]

A final example of a small figurative second-century bronze found in a private house is a 15-cm-high satyr (fig. 19)[50] that is not fully three-dimensional but – except for the left hand and reverse of the pelt – cast flat on the back for attachment as an ornament onto some item of furniture, perhaps a wooden chest for fabrics or valuables. Its gaze and gesture, with hand raised as if to strike with club or lagobolon, suggest it was part of a group, perhaps with apotropaic overtones. It was found in a house in Pergamon[51] and was probably produced by a workshop there or in some other center in Asia Minor.[52]

There are no bronze statuettes known to have been found in a domestic context in Egypt, yet many small Hellenistic bronzes are said to have been found there and have been attributed – perhaps, at times, somewhat indiscriminately – to Alexandria, capital city of the Ptolemies. Further, genre figures – as well as pygmies, dwarves, hunchbacks, and crippled phallic figures – from various provenances, both within and without Egypt, have often been assigned to Alexandria because of the long literary tradition of taste for such images in that city. Herondas, who described genre figures in a temple of Asklepios (*Mime* IV), is thought to have written in a Ptolemaic context. Yet other scholars have placed the origin of such works in Asia Minor.[53]

One of the problems adding to the confusion about what can truly be called Hellenistic Alexandrian is the frequently difficult distinction between what is Hellenistic and what is Roman. A group of fourteen bronzes found in Egypt were isolated by Helmut Kyrieleis as Hellenistic on the basis of their inventiveness and lively modeling.[54] All of these bronzes, he pointed out, have a particular raw, unpolished surface and cursory modeling of details, qualities that contrast with more finished bronzes from Greece and Asia Minor – like the Dionysos from Aitolia (fig. 14) and the satyr from Pergamon (fig. 19), for example – in which details of face, hair, and dress are more distinctly delineated. The observation of surface is a useful starting point, but careful examination of each and every bronze is required. Some of the bronzes in Kyrieleis's group may be called "genre" figures, others are clearly not.

One of the most distinguished in the latter category, said to be from the Faiyum (west of the Nile valley), is a

FIG. 18

Bronze silenus herm. Found in a house in the Skardhana quarter of Delos. Delos Museum inv. 1007. Photo courtesy Ecole française d'archéologie, Athens.

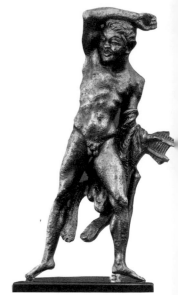

FIG. 19

Bronze satyr appliqué. From a house in Pergamon. Berlin, Pergamonmuseum, Staatliche Museen zu Berlin, inv. 7466. Photo courtesy Pergamonmuseum.

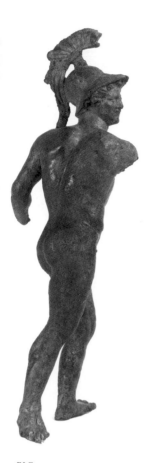

FIG. 20

Bronze statuette of a striding, helmeted man. Baltimore, The Walters Art Gallery inv. 54.1046. Photo courtesy The Walters Art Gallery.

striding, turning helmeted man, 25.4 cm high, now in the Walters Art Gallery, Baltimore (fig. 20).[55] The pose, with the glance over the shoulder, suggests this figure was part of a group, and with all components, the ensemble was almost surely a small-scale replica of a larger monument, possibly erected by one of the Ptolemies. Its relationship to the so-called Pasquino group is obvious, and the original monument should be dated to the same time.[56]

Wherever it stood, the monument was apparently famous in antiquity, as several Roman copies of this figure exist.[57] The use to which a *Hellenistic* copy of such a monument would be put is unknown, as the figure does not appear to be one of the Ptolemies, whose images in the minor arts contemporary to them are frequent. The face is reminiscent of the Terme "ruler"; it may represent some Hellenistic prince, or it may be a legendary figure.

Two bronze groups of wrestlers, one of which was found in Egypt, have been identified by Kyrieleis as small-scale replicas of Ptolemaic monuments undoubtedly erected in Alexandria.[58] The first (fig. 21a) was found in Antakya, the ancient Antioch on the Orontes, and is now in Istanbul.[59] It replicates a monument commissioned by Ptolemy III Euergetes (246–221) in the '40s of the third century B.C. to commemorate his military triumph in northern Syria over the armies of the Seleucids in the so-called Laodicean or Third Syrian War (246–241). Ptolemy III is depicted as Hermes, with whom he was associated. The second group of wrestlers (fig. 22a), found in Kharbia in Lower Egypt and now in the Walters Art Gallery, Baltimore,[60] replicates a monument erected in the late third or early second century B.C., which copied the earlier monument, now portraying Ptolemy V Epiphanes (210/205–180) as protagonist. The young king's portrait as Horus has also been identified by Kyrieleis in similar small bronzes in Athens and London.[61] Ptolemy V brings to his knees the crude god Seth, a symbol of the nationalistic revolts in Upper Egypt in which he fought, with his army, his native subjects.

One wonders if the originals of these Ptolemaic monuments, which must have been commissions of the highest importance in the second half of the third century, could not have been executed by representatives of some Hellenistic center of bronze-working famous enough to be better known to us than a "school" of Alexandria, the identification of which is so problematic.

The school of Rhodes may be a plausible candidate. Our knowledge of a Rhodian school of bronze sculpture, famous in antiquity, and famous for its sculptural groups, depends mostly on the attestations of Pliny[62] and other ancient writers, since material evidence on Rhodes itself exists only in the cuttings in

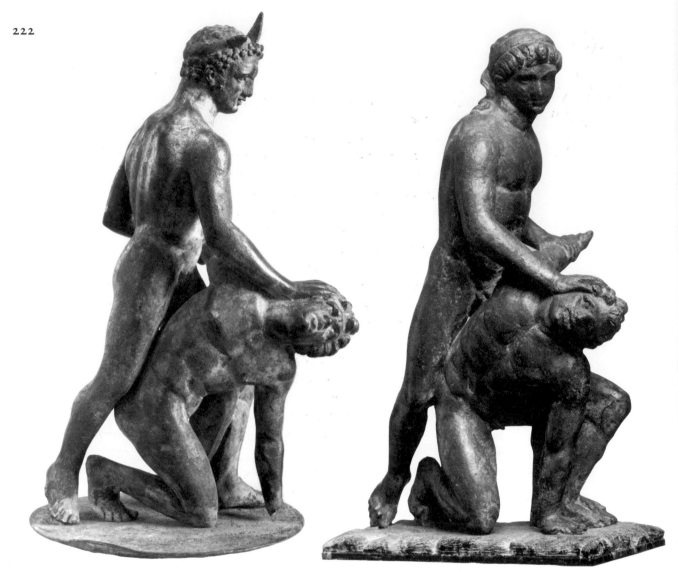

FIG. 21a

Bronze wrestling group with
Ptolemy III as victor. Found in
Antakya, ancient Antioch on the
Orontes. Istanbul, Archaeological
Museum inv. 190. Photos courtesy
DAI, Athens.

FIG. 22a

Bronze wrestling group with
Ptolemy V as victor. Found in
Kharbia, Lower Egypt. Baltimore,
The Walters Art Gallery inv.
54.1050. Photos courtesy The
Walters Art Gallery.

numerous bases, which indicate life-size bronze portrait statues. A new
dissertation, by Virginia Goodlett, on the double signatures of
collaborating Hellenistic artists – modeler and bronze caster – suggests
that on Rhodes, at least, these skills and professions were handed down
through generations of families who remained on the island,[63]
corroborating Gloria Merker[64] and other scholars who have believed in
the relative stability of the Rhodian school, except for a period of
political decline during the second half of the second century B.C. If a
reasonably long and stable tradition of bronze sculptors on Rhodes thus
seems likely to have existed, one might well expect, by inference, the
development of a recognizable style with characteristics independent
enough to be revealed by skillful copyists.

Rhodes was the richest state in the Hellenistic
East after the three great monarchies and was a close ally of Ptolemaic
Egypt from the end of the fourth century on. This alliance drew support
from strong economic ties. Considerable trade between them is attested

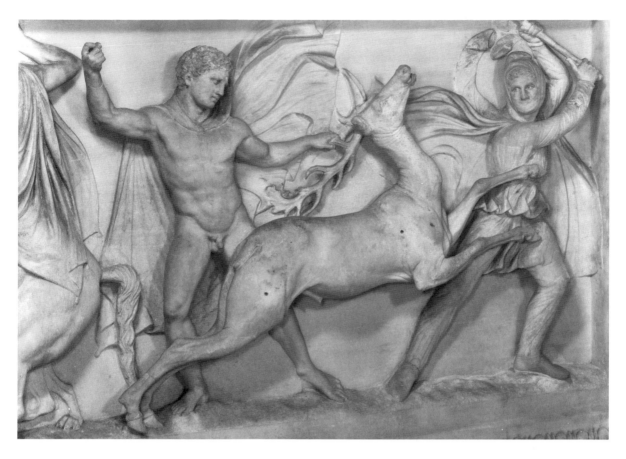

FIG. 23a

Detail of the stag hunting scene
from the Alexander Sarcophagus.
Istanbul, Archaeological Museum.
Photos courtesy Archäologisches
Institut der Universität Trier, D.
Johannes, photographer.

by the very great numbers of stamped amphora handles from Rhodes
found in Egypt.[65] In the environment of strong economic and political
associations between Egypt and Rhodes, then, we may consider — on the
one hand — a rich Ptolemaic court desiring impressive monuments to
demonstrate its power to its diverse and agitated peoples in the late third
century, and — on the other — a famous school of sculptors who signed
their names with pride.

Kyrieleis's suggested dates for the replicas
places the one of the Ptolemy V monument (fig. 22a) close to the date of
the monument itself, circa 200 B.C., and the one of the Ptolemy III
monument (fig. 21a), because of the nature of its plasticity, about one
hundred years later, that is, about 150 years after the date of the
monument it replicates, or circa 100 B.C. Despite the portrait
characteristics and the differences in the Hermes and Horus hair styles,
the faces of the two kings in the small bronzes are surprisingly similar in
general shape and disposition of features (compare figs. 21b and 22b). It
must be remembered that the original monuments themselves were
executed no more than forty to fifty years apart (circa 240 and 200 B.C.).

The so-called Alexander Sarcophagus (figs.
23a–d), completed in 311 B.C., is believed by some scholars to be
Rhodian in origin.[66] Interesting stylistic affinities can be seen in a
comparison of figures on the sarcophagus to the Baltimore bronze group

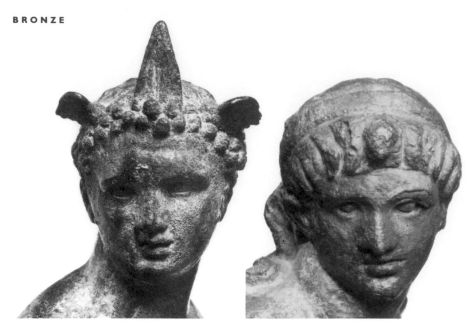

(fig. 22a).⁶⁷ Besides close parallels in stance and proportions of the body, a related style can be seen in the heads. The head of Ptolemy V (fig. 22b) is similar in both shape and "set" in its placement on the neck to the head of the nude stag hunter on the carved marble sarcophagus (fig. 23b). The faces are alike in their proportion of jaw to cheekbone, their low foreheads and small even features, and their expressions of sweetness. Comparison of the Ptolemy III head in the bronze group in Istanbul (fig. 21c) to the same marble head (fig. 23b), reveals these similarities in style even more dramatically. The relationship of head to body in all three figures shows the same kind of solution for bringing tension and alertness to a figure in suspended action. Comparisons of the Ptolemy III head (figs. 21a and c) and the Ptolemy V head in left profile (fig. 22c) to another hunter on the sarcophagus, this one depicted in profile (fig. 23c), is also telling. Finally, the faces of the two defeated wrestlers in the bronze replicas are almost identical (figs. 21a, 22a). Comparison of them (detail of Ptolemy V group, fig. 22d) to a similarly oriented figure in distress on the Alexander Sarcophagus (fig. 23d) shows the same eyes – round and wide, deeply set under the brows, with the somewhat heavy eyebrows falling at a steep curving angle. The bronze figure is depicted as a barbarian: the face is broader and cruder than the idealizing marble one.

If we believe, then, that the Alexander Sarcophagus and some related marble heads are, in fact, Rhodian, and if these small bronze replicas can be assumed to represent more or less faithfully the original Ptolemaic monuments, we might suspect the original monuments to have been Rhodian, whether designed and executed in Rhodes, or – probably more likely – by Rhodians in Alexandria. The replicas themselves were perhaps also modeled and cast by Rhodians in Alexandria, for, as Roman copies of Greek originals show us, period style is easy enough to duplicate; regional style is probably not.

On the level of royal commissions, thus, there may have been some sculptural groups in Hellenistic Alexandria that

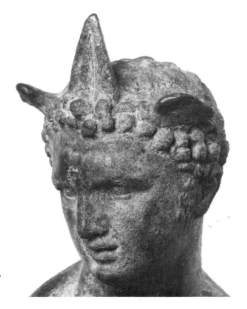

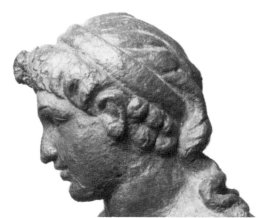

FIG. 21c

Three-quarters view of head of
Ptolemy III, figure 21a.

FIG. 22c

Profile view of head of Ptolemy V,
figure 22a.

FIG. 23b

Head of a hunter from the
Alexander Sarcophagus,
figure 23a.

FIG. 23c

Profile head of another hunter
from the Alexander Sarcophagus,
figure 23a.

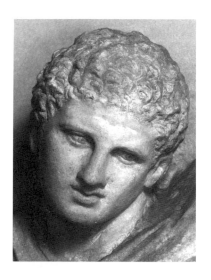

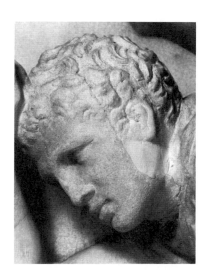

could be called Rhodian in workshop origin. Certainly the diversity of
small Hellenistic bronzes found in Egypt should alert us to probable
eclectic origins of manufacture, for them, and for larger monuments that
they may copy.

 With the gradual absorption of the Hellenistic
world by the Romans in the second and first centuries B.C., Roman taste
in the arts began to assert itself as Roman merchants commissioned
portraiture from Greek artists on Delos and undoubtedly also
commissioned sculpture, including small bronzes, from Greek artists
resident in Alexandria and other cities. There were Romans in
Alexandria at least as early as 129 B.C.,[68] and it may be that many bronze
genre works associated with Alexandria by provenance in Egypt were
actually made by Greeks for Romans.

 The bronze figure of a Black child (fig. 24),
probably a jockey on a horse or dolphin, found in the sea off the coast of

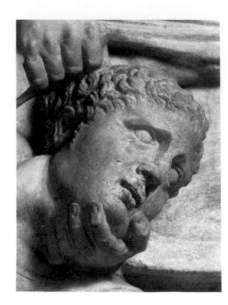

FIG. 22d

Face of defeated wrestler in
Ptolemy V group, figure 22a.

FIG. 23d

Face of a wounded hunter from
the Alexander Sarcophagus,
figure 23a.

Turkey and now in the Archaeological Museum in Bodrum,[69] was
undoubtedly made by Greeks for Greeks, to be placed, with the animal it
rode, as a votive within a sanctuary like the realistic figures that
Herondas describes (*Mime* IV). Another Black child, a lampadarius (fig.
25) found in Spain,[70] reflects the taste of a Roman household. The
Bodrum child has the finely wrought realism and introspection of mood
that we associate with Delian portraiture of around 100 B.C. The face of
the Roman boy – equally serious in demeanor – is more masklike in the
manner of the realism of Republican portraiture. It is likely that it was a
local product, as its find spot, Tarraco, the modern Tarragona, was one
of the most important cities in Roman Spain. A figure of a young Black
found in the Faiyum (fig. 26) and now in the Louvre,[71] perhaps made in
Egypt, may also be pre-Imperial Roman, made by Greeks for their
Roman clientele.

 With the movement of Greek artists of all
media inevitably and increasingly to Italy, that focus of political and
cultural power became the center from which artistic ideas and period
style radiated and from which art was exported throughout the empire.
Like the production of terra sigillata, the most famous, probably the
most productive, and surely the oldest place of fabrication of which was
Arretium (Arezzo in Tuscany), the manufacture of small bronzes for
sanctuary dedication and domestic use spread, in an analogous way,
from Rome and other Italian cities to centers of population throughout
the Empire.

 Provenances and workshops in the
northwestern regions of the Roman Empire – in what is now Europe –
have recently become a major focus of study in almost every European
country. Work by such scholars as Heinz Menzel in Germany, Germaine
Faider-Feytmans in Belgium, J. M. C. Toynbee in Britain, Stephanie

FIG. 24

Bronze figure of a Black child.
Found in the sea off the coast of
Turkey. Bodrum, Archaeological
Museum inv. 756. Photo courtesy
DAI, Athens.

FIG. 25

Bronze lampadarius in the form of
a Black child. Found in Tarragona,
the ancient Tarraco. Tarragona,
Museu Nacional Arqueológico
inv. MNAT-527. Photo courtesy
Generalitat de Catalunya,
Departament de Cultura.

FIG. 26

Bronze statuette of a Black youth
with his hands tied behind his
back. Found in the Faiyum. Paris,
Musée du Louvre inv. Br. 361.
Photo courtesy Musée du Louvre,
M. Chuzeville.

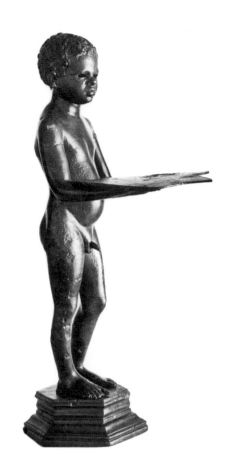

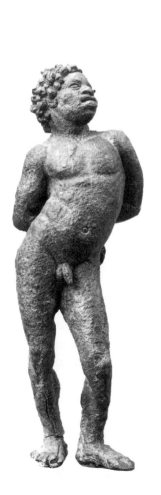

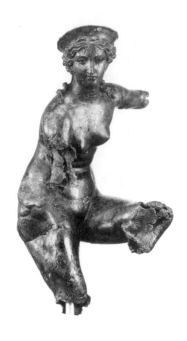

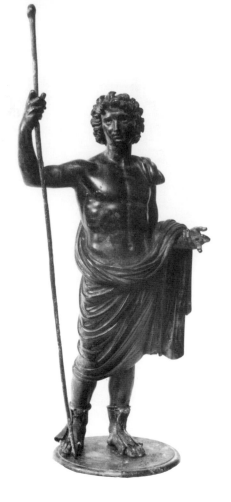

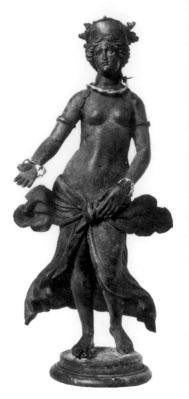

FIG. 27

Bronze statuette of Venus untying her left sandal. Found at Colonia Ulpia Traiana, near Xanten on the Lower Rhine. Bonn, Rheinisches Landesmuseum inv. C 6379. Photo courtesy Rheinisches Landesmuseum.

FIG. 28

Bronze statuette of a *genius populi romani*. Found in Schwarzenacker (Homburg-Saar). Saarbrücken, Landesmuseum für Vor- und Frühgeschichte. Photo courtesy Landesmuseum für Vor- und Frühgeschichte.

FIG. 29

Bronze statuette of Venus. Found in Augst. Augst Museum inv. 60.2561. Photo courtesy Römisch-Germanisches Zentralmuseum, Mainz.

Boucher in France, and others from Spain to Romania, has not only expanded our knowledge of the internationality of trade in small bronzes made in the Greek tradition during the first two centuries of the Imperial period but has also alerted us to the existence of local workshops beginning in southern Gaul and the Lower Rhine and, with the growth of the empire in the second century, stretching far beyond. Space does not allow more than a brief discussion of a few of the Roman bronzes, the provenance of which is modern Europe.

Bronzes made in Italy were inevitably imported into Gaul and the Lower Rhineland. A Venus taking off her left sandal (fig. 27),[72] a classicizing version of a Hellenistic prototype of about 200 B.C. widely copied by the Romans in both bronze and marble, was found at Colonia Ulpia Traiana, near Xanten, on the Lower Rhine near Bonn, where Roman families had settled by A.D. 69–70. A 25.5-cm-high "genius populi romani" (fig. 28),[73] perhaps loosely based on Hellenistic so-called Alexander statuettes, found in a cellar in a Roman city, the ancient name of which is lost, but which is now called Schwarzenacker (in the Homburg-Saar region of Germany), is an example of Augustan classicizing and also an import.

Most bronzes from these outposts of the Roman Empire, however, are both of later date and were made north of the Alps. There are provincial parallels[74] to a Venus (fig. 29) discovered in excavations in Augst, Switzerland, which has been attributed by Annemarie Kaufmann-Heinimann, with some other statuettes found in

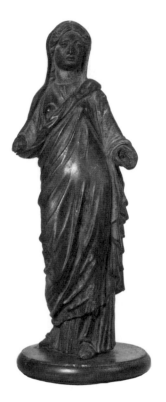

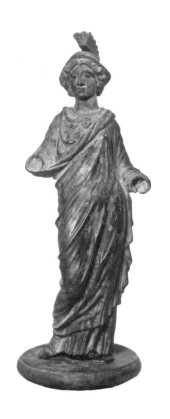

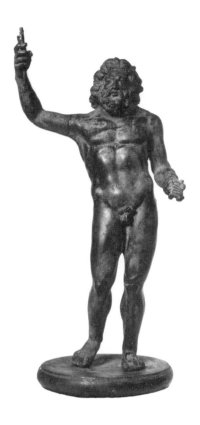

FIG. 30

Bronze statuette of Juno. Found in
Muri near Bern. Bern,
Historisches Museum inv. 16173.
Photo courtesy Römisch-
Germanisches Zentralmuseum,
Mainz.

FIG. 31

Bronze statuette of Minerva.
Found in Muri near Bern. Bern,
Historisches Museum inv. 16171.
Photo courtesy Römisch-
Germanisches Zentralmuseum,
Mainz.

FIG. 32

Bronze statuette of Jupiter. Found
in Muri near Bern. Bern,
Historisches Museum inv. 16172.
Photo courtesy Römisch-
Germanisches Zentralmuseum,
Mainz.

that city, to a late second-century-A.D. workshop in Augst itself.[75]
Kaufmann-Heinimann believes this workshop developed a high-quality
technique under the influence of older workshops in southern Gaul.[76]
Annalis Leibundgut has suggested another workshop in Switzerland as
the origin of statuettes of Juno, Minerva, and Jupiter (figs. 30, 31, 32),[77]
along with a few other bronzes found in Muri, near Bern. Two different
models were probably used in each case for head and body, a flexible
method of assembling statuettes that allowed many and new variations
on Classical and Hellenistic prototypes, often mixing the two.[78]

One of the most spectacular Roman finds
north of the Alps is a treasure, perhaps the inventory of a temple,
discovered by chance in 1979 in Weissenburg in Bavaria, believed to have
been buried during the third century A.D. at the time of the Germanic
invasion. It yielded bronze statuettes of the highest quality from many
different workshops and areas of the empire. A provincial origin is
suggested for the statuette of Mercury (fig. 33) by the heavily incised
lines dividing the legs from the groin and by the lines in details of the face
and elsewhere on the surface. It was probably produced somewhere in
Gaul in the second half of the second century A.D.[79] A dedicatory
inscription to the god, engraved on the front of the octagonal base,
suggests its votive use. The silver torque suggests Celtic associations,
while the money sack in his right hand associates the god with his Gallic
counterpart, who was said to influence financial matters. The Lar (fig.
34)[80] with silver-inlaid eyes and bands of copper in the garment is an
Italian import, perhaps made in Rome around the middle of the second

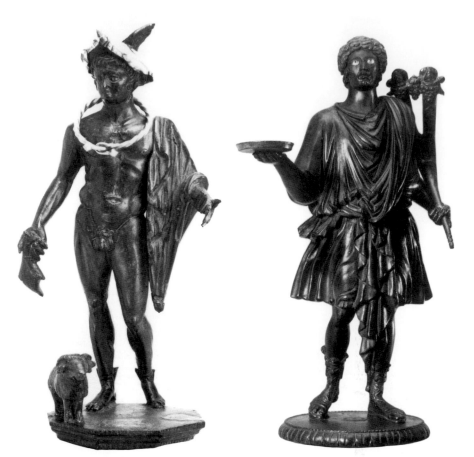

FIG. 33

Bronze statuette of Mercury.
Found in Weissenburg. Munich,
Weissenburg i.B. Römermuseum,
at the Prähistorische
Staatssammlung, inv. 1981.4389.
Photo courtesy Museumsverein
der Prähistorischen
Staatssammlung.

FIG. 34

Bronze statuette of a Lar. Found in
Weissenburg. Munich,
Weissenburg i.B. Römermuseum,
at the Prähistorische
Staatssammlung, inv. 1981.4373.
Photo courtesy Museumsverein
der Prähistorischen
Staatssammlung.

century A.D. This is a *lar familiaris*, guardian spirit of the household, whose usual place was in a shrine within a private house.

Perhaps it is fitting to end these observations with two Roman bronzes with the same provenance but with different workshop origins. "How important is provenance?" Very. But it does not answer all the questions.

NEW YORK CITY

Notes

Harward:
V. J. Harward, *Greek Domestic Sculpture and the Origins of Private Art Patronage* (Ann Arbor, Mich., University Microfilms, 1982).

Langlotz:
E. Langlotz, *Frühgriechische Bildhauerschulen* (1927; reprint Rome, 1967).

1 It is fair, I think, to use the term "court style," to describe the special combination of late Classical form and highly ornate – even opulent – decoration of objects, like the Derveni krater, made in the orbit of the fourth-century Macedonian dynasty. See B. Barr-Sharrar, "Macedonian Metal Vases in Perspective: Some Observations on Context and Tradition," in B. Barr-Sharrar and E. N. Borza, eds., *Studies in the History of Art*, vol. 10, *Macedonia and Greece in Late Classical and Early Hellenistic Times* (Washington, D.C., 1982), pp. 123–139, esp. pp. 132–134 and related notes.

2 Marble sculpture produced in Alexandria is sometimes distinguished in its appearance by economical use of the material, all of which was imported, resulting in piecing and the use of stucco. This is not "style," however. See below (note 53).

3 Langlotz.

4 Sometimes misleading, as a work can be inscribed after importation.

5 This began immediately. In *Greek and Roman Bronzes* (1929; reprint Chicago, 1969), p. 88 n. 1, Winifred Lamb assigned most of Langlotz's Argive bronzes to "Arcadia" because she found them provincial.

6 H. Payne, *Necrocorinthia* (Oxford, 1931).

7 K. Wallenstein, *Korinthische Plastik des siebenten und sechsten Jahrhunderts vor Christus* (Bonn, 1971).

8 Munich, Staatliche Antikensammlungen inv. 4339, M. Maass, *Griechische und römische Bronzewerke der Antikensammlungen* (Munich, 1979), pp. 17–19, no. 6; full bibl., p. 19.

9 Athens, National Museum, usually dated 580–570 B.C., H of face: 21.5 cm.

10 Munich, Staatliche Antikensammlungen inv. 168, G. M. A. Richter, *Kouroi* (1960; 3rd edn., London, 1970), pp. 84–85, no. 73, p. 75, figs. 245–250.

11 G. M. A. Richter, *AJA* 42 (1938), pp. 337–344. As Miss Richter demonstrated in her book on the Archaic kouros (note 10), body structure is fundamental to determining chronology, but unless it has very distinctive characteristics, it may not necessarily be helpful in distinguishing a local school.

12 From Sparta: Boston, Museum of Fine Arts, H. L. Pierce Fund, inv. 99.489; from Arkadia: H. L. Pierce Fund, inv. 04.6, M. True, in *The Gods Delight: The Human Figure in Classical Bronze*, The Cleveland Museum of Art and other institutions, November 1988–July 1989 (A. P. Kozloff and D. G. Mitten, organizers), (Cleveland, 1988), pp. 77–86, nos. 8, 9. M. Comstock and C. Vermeule, *Greek, Etruscan and Roman Bronzes in the Museum of Fine Arts, Boston* (Boston, 1971), pp. 24–26, nos. 22, 23. The Sparta figure is dated by True to 500–490, the one from Arkadia to 510 B.C. Both are dated by Comstock and Vermeule to 520–510 B.C.

13 Langlotz, pp. 30–54, pls. 15–22.

14 M. Herfort-Koch, *Archaische Bronzeplastik Lakoniens*, Beiheft 4 of *Boreas* (Münster, 1986), p. 53 with n. 193.

15 See True (note 12), loc. cit.

16 Of those in Langlotz's first grouping, besides the three from Arkadia and the reputed provenance in Sparta, one was from Adritsana. Langlotz, pp. 30–54, pls. 15–22. Three more of these figures are now known – none, it seems, from Arkadia. Two are in the Athens National Museum: one without provenance in the Stathatos collection, published by E. Kunze in *Drei Bronzen der Sammlung Helen Stathatos. MarbWPr* 100 (1953), pp. 9–13, who attributed it to Sikyon; a second is said to be from Ithome in Thessaly. A third, in the Metropolitan Museum of Art, New York, Baker Collection, inv. 1972.118.67, has no given provenance. Cl. Rolley, *Les bronzes grecs*

(Fribourg [Switzerland], 1983), p. 95, seems to suggest that all three are probably Sikyonian, although he does not identify the Boston pair by name.

17 Probably based on Attic votive statuettes of the Athena Promachos. See M. Jost, "Statuettes de bronze provenant de Lycosoura," *BCH* 99 (1975), pp. 335–355. Compare these to the Athena votive statuette original to Attica, here figure 9. Small bronze votives of hoplites from Lykosoura are possibly based on Lakonian prototypes: Jost, pp. 355–363.

18 True (note 12), loc. cit.

19 Like the Archaistic "Herculaneum Pallas" Athena, or the striding Artemis from Pompeii. J. J. Pollitt, *Art in the Hellenistic Age* (Cambridge, 1986), pp. 175–184, figs. 193, 194. Pollitt does not discuss the Hermes Kriophoros. The most recent suggestion that this statuette may be Archaistic is by K. D. Morrow, *Greek Footware and the Dating of Sculpture* (Madison, 1985), p. 41, who suggests that the figure's boots – or *endromides* – the long ovoid tongues and buttons of which have no extant parallel in the Archaic period, may indicate that the bronze is Archaistic.

20 A stylistic group of karyatid mirrors isolated and described by L. O. Keene Congdon, *Caryatid Mirrors of Ancient Greece: Technical, Stylistic and Historical Considerations of an Archaic and Early Classical Bronze Series* (Mainz, 1981), pp. 46–49, is considered by her to be Lakonian and the earliest group of this type.

21 Munich, Staatliche Antikensammlungen und Glyptothek inv. 3842, H, figure alone: 19 cm, Maass (note 8), pp. 13–15, no. 4, dated by Maass to circa 540; Langlotz, p. 86, no. 12; Congdon (note 20), p. 46, no. 5, pl. 4; Th. Karayorga, *Deltion*, 1965, pp. 96–109, pl. 53a. New York, the Metropolitan Museum of Art 74.51.5680, H: 21.9 cm, J. R. Mertens, *MMAB*, Fall 1985, pp. 22–24, no. 11; Herfort-Koch (note 14), p. 99, no. 61, pl. 8.7, dated by her to 540–530; Langlotz, p. 87, no. 17, pl. 46; Congdon (note 20), p. 46, no. 8, pl. 6.
 Those discovered since Langlotz's publication are in Herfort-Koch (note 14): *K*

68, p. 101, pl. 9.6–7 = Sparta Museum inv. 594, handle only, from Sparta, dated there 520–500; *K 56*, p. 97, pl. 7.5–6 = Athens, National Museum 7548, handle only, from Amyklai, dated 550–540; *K 57*, p. 97, pl. 8.1–2 = Sparta Museum, from Vasilikis, Taygetos, dated 550–540. For the latter two, see also Karayorga (above, this note), pl. 52. (Amyklaion) and pls. 50–51 (Vasilikis, Taygetos).
 Other provenances of such mirrors or handles are Nemea (Vienna, Kunsthistorisches Museum inv. VI 2925), Caere (Dresden, Staatliche Kunstsammlung inv. H. 4 44/16), and South Italy (New York, the Metropolitan Museum of Art 1938.11.5). These are in Herfort-Koch (note 14): *K 66*, p. 101; *K 63*, p. 100; and *K 60*, p. 98, pl. 8.3. The latter also in True (note 12), pp. 69–74; Mertens (above, this note), pp. 23–24, no. 12; and Karayorga (above, this note), pl. 53b. Dated by True to circa 520; by Herfort-Koch to 540–530. In her original publication of this mirror, acquired by the Metropolitan Museum of Art in 1938, Gisela Richter challenged Langlotz, assigning it and those others known at the time to Corinth (note 11).

22 Athens, National Museum inv. 16365, Herfort-Koch (note 14), pp. 106–107, K 89, pl. 12.5–7, dated by her to 500–490 B.C.

23 Athens, National Museum 6445, found on the Akropolis. H. G. Niemeyer, *Attische Bronzestatuetten der Spätarchaischen und Frühklassischen Zeit. AntP*, installment 3, part 1 (Berlin, 1964), pp. 24–25, pls. 17–19, 33b–c.

24 At least one third of the Akropolis marble sculptors who left their signatures may be non-Athenian. J. Boardman, *Greek Sculpture: The Archaic Period* (New York and Toronto, 1978), p. 74. Solon encouraged the immigration of artists early in the sixth century, and it is likely that the tradition continued.

25 Niemeyer (note 23), pp. 7–15.

26 Athens, National Museum inv. 6447, found on the Akropolis, Niemeyer (note 23), pp. 20–22, pls. 11, 34a.

27 Langlotz, pp. 54–67, pls. 23–32. J. Charbonneaux, *Les bronzes grecs* (Paris, 1958), pp. 72–74, while describing the Argive torso as it is known from the Kleobis and Biton marbles in Delphi, inscribed by (Poly)medes from Argos, and a small bronze kouros found in 1949 in the Hera sanctuary in Argos, nevertheless suggested that a distinction of workshops at this period in the northern Peloponnesos was more theoretical than actual. Recently, Rolley (note 16), pp. 86–90, fig. 64, has added to these two bronze male statuettes as evidence to support the hypothesis of the existence of a late Archaic figurative style in Argos. One is without provenance (Paris, Musée du Louvre inv. MNE 686), the other was found in Boeotia.

28 R. Thomas, *Athleten Statuetten der Spätarchaik und des Strengen Stils* (Rome, 1981), pp. 153–158. Products from the northern school are found mostly in Lusoi, the Lykaios mountains, and Mantineia; those from the south, mostly in Tegea. Thomas suggests provincial local workshops in Lusoi and Lykosoura and one, of very high quality, in Tegea, finds from which allow a stylistic group to be formed.

29 Berlin, Charlottenburg, Antikenmuseum, Staatliche Museen Preußischer Kulturbesitz, inv. 8089.

30 Syracuse, Museo Archeologico Regionale inv. 31.888.

31 Paris, Bibliothèque Nationale, Cabinet des Médailles, inv. 928. Formerly collection of the duc de Lyon.

32 Paris, Musée du Louvre inv. 154.

33 In the *Deipnosophistai* of Athenaeus of Naukratis, Kallixeinos describes (V.199e) as "Lakonian" and "Corinthian" elaborate toreutic vessels paraded in the procession of Ptolemy Philadelphos.

34 Athens, National Museum inv. 15209, S. Karouzou, "Eine Bronzestatuette des Dionysos aus Aetolien," in *Wandlungen: Festschrift Ernst Homann-Wedeking* (Munich, 1975), pp. 205–216, pls. 40–43.

35 Athens, National Museum inv. 13398, H: 43 cm, P. C. Bol, *Die Skulpturen des Schiffsfundes von Antikythera* (Berlin, 1972), pp. 13–14, pls. 2.1–3, 4.4–6; the other two, pls. 1.1–3, 3.1–3, and 4.1–3 and 7–8.

36 Recently, R. Ling in the *CAH*, vol. 7, part 1, volume of plates, p. 134.

37 Apparently based on new study of the coins. Reported by N. Yalouris at a Hellenistic symposium in San Antonio, Texas, in March 1988, and reported to me by Robert Guy.

38 W. Fuchs, *Der Schiffsfund von Mahdia* (Tübingen, 1963), p. 20, no. 11, pl. 20. In the Bardo Museum, Tunis, H with base: 42 cm. Fuchs attributes this bronze and others from the shipwreck to the workshop of Boethius, son of Athanaionos of Chalkedon, which he places in Athens.

39 There was apparently an increasing emphasis on the privacy of religion as early as the middle of the fourth century, when small statuettes of deities began to appear in private houses. The purpose of this domestic use was not decorative, as was the case with terracottas, which began to appear widely about the same time, but religious. This exclusively religious use of bronze and marble sculpture in the home, at least by the Greeks themselves for most – if not all – of the Hellenistic period, has been clearly demonstrated in the dissertation by V. J. Harward. Terracotta figures that may have been purely decorative have been found in excavated homes dated as early as the end of the fifth century (in Himera, destroyed in 409 B.C.: see Harward, p. 54, with no. 131). Bronze and marble genre sculptures, however, were produced only for dedication in sanctuaries and for personal religious rites in the home. Harward suggests that too much emphasis has been placed on too little literary evidence (in the case of the Herakles Eptrapezsios, for example: Harward, pp. 28–30). Wall-painting, tapestry, and often floor mosaic, all aspects of the room in which the symposium took place, as well as the silverware used at the preceding *deipnon*, were considered the trappings of a luxurious home, not its sculpture: Harward,

pp. 57–101, passim; see also B. Barr-Sharrar, "The Hellenistic House," in E. Reeder, ed., *Hellenistic Art in the Walters Art Gallery* (Baltimore, 1988), pp. 59–67.

40 Pella Museum 383, Harward, p. 198, no. 87, pl. 17.

41 Harward, pp. 135–136, with nn. 80–81. He lists others of marble, nos. 134–137. Bronze and marble images of gods could be honored with offerings of frankincense and barley cakes or wafers, as well as fruit and libations of wine or water, crowned with garlands or wreaths, or polished as an act of ritual: Harward, pp. 80–101.

42 It should probably be dated to a time before the destruction of Pella by the Romans in 168 B.C., although recent excavations suggest that the inhabitation of Pella continued.

43 Both Lysippos and his Poseidon were traditionally connected to the Macedonian royal house. Lysippos was the court sculptor for Philip II and Alexander the Great, and the image associated with him of Poseidon with one foot raised can be seen on the reverse of coins of Demetrios Poliorketes. Even without these associations, Poseidon would be an appropriate choice for veneration in an aristocratic house in Pella during the turbulent Middle Hellenistic period, as the military renown of the Antigonids included considerable naval power.

44 Munich, Staatliche Antikensammlungen inv. Sig. Loeb 15; the trident is modern; Maass (note 8), p. 25, no. 9, with bibl.

45 The most recently discovered seems to be the one found in a niche in a house on Delos, 30 cm high, a four-sided base with a dedication to Artemis Soteira from a Roman, Spurius Stertinius; M. Kreeb, "Studien zur figürlichen Ausstattung delischer Privathäuser," *BCH* 108 (1984), p. 328. The Artemis statuette – whether bronze or marble – has not been identified, if it still exists. Harward, pp. 132–133, lists four more examples from Delos: the famous marble Aphrodite, Pan, and Eros group from the establishment of the Poseidoniasts, and three inscribed bases from the House of the Herm. Harward suggests that statuettes of

Hephaistos may have stood in a place near the hearth, Hekate or Hermes near the outer door, and other gods – chosen for reasons personal to the household – wherever appropriate or convenient. Cybele was popular in Priene. See J. Raeder, *Priene: Funde aus einer griechischen Stadt* (Berlin, 1983), p. 16.

46 Delos Museum 1007. Harward, pp. 148, 153, no. 5, pls. 28–29; Kreeb (note 45), p. 339. For the terminus ante quem, G. Siebert, "Mobilier délien en bronze," *Etudes déliennes*, Suppl. 1 of *BCH* (Athens, 1973), p. 581.

47 Harward, p. 148, quotes a reference in Athenaeus's *Deipnosophistai* (XI.460e) to herms guarding symposium silverware stored within the house.

48 Numerous small marble Dionysiac herms were found on Delos. But see Harward on the changing nature of the herm in the Hellenistic period: Harward, pp. 128–131, 142–149.

49 The validity of Pliny's description of Delos as a location for the making of klinai (*H.N.*, XXXIV.9) – of which legs as well as decorations for the wooden horizontal supports and leaning headrests were of cast bronze – is now proven by excavations in the Skardhana quarter. They revealed not only bronze klinai elements but also plaster casts for the production of the wax models that produced them. Siebert (note 46), passim. Pliny says that Delian bronze was also used for the statues of gods and men.

50 Berlin, Pergamonmuseum, Staatliche Museen Preußischer Kulturbesitz, inv. 7466, Harward, pp. 200–201, no. 90; Rolley (note 16), p. 180, dates it 160–150 B.C.

51 Three bronze statuettes, said at the time of excavation to be Hellenistic, were found in another house in Pergamon, but the context of their discovery was disturbed, and they may well be of Roman date, Harward, p. 201 with n. 8; E. Boehringer, "Die Ausgrabungs Arbeiten zu Pergamon im Jahre 1965," *AA*, 1966, pp. 440–443, Terrassenhaus II. They are a satyr, who must originally have carried a wine sack, standing on a base; a replica of the Herakles Farnese; and a bearded soldier in cuirass and helmet.

52 The bronze statuette of a running satyr from the Mahdia shipwreck (in the Bardo Museum in Tunis, Fuchs [note 38], no. 19, pl. 19), probably a few decades later than the Pergamon figure, may also be from a workshop in Asia Minor. The individuality of its slightly fleshy face, with low brow, square jaw, and broad cheek, small well-articulated mouth, and eyes with clearly modeled lids, bears a strong resemblance to the face of a figure carved into the marble frieze at Lagina, see A. Schober, *Der Fries des Hekateions von Lagina* (Vienna, 1933), p. 86, fig. 31. The locks of hair that frame the two faces are similarly differentiated, and the set of the head on a muscular neck is also the same.

A small second-century silver bust of Eros, said to be from Nihavand, Iran, in the Staatliche Antikensammlungen, Munich (inv. SL 661 d), shows the same general facial characteristics and great care for the artfully modeled, ornamental locks of hair that frame the face, see A. Oliver, *Silver for the Gods: 800 Years of Greek and Roman Silver*, Toledo Museum of Art (Ohio) and other institutions, October 1977–April 1978, pp. 72–73, no. 37; and B. Barr-Sharrar, *The Hellenistic and Early Imperial Bust* (Mainz, 1987), p. 137, pl. 69.

53 Discussed by Nikolaus Himmelmann, *Alexandria und der Realismus in der griechischen Kunst* (Tübingen, 1983), pp. 20–22, with notes. Himmelmann's systematic work may begin to clear up some of the confusion surrounding genre sculpture in general, both large and small. As R. R. R. Smith says (*Hellenistic Sculpture: A Handbook* [forthcoming]), there is little to show that genre and grotesque realism were more favored at Alexandria than in any of the other centers that perpetuated the *koine*. Further, ". . . the Ptolemies provided patronage for a diverse range of sculptural products . . . there is no evidence of a specifically Alexandrian style."

54 H. Kyrieleis, "Kathaper Hermes kai Horos," *AntP* 12 (1973), p. 138.

55 Baltimore, the Walters Art Gallery inv. 54.1046, H: 25.4 cm, see Reeder (note 39), pp. 149–150, no. 62.

56 Proposed dates for the Pasquino group have ranged from the middle of the third to the first century B.C. E. Berger, "Der neue Amazonenkopf im Basler Antikenmuseum: Ein Beitrag zur hellenistischen Achill-Penthesilea Gruppe," in *Gestalt und Geschichte: Festschrift Karl Schefold*. Vereinigung der Freunde Antiker Kunst. Beiheft 4 of *AntK* (Bern, 1967), pp. 72, 75, dates it to the first century; Ernst Kunzl has dated it to the second century: *Frühhellenistische Gruppen* (Cologne, 1968), pp. 148–155; Bernhard Schweitzer dated it to the third century: *Das Original der sogenannten Pasquino Gruppe*. *AbhLeip*, 43 (1936), no. 4.

57 One in the Museo archeologico, Naples, from Pompeii; another in the Museo nazionale di antichità, Parma (inv. 325), from Piacenza.

58 Kyrieleis (note 54), pp. 133–146.

59 Istanbul, Archaeological Museum inv. 190, Kyrieleis (note 54), pp. 133–134 and passim, pls. 46–48, figs. 13, 27.

60 Baltimore, the Walters Art Gallery inv. 54.1050, H: 19.7 cm, Reeder (note 39), pp. 151–152, no. 63.

61 Kyrieleis (note 54), pp. 133–134 and passim, pls. 46–48, figs. 13, 27.

62 Pliny, *H.N.*, XXXVI.34, 37.

63 V. Goodlett, *Collaboration in Greek Sculpture: The Literary and Epigraphical Evidence* (Ann Arbor, Mich., University Microfilms, 1989), pp. 20–22, 25, 124–159. As Goodlett states (p. 19), the epigraphical testimonia to collaboration are the best available evidence for the structure of sculpture workshops.

64 G. Merker, *Studies in Mediterranean Archaeology*, vol. 40, *The Hellenistic Sculpture of Rhodes* (1973), passim.

65 Out of 100,000 amphora handles reported, 98,000 are Rhodian; of those, about 80,000 were found in Alexandria. Rhodian trade apparently reached its peak in the years just before and after 200 B.C., *CAH*, vol. 7, part 1, p. 274. After South Russia, Rhodes was the biggest consumer of Egypt's grain, ibid., passim. Ptolemy III gave considerable aid to

Rhodes after an earthquake in 227/226, E. R. Bevan, *The House of Ptolemy* (1927; reprint Chicago, 1968), p. 203; Polybius V.88–89. After Egypt's help to Rhodes in withstanding Demetrios's famous siege of the city in 304, Rhodes had established a cult of Ptolemy I as "savior," thus Ptolemy I Soter. Later Ptolemy and Berenice, probably Ptolemy III and Berenice II (*CAH*, vol. 7, part 1, p. 92 n. 103), were worshiped as gods.

66 Jiří Frel, "The Rhodian Workmanship of the Alexander Sarcophagus," *IstMitt* 21 (1971), pp. 121–124, pls. 38–43.

67 I am grateful to Günter Kopcke for first suggesting this comparison to me.

68 Bevan (note 65), p. 312.

69 Bodrum, Archaeological Museum inv. 756, H: 47 cm, E. Arkurgal, *Griechische und Römische Kunst in der Turkei* (Munich, 1987), no. 36.

70 Found in Tarragona, the ancient Tarraco, founded in 45 B.C. In the Museu Nacional Archeológico de Tarragona, M. Tarradell, *Römische Kunst in Spanien* (Düsseldorf and Lausanne, 1970), pls. 47–48.

71 Paris, Musée du Louvre, H: 13.2 cm, Rolley (note 16), fig. 192.

72 Bonn, Rheinisches Landesmuseum inv. E 94,68, H: 40 cm, H. Menzel, *Die römischen Bronzen aus Deutschland*, vol. 3, *Bonn* (Mainz, 1986), p. 44, no. 98, pls. 52–55.

73 A. Kolling, *Funde aus der Römerstadt Schwarzenacker* (Homburg-Saar, 1971), pp. 54–55, pls. 71–72.

74 One is from Trier: H. Menzel, *Die römischen Bronzen aus Deutschland*, vol. 2, *Trier* (Mainz, 1966), no. 80, pl. 38. Another from Verulamium, idem, "Römische Bronzestatuetten und verwandte Geräte: Ein Beitrag zum Stand der Forschung," in H. Temporini and W. Haase, eds., *Aufstieg und Niedergang der römischen Welt*, vol. 2 (Berlin, 1985), pl. 13.1. Also: J. M. C. Toynbee, *Art in Britain under the Romans* (Oxford, 1964), pp. 83ff., pl. 18c–d.

75 Augst Museum inv. 60.2561, found in Augst in 1960, H: 18.7 cm, A. Kaufmann-Heinimann, *Die römischen Bronzen der Schweiz*, vol. 1, *Augst und das Gebiet der Colonia Augusta Raurica* (Mainz, 1977), pp. 69–70, no. 69, pls. 71–73.

76 Kaufmann-Heinimann (note 75), loc. cit.

77 Bern, Historisches Museum: Juno, inv. 16173, H: 31 cm; Minerva, inv. 16171, H: 32.8 cm; Jupiter, inv. 16172, H: 31.5 cm. A. Leibundgut, *Die römischen Bronzen der Schweiz*, vol. 3, *Westschweiz, Bern und Wallis* (Mainz, 1980), no. 42, pp. 46–47, pls. 54–56; no. 43, p. 48, pls. 57–59; no. 6, pp. 16–17, pls. 11–13.

78 This process is discussed by Leibundgut (note 77, loc. cit.) and by J. J. Herrmann, Jr., "Roman Bronzes," in *The Gods Delight* (note 12), pp. 280–281.

79 Weissenburg i.B., Römermuseum, at the Prähistorische Staatsammlung, Munich, inv. 1981.4389, H: 15.6 cm (with base: 21.6 cm). H. J. Kellner and G. Zahlhaas, *Der römische Schatzfund von Weissenburg*, 2nd edn. (Munich and Zurich, 1984), p. 21, no. 18, pl. 13.

80 Weissenburg i.B., Römermuseum, at the Prähistorische Staatsammlung, Munich, inv. 1981.4373, H: 20.4 cm (with base: 25.9 cm). Kellner and Zahlhaas (note 79), p. 28, no. 25, pls. 17, 18.

The Use of Scientific Techniques in Provenance Studies of Ancient Bronzes

Pieter Meyers

Since the middle of the nineteenth century numerous attempts have been made at provenance studies of copper and bronze objects. Such studies were nearly always based upon elemental compositions. The results have been highly disappointing, even though analytical techniques have improved considerably, and accurate multielemental analyses have been performed in great numbers. Only a few successful provenance studies are known.

Much more recently, during the 1960s, another technique, lead isotope ratios analysis, has been introduced for provenance determinations. Initially, this technique was only applied to lead and lead-bearing materials, but during the last decade several projects involving copper-based artifacts have been carried out.

In the discussion that follows a critical evaluation will be presented of provenance studies using scientific techniques. An attempt will be made to clear up the confusion that exists about the usefulness and validity of elemental compositions and lead isotope ratios in provenance studies. Misconceptions will be pointed out, and the conditions will be outlined under which these analytical techniques can be useful, and explanations will be presented for the many failures.

In the final paragraphs requirements will be listed for future research aimed at establishing more secure provenance assignments for the many bronze artifacts from classical antiquity.

The term "provenance studies" needs to be defined since it can have three different meanings, depending on the context in which the word "provenance" is used. Provenance can mean (a) the origin of the source materials, (b) the location of manufacture of the artifact, and (c) the find place. In the context of scientific techniques, provenance studies do not apply to the find place of artifacts, but based upon definitions (a) or (b) they fall into two distinctly different categories, I and II.

Category I involves studies that are concerned with the location of the source of materials from which artifacts are made. For bronzes this usually means the location of the copper ore

sources. In studies of this category potential source materials, e.g., copper ore sources, are identified and characterized by certain measured variables. A similar characterization is carried out on artifacts. The provenance study is considered successful if source and artifact can be matched based upon the measured characteristics. Such studies may answer questions important to archaeologists such as development of technology, economic situations, and trade relations. They usually require analysis of excavated artifacts and analysis of source material such as copper ores or smelting slags.

Category II includes studies that are aimed to group artifacts with a common origin and/or to differentiate between artifacts with different origins. Such studies often involve only artifacts without properly documented provenances. Observations or measurements are made of certain technical or compositional properties of the objects that are characteristic for their origin, because either the same raw materials were used or similar methods of manufacture or decorating techniques were involved.

For provenance studies based upon scientific techniques to be successful a number of considerations are important. Considerable expertise is usually required in the specialization area of observation/measurement such as neutron activation analysis or atomic absorption spectrometry for elemental analysis or mass spectrometry and geochemistry for lead isotope ratios studies. However, it is equally important to have detailed art historical and archaeological information available on the artifacts being studied, and a general understanding of the society that produced them may be most useful. In many cases other specialized knowledge such as that of local geology, geochemistry, and archaeometallurgy may be essential.

More often than not a team of specialists is required to carry out provenance studies, and an intensive collaboration is needed to produce meaningful results.

Among the various scientific measurements or technical observations that can be made on copper-based artifacts, only elemental analysis and lead isotope ratios analysis have found consistent use in provenance studies. Other characteristics such as casting and decorating techniques can certainly be informative when used in association with elemental compositions or lead isotope ratios. However, they have only limited applicability, and by themselves they are not sufficiently discriminating. Before attention is focused on elemental analysis and lead isotope ratios analysis, it may be instructive to mention a few cases where such analyses have contributed to provenance assignments.

In 1978 a Roman bronze head of a woman (fig.

FIG. 1

Bronze head of a woman. Roman, A.D. 100–150. Princeton University, The Art Museum, Museum purchase, Fowler McCormick Fund, inv. y1980-10. Photo courtesy The Art Museum.

1) was offered for sale at auction. For stylistic reasons the authenticity of this bronze was seriously questioned at the time. Therefore, a technical examination was carried out to verify or reject a Roman date of manufacture.[1] The results of this study revealed that the method of manufacture, i.e., hollow lost-wax casting, was fully consistent with a Roman date and that the extent, type, and structure of the corrosion could only be the result of a natural, long-term corrosion process. Based upon this technical examination there could be no doubt that this bronze was manufactured in antiquity.

The most peculiar part of this object is the hairnet, which, because of the realistic details and casting flaws, could

only have been produced by the use of a real textile hairnet, applied over a wax head, followed by the usual process of investment, burn-out, and bronze casting operation. This unique manufacturing process – "lost wax and lost hairnet" casting – is by itself not proof of authenticity; however, it was soon realized that the hairnet's construction showed great similarities with those of Coptic hairnets in the collection of the Metropolitan Museum of Art, thus providing additional evidence that the head was manufactured in antiquity. Its association with Coptic hairnets initially suggested an Egyptian provenance. However, a recent publication discussing the bronze head, which in the meantime had been acquired in 1981 by the Art Museum, Princeton University, does not mention Egypt as a possible provenance but instead suggests that the object is a Roman product of a Roman lady with a hairnet from Greece.[2] Nevertheless, it is the detailed structure of the hairnet, a result of a technological phenomenon, that provides the most characteristic information for establishing a provenance. It is only because of the paucity of surviving hairnets or depictions thereof that reliable comparisons and an accurate provenance assignment can as yet not be made.

In a technical study of Himalayan copper-based statues from the medieval period, Chandra Reedy has convincingly demonstrated that details of the casting method and differences in decorating techniques were useful in provenance studies.[3] For example, whether or not the design was completed on the back side of a statue was a significant criterion in differentiating between statues from western Tibet (often without complete decoration on back) or from central or eastern Tibet (with decoration on back).

Provenance studies by elemental analysis are based upon the assumption that the elemental composition of the copper or copper alloy maintains some of the compositional characteristics of the ore sources from which it is produced. Since the middle of the nineteenth century numerous projects have been carried out either to link copper-based objects to ore sources or to group artifacts with common compositional patterns.

Many were small projects that fizzled away if the answers were not immediately forthcoming. Some were comprehensive long-term research projects that included hundreds or even thousands of analyses, years of laboratory work, archaeological expeditions, many done by competent scholars. Publications tend to include long lists of elemental compositions, but the results have almost always been the same, with no successful provenance assignments or, at best, very little information relative to the amount of effort involved.

For example, in the beginning of the second

quarter of this century members of the "Sumerian Project," a team of highly respected scholars, set out in a most determined way to establish the sources of Sumerian copper. Even though exhaustive research was carried out over many years, not much information was produced.[4]

Probably the largest failure in provenance studies was the huge project on European Bronze Age material conducted by a group of researchers in Stuttgart, Germany.[5] The results of 20,000 analyses were published in the late '60s. John Coles has provided a blistering condemnation of this work that probably correctly reflects the way many scholars have judged this study: "Spectrographic analysis of the metal products of the European bronze age is perhaps the most monumental disaster of all the contemporary studies. . . . It has provided a few answers in restricted areas of enquiry, and created mass confusion in others."[6]

These and other nonproductive studies have given elemental analysis as a means for provenance studies a bad reputation to the extent that there are only very few believers in this method. Even Paul Craddock of the British Museum Research Laboratory, a prominent and highly regarded scientist, whose major work has been in elemental analysis of copper-based artifacts, does not believe in the use of elemental compositions for provenance determinations: "real problems lie . . . fundamentally in the almost total lack of information on the chemical processes and compositional changes between the ore source and the finished metal of the analyzed artifact which can only be bridged by often untenable assumptions."[7]

At this stage it may be useful to review the principles of provenance studies based upon elemental compositions. The copper in artifacts can either be native copper or be smelted from copper ores. Among the latter are two different classes, namely the brightly colored blue and green oxidized ores and the mostly gray and black reduced ores.

In the smelting process drastic changes take place: most of the chemical elements will be separated from the copper, ending up in the smelting slag or forming volatile compounds and disappearing. A few elements may be introduced into the copper through the addition of flux and fuel. Others are added as alloying metals or enter in the alloy as impurities of the alloying metals. It is therefore clear that the elemental composition of the copper or copper alloy will have little similarity to that of the copper ore. Smelting tests in the laboratory have shown that it is very difficult to predict what fraction of each element will end up in the metal. There are too many variables – e.g., temperature, ore composition, oxidation-reduction condition, flux, and fuel – that will affect final concentrations. However, all this does not

prove that certain relationships between various elements are not maintained in the transition from ore to metal.

The only true test to answer whether or not provenance studies are feasible is to study properly designed research experiments. For example, a realistic and practical project of category I (correlation of artifacts with ore source) includes the following: (1) analyses of sets of samples of probable ore sources; (2) analyses of sets of samples from artifacts of copper produced from those ore sources (the number of samples in both categories must be large enough to be statistically significant); and (3) comparison of the two data sets.

The data sets comparison may well be the most critical part of any provenance study. Traditionally, comparisons between elemental compositions were carried out by simply comparing numbers and ratios, or by plotting elemental compositions in two-dimensional graphs. For studies of copper and bronze artifacts such basic comparisons are inadequate as they cannot take into consideration the complicated relationships between many of the elements. Because of the often large numbers of elements determined and the complicated interelemental relationships (correlations), computer-aided multivariate statistics must be employed.

First developed in the biomedical and social sciences, multivariate statistical programs are now widely available. They are often used in provenance studies of ceramics, where they have been most successfully employed to link pottery to specific clay sources.[8]

Multivariate statistical calculations can provide the answer to the basic question whether or not there exists a characteristic relationship between the elemental compositions of copper ores and those of artifacts made with copper from those ores. Similar calculations may also identify systematic differences between two or more groups of objects, each of which is composed of objects made from copper with a common ore source.

The advantage of this approach, a relatively new one in the study of metals, is that it is no longer necessary to understand what exactly happens to individual elements during smelting and alloying. No assumptions are necessary. All that is needed are sets of accurately determined compositional data of well-documented and significant ore samples and artifacts. Only very few studies have as yet been reported using statistical methods. Some of those may serve here to illustrate the methodology.

In a study of native American copper artifacts, George Rapp and co-workers analyzed almost six hundred samples of native copper from about ten major geological deposits in North America.[9] Using neutron activation analysis, the concentration of

approximately twenty-eight elements was determined quantitatively. Differences in the native copper deposits were identified using discriminant analysis, a multivariate statistical technique that specifically identifies what separates one group from another. In this study more than seven hundred copper artifacts were analyzed. Using probability calculations, another aspect of multivariate statistics, the large majority of the artifacts could be unambiguously linked with one of the native copper deposits.

Obviously this is a very successful provenance study. However, the situation in this project is unique as it involves native copper with limited and relatively well-known sources; no smelting, melting, or alloying is involved.

Could this approach also work in a similar situation involving smelted and alloyed copper? An answer to this question can be found in the work of Thierry Berthoud, who was interested in the sources of copper used for objects found in Mesopotamia dated to the fourth and third millennia B.C.[10] He and his co-workers collected and analyzed samples of copper ores from likely or known sources in the Near East, predominantly in Iran, Afghanistan, Cyprus, and Oman. He also sampled and analyzed artifacts from excavated sites such as Susa, Ur, Sialk, and Shar-i-Sokhta. Quantitative analysis for thirty-one elements was carried out by spark source mass spectrometry, a technique that allows fast multielement analysis, but with relatively poor accuracy.

In order to compare the copper data with the artifact data, a mathematical model was developed that allowed the transformation of ore compositions into "metal" compositions, which could be compared directly to those of the artifacts. To interpret the large amount of analytical data, a multivariate statistical technique known as principal component analysis was used. Even though this particular method would now be considered less than ideal for comparing groups of copper and bronze analyses, it was remarkably successful in linking different groups of objects with each other and also groups of objects with ore sources.

For example, Berthoud was able to show that fourth-millennium-B.C. objects found in Susa, Sialk, and Tepe Yahya were made of copper smelted from ore sources in Iran. Third-millennium-B.C. copper and bronze objects, excavated in various sites in Mesopotamia, however, could be correlated with ore sources in Oman. Apparently the extensive copper deposits in Oman served at that time as a major source for supply of copper in Mesopotamia. Archaeological evidence has since confirmed the significance of Oman as a source for copper. According to contemporary cuneiform texts, copper was

brought to Mesopotamia from "Makkan." The location of "Makkan" has been the subject of debate, but the results of Berthoud's work provide strong support for locating ancient "Makkan" in present-day Oman.

The previous example shows that provenance studies can be carried out on excavated objects from a period when smelting, alloying, and trade were relatively simple matters. But is it also possible to perform successful provenance studies on objects without known origin from areas where information on copper ores is not readily available, that is, category II provenance studies? The main interest here would be in grouping objects made from copper produced from common sources.

In a recently completed study of Himalayan bronzes, approximately 340 copper-based objects varying in date from the fifth to the fifteenth century A.D. were subjected to a comprehensive technical study.[11] The aim of this study was to assign a regional provenance to each of the objects studied. The geographic areas of interest included Afghanistan, north Pakistan, Kashmir, Himachal Pradesh, western Tibet, central Tibet, eastern Tibet, and Nepal.

The technical study included elemental analysis of metal samples by inductively coupled plasma emission spectrometry, a technique that provided accurate quantitative data for fifteen elements. Also part of the technical study was a detailed analysis of the casting and decorating techniques, and petrographic and neutron activation analyses of the casting core when present.

The casting core, especially its elemental composition, provided clearly the most discriminating information in differentiating between separate provenances, but unfortunately this information was often not available as many objects never contained a casting core, while the casting core of others had been removed. Elemental compositions of the metal did prove to be extremely useful in assigning regional provenances, especially when used in combination with other characteristics.

Initially, groups were formed for each of the regions of interest based on conventional art historical criteria using only those objects with the most plausible provenance (inscriptions, similarity to monuments or sculpture, style, iconography). These groups were then refined using elemental analysis data in combination with other characteristics using multivariate statistical methods. One of these methods, discriminant analysis, indicated the mathematical variables that provided the largest separation between the groups; it showed which of the technical or compositional characteristics contributed to this separation and also any of the objects with initial plausible attributions that did not conform to their group. With the groups now

firmly defined, it became possible using probability calculations to assign regional provenances for the large majority of all the objects studied.

Even though elemental compositions by themselves did not provide complete separation between the various regional groups of Himalayan bronzes, they made a significant contribution. The success in using elemental compositions for provenance assignments came as somewhat of a surprise, because it was assumed that much if not all copper was probably imported into the Himalayan area and would therefore not be region specific. Furthermore, it was feared that there would have been so much remelting that even if there initially were location-dependent compositions, they would not have lasted very long. Obviously, such assumptions were not true.

Another successful provenance study project of the category II class deals with Chinese bronzes.[12] Approximately four hundred ceremonial vessels dating to the Shang and Zhou dynasties (fifteenth–third century B.C.), all without known provenance, were sampled, and elemental analyses were carried out using neutron activation analysis and atomic absorption spectrometry. Accurate quantitative data were obtained on twelve elements.[13]

Initially, differences between groups of objects became clear to the investigators just by examining conventional elemental composition graphs ("correlation plots"). These differences were, however, not sufficiently informative to allow more than a few incidental conclusions on provenance questions. Multivariate statistical calculations were carried out on the data set in association with stylistic and iconographic information and also with lead isotope ratios that had been determined for these objects (see below).

Even though this study has as yet not been fully completed, it has convincingly demonstrated that significant provenance information can be obtained from compositional data. For example, a large group of objects, stylistically characterized as of the "Anyang" style, formed a sufficiently homogeneous compositional group to warrant the assumption that all the vessels in this group contained copper from a common source. Apparently a steady and constant supply of copper was provided to the bronze workshops in Anyang, at that time the capital of the Shang Empire. However, a number of exceptions were identified, i.e., objects that statistically were not members of this group. They included objects stylistically identifiable as provincial (not made in Anyang) and all objects that could be characterized as from the early Anyang period or earlier. This finding allows estimates of the time when the major supply source of copper for Anyang became effective.[14]

Such observations, together with other technical conclusions and historical, archaeological, and stylistic

evidence, can provide important information on the organizational and economic aspects of the impressive bronze production in China and on the society that produced them. Further research in this project will undoubtedly produce additional information on provenance issues of Chinese bronzes.

Other successful projects have been completed and some are currently in progress, but the examples mentioned above may serve to demonstrate that elemental analyses of copper-based artifacts can provide significant information on their provenance. However, this will happen only in research projects that are properly designed, around a significant set of artifacts and – where pertinent – copper ores, and with the appropriate use of multivariate statistics. Even then, the small number of successful provenance studies does not allow a generalization. For instance, it should be realized that the studies mentioned above involve objects made of native copper or of copper smelted from oxidized ores. The large majority of copper-based artifacts through history are made using copper derived from reduced ores. It is still to be proven that this class of copper-based objects will exhibit similar compositional behavior and will be susceptible to successful provenance studies.

Provenance studies based upon lead isotope ratios are based on the following principle. The element lead has four stable isotopes: lead-204, lead-206, lead-207, and lead-208. Because of their origin, as final stable products in a chain of natural radioactive products, the relative abundances of the isotopes vary slightly but significantly as a function of their geological age.

Lead-bearing mineral deposits can be characterized by the relative lead abundances or, as they are usually expressed, by the lead isotope ratios. These lead isotope ratios can be measured accurately, even on minute samples, using a mass spectrometer.

The idea for provenance studies using lead isotope ratios is based upon the assumption that the isotope ratios: (1) are constant within one deposit, (2) show significant variation between different ore deposits, and (3) do not change in the transition from ore to metal. Consequently, artifacts containing lead from the same source would have similar lead isotope ratios, which would differ from those of artifacts with lead from other lead sources.

Since the 1960s, when this technique was first suggested as a means for provenance studies, a number of successful studies have been reported, mostly dealing with lead-containing materials, such as lead-white in paintings, lead glass and glazes, and lead and silver artifacts.

The research of Noel Gale in Oxford has been extremely significant. In his study of sources of lead and silver during the Bronze Age in the eastern Mediterranean he sampled and analyzed both ore sources and lead and silver artifacts. One of the major findings in this project is undoubtedly that there were only two significant sources for early Cycladic lead and silver: Laurion in Greece and the island of Siphnos were for a long time the only major suppliers of those metals.[15] The remarkable research by Gale and Stos-Gale makes it necessary to reevaluate the existing models for trade during the Mycenean and Minoan.[16]

Even though there are limitations to the use of lead isotope ratios in provenance studies of lead-containing materials, as will be indicated below, the usefulness of this technique has clearly been demonstrated. However, is this technique also applicable to copper ores and copper artifacts?

The answer is yes, according to Gale and Stos-Gale, who have carried out several provenance studies involving copper ores and artifacts. They have stated that since copper ores usually contain small amounts of lead, which, at least in part, is carried into the copper metal as an impurity, the lead isotope ratios in copper ore and copper metal are identical. In certain cases lead isotope ratios in artifacts will therefore be indicative of their origin.[17]

The main problem with this assumption is that the concentration level of lead in ores as well as in the copper metal is so low that contamination with lead from flux, fuel, or alloying metals is easily accomplished. When the contaminating lead has different lead isotope ratios, the measured values of the artifacts will likely be different from those of the copper ore. For that reason the general validity of this method for copper has been questioned.[18]

When lead is added as an alloying element, then the lead isotope ratios will not characterize the copper but the added lead.

Among the various projects carried out by Gale and Stos-Gale, the research on Cycladic copper is of considerable interest. Lead isotope ratios analyses of ore samples from various deposits and smelting sites, such as those on the island of Kythnos and from Laurion on the Greek mainland, as well as analyses of Cycladic copper artifacts provided a preliminary data base for Cycladic copper.[19] They also measured lead isotope ratios in objects from Troy and from Kastri on Syros. They convincingly showed that these objects were related to each other, but that they were distinctly different from Cycladic copper, and they suggested that the copper sources for these objects could be found in Anatolia.[20]

The same team analyzed and characterized copper ores in Cyprus and concluded, based on lead isotope ratios, that some oxhide ingots were made from Cypriot copper.[21] The results also indicated that no Minoan and very few other Bronze Age Aegean objects matched the lead isotope ratios characteristic for Cyprus and proposed that no Cypriot copper could have been used for these objects.[22] These findings raised severe doubts about the widely accepted identification of Cyprus with Alashiya, mentioned in cuneiform writings as an important source for copper during the Middle Bronze Age.[23]

The various research projects presented by Gale and Stos-Gale and co-workers certainly appear to make a convincing case for the use of lead isotope ratios in provenance studies; the specific issues and conclusions discussed cannot easily be refuted. But closer examination of available published data has raised some questions about the general applicability of lead isotope ratios for copper-based objects.

Lead isotope ratios data become all of a sudden much less convincing than those in the publications of Gale and Stos-Gale when data is included from a group of German investigators.[24] This team collected ore samples mostly from various areas in Turkey and reported that there is a lack of specificity among Anatolian sources; they noted that lead isotope ratios are not always constant within one deposit and that there is overlap between lead isotope ratios from ores in Anatolia and the Aegean.

Reedy and Reedy recognized another shortcoming in lead isotope ratios studies, in particular the primitive manner in which data analysis is performed.[25] The system used is one borrowed from geology, where it is used to indicate the age of ore deposits. It uses only two of the three variables and because of strong correlations it shows differences and similarities out of proportion.

Reedy and Reedy undertook the task to apply multivariate statistics to a set of lead isotope ratios. They collected all published data on ore samples and performed discriminant analysis using the well-documented ore deposits of Laurion and Siphnos as comparison groups. They prepared graphs of the data on the ore sources in a scientifically most desirable way. The results were not pretty: ore sources from Laurion and Siphnos do indeed form well-defined groups, but sources in mainland Greece and Anatolia are almost randomly distributed in the graphs, certainly without clear groupings. These results do not appear to be promising for provenance studies involving the sampled ore sources.

However, problems may not be as severe as they appear, and in order to do proper provenance studies it may be

necessary to be very specific in the selection of ore source samples. As Gale and Stos-Gale have indicated in more than one of their publications, it is necessary in copper provenance studies to use selected copper ore samples from potential copper sources only. (In the work of the German team and also in the study by Reedy and Reedy data is included for both lead sources and copper sources.) Comparing data of lead ores and copper ores with little or no regard for which is the likely source for the lead in the artifacts of interest may not be a valid or realistic proposition. Furthermore, more reliable results will be obtained by using proper statistical procedures, glaringly absent not only from the work of Gale and co-workers but also in all other publications dealing with lead isotope ratios studies of ores and/or artifacts.

Since the lead isotope work mentioned above relates to matching artifact with source (category I), the final example will deal with an attempt to group objects with a common ore source through matching lead isotope ratios (category II provenance study).

In the technical study of Chinese bronzes from the Shang and Zhou dynasties, mentioned previously, lead isotope ratios were determined in small samples from each of the approximately four hundred objects.[26] Multivariate statistical calculations were performed on the data, which resulted in the recognition of approximately twelve groupings, some of which were clearly defined, others less so. It is assumed that within each of the groups the lead in each of the objects originated from the same ore source. Most of the bronzes contained lead in excess of 2–3%, indicating that lead was deliberately added as an alloying metal to the copper. Therefore, the lead isotope ratios are indicative of the origin of the lead, not of the copper.

These twelve initial groupings appear to be meaningful, for they correlate strongly with the presumed dates of the objects and other stylistic properties. For example, four of the groups are composed almost totally of objects of Shang date, while other groups contain only later bronzes. Of interest is the observation that vessels identifiable as of "Anyang" style occur in five of the groups. As mentioned above, elemental analyses indicated that these vessels had only one common source for the copper metal; lead isotope ratios suggest that there were possibly five different sources for the lead metal.

Even though this study is currently unfinished, it has indicated the considerable potential of both lead isotope ratios and elemental analysis studies for provenance determinations. After refinement of the groups, taking into account art historical information as well as the compositional data, it will be possible to provide a better classification of these unprovenanced vessels and suggest improved models for the production and distribution of these objects.

As yet, no systematic provenance study on classical bronzes has been completed, although lead isotope ratios have been determined on numerous Greek, Hellenistic, and Roman artifacts.[27] Large numbers of elemental compositions have been reported in the literature, but most compositions published lack a sufficient number of accurately determined minor and trace elements to make them useful in provenance studies. The chance of success of provenance studies on classical bronzes would be considerably enhanced if the following criteria were met:

I All areas of expertise – art historical, archaeological, technical, and scientific – must be represented in the study

2 Information on potential ore sources, on smelting and alloying sites, and on manufacturing places must be researched

3 A large number of artifacts should be included and subjected to (a) extensive stylistic and iconographic examination; (b) technical study to establish method of manufacture and decorating techniques; (c) multielemental analysis of the metal alloy; (d) lead isotope ratios analysis; (e) petrographic and elemental analysis of casting core, if present; and (f) multivariate statistics of combined data sets

If such a study could be undertaken, which for various reasons would not be an easy task, it could confidently be predicted that much important information would be collected. Not only would it be possible to link artifacts to specific metal ore sources but relationships between individual objects could be better defined, and attributions and dating of individual objects could be improved.

Los Angeles County Museum of Art
LOS ANGELES

Notes

1 P. Meyers, unpublished examination results (1978).

2 I. Jenkins and D. Williams, "A Bronze Portrait Head and Its Hair Net," *Record of the Art Museum, Princeton University* 46. 2 (1987), pp. 9–15.

3 C. L. Reedy, *Himalayan Bronzes: Using Technical Analysis to Determine Regional Origins* (forthcoming).

4 C. H. Desch, *Report of the Committee on Sumerian Copper*, British Association for the Advancement of Science, Section H (London, 1928–1938).

5 S. Junghans, E. Sangmeister, and M. Schröder, *Kupfer und Bronze in der Frühen Metallzeit Europas*, vols. 1, 2 (Römisch-Germanisches Zentralmuseum, Berlin, 1968).

6 J. M. Coles, "The Bronze Age in Northern Europa: Problems and Advances," in F. Wendorf and A. E. Close, eds., *Advances in World Archaeology*, vol. 1 (New York, 1982), pp. 287–288.

7 P. Craddock, "Three Thousand Years of Copper Alloys: From the Bronze Age to the Industrial Revolution," in P. E. England and L. van Zelst, eds., *Application of Science in Examination of Works of Art* (Boston, 1985), pp. 59–67.

8 D. Fillières, G. Harbottle, and E. V. Sayre, "Neutron Activation Study of Figurines, Pottery and Workshop Materials from the Athenian Agora, Greece," *JFA* 10 (1983), pp. 55–69.

9 G. Rapp Jr., J. Allert, and E. Henrickson, "Trace Element Discrimination of Discrete Sources of Native Copper," in J. B. Lambert, ed., *Archaeological Chemistry*, vol. 3, *Advances in Chemistry Series*, no. 205, American Chemical Society (Washington, D.C., 1984), pp. 273–293.

10 T. Berthoud, *Etude par l'Analyse de Traces et la Modélisation de la Filiation entre Minerai de Cuivre et Objets Archéologiques de Moyen-Orient (IVème et IIIème Millénaire Avant Notre Ere)*, Ph.D. diss., Université Pierre et Marie Curie (Paris, 1979).

11 See above (note 3).

12 All objects when examined were part of the Arthur M. Sackler collections. Currently, most of the objects are divided between the Arthur M. Sackler Galleries, Washington, D.C., and the Arthur M. Sackler Foundation, New York City.

13 Parts of this study have been reported in P. Meyers, "Characteristics of Casting Revealed by the Study of Ancient Chinese Bronzes," in R. Maddin, ed., *The Beginning of the Use of Metals and Metal Alloys* (Cambridge, Mass., and London, 1988), pp. 283–295; I. L. Barnes et al., "The Technical Examination, Lead Isotope Determination and Elemental Analysis of Some Shang and Zhou Dynasty Bronze Vessels," in Maddin (this note), pp. 296–306; R. W. Bagley, *Ancient Chinese Bronzes in the Arthur M. Sackler Collections*, vol. 1, *Shang Ritual Bronzes in the Arthur M. Sackler Collections* (Cambridge, Mass., 1987), pp. 553–560.

14 P. Meyers, unpublished information.

15 N. H. Gale and Z. A. Stos-Gale, "Lead and Silver in the Ancient Aegean," *Scientific American* 244.6 (1981), pp. 176–192.

16 Z. A. Stos-Gale and N. H. Gale, "The Sources of Mycenean Silver and Lead," *JFA* 9 (1982), pp. 467–485.

17 N. H. Gale and Z. A. Stos-Gale, "Bronze Age Copper Sources in the Mediterranean: A New Approach," *Science* 216 (1982), pp. 11–19.

18 See above (note 7).

19 Z. A. Stos-Gale, N. H. Gale, and U. Zwicker, "The Copper Trade in the South East Mediterranean Region: Preliminary Scientific Evidence," *Report of the Department of Antiquities, Cyprus* (1986), pp. 122–144.

20 N. H. Gale, Z. A. Stos-Gale, and G. R. Gilmore, "Alloy Types and Copper Sources for Anatolian Copper Alloy Artifacts," *Anatolian Studies* 35 (1985), pp. 143–173.

21 See above (note 19).

22 See above (note 17).

23 J. D. Muhly, "Lead Isotope Analysis and the Kingdom of Alashiya," *Report of the Department of Antiquities, Cyprus* (1983), pp. 210–218; N. H. Gale and Z. A. Stos-Gale, "Lead Isotope Analysis and Alashiya: 3," *Report of the Department of Antiquities, Cyprus* (1985), pp. 83–99.

24 T. C. Seelinger et al., "Archäometallurgische Untersuchungen in Nord- und Ostanatolian," *JRGZM*, 1985, pp. 597–659; G. A. Wagner et al., "Geologische Untersuchungen zur Frühen Metallurgie in N. W. Anatolien," *Bulletin of the Mineral Research and Exploration Institute of Turkey* 100/101 (1985), pp. 45–81.

25 C. L. Reedy and T. R. Reedy, "Lead Isotope Analysis for Provenance Studies in the Aegean Region: A Reevaluation," in E. V. Sayre et al., eds., *Materials Research Society Symposium Proceedings*, vol. 123, *Material Issues in Art and Archaeology* (Pittsburg, 1988), pp. 65–70.

26 See above (note 13).

27 R. H. Brill, private communication.

Connoisseurship and Antiquity

George Ortiz

I have been asked to talk on connoisseurship and I do not know how one defines connoisseurship. The connoisseur is the one who knows – he is the expert. Well, I am not exactly the one who knows, the expert; but if connoisseurship can be segmented, I would divide it into aesthetics, the knowledge of authenticity, and straightforward knowledge.

Aesthetics – I cannot tell you anything about aesthetics. It is having an eye, which is inborn but can be developed; it is a personal reaction; it comes from taste; it comes from *accoutumance*, being used to things, being acquainted with them; and it is instinctive. It is like falling in love. I cannot give you a formula for falling in love.

As for the third part, which is knowledge: here scholars have spent a long time studying, researching, and working and thence their expertise, and I cannot start talking about art history, schools of sculpture, or comparing, the way they can. So I am only going to talk about authenticity.

My approach to this question has to be entirely intuitive. Now, intuition, in the Shorter Oxford English Dictionary, is: received or assimilated knowledge by direct perception or comprehension which enables "the immediate apprehension of an object by the mind without the intervention of any reasoning process." I think it is the expression of the unconscious consequence of our stream of consciousness. Consciousness is the totality of impressions, thoughts, and feelings which make up a person's conscious being. Therefore one can develop it by looking at original works of art and *only* original works of art and in the flesh, which means in the museums where there are only authentic pieces, that is to say, in Greece, in Italy, and certain other places, and you acquire and develop the right ethos.

Do not think that one cannot assess works of art with intuition. Allow me to say that Nehru, who was rather an ideologue and not subject to this sort of approach, said in résumé that the solution of problems by way of observation, precise knowledge, and deliberate reasoning is a method of science, but he also added: "Let us therefore not rule out intuition and other methods of sensing truth and reality."[1] I will not go as far as Bergson, who said that "intuition is the

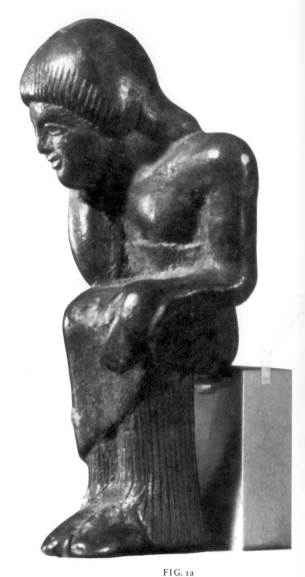

FIG. 1a

Bronze statuette. Front. Basel,
Antikenmuseum, Käppeli inv.
503. Photos courtesy
Antikenmuseum.

FIG. 1b

Left side of statuette, figure 1a.

only method or the only means to know," nor as far as the painter
Hogarth: "the painters and connoisseurs are the only competent judges."
 In 1955, I received a letter from Professor
Langlotz asking me if I would like to purchase the bronze shown in
figures 1a–b,[2] and he sent me the photographs. I was a young man and
crossed France by car and went to see him. I was going to see the god
because he had written *Frühgriechische Bildhauerschulen*,[3] and I was
interested in different bronze centers and different schools of sculpture. I
arrived on his sixtieth birthday in the afternoon, he gave me the bronze
in my hand, and I got a shock: the god became undeified as I saw the
bronze was a fake. It was a fake because the metal was fake, and it was a
fake because the statuette was full of incongruities. For instance the
hand, as in a mitten, is wrapped around the figure's knee in a way
impossible in antiquity. The modeling is unnaturalistic though the pose
is most naturalistic. Different parts of the bronze contradict each other
such as the harsh, slipshod strokes that engrave the fringe of the hair,

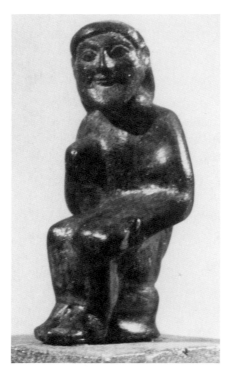

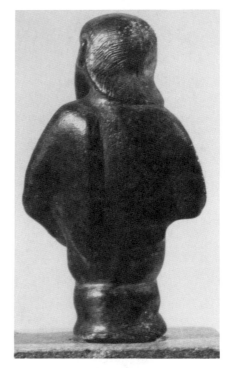

FIG. 2a

Bronze statuette. Front. Munich,
Staatliche Antikensammlungen
und Glyptothek inv. 3707. Photos
courtesy Staatliche
Antikensammlungen und
Glyptothek, Heinz Juranek.

FIG. 2b

Back of statuette, figure 2a.

FIG. 2c

Right side of statuette, figure 2a.

FIG. 2d

Left side of statuette, figure 2a.

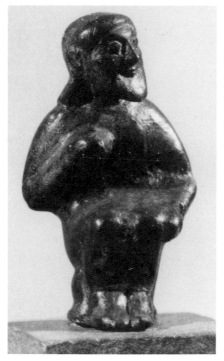

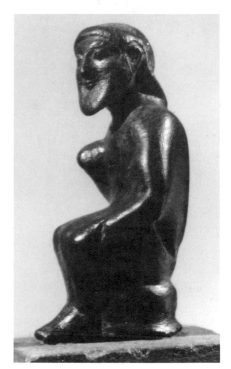

which bear no relationship to the soft, exaggerated contours of the body in general. The same criticism goes for the geometriclike shape of the bottom of the figure's undergarment with the line going from the back of the knees to the bottom of the undergarment creating a sort of cube that in its harshness is completely out of context with the rounded, "Ionian" forms of the rest. The modeling and expression of the left hand are totally impossible for antiquity. In short, the different parts of the figure are in contradiction with one another, not to mention what would be the comical side of the round face, the right breast, the oversized head and feet if they were not ridiculous.

I had written Langlotz what I perceived from the photographs just after receiving his letter and before having the bronze in hand: "My feeling makes me think that this has some relation with the metopes from the mouth of the Sele (that is, near Paestum), the left hand seems worked like the hands on patera handles" – now if you know patera handles from South Italy, that's the way the hand goes up next to the ram – "and the face resembles small figures that are on cista feet from Praeneste." And Langlotz wrote back: "The style is very fine, circa 470 B.C., the school is not clear to me" – I repeat: the school is not clear to me – "I would like to think that it is from a center in Magna Graecia."[4]

How could Langlotz slip up on this? The man who attributed every bronze ever known to a school, in this case said: "I would like to think that it is of a certain place." Now, how can he "like to think." I mean, he should know, and he would have known. There are only two possibilities: Some scholars have made certain allusions, deprecatory remarks about Professor Langlotz, but I do not want to envisage anything but integrity. However, the answer may be the following: Richard Feynman, who received the Nobel Prize for physics in 1965 and whom I had the privilege to know, but who unfortunately died recently, said, "The first principle is that you must not fool yourself, and you are the easiest person to fool," and this, I think, is the explanation. Langlotz bought this bronze as a young man, before he wrote *Frühgriechische Bildhauerschulen*, in Athens about 1924 from Theodore Zoumboulakis. Zoumboulakis had very good objects, but he also had fakes, and I suppose Langlotz fell in love with this piece; when you are a young man you do fall in love with your first purchase, and perhaps this was his first love. Notwithstanding his unbelievable knowledge, he was obviously unable to question his first assessment, and his incapacity to attribute the piece to a definite school is an indirect confirmation of my first impression.

We are talking about a bronze that Langlotz attributed to the Severe Style, circa 470 B.C. As a comparison, we have a

late sixth-century-B.C. bronze which is Ionian, East Greek, and which Langlotz himself attributed to East Greece, and which is in Munich (figs. 2a–d).[5] The Munich figure, which is far earlier in date and therefore, if anything, ought to be more rigorous, more severe, less expressive, is beaming with life and humor. He is a total entity and his different parts are in harmony with one another, there are no contradictions. Both spirit and mood emanate from his whole. No separate parts strike or shock as in the Käppeli bronze (figs. 1a–b). Look and feel the spirit, look at the life, look at the harmony in the whole thing, look at this little fellow – he is provincial but he is real – and look at the other, he looks like a silly dud. This is because as in the Munich bronze a genuine artistic creation, once conceived in the mind, is realized in a natural creative flow, whereas the faker is laboring each part and each detail as a separate whole and therefore, however brilliant he be, he can never realize a sculpture that will exude a natural harmony. He is trying to do something that isn't, trying to express an ethos that is not his and, however remarkable his observation of ancient sculpture, he is not living the day and life, the mores, the religious beliefs of the age that created the originals. The faker is a product of his own day and age and can never free himself from that imprint. The sculptor is a living being projecting himself unconsciously when he creates, and therefore there has to be harmony. A work may be provincial, but it still has to have harmony.

Remark the stiffness of the right leg, the rounded shoulder, the big chin, the mouth – it's ridiculous; look at the fineness of the engraving. Compare the natural lie of the hair on the Munich bronze (fig. 2d) and then look at the hair on the Käppeli figure (fig. 1b).

Now here, I am going to attempt to show you my approach. A Cleopatra head entered the West Berlin museum around 1976 I believe (figs. 3a–b).[6] This is certainly not my period, nor is it my forte. I saw the head in an exhibition, I think in Brooklyn, and I looked and looked at it and I didn't like it. I didn't understand it, it didn't speak to me, though it should have. Why didn't it? I looked again and wondered why, and I looked at those eyes, insipid eyes, and I looked at that pretty face – it is pretty, but is this Cleopatra? Is this Cleopatra who descends from two and a half centuries of Ptolemies, from Ptolemy I Soter, Alexander the Great's friend, the descendant of two and a half centuries of dynasty, of power? Is this the woman who at eighteen ruled with her brother Ptolemy XIII, the woman who was evicted by her brother and his young friends and was reinstated in power at the age of twenty-one by Julius Caesar, who was about fifty-two years old when he arrived in Egypt? She managed to get into the palace rolled in a carpet or some linen and seduced him; but you don't seduce a man of fifty-two,

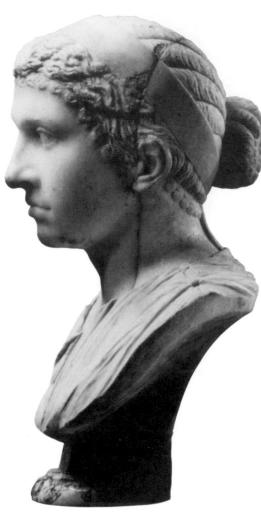
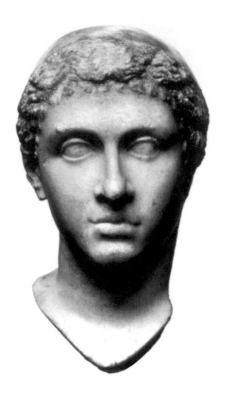

FIG. 3a

Marble portrait of Cleopatra.
Front. Berlin, Antikenmuseum,
Staatliche Museen Preußischer
Kulturbesitz, inv. 1976.10 (from
JbBerlMus 22 [1980], p. 7, fig. 1).

FIG. 3b

Left side of portrait of Cleopatra,
figure 3a. Photo courtesy
Antikenmuseum.

FIG. 4a

Limestone portrait of Cleopatra.
Front. London, The British
Museum inv. 1879.7-12.15 (from
MedKøb 35 [1978], p. 60, fig. 8).

FIG. 4b

Left side of portrait of Cleopatra,
figure 4a (from *MedKøb* 35
[1978], p. 60, fig. 8).

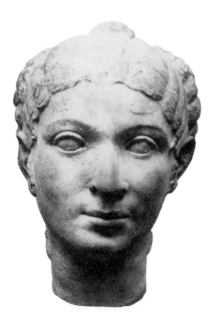
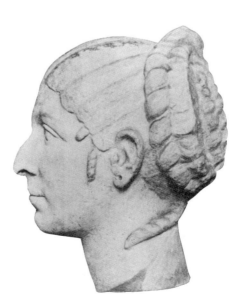

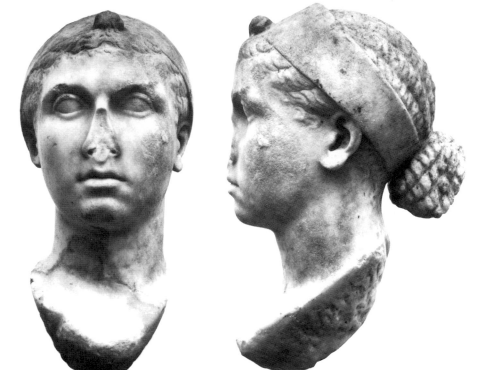

FIG. 5a

Marble portrait of Cleopatra. Front. Rome, Vatican Museums inv. 38511. Photos courtesy Vatican Museums.

FIG. 5b

Left side of portrait of Cleopatra, figure 5a.

much less Julius Caesar, if you are nothing but a pretty thing. You may seduce him for twenty-four hours, forty-eight hours, but you don't seduce him for two years and give him a son and change his outlook on the Roman Empire. Cleopatra had brains, she had real brains and real political sense; she had a personality, a great personality, and her beauty was an inner beauty, and she was intelligent enough to use her womanliness when she needed to. That is her characterization.

Now compare her with the Cleopatra in the British Museum (figs. 4a–b).[7] Look at those eyes, look at the character expressed by that face, look at her mouth: this is Cleopatra. The Berlin head is on a nineteenth-century bust, a bust such as you can find in any pawnshop, and they have put the head on the bust to make it look genuine.[8] Look at the silly little locks over the forehead, they are sloppy for something that finely worked; look at the hair between those little locks and the headband, it has nothing to do with the hair behind the headband, it should be a continuity; and the headband that is the diadem, a symbol of royal power in Ptolemaic times, should not crush and cut into the hair, it ought to rest on top of it. On the Vatican head of Cleopatra (figs. 5a–b),[9] look at the diadem, the way it rests on the hair: the hair is the same below and behind it. Then look at her eyes, the character expressed in her face, the chin; this is Cleopatra. The Cherchell head[10] also shows the diadem to rest upon the hair, though there are free locks covering it in front.

With all these comparisons, even in the profile, once again the so-called Cleopatra in Berlin is characterless and pretty,

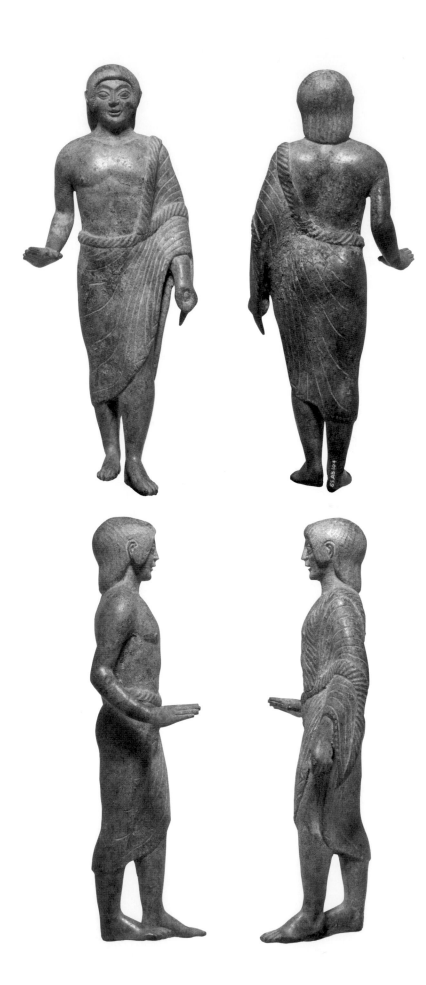

FIG. 6a

Etruscan bronze statuette. Front.
Malibu, The J. Paul Getty
Museum inv. 85.AB.104.

FIG. 6b

Back of statuette, figure 6a.

FIG. 6c

Right side of statuette, figure 6a.

FIG. 6d

Left side of statuette, figure 6a.

she is insipid. The probable explanation is to be found in the coins of Cleopatra, of which the faker is obviously aware; that is why he has made such a flat headband. It should also be noticed that the Berlin Cleopatra has a greasy surface because it has been acid-cleaned; it is difficult to give the surface of marbles a genuine look, and that is why fake marbles are frequently acid-cleaned so that one cannot tell whether the surface is original or not. There is also a reddish color on the forehead, which has generally seeped into the marble and has faded away, perhaps because of the acid treatment; is it colored marble, or is it color that has been added and has seeped in with the acid? I don't know.

I am not, thank God, the only one who thinks the Berlin Cleopatra is a fake; Flemming Johansen of the Ny Carlsberg Glyptotek, which has the greatest ancient portrait collection in the world – over two thousand pieces – also doubts its authenticity.[11]

Let us now turn to an Etruscan bronze (*The Gods Delight*, no. 37) as I was asked to relate my talk to this exhibition (figs. 6a–d).[12] I have never had this bronze in my hands, I have only seen it through the case. I saw it for the first time in Cleveland and it gave me somewhat of a shock because it looks very good, but once again I couldn't understand it and I didn't know why I couldn't understand it. I looked and I looked at those eyes that are trying to give it life, and then the hair that is put on like a wig and looks later in date than the rest. Then there is the whole stiffness and heaviness – it must be a heavy, heavy bronze, solid cast like a lump – and I can almost feel the modern metal. Look at the left leg, like that of a poor woman with elephantiasis; look at that left foot: this is meant to be a sophisticated bronze, a fine bronze. Observe the left arm hanging down, and the drapery – is that a natural way for drapery to fall? On the right side of the bronze the drapery tries to follow the contour of the body from the waist down, while on the left there are labored lines following an unnatural, regular pattern. Unnatural also is the way the drapery lies over the left lower arm; the way the edge of the tebenna drops to meet the edge across the waist is also an impossible stylization.

Look how poorly rendered are the breast muscles, how labored, and how there is no outline for the abdominal muscles. What does the faker have difficulty with? He has difficulty with muscular development, and if you observe the Hirshhorn bronze (*The Gods Delight*, no. 38; figs. 7a–c), you see the collarbone well marked as well as all the stomach muscles; the six sections are well defined as on the Getty Tinia (*The Gods Delight*, no. 39; figs. 8a–d). On the fake this is not so, for the faker is going to give himself away, as it is too difficult to render these details correctly.

Though the faker of the Getty bronze (fig. 6)

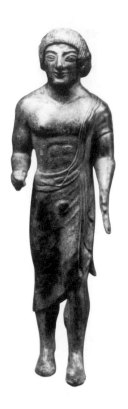

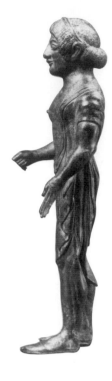

FIG. 7a

Etruscan bronze statuette. Front. Washington, D.C., The Smithsonian Institution inv. 66-5172, ex-Hirshhorn (from *The Gods Delight*, p. 217).

FIG. 7b

Back of statuette, figure 7a (from *The Gods Delight*, p. 218).

FIG. 7c

Left side of statuette, figure 7a (from *The Gods Delight*, p. 218).

has found the models for the different parts of his statuette in the Hirshhorn figure, the Getty Tinia, and the Harvard University Turan (figs. 7, 8, 9),[13] as well as in the Elba bronze in Naples,[14] by putting these together, he has not been able to overcome the problems that I have previously explained that the faker meets and has to solve. Unlike the Hirshhorn bronze where you have the sex indicated by a protuberance, in the Getty bronze (fig. 6a) the faker did not put in the sex. It is difficult to put in the sex, you might not get it quite right, but the Etruscans always put it in. Now look at the difference: in the Hirshhorn bronze there is a spirit and a harmony of the whole, the legs, the arms, and the hand. See how the drapery flows; wear a drapery over your shoulder, a towel, a pashmina, or a shatush: it falls naturally and not like that stiff misrepresentation.

 The Getty Tinia (fig. 8) is a marvellous bronze. Look at the beard and how it is made, how fine the hair is, and compare these features that are so natural here with those of the Getty bronze (fig. 6a), where they appear labored and mechanical.

 At this stage a little history might not be uninteresting. In the early 1950s, during dredging of a canal between Populonia and Vetulonia, the Piombino bronzes were found: the Hirshhorn bronze, the Getty Tinia, and the Harvard Turan. They were bought by Minassi in partnership with Fausto Ricardi, who was the greatest faker of this century, a fabulous faker who lived roughly between 1900 and 1980. This is the sort of thing you like, facts, history . . . Ricardi then had the Piombino find in his workshop for six weeks.

FIG. 8a

Etruscan bronze Tinia (Zeus).
Front. Malibu, The J. Paul Getty
Museum inv. 55.AB.12.

FIG. 8b

Back of Tinia, figure 8a.

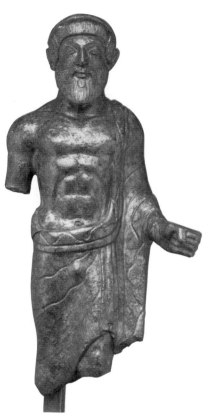

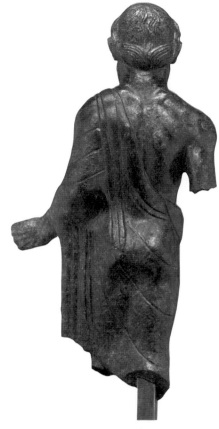

FIG. 8c

Right side of Tinia, figure 8a.

FIG. 8d

Left side of Tinia, figure 8a.

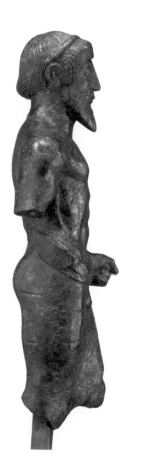

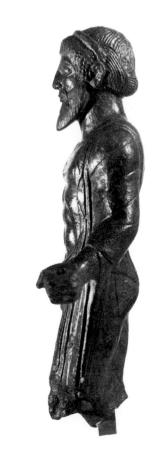

The greatest faker of this century had the Piombino bronzes, and he made the Getty bronze statuette, he made it based on these three pieces. Compare the drapery; Ricardi took different elements from the different bronzes, as well as from the Elba bronze, which was obviously a bronze from the same "ambiance," found in 1764 and now in the Naples Museum, which any Italian, especially a good faker, would know about; the Elba bronze has exactly the same dots on the bottom of its drapery as the Getty bronze (fig. 6). For a series of fakes by the same faker, but of an earlier period and less good, there is the article by E. Homann-Wedeking.[15]

After the Piombino find, I saw fakes in Rome at Ciliano's that were made by Fausto Ricardi, but they didn't pass the mark. I criticized the fakes and unfortunately told Ciliano why they were fake. So I suppose these (the Getty bronze, fig. 6, and others) are Ricardi's second try.

Now look at the backs of the Hirshhorn bronze and the Getty Tinia (figs. 7b, 8b). The hair lies from top to bottom in harmony, whereas on the Getty bronze (fig. 6b) it is made up of individual segments as though it had been raked; it is not just one continuity. Since when do you have hair combed like that? There are some African hairdos like that, but not in Etruscan times. Also, if one compares the left profile of the Getty bronze (fig. 6d) with that of the Hirshhorn bronze (fig. 7c) and that of the Getty Tinia (fig. 8d), one should notice the lack of depth, of flesh.

There are more fakes by the same faker: a Käppeli bronze (fig. 10),[16] which I have never had in my hands, but it is by the same forger; and the bronze that Professor Jucker saw in 1974 (fig. 11),[17] and which I heard about. Let us not forget that Ricardi is living in Rome. I can remember that when I was a young man visiting Rome, in the district where the artisans worked there were women who plied their trade who went around smoking, with a gesture like that of the Jucker bronze, holding their bag and swinging; that was life in postwar Italy, that's not Etruscan. That's not the way their Etruscan counterparts did it. This is the way life works: Ricardi is inspired, he is influenced by his day and age and – unconsciously and without realizing it – he makes something that looks rather comical. If you want more fakes by the same faker, you have two bronzes that I have never examined but only seen photographs of, in the Emil C. Bührle collection in Zürich.[18]

If you want to make analyses of these bronzes and want to go about it scientifically, I suggest you thoroughly study the Hirshhorn bronze, the Harvard Turan, and the Getty Tinia as to surface, patina, metal composition, etc., making sure that you choose the parts that are original, for they have been restored as certain parts of them had

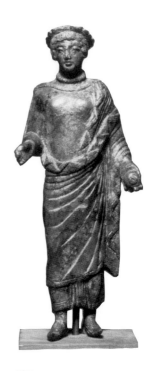

FIG. 9

Etruscan bronze Turan (Aphrodite). Cambridge, Mass., Harvard University, Arthur M. Sackler Museum, Alpheus Hyatt Fund, Francis H. Burr Fund and through the generosity of twenty-four friends of the Fogg, inv. 1956.43. Photo courtesy Harvard University Art Museums.

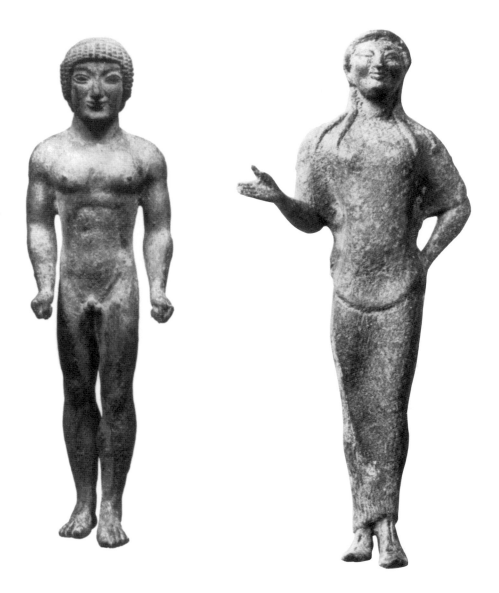

FIG. 10

Etruscan bronze statuette. Basel, Antikenmuseum, Käppeli inv. 513 (from *Kunstwerke der Antike* [1963], B 15).

FIG. 11

Etruscan bronze kore. Whereabouts unknown. Photo courtesy Dr. Ines Jucker.

active cuprous chloride. Then you take samples of and study the surface and patination of these, the Bührle bronzes, and the Getty bronze (fig. 6), and you will be able to start comparing; this ought to prove a most enlightening experience. Also, take a microscope and look at the way the fingers are done – whether Ricardi has used the same instrument for the fingers, the toes, between the toes. That is the way I suggest you approach it, to find out whether I am completely crazy or whether I am on to something.

Now, if we don't clear out these fakes, how can one build up the right sense of ethos? How do I get the right sense of ethos? Because my approach is one of feeling, because I abstract the mind and, like a child in front of something, I let it speak to me and my whole stream of consciousness reacts to it. But how can I build up this stream of consciousness, how are the young of tomorrow going to build it up if they are going to work with computers, with photographs, and with objects that have been in and are accepted by literature as genuine

for a hundred years or so? We must clear them out before it is too late.

I have always thought the Etruscan head in the British Museum a fake (figs. 12a–c).[19] In anticipation of this talk, they let me handle it in the British Museum, and it is a solid lump of beautiful fakery; its maker has cast in the damage that weathering could have perpetrated.

And then there is the famous Tarentine bronze mask formerly in the Loeb collection and now in Hamburg (fig. 13). Sieveking wrote about this piece and thought it was very odd;[20] he could find nothing comparable except terracotta masks from South Italy, which have nothing to do with it but are at its source; it weighs over a kilo. I have had it in my hands, and the metal is absolutely modern. It is cold, mechanical, we have no explanation as to its use; the groove above the forehead locks forms an unnatural line, but is necessary since the faker has got his proportions wrong, and the chin is not an antique chin.

These objects are in the literature since 1895. As for the British Museum head (fig. 12), they have done a spectrographic analysis of the metal in 1965, and the result of it is that there is nothing that conflicts in the metallurgy with what a head should be in that period. The bronze probably has a core[21] and if so, a thermoluminescence test would surely prove most useful.

Then there is another bronze in the British Museum that was in the Montague sale in 1897 (fig. 14),[22] which in those days would have meant that it was known long before that. The faker never works *ab nihilo*, unless he makes an awful figure. Here is probably the inspiration for the hair style of the British Museum's head (fig. 12c). On the Montague head, the roll at the back is in keeping with the hairband, whereas on the British Museum head the function of the hairband has been misunderstood. The Ariccia head in Copenhagen (fig. 15)[23] has the same hole in the back of the head as the British Museum head, and as for the small 4-cm-high head in Berlin (fig. 16),[24] which I have never had in my hands and have never seen except on this photograph, I don't know whether it is right or wrong; there is red oxidation here and it seems obviously to have been depatinated. If the head is right, then it is an inspiration for the British Museum head; if it is wrong, it is another work by the same faker in the same spirit.

The time allotted for this talk will not enable me to go into all the details, therefore, please excuse me for the incompleteness of my exposé with respect to certain items that I have already brought up and others that are to follow.

There is the little bronze kouros in the British Museum which I examined also, having always thought it to be a fake (fig. 17);[25] Dr. Dyfri Williams agrees with me, and the bronze has been

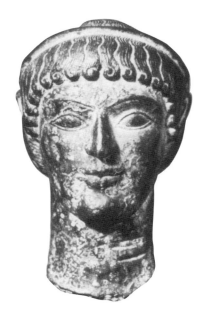
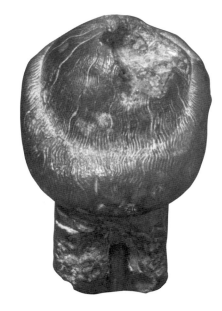
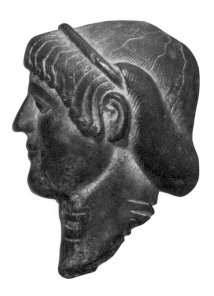
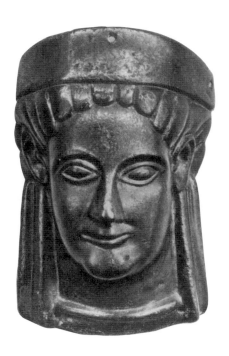

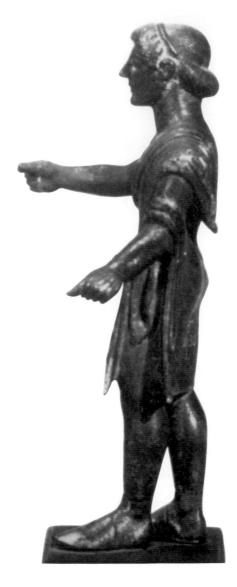

FIG. 14

Bronze statuette. London, The British Museum inv. 1897.10-30.1 (from S. Haynes, *Etruscan Bronzes* [London, 1985], p. 169, no. 76).

taken off exhibition.[26] Without going into details, if one looks at genuine bronzes and then at the kouros in the British Museum and another kouros in Rhode Island (fig. 18),[27] one can feel the difference in spirit. Observe the sharp, unnatural plate beneath the feet of the British Museum statuette, the waist, the way the forearms are cast with the hips – it is not as bad as the Rhode Island bronze – but its plastic rendering is just impossible for a genuine ancient creation. Look at the eyes, the whole spirit is just not there. These bronzes express a feeling that is all wrong and that bears no relation to a genuine product of the Archaic period in Greece. One has to use one's eyes. If you observe the hair, you see that the faker has made a little dot in the center of the Rhode Island piece, and he has worked around and around as with a compass to make it regular, because he does not know quite how to do it; on the British Museum piece the hair is more successful.

Let us now discuss some recent forgeries; the two previous bronzes, the one in the British Museum and the one in

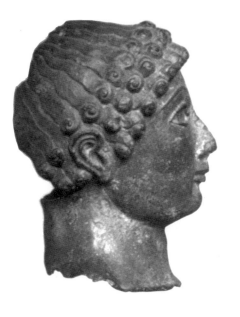

FIG. 15

Etruscan bronze head.
Copenhagen, Ny Carlsberg
Glyptotek inv. 29. Photo courtesy
Ny Carlsberg Glyptotek.

FIG. 16

Bronze head. Berlin,
Antikenmuseum, Staatliche
Museen Preußischer Kulturbesitz,
inv. misc. 8195. Photo courtesy
Antikenmuseum.

Rhode Island, may have been based on one in Athens (fig. 19).[28] Found in
the Ptoon in Boeotia in 1882 it was published very quickly for the
period, five years later in *Bulletin de Correspondance Hellénique*. It is
supposed to be an Argive bronze, though some think it a local imitation
of an Argive bronze, and I am tempted to think that it is a local
provincial imitation of an Argive bronze which also served as one of the
models for the bronze kouros that entered the Louvre recently (figs. 20a–
b).[29] The Louvre bronze has been published by Cl. Rolley,[30] who brings
up as a comparison for it the Ptoon bronze, which he considers to be an
Argive original. However, one can see how different is the spirit. The
Ptoon bronze has a certain provincial touch to it, but it is a cohesive
whole, and it exudes a certain naive charm, whereas the Louvre kouros,
which is meant to be a very fine Archaic achievement from a major
center, is once again spiritless and, as I call them, a silly dud. Its nature is
totally different. Also the Louvre bronze is covered with all these little
pockmarks that are meant to simulate former bronze disease, which they
are not, and which have been made by the faker. The hands are all wrong
with their twist at the wrists; the attachment of the hand to the wrist as a
continuation of the forearm is not rendered in keeping with ancient
renderings. Yet this is meant to be a very fine bronze, it is meant to be
like Kleobis and Biton, to which Rolley compares it, though it is a little
later than Kleobis and Biton.

The faker has had difficulty in rendering the

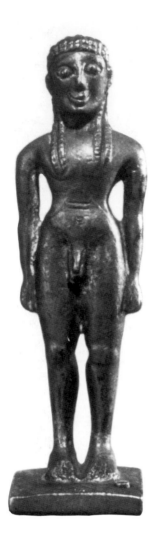

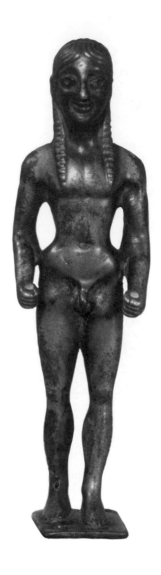

plasticity of the eyes and in giving them an expression. No wonder he has difficulties – he is not in the spirit of the period, and so there are problems; one should note that fakers have problems, and among these the main stumbling block is the rendering of a spirit that expresses the ethos of the period. Let us note en passant: the uniformity and type of wear and tear over the whole figure, the pockmarks already mentioned, the line of the back of the figure when seen in profile, and the unnatural way the head is attached to the trunk.

 The famous Munich Zeus (figs. 21a–b)[31] was offered to me before Munich bought it. It was put in my hands and I didn't like it, but it is very well made. It is a master fake in my opinion, very, very well made. It is very difficult to perceive and even more difficult to define what is wrong with it, but I felt uncomfortable enough not to acquire it though I was never able to decide with certainty. Recently I went to Munich and asked Professor Vierneisel if I might examine it, and he had it taken out of a sealed case which had not been opened for four years and let me examine it all morning. I wish to

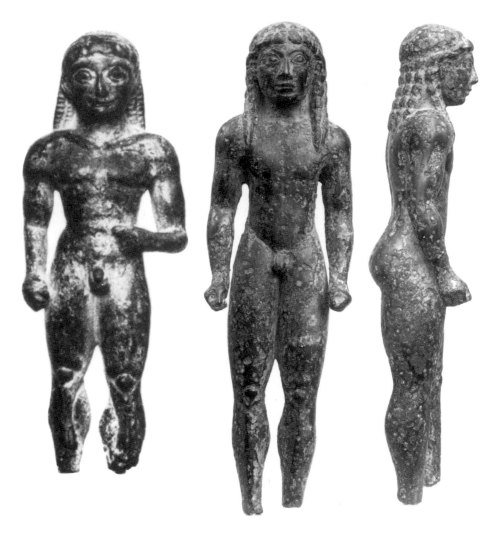

FIG. 19

Bronze statuette. Athens, National Museum inv. 7382 (from Cl. Rolley, *Monumenta graeca et romana*, fasc. 1, *The Bronzes*, vol. 5 of *Greek Minor Arts*, H. F. Mussche, ed. [Leiden, 1967], pl. 17, fig. 55).

FIG. 20a

Bronze kouros. Front. Paris, Musée du Louvre inv. MNE 686. Photos courtesy Musée du Louvre.

FIG. 20b

Right side of kouros, figure 20a.

express my gratitude to him, because he knew perfectly well I suspected it was a fake, and after I examined it, I told him I was now sure it was a fake. Notwithstanding that, he had the slides for my talk made for me, for which I am most grateful.[32]

Now, the first thing is that we are supposed to have a Corinthian bronze, but look at those eyes just cut out and stupidly flat. He is meant to be a god, the king of all gods, the head of all the Olympian gods, he should have some real presence. As for those open legs, you don't open your legs at that angle (a very attenuated V) in the Archaic period, you keep your legs almost on parallel lines. One may have a somewhat similar stance when one is about to throw a javelin, when one leg is forward like here and the back leg considerably more open. His stance is wrong, and it is also wrong if he is meant to be about to throw what he is holding in his upraised right hand. He is simply holding up what he has in his right hand. His whole stance doesn't really work. Of course, the inspiration for the thunder in the left hand and its different form in his right hand as well as the hands themselves[33] is to be found in the seated Lykaion Zeus (fig. 22).[34] Furthermore, the Lykaion

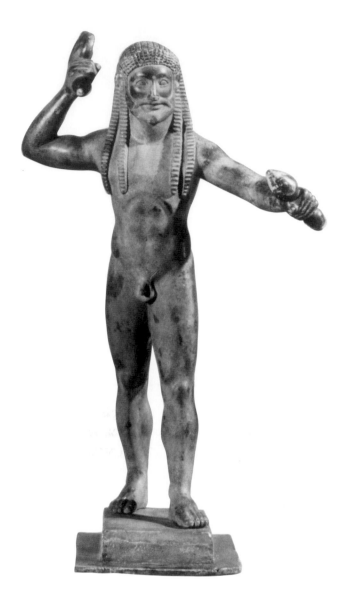

FIG. 21a

Bronze statuette of Zeus. Front.
Munich, Staatliche
Antikensammlungen und
Glyptothek inv. 4339. Photos
courtesy Staatliche
Antikensammlungen und
Glyptothek, Heinz Juranek.

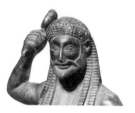

FIG. 21b

Head of Zeus statuette, figure 21a.

Zeus has also been the model for the beard and mustache of the Munich
figure, but it is to be noted that the Lykaion Zeus is a harmonious whole,
and his face, especially his eyes and cheeks, give a feeling of life. And in
spite of the fact that he is seated, he is far more alive than the dull, static
figure which is meant to express a certain dynamism. I see in the Munich
Zeus an unnatural contrast between the sharpness and hardness of the
hair and the line of the beard in relation to the figure's cheeks, the general
fleshy blandness of the face that is also to be found in his buttocks and
his thighs, especially noticeable in the profile views. The line and
rendering of the beard and the mustache as well as the lack of eyebrows
are artistically so poor and in such contrast to the hair and supposed
sophistication of an Archaic bronze from a major center that there is, in
my opinion, no way the figure can be genuine.

 By comparison, the British Museum
banqueteer (fig. 23)[35] is not only a masterpiece but it is a real Corinthian
bronze from the same school and of about the same date, circa 520 B.C.,

that the Munich Zeus is meant to be. Now, if one looks at the details of the banqueteer, he is full of spirit: the plastic quality of his arms and bust (note the collarbones), the engravings of his beard, his smile, etc., exude life. One might say that the subjects are different, that a god has to be serious whereas a banqueteer may be full of fun, may have had too much to drink. This is possible but, I repeat, there is an aliveness, a spirit expressed in the banqueteer that is full of harmony and unity.

Technically there is something very odd about the Munich Zeus, which is the oxidation on the tip of his nose and on all the other protuberances of the statuette, such as the point of the sex, the point of the elbow, the points of the thunderbolts, etc.; they all have the same chipping, the same oxide, and they are as hard as all the rest of the statuette. If you hit them, they ring metallic, heavy, and if you flick them, nothing comes off, as nothing should if the bronze is modern. It is impossible in an ancient bronze to have exactly the same oxidations, cuprous chloride conditions on different parts that exhibit an identical development and are in an identical solidified state. Furthermore, on the hair, on the two hairbands, there are the traces of vents toward the center of the back of the head which, curiously, have not been worked out and which might indicate that the hair may have been made in two halves. Furthermore, on the "volute thunderbolt" in the right hand there is a protuberance and a depression that are meant to give the impression of damage by bronze disease, when in fact these details have, in my opinion, been cast with the bronze. That of course would be impossible if the bronze were ancient, for had there been a casting fault or vent, it would have been worked over in the cold and be invisible today, for the Zeus statuette is a finished product.

As to the bronze base, it has a funny line going around it which I cannot explain. The statuette has been put on the base like an Etruscan bronze as it has tangs under the feet that have been smashed up flat on the underside of the base to transform them into rivets that hold the statuette in place.

If the Munich Zeus is not engraved or better detailed where one would expect it to be, it is simply that this is one of the main difficulties a faker meets, as it is here he is most likely to give himself away. Furthermore, what a faker cannot achieve is the unity, harmony, and spirit that a genuine Greek bronze from a major center always exudes.

Now allow me to bring up certain bronzes in the exhibition *The Gods Delight* and relate them to two or three pieces in my collection.

Though the two statuettes of Hermes (*The Gods Delight*, nos. 8 and 9; figs. 24, 25)[36] are not exactly the same

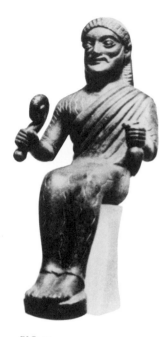

FIG. 22

Bronze statuette of Lykaion Zeus. Athens, National Museum inv. 13.209 (from K. Papaioannou et al., *L'art grec*, J. Mazenod, ed. [Paris, 1972], p. 381, fig. 314). Photo courtesy Editions Citadelles, Paris.

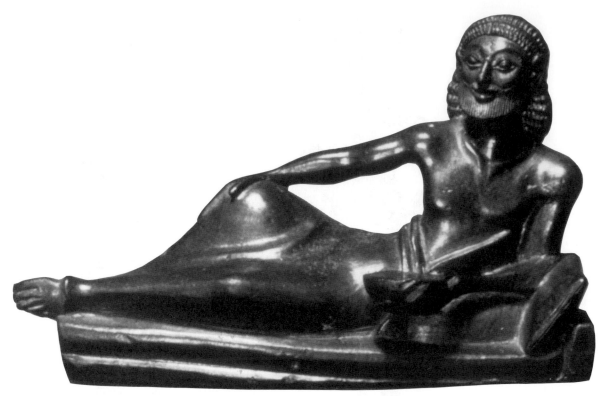

school as the British Museum banqueteer, they are of the end of the sixth
century B.C. and beaming with spirit. The more one looks at genuine
bronzes, the more one marvels. Whether the Hermes Kriophoros (fig. 24)
is Arkadian or Sikyonian, I don't know. I think more probably that he is
a marvellous Arkadian bronze, but the other Hermes (fig. 25) is
Sikyonian, I am sure; Langlotz attributed it thus, so does Marion True,
and so do many other people. I think it is important to look at the
profiles for what they tell us of the period.

 In relation to these let me bring up a marble
that is the finest object in my collection by far; it is probably a
representation of Hermes (fig. 26).[37] It was found a long, long time ago
on the side of a field in a heap of stones at Sikyon; and here is the miracle,
the proof that we have been waiting for – that Langlotz had been waiting
for – because it is a product of the same school as the Hermes
Kriophoros (fig. 25), though it is slightly later in date. Now, Langlotz
says about Sikyon (allow me just to read in translation the two lines in
his chapter on Sikyon, which fit this beautifully; I wish he were here):
"The thinner drapery of the Sikyonians clings tightly to the body, forming
few but very marked lines and pleats. The latter . . . fit the new rhythm of
the stance. Their function [is] to stress the structure of the build."[38] And
life is coming through – this is High Classical or Severe Style.

 There is a little bronze Kriophoros in my
collection, probably also a Hermes (fig. 27),[39] of which the head is
missing. I don't know whether it is from an Attic workshop – the
sensitivity of the animal is extraordinary, it is a little bit like certain Attic

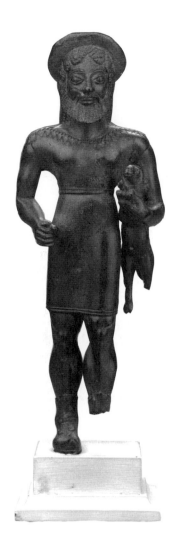

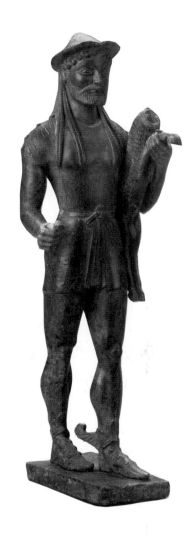

rhyta in terracotta – from a Peloponnesian (Sikyonian, Corinthian, or Arkadian), or from a Sicilian workshop. I would like to know and would be most grateful to anyone who can help me pinpoint the school. The lightness of its drapery also fits Langlotz's characterization of the Sikyonian school, and I would place it chronologically after my marble figure.

The marble kouros (fig. 26) stands with the right foot forward rather than the left as in the three bronzes brought up as comparisons (figs. 24, 25, 27), for he is more recent and exemplifies an innovative transition. He epitomizes, I think, the birth of High Classical or early Severe Style, when the human form is embodied with new life as it starts its astonishingly rapid evolution toward naturalism.

Let us now look at my Polykleitan bronze, which I think is end of the fifth century B.C. (figs. 28a–b);[40] it is reputed to have been found with the Getty "Dead Youth" (figs. 29a–c),[41] and I am sure that they were found together. Though it is very difficult to compare the two in view of their different positions, the different views in the illustrations, etc., let us try. The movements of the hands – the left hand on my bronze and the right hand on the Getty bronze – and their

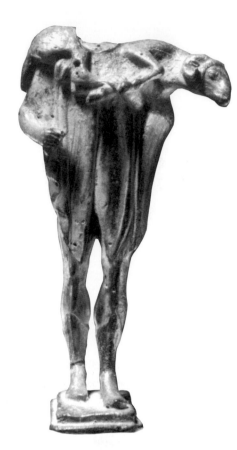

FIG. 26

Marble statue of Hermes(?).
Geneva, George Ortiz collection.
Photo: D. Widmer, Basel.

FIG. 27

Bronze statuette of Kriophoros.
Geneva, George Ortiz collection.
Photo: R. Steffen, Geneva.

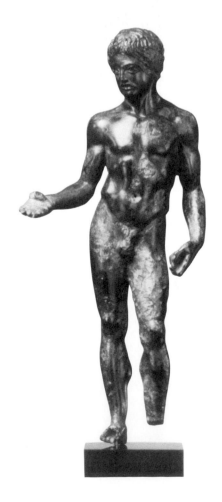

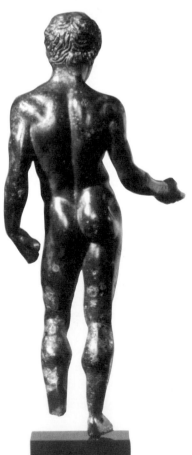

FIG. 28a

Bronze Polykleitan youth. Front.
Geneva, George Ortiz collection.
Photos: D. Widmer, Basel.

FIG. 28b

Back of youth, figure 28a.

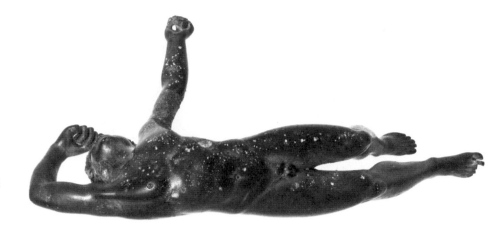

FIG. 29a

Bronze statuette of a "Dead
Youth." Front. Malibu, The J. Paul
Getty Museum inv. 86.AB.530.

FIG. 29b

Left side/front view of "Dead
Youth," figure 29a.

FIG. 29c

Back of "Dead Youth," figure 29a.

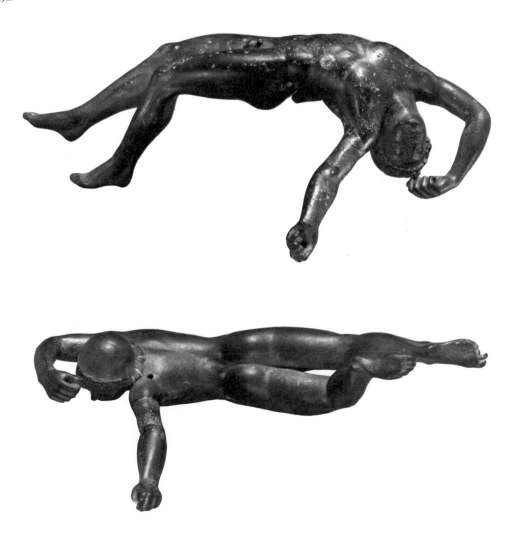

freedom are very similar; the mouths are very similar; and as to the surfaces, they are also very similar, where the surface is not damaged on mine. They both have the same blackish patina, and when we (David Scott, Jerry Podany, and I) looked at them both in the Getty laboratory, these two scientists also observed that the surfaces did indeed look very much the same. Of course, the Getty "Dead Youth" is a magnificent masterpiece in superlative condition.

Among many comparisons there is a marble relief in Copenhagen,[42] which is Attic, 420–400 B.C. I know that Marion True thinks that the "Dead Youth" is Attic. I have no objection to this. The mouths on the two bronzes (figs. 28, 29) and on the youth of the Copenhagen relief are very close; likewise the hand and the fingers of the old man on the relief are very similar to those of the left hand of my Polykleitan youth; but then of course we are, in my opinion, in the same period, consequently it should be so. By the way, in the detail of my bronze (fig. 28) the left eye is very close (I am speaking from memory) to horseman 121 on slab 29 of the North Frieze of the Parthenon, which confirms that we are still unquestionably in the fifth century B.C., I think.

As to the "Dead Youth" in the Getty, I don't think that it is in the Severe Style. One ought to date by the latest characteristics, and though the eyes and the face look fairly severe, the mouths of the pieces we are discussing are very close, and when taken in conjunction with the freedom of the hand and the way the body contorts in a surprising manner for the first half of the fifth century, as Marion True herself points out, it can in no way be earlier than toward the end of the fifth century B.C. in my opinion. One always has to date something by its latest characteristics and not by its earliest.

I feel that we should finish on the back views of my Polykleitan youth (undamaged surface) and the "Dead Youth" (figs. 28b, 29c) for, whether they are of the same period or possibly from the same workshop – though I wouldn't go as far as to say this – their surface patina and other details are very similar.

GENEVA

Notes

1 Excerpt from: Jawaharlal Nehru, *Discovery of India*, in the chapter "Life's Philosophy":

 The real problems for me remain problems of individual and social life, of harmonious living, of a proper balancing of an individual's inner and outer life, of an adjustment of the relations between individuals and between groups, of a continuous becoming something better and higher, of social development, of the ceaseless adventure of man. In the solution of these problems the way of observation and precise knowledge and deliberate reasoning, according to the method of science, must be followed. This method may not always be applicable in our quest of truth, for art and poetry and certain psychic experiences seem to belong to a different order of things and to elude the objective methods of science. Let us therefore not rule out intuition and other methods of sensing truth and reality. They are necessary even for the purposes of science.

2 Basel, Antikenmuseum, Käppeli, inv. 503, ex-Langlotz collection.

3 E. Langlotz, *Frühgriechische Bildhauerschulen* (Nürnberg, 1927).

4 Letter of June 27, 1955.

5 Munich, Staatliche Antikensammlungen und Glyptothek inv. 3707, M. Maass, *Antikenmuseum München: Griechische und römische Bronzewerke* (Munich, 1979), p. 20, no. 7.

6 Berlin, Antikenmuseum inv. 1976.10, K. Vierneisel, "Die Berliner Kleopatra," *JbBerlMus* 22 (1980), pp. 5–33.

7 London, British Museum inv. 1879.7-12.15, limestone

8 This is the sort of treatment that an ancient head would have received from the Renaissance through the nineteenth century.

9 Vatican Museums inv. 38511.

10 Cherchell, Archaeological Museum inv. 31.

11 F. Johansen, "Antikke Portrætter af Kleopatra VII og Marcus Antonius," *MedKøb* 35 (1978), pp. 55–81.

12 Malibu, the J. Paul Getty Museum inv. 85.AB.104, *The Gods Delight: The Human Figure in Classical Bronze*, The Cleveland Museum of Art and other institutions, November 1988–July 1989 (A. P. Kozloff and D. G. Mitten, organizers) (Cleveland, 1988), no. 37. Numbers throughout this article refer to the entries in that catalogue.

13 Washington, D.C., Smithsonian Institution inv. 66-5172; Malibu, the J. Paul Getty Museum inv. 55.AB.12; Cambridge, Mass., Arthur M. Sackler Museum inv. 1956.43, *The Gods Delight* (note 12), nos. 38, 39, 43.

14 Naples, National Museum inv. 5534, H. Jucker, "Etruscan Votive Bronzes of Populonia," in S. F. Doeringer, D. G. Mitten, and A. Steinberg, eds., *Art and Technology* (Cambridge, Mass., 1970), pp. 199–200, figs. 8a–f.

15 E. Homann-Wedeking, "Bronzestatuetten etruskischen Stils," *RM* 58 (1943), pp. 87–105.

16 Basel, Antikenmuseum, Käppeli, inv. 513, E. Berger, H. A. Cahn, and M. Schmidt, *Kunstwerke der Antike aus der Sammlung Käppeli* (Lucerne, 1963), B 15.

17 I am deeply indebted to Dr. Ines Jucker for the photograph of this object and would like to express my thanks to her.

18 H. Jucker (note 14), pp. 206–207, figs. 23a–g.

19 London, British Museum inv. GR.1898.7-16.2, ex-Castellani and Tyskiewicz collections.

20 J. Sieveking, "Archaische Bronze aus Tarent," in *Festschrift für James Loeb* (Munich, 1930), pp. 91–94. On December 20, 1989, not being able to find the inventory number for this bronze, which the Getty editor required, I telephoned the director of the Hamburg Museum für Kunst und Gewerbe, Dr. Wilhelm Hornbostel. He gave me the number and informed me orally that he had published the head as a forgery in 1974 in the reports of the museum and that the forgery had been confirmed by the metal analysis. Not having had access to this publication, I was ignorant of the article and look forward to receiving a copy of it from Dr. Hornbostel himself.

21 See the hole in the back of the head, figure 12b.

22 London, British Museum inv. 1897.10-30.1.

23 Copenhagen, Ny Carlsberg Glyptotek inv. 29.

24 Berlin, Antikenmuseum, inv. misc. 8195.

25 London, British Museum inv. GR.1905.6-10.1. I should like to thank Professor Brian Cook, Dr. Dyfri Williams, and all the others who made it possible for me to examine these various objects in the British Museum in January 1989.

26 Dyfri Williams, in a letter dated March 10, 1989: "Since your most enjoyable visit here, I have taken off show that small fake kouros and consigned it to the store. I am very grateful to you for pointing it out to me."

27 Providence, Rhode Island School of Design, Museum of Art inv. 54.001, D. G. Mitten, *Museum of Art, Rhode Island School of Design: Classical Bronzes* (Providence, R.I., 1975), pp. 34–40, no. 11.

28 Athens, National Museum inv. 7382, M. Holleaux, "Fouilles au temple d'Apollon Ptoos," *BCH* 11 (1887), p. 354, pl. X.

29 Paris, Musée du Louvre inv. MNE 686, ex-Gillet collection.

30 Cl. Rolley, "Une statuette archaique au Musée du Louvre," *RA* 1 (1975), pp. 3–12.

31 Munich, Antikensammlungen inv. 4339, G. Kopcke, "Eine Bronzestatuette des Zeus in der Münchner Glyptothek," *MüJb* 27 (1976), pp. 7–28; Maass (note 5), pp. 17–19, no. 6.

32 I am all the more indebted to Professor Vierneisel for all the help extended to me during my trip to Munich since he does not agree with my assessment of the Zeus. In his letter dated January 19, 1989, accompanying the slides of the Zeus, he wrote (translated from the German):

I can understand your scepticism toward the Zeus, but I have been tackling the problem of this figure slightly longer and have also examined again more in detail the metal surface of other pieces in our collection. I cannot share your doubts and tend to think rather that this Zeus is a work that is quite out of the ordinary and therefore is confusing because of its uniqueness.

33 Kopcke (note 31), pp. 10ff.

34 Athens, National Museum inv. 13.209.

35 London, British Museum inv. 1954.10-18.1.

36 Boston, Museum of Fine Arts, H. L. Pierce Fund, inv. 04.6 and 99.489, *The Gods Delight* (note 12), nos. 8, 9.

37 Preserved H: 43 cm.

38 Langlotz (note 3), p. 51: "Das dünnere Gewand der Sikyonierin schmiegt sich eng dem Körper an und bildet wenige, sehr prägnante Faltenzüge. Diese . . . müssen ihrerseits dem neuen Rhythmus der Körperhaltung entsprechen. Ihre Funktion, die Struktur des Baues zu betonen."

39 Preserved H: 11.2 cm. Ex-Giorgio Sangiorgi collection, Rome, *Meisterwerke griechischer Kunst*, Kunsthalle Basel, June–September 1960 (catalogue edited by Karl Schefold), no. 254; *Hommes et Dieux de la Grèce Antique: Europalia 82, Hellas-Grèce*, Palais des Beaux-Arts, Brussels, October–December 1982 (catalogue edited by H. F. Mussche et al.), no. 146.

40 H: 16.6 cm. Consider for the period the bronze from Cyprus, New York, the Metropolitan Museum of Art 74.51.5679 (CB 453), which, though very different in build, is somewhat of the same spirit. It represents the same sort of figure and has a very similar left hand.

41 Malibu, the J. Paul Getty Museum inv. 86.AB.530, *The Gods Delight* (note 12), no. 10.

42 Copenhagen, Ny Carlsberg Glyptotek inv. 197.

List of Ancient Objects Illustrated

This list includes the catalogue number from
The Gods Delight, where pertinent.

Athens, Agora Museum

Mold for statue of a kouros, inv. S 741, p. 132

Mold for head of a kouros, inv. S 797, p. 132

Fragment of mold for drapery, inv. B 1189l,
p. 139

Fragment of mold for fingers, inv. B 1189f,
p. 139

Hermes, inv. B 248, p. 140

Athens, National Museum

Marble head of warrior from Temple of
Aphaia, Aegina, inv. 1938, p. 127

Head of warrior from the Akropolis, inv.
6446, p. 127

Head of a griffin-protome, inv. 7582, p. 134

Archaic terracotta akroterion from Kalydon,
no inv. no., p. 211

Statuette of Apollo, inv. 16365, p. 215

Statuette of an athlete, inv. 6445, p. 215

Statuette of Athena Promachos, inv. 6447,
p. 216

Statuette of Dionysos, inv. 15209, p. 218

Male figure with himation, inv. 13398, p. 218

Statuette of a kouros, inv. 7382, p. 271

Statuette of Lykaion Zeus, inv. 13.209, p. 273

Augst Museum

Statuette of Venus, inv. 60.2561, p. 228

Autun, Musée Rolin

Gladiators, inv. 3033.V.201, p. 173

Baltimore, The Walters Art Gallery

Seated flute-player, inv. 54.789, p. 128, cat.
no. 1

Statuette of a striding man, 54.1046, p. 221

Wrestling group with Ptolemy V as victor, inv.
54.1050, pp. 222, 224–226

Basel, Antikenmuseum

Statuette, inv. Käppeli 503, p. 254

Etruscan statuette, inv. Käppeli 513, p. 265

Bath, Roman Baths Museum

Head of Minerva, inv. 1978-1, pp. 118–119

Bavay, Musée de Bavay

Head of Jupiter, inv. 59.B.1, p. 169

Lar, inv. 59.B.14, p. 170

Base of a statuette, inv. 69.B.1, p. 172

Ornamental corner plate, inv. 69.B.70, p. 172

Berlin, Antikenmuseum, Staatliche Museen Preußischer Kulturbesitz

Kouros statuette from the Heraion of Samos,
inv. 31098, pp. 28, 131

Handle of a volute-krater, inv. M 149 b, p. 96

Kriophoros, inv. misc. 7477, p. 129

Attic red-figured kylix by the Foundry Painter,
inv. F 2294, p. 133

Hellenistic mirror, inv. 10555, p. 186

Gorgoneion, inv. misc. 8183, p. 192

Copper or bronze leaves, inv. P55, p. 193

"Ball-player," inv. 8089, p. 217

Marble portrait of Cleopatra, inv. 1976.10,
p. 258

Head of a man, inv. misc. 8195, p. 269

Berlin, Museum für Vor- und Frühgeschichte, Staatliche Museen Preußischer Kulturbesitz

Silenus mask, inv. VIIa 516, p. 182

Belthook, inv. IIId 5453, pp. 184–185

Celt, inv. II 950, p. 187

Berlin, Antiken-Sammlung, Staatliche Museen zu Berlin

Patera handle, inv. M.I.10 162, p. 88

Berlin, Pergamonmuseum, Staatliche Museen zu Berlin

Satyr appliqué, inv. 7466, p. 220

Bern, Historisches Museum

Statuette of Juno, inv. 16173, p. 229

Statuette of Minerva, inv. 16171, p. 229

Statuette of Jupiter, inv. 16172, p. 229

Bodrum, Archaeological Museum

Figure of a Black child, inv. 756, p. 227

Bonn, Rheinisches Landesmuseum

Statuette of Venus, inv. C 6379, p. 228

Boston, Museum of Fine Arts

Hermes Kriophoros, inv. 04.6, pp. 130, 212, 275; cat. no. 8

Hermes Kriophoros, inv. 99.489, pp. 130, 212, 275; cat. no. 9

Brooklyn Museum

Egyptian statuette, inv. 37.364E, p. 64

Statuette of Pharaoh Osorkon I, inv. 57.92, p. 68

Weapon handle, inv. 49.167a, p. 69

Statuette of the god Amun, inv. 37.254E, p. 71

Statuette of the god Osiris, inv. 39.93, p. 73

Statuette of an Egyptian official, inv. 37.363E, p. 74

Doll, queen, or goddess, inv. 42.410, p. 75

Kushite female figure, acc. L76.9.2, p. 76

Budapest, Museum of Fine Arts

Oinochoe, inv. 56.11.A, p. 92

Cambridge, Mass., Harvard University, Arthur M. Sackler Museum

Etruscan Turan, inv. 1956.43, p. 264; cat. no. 43

Chalon-sur-Saône, Musée Denon

Unfinished torso, inv. 49-5-8, p. 163

Panther, inv. CA 375, p. 166

Copenhagen, Ny Carlsberg Glyptotek

Etruscan head, inv. 29, p. 269

Delos Museum

Silenus herm, inv. 1007, p. 220

Delphi Museum

Charioteer, inv. 3484, 3540, p. 126

Geneva, George Ortiz collection

Statue of Hermes, p. 276

Statuette of Kriophoros, p. 276

Polykleitan youth, p. 276

Hamburg, Museum für Kunst und Gewerbe

Tarantine mask, inv. 1970.18, p. 267

Istanbul, Archaeological Museum

Alexander Sarcophagus, no inv. no., pp. 188, 223, 225–226

Wrestling group with Ptolemy III as victor, inv. 190, pp. 222, 224–225

London, The British Museum

Standing figure of a woman, inv. 43373, p. 104

Kneeling figure of the soul of Nekhen, inv. 11497, p. 105

Seated figure of Isis, inv. 43380, p. 106

Arm from a Roman statue, inv. 1904.2-4.1249, p. 107

Equestrian statuette of Alexander the Great, inv. 1901.7-10.1, p. 108

Equestrian statuette of Selene(?), inv. 1901.7-10.2, p. 108

Seated figurine of a goddess, inv. 1824.40-20.1, p. 111

Statuette of "Herakles," inv. 1895.4-8.1, p. 116

Limestone portrait of Cleopatra, inv. 1879.7-12.15, p. 258

Etruscan head, inv. GR 1898.7-16.2, p. 267

Statuette, inv. 1897.10-30.1, p. 268

Kouros, inv. GR 1905.6-10.1, p. 270

Banqueteer, inv. 1954.10-18.1, p. 274

Lyons, Musée des Beaux-Arts

Etruscan statuette, inv. A 2009, p. 167

Mainz, Römisch-Germanisches Zentralmuseum

Helmet, inv. 0.39510, p. 191

Malibu, J. Paul Getty Museum

"Dead Youth," inv. 86.AB.530, pp. 33, 277; cat. no. 10

Etruscan kouros, inv. 85.AB.104, pp. 34, 260; cat. no. 37

Roma, inv. 84.AB.671, pp. 36–37, 39–41; cat. no. 64

Incense burner in the form of a singer, inv. 87.AB.144, pp. 44, 47; cat. no. 55

Incense burner in the form of an actor, inv. 87.AB.143, pp. 44, 46; cat. no. 54

Bank in the form of a girl, inv. 72.AB.99, pp. 48–50; cat. no. 70

Venus, inv. 84.AB.670, p. 51; cat. no. 65

Togate magistrates, inv. 85.AB.109, pp. 52–53; cat. no. 63

Herm, inv. 79.AA.138, pp. 54–58

Hydria, inv. 73.AC.12, p. 95

Etruscan Tinia (Zeus), inv. 55.AB.12, p. 263; cat. no. 39

Munich, Staatliche Antikensammlungen und Glyptothek

Attic amphora, inv. 1410, p. 189

Kylix by the Penthesilea Painter, inv. 2688, p. 191

Statuette of Zeus, inv. 4339, pp. 210, 272

Archaic mirror, inv. 3482, p. 214

Statuette of Poseidon, inv. Sig. Loeb 15, p. 219

Statuette, inv. 3707, p. 255

Munich, Weissenburg i.B. Römermuseum, at the Prähistorisches Staatssammlung

Statuette of Mercury, inv. 1981.4389, p. 230

Statuette of a Lar, inv. 1981.4373, p. 230

New York, The Metropolitan Museum of Art

Silver oinochoe, 66.11.23, p. 87

Terracotta vase in the shape of a male bust, 1986.11.14, p. 90

Head of a griffin-protome, 1972.118.54, p. 135

Krater, 50.11.4, p. 188

Mirror handle, 74.51.5680, p. 214

New York, Sotheby's

Statuette of a goddess (ex-Hunt collection, Fort Worth), p. 175

Olympia Museum

Youth from the handle of a tripod, inv. B 2800, p. 86

Legs of a kouros, inv. B 1661, Br. 2702, Br. 12358, p. 131

Head of a griffin-protome, inv. B 145, B 4315, p. 135

Sacrificing hero, inv. B 6300, p. 181

Paris, Bibliothèque Nationale, Cabinet des Médailles

Statuette of a youth, inv. 928, p. 217

Paris, Musée du Louvre

Oinochoe, inv. 2955, p. 89

Terracotta alabastron ending in a woman's bust, inv. S 1072 (D 161), p. 91

Mercury, inv. BR 183, p. 171

Hydria, inv. G 179, p. 190

Statuette of Dionysos, inv. Br 154, p. 217

Statuette of a Black youth, inv. Br 361, p. 227

Kouros, inv. MNE 686, p. 271

Pella Museum

Statuette of Poseidon, inv. 383, p. 219

Princeton University, The Art Museum

Head of a woman, inv. y1980-10, p. 239